"Finally a book that recognizes misunderstood biblical women as Kingdom builders rather than home-wreckers. What a joy to know teachers have a resource for exhorting their congregations to be like Peter and Paul, and also like Tamar and Rahab. As each chapter vindicates another woman, God's love for the marginalized and oppressed jumps off the pages reminding us that he welcomes men and women to pick up the hammer and get to work in the *Missio Dei*."

—**Nika Spaulding,**
Resident Theologian,
St Jude Oak Cliff

"*Vindicating the Vixens* is a monumentally important work in that it confronts the prevalent misinterpretations of some of the most critical women in Scripture. The faithful and meticulous research of Dr. Glahn and the contributing authors advances the powerful message of the book—God's passion for the marginalized, the misunderstood, and the outsider. This book will challenge the way you look at women, both those in the Bible and those you meet every day."

—**Paul Lanum,**
Vice President of Publishing,
RightNow Media

"One of the most important tasks of the believer is to practice faithful exegesis of Scripture—to allow the text to speak for itself without inserting personal or cultural bias. Through the centuries, many women of the Bible have been unfairly labeled, and thus, inaccurately taught. Drawing from faithful study, insight, and experience, the authors expose the errors passed down through the generations and bring to light this beautiful truth: The God of the Bible highly esteems and works through women. Let the vixens be vindicated and the word of God celebrated! I am so grateful for this book."

—**Rebecca Carrell,**
Conference Speaker, Bible Teacher,
KCBI Morning Show Co-Host

"The biblical narrative provides an accurate description of gender. All human beings bear the imago Dei and enjoy the same God-given value and dignity. The fall distorted the relationship of humanity with God regardless of one's gender. The salvation and restoration that Christ brings to humanity makes no distinction between male or female and, in fact, destroys all human-made gender marginalization. For this reason, it becomes imperative to handle faithfully the biblical text in order to have an appropriate understanding of gender, sexuality, and marginalization. Sandra Glahn selected an important group of contributors who together portray a faithful description of key women in the Bible. This exceptional and relevant text fills an unfortunate gap created by distorted, traditional perspectives and not from the Scriptures."

—**Octavio Javier Esqueda,**
Professor of Christian Higher Education,
Talbot School of Theology at Biola University

"I always love the stories of God's daughters in the Bible—God's storybook of the relentless love and pursuit of His people. I especially love when the fuller stories open our eyes to surprising realities. In *Vindicating the Vixens*, Sandra Glahn has pulled together a treasure trove of those stories, written with careful theology, cultural comprehension, and captivating narrative. I can name a few of my favorites—Eve, Ruth, Deborah, Mary Magdalene—but truly, I loved getting to know every one of these too-often maligned sisters better. And so will you, I'm sure."

—Judy Douglass,
Writer, Speaker, Encourager, Director of Women's Resources,
Office of the President, Cru

"*Vindicating the Vixens* is a course correction for the Church—and an invaluable one at that. Chapter after chapter it redeems the reputation of many of the biblical women we've often misunderstood. In the process, it removes misunderstandings, misplaced convictions, and unintentional bias and in their place leaves a better sense of God's love and justice. Reassessing my forgone conclusions has never felt so valuable."

—Kelsey Hency,
Editor in Chief,
Fathom

VINDICATING *the* VIXENS

REVISITING SEXUALIZED, VILIFIED, AND MARGINALIZED WOMEN OF THE BIBLE

SANDRA GLAHN

EDITOR

Kregel
Academic

To those who seek to act justly.

He has shown you, O mortal, what is good.
And what does the LORD require of you?
To act justly and to love mercy
and to walk humbly with your God.
 —Micah 6:8, NIV

Profits from this book benefit the work
of the International Justice Mission.

LIST OF CONTRIBUTORS

Eva Bleeker (MACE, MAMC, MS) holds two master's degrees from Dallas Theological Seminary and an MS in Narrative Medicine from Columbia University in the City of New York. She serves as a hospital chaplain in Northern Virginia.

Sarah Bowler (ThM), communications manager at EvanTell, focused her graduate work on Old Testament Studies. She is the author of *Bathsheba's Responsibility in Light of Narrative Analysis*.

Lynn H. Cohick (PhD) is professor of New Testament at Wheaton College. She is the author of commentaries on Ephesians and Philippians as well as *Women in the World of the Earliest Christians*. She is also the coauthor of *The New Testament in Antiquity*, as well as numerous journal articles.

Sandra L. Glahn (ThM, PhD), general editor, is associate professor of Media Arts and Worship at Dallas Theological Seminary. She is the author or coauthor of more than twenty books, including the Coffee Cup Bible Study series, and she lectures in the areas of gender, sexuality, aesthetics, bioethics, and medieval art and spirituality. She is also a regular blogger at aspire2.com and bible.org.

Carolyn Custis James (MA) has authored six books, including *Malestrom: Manhood Swept into the Currents of a Changing World*, and *Half the Church: Recapturing God's Global Vision for Women*. She blogs at carolyncustisjames.com, MissioAlliance.com, and Huffington Post/Religion; and is an adjunct faculty member at Biblical Theological Seminary in Philadelphia. She is a consulting editor for Zondervan's Exegetical Commentary Series on the New Testament. Additionally, she is a visiting lecturer at various theological seminaries.

Glenn R. Kreider (ThM, PhD) is professor of theological studies at Dallas Theological Seminary and is the author of *God with Us: Exploring God's Interaction with God's People throughout the Bible*.

Marnie Legaspi (ThM) received her BS in Bible from Lancaster Bible College, after which she became a church planter in Eastern Europe. She earned her master's degree in Systematic Theology at Dallas Theological Seminary, and her current vocation is working as a full-time mother.

An Arab Christian scholar from Lebanon, **Tony Maalouf** (ThM, PhD) is distinguished professor of World Christianity and Middle Eastern Studies at Southwestern Baptist Theological Seminary in Fort Worth, Texas. He is the author of *Arabs in the Shadow of Israel: The Unfolding of God's Prophetic Plan for Ishmael's Line.*

Christa L. McKirland (MA, ThM), is pursuing a doctorate in theology at the University of St. Andrews in Scotland. Her graduate studies focused on the role of the image of God in human embodiment. She is the coauthor of *Who's in Charge? Questioning Our Common Assumptions about Spiritual Authority.*

Eugene H. Merrill (PhD), a past president of the Evangelical Theological Society, is now an independent scholar. Retired after thirty-eight years from Dallas Theological Seminary, he still serves as distinguished professor of Old Testament Interpretation at the Southern Baptist Theological Seminary. Having earned degrees in Judaica (MA) and Middle Eastern Studies (PhD), he lectures in the areas of Hebrew and Semitic languages, biblical backgrounds, and Old Testament theology. Currently involved in an excavation at the possible site of biblical Ai, Dr. Merrill is the author of numerous reference books, and he has served as contributor, translator, and editor for numerous study Bibles.

Amy Peeler (PhD) is associate professor of New Testament at Wheaton College and associate rector at St. Mark's Episcopal Church, Geneva, Illinois. She is the author of *"You Are My Son": The Family of God in the Epistle to the Hebrews.*

Ronald W. Pierce (MDiv, ThM, PhD) is professor of Biblical & Theological Studies in the Talbot School of Theology at Biola University. He served as coeditor of, and contributor to, *Discovering Biblical Equality.* He also authored *Partners in Marriage & Ministry,* as well as a commentary on Daniel.

Timothy J. Ralston (ThM, PhD) is a specialist in New Testament and professor of Pastoral Ministries at Dallas Theological Seminary, where he teaches courses on worship, aesthetics, pastoral theology, and homiletics. He is the author of numerous scholarly essays and journal articles.

After graduating from Bible college in his home country of Australia, **Henry Rouse** (ThM) was a school chaplain and a youth pastor for thirteen years. After earning his ThM in the US, he served on the faculty of Adelaide College of

Ministries in Adelaide, Australia, teaching biblical interpretation and preaching classes. He is currently an itinerant preacher in Adelaide, developing church-based resources aimed at training lay people to study and teach the Bible.

Vocalist and New York native **Sharifa Stevens** (ThM) earned a bachelor of arts degree from Columbia University in the City of New York before moving to Dallas, Texas, where she received a master of theology degree from Dallas Theological Seminary. She currently serves as a writer for the Pastoral Ministries Department of Insight for Living Ministries.

An architect turned vocational discipleship leader, **Karla D. Zazueta** (MACL) holds a master's degree from Dallas Theological Seminary and serves alongside her pastor-husband at Stonebriar Community Church (Spanish Ministries) in Frisco, Texas. She is the author of *Discipleship for Hispanic Introverts: Providing a Cross-Cultural Context for Life Change*. She is also a regular blogger at bible.org.

CONTENTS

PREFACE

SANDRA GLAHN, PHD

The Scriptures contain many stories that include bad girls of the Bible. Jezebel had a man falsely accused and stoned to death so she could grab his property (1 Kings 21). Potiphar's wife abused political and sexual power (Gen. 39). And Salome was complicit in the beheading of John the Baptist (Matt. 14:1–12). To name a few.

Yet the Scriptures include numerous stories of men who did evil, too. The first murderer? Cain (Gen. 4). The biggest womanizer? Solomon (1 Kings 11). Jehoram killed his six little brothers and a few officials to secure the position on his father's throne (2 Chron. 21:1–4). And let's not forget the one who betrayed the Lord with a kiss (Luke 22:48).

Doubtless, sin is an equal-opportunity enterprise. And certainly the desire of the team of scholars assembled for this project is not to vindicate women whose actions we should all despise. Nor is it our goal to make men look bad and women look good.

Our motivation is to handle faithfully the biblical text, which involves bringing to light a number of women labeled as "bad girls" who deserve a fresh look. Eve is blamed for the guilt of the whole human race. Yet, is that how the author of Genesis intended his readers to perceive her? People say the Middle East's problems go all the way back to Sarah because she was so desperate to conceive that she chose a sinful way to build Abraham's legacy. But did she? And was the author of the book of Esther really trying to show through Vashti's choice that bad things happen when women refuse to submit—even to unjust husbands?

In many cases the evil which people have seen in some of the Bible's so-called bad girls is sexual, even when the text suggests otherwise. Or sometimes the women in question were involved with sexual acts, but is it possible that we accuse them falsely? For example, some blame Bathsheba for seducing King David, but is that really how the text describes her actions?

People remember that the Canaanite Rahab was a harlot, but wasn't that her occupation before her statement of faith in Yahweh? Ruth gets accused of propositioning Boaz at the threshing floor. But did she? People vilify Tamar for seducing Judah, but is it possible she was exercising a legal right? (And why is Judah remembered for something other than his immoral act when we read about *him* in Jesus's genealogy?) Vashti's narrative is treated as if she was all that stood in the way of a Disney-princess love story rather than as a victim of exploitation. So why do we downplay the pain inflicted on her? People say Mary Magdalene was a reformed prostitute, but doesn't the text say only that she was delivered from demons? And when the women of Jesus's genealogy are mentioned, often speakers say that they were added to show that God forgives sexual sin. But is a focus on their sexual histories really what the Gospel writers were going for?

Then there's "the woman at the well." Jesus, a Jew, spent time with and spoke to a Samaritan at a time when Jews and Samaritans refused to speak to each other. Indeed, he spoke to a *woman*, even when doing so was taboo (see John 4:27). Now, while this woman's past with five husbands has led many to assume that she dumped multiple partners and had loose morals, is it possible that we have grossly misunderstood her—and what Jesus was communicating when he brought up her past?

Our view of these women and others has important ramifications. I was taught repeatedly that Jesus brings up the Samaritan woman's sin because that is what we should do when we talk with people about Jesus—start by talking about people's separation from God. But what if Jesus was actually reaching out to her with empathy at her greatest point of loss? Might that affect how we communicate the good news?

In her address to a 1940s British Public Morality Council, Dorothy L. Sayers talked about what she called "The Other Six Deadly Sins." Although more than seven decades have passed since she delivered the speech, little has changed. Sayers noted that a person may be "greedy and selfish; spiteful, cruel, jealous, and unjust; violent and brutal; grasping, unscrupulous, and a liar; stubborn and arrogant; stupid, morose, and dead to every noble instinct"[1] yet still we are ready to say of that person that he or she is not immoral if none of the sins in question were sexual. Sayers tells of a young man who once requested of her with perfect simplicity, "I did not know there were seven deadly sins. Please tell me the names of the other six."[2]

The tendency to blame women for sexual offenses has affected how we read about them in the pages of holy writ. And in numerous cases—some of which this work will explore in depth—women in Bible stories have either been falsely accused or their actual sexual sin has been held against them like a scarlet *A*, when that sin was not even the point of the biblical writer.

1. Dorothy L. Sayers "The Other Six Deadly Sins," *Creed or Chaos?*, 63.
2. Ibid.

In addition to maligning some Bible women, we have marginalized others, wrongly downplaying or even ignoring their contributions. For example, Hagar was a God-fearing, abused slave from whom African Americans have long drawn inspiration. Yet most Bible studies done in white churches approach Sarah as the flawless hero and ignore Hagar altogether.

Some say that God used Deborah as a prophet/judge only because a good man couldn't be found, but does the text say anything of the sort? When I was in Bible college, I had a New American Standard Bible that featured some charts, and I noticed that the roll of judges included Barak, whom the text does not call a judge, but excluded Deborah, who is called both judge and prophet—joint titles given only to one other person, Samuel. Wondering about this omission, I read commentaries. And I found that the reason some gave as justification for replacing Deborah was that the writer of Hebrews 11 mentions Barak, but not Deborah. This, they said, proves he was the *real* judge.

But that Hebrews text actually says this: "And what more shall I say? For time will fail me if I tell of Gideon, Barak, Samson, Jephthah, of David and Samuel and the prophets, who by faith conquered kingdoms, performed acts of righteousness, obtained promises, shut the mouths of lions, quenched the power of fire, escaped the edge of the sword, from weakness were made strong, became mighty in war, put foreign armies to flight" (Heb. 11:32–34). Certainly it's true that the author mentions Barak and not Deborah by name. But the phrase "and the prophets" is broad enough to include her. And the writer goes on to describe those who "put foreign armies to flight." Certainly Deborah is included in that group, as well (see Judges 4–5).

With the mention of David, the author of Hebrews includes the era of kings in the annals of faith history. And during that time, Huldah was among the prophets. Yet many people, folks with a lot of Bible training, have never heard of her. Why not?

All of the abovementioned women are the subjects of a fresh look in this work. Additionally, a chapter has been included to revisit the Virgin Mary, because many Protestants—perhaps in a pendulum-swing away from what they view as Mary-worship—ignore Mary altogether. I've attended numerous women's Bible studies focused on women of the Bible, and not one has ever included Jesus's mother. Yet where Protestants are quick to view the Virgin Mary as flawed, others have made her so pure that she remains unapproachable to the average person. The result: Another good Bible woman struck from the list of lives for us to emulate.

Like Dorothy L. Sayers, I never wanted to make "women's issues" my topic of focus. But I've also seen new life breathed into women who see with fresh eyes how the text values them—rather than criticizes, minimizes, or stereotypes them. And I've also see the positive effects on men and on male/female relationships when men gain a clearer understanding of the text as it relates to great women of faith. Additionally, if the author's point in the case of each of these

women differs from what we've made it—and this is a key question—what *are* the truths and applications we've missed?

One of the greatest surprises—and pleasures—for me as I edited this work was to find, as the chapters came in, that as slandered or ignored women in the Bible were vindicated, we recovered more than just a sense of how we should honor them. We could also see more clearly the point that the biblical author was actually trying to make by including these women in their stories. And time and again, God's heart for the the silenced, the marginalized, the powerless, the Gentile, the outsider, was what had been missing.

I've gathered a team of male and female scholars from different nationalities and ethnicities, as well as educational institutions and religious traditions, to address these issues and more. The writers are "all over the map" on their view of women preaching and even in their approaches to the women explored in this book. But they agree on this: We must revisit what the Scriptures say about some Bible women we have sexualized, vilified, and/or marginalized. Because, above all, we must tell the truth about what the text says.

Maybe you suspect we're doing this because the radicals and liberals are taking over (cue evil laugh). Or you might think we're pushing some social agenda. Neither is the case. Conversely, there are compelling reasons that a reexamination is necessary.

First, doubtless the issue of gender roles in the church and society is a hot topic, and there are some radicals out there. We need to make sure our position is truly grounded in the Word. As such, we acknowledge that more men and women should be partnering in ministry, imaging God as male and female. If we are *rightly* criticized for having vilified some women in the Bible, let us embrace the fact that Jesus is the Truth, and listen to truth, regardless of its source.

Another reason to reexamine some passages is because of what's at stake. Our own view of women reveals what we think God says about half the people on the planet. And our view of women will also determine how we treat our female friends and coworkers, our mothers, our daughters (if we're parents), and our wives (if we're husbands). Our perspective affects how we view power and how we see sex. If our views are based on faulty interpretations of Scripture, we will embrace a faulty view of God. Indeed, God's very reputation is at stake if we misunderstand how to view those who image him.

A third reason to reexamine some women in the Bible is because new information has come to light. The Internet has given researchers access to information and to additional colleagues inaccessible even ten years ago. Online availability of ancient documents, archaeological finds, geographical surveys, and research projects from all over the world have given us clearer pictures of what the ancient world looked like. Social history studies are helping scholars better identify how people wore their hair and why, how they greeted each other, and ancient views of acceptable and unacceptable practices. Gender studies help us read between the lines for power differentials and subtexts.

Does new information and nuanced language solve all our problems? No. But an exploration of it will help us better understand how cultures and societies have developed over millennia, and how beliefs and viewpoints have changed. And these factors will hopefully help us better understand how to view Scripture and apply it in our own time. The world has not always had a postmodern or post-Industrial Revolution way of looking at life and labor or the roles that humans play. So we need to take a step back and consider how those before us did see life and roles. Perhaps new data does not answer all our questions, but it may help us ask better questions.

One more significant change in recent years is a beautiful broadening of the makeup of participants in biblical translation and interpretation. More women have entered the academy, and more members of underrepresented groups are engaging in theological conversations. And the enhanced ability to share information from a distance allows us to welcome more international perspectives and include broader socioeconomic representation, all of which creates synergy and enriches our knowledge. Aussie Henry Rouse, whom you will meet in the chapter on hermeneutics, put it this way:

> For the first forty years of my life, my library of Christian authors consisted primarily of white western males. But what happens when the task of biblical interpretation is faithfully applied by an Asian woman or a Latino man? Does an Ethiopian believer see things that a European misses? Would a woman catch things in the text that a man might miss? Does this Aussie bloke see things slightly differently from how an American might? (Consider what we envision when we hear the word "football.") The truth is that never before has there been such a diversity of eyes on the text in conversation with one another. It is no longer just males who do biblical interpretation, nor is it just people from your demographic grouping. And this is a wonderful development. We do well to listen to what everyone has to say, especially because the new eyes are just as well educated (sometimes more), trained (sometimes more) and godly (sometimes more) as you and I are. ˈ

Although the authors contributing to this book may have many differences, we are united in our desire to be faithful in biblical interpretation (more on that ahead, too), and our desire is to reexamine the topic thoughtfully, intelligently, and prayerfully.

Not all contributors agree with each other on every point. But I have left in their varying views, in order to challenge our thinking and drive us back to the text. I've been guided in this by Rupertus Meldenius (c. 1627), who wrote, "In essentials unity, in non-essentials liberty, in all things charity." Additionally, the authors' contributions have not been edited in a way that would give them similar voices. So you will find variety in tone, style, and even number of footnotes and transliterations from chapter to chapter.

Also, to benefit sexualized, vilified, and/or marginalized women in our own day, profits from this project will benefit the International Justice Mission (IJM), which seeks in the name of Christ to empower the sexualized, marginalized, and vulnerable.

Despite her hesitation about addressing issues related to women, Dorothy L. Sayers eventually felt compelled to speak out. That's because she noticed some characteristics of Christ's interactions with women that drive us, too:

> Perhaps it is no wonder that the women were first at the Cradle and last at the Cross. They had never known a man like this Man—there never has been such another. A prophet and teacher who never nagged at them, never flattered or coaxed or patronised; who never made arch jokes about them, never treated them either as "The women, God help us!" or "The ladies, God bless them!"; who rebuked without querulousness and praised without condescension; who took their questions and arguments seriously; who never mapped out their sphere for them, never urged them to be feminine or jeered at them for being female; who had no axe to grind and no uneasy male dignity to defend; who took them as he found them and was completely unself-conscious. There is no act, no sermon, no parable in the whole Gospel that borrows its pungency from female perversity; nobody could possibly guess from the words and deeds of Jesus that there was anything "funny" about woman's nature.[3]

It is this Jesus whom we hope to help readers see more clearly, love more dearly, and follow more nearly until his kingdom comes and his will is done on earth as it is in heaven.

Sandra L. Glahn
Dallas, Texas
Summer 2016

3. Dorothy L. Sayers, *Are Women Human? Astute and Witty Essays on the Role of Women in Society*, 68–9.

ABBREVIATIONS

AB The Anchor Bible

ANET *Ancient Near Eastern Texts Relating to the Old Testament*

BADG *A Greek-English Lexicon of the New Testament and Other Early Christian Literature*

BDB *Brown-Driver-Briggs Hebrew and English Lexicon of the Old Testament*

COS *The Context of Scripture*

GKC *Gesenius' Hebrew Grammar*

HALOT *Hebrew and Aramaic Lexicon of the Old Testament*

NIDOTTE *New International Dictionary of Old Testament Theology and Exegesis*

TDOT *Theological Dictionary of the Old Testament*

INTRODUCTION:
THE HERMENEUTICS OF "HER"

HENRY ROUSE, THM

I grew up in the 1970s. We didn't have smartphones, text messaging, emails, or the Internet. But we had color TV, and we watched *Happy Days*. Life was good. I started using Brylcreem when I was fourteen, had my sights set on a black leather jacket, and "The Fonz" was my hero. You remember Fonzie, right? Blue jeans, leather jacket, motorcycle—he was cool, slick, and tough. All the guys wanted to be like him, and all the girls wanted to be with him. Everything he did was great. He saved females in trouble, rescued nerds from bikers, and taught us all lessons about working hard, respecting our parents, and being cool. Fonzie had only one problem: He could never admit he was wrong. He knew when he was wrong, and he would *try* to admit it, but he just couldn't say the words. "I was wr-wr-wr-wr . . . I was wr-wr-wr-wr . . . I was not exactly right."

Like Fonzie, most of us find it hard to say, "I was wr-wr-wrong." It's hard to admit to my kids when I get angry and I need their forgiveness. It's hard to confess to my wife that I forgot that important thing because I failed to pay attention. I don't like being wrong, and I don't like admitting it. It makes me feel weak. And it assaults my pride. And if I admit I'm wrong in one area, in how many other areas have I been wrong? My own self-delusions of intelligence and superiority come crumbling down. So, I prefer to protest, shift the blame, excuse, and rebut—just let me keep my pride intact.

What does this have to do with hermeneutics and women in the Bible? A lot. What if I've been wrong about a lot of Bible stories? Seriously, what if I, what if you, have been wrong? What if some of our views about certain women in the Bible are mistaken? What if the conclusions we have drawn from these faulty views are misguided? And what if these misguided conclusions have led us to poor applications? Would you and I be prepared to admit we were wrong? Would we be willing to confront ourselves in the mirror and be really honest?

Or are we just like Fonzie—too tough and too cool ever to admit that we could be wr-wr-wr-wr . . . not exactly right?

Before we go any further, I want to be really frank. This is not some book written by theologically liberal, wannabe scholars attempting to be politically correct or manipulating the text in order to be culturally relevant. The contributors to this book love God's Word. And we don't see our task as reinterpreting the text to make it more relevant or more acceptable than it already is—as if that were possible. Our goal is simply to study it and make sure we are being faithful to it. We are not questioning the inspiration, inerrancy, or infallibility of the Scriptures. We are, however, questioning the inspiration, inerrancy, and infallibility of our human interpretation of them. I say these things because often those who challenge us to revisit some of the texts we'll explore in this work get accused of having a low view of Scripture. But as I said, the issue here is not one of inspiration but of interpretation.

Indeed, each one of the contributors to this book believes that Scripture is God's revelation of himself, his work, and his plans for humanity. Being divinely inspired by the Holy Spirit, the original text is authoritative, reliable, and useful in all that it teaches. And any view that treats it as less than this, we believe, diminishes its authority, reliability, and usefulness in the affairs of human life. It is the very Word of God.

Not only are the Scriptures God-breathed, we believe, but they also consist of writing. Of all the means of communication God could have used, he chose to inspire human authors to write. He could have used a DVD (Divine Video Disk) series with episodes from every era of biblical history—a holographic projection, perhaps, with messages from Adam and Eve, Abraham, Ruth, Peter, Paul, and Mary. Yet God chose to use human beings with all their faults and failures, personalities and problems, backgrounds and baggage. And he moved them to write. So the Word that we have is the *written* Word. It's divine in its source, absolutely; but it's also literature. And as it is a work of literature, we must—and this is critical—discuss and study it as literature without diminishing its divine origin.

Our motives in studying are also essential. As the late Dr. Howard Hendricks used to warn, study of the Bible is not meant to make us smarter sinners. We are not increasing knowledge of the text or correcting faulty understanding so we can wow our friends with great dinner conversations, impress ourselves with the abundance of our theological knowledge, or make us critics about everyone else's misguided efforts. The goal of our instruction is love (1 Tim. 1:5), the personification of which is Jesus Christ. Conformity to his image is our goal. And the bearing of God's image is not solely for our own benefit. We are meant to be light to others in order to bring them to know God (Isa. 49:6, Matt. 5:14–16). It is our belief that a more accurate understanding of how the Scriptures present women in the text will help tear down walls of misogyny that have stood as barriers between people and the God who inspired the Word.

So how do we handle the text? *How* we study Scripture, the process we use to understand it, is hermeneutics. And part of the challenge in understanding Scripture is that people use different hermeneutics. Rather than going into an extended discussion of various methods, however, we will simply outline the method used by the authors of this book.

As we approach Holy Writ, there are certain literary rules we follow to interpret it accurately, understanding writing as a science, an art, and a practice that requires the help of the Holy Spirit. Yet to call it an "art" is not to suggest that we interpret Scripture as we would an abstract painting or sculpture, in which authorial intent often matters little. Hermeneutics is the craft of using well the laws of interpretation, and doing so in the context of community.

That community can involve our brothers and sisters in the faith from past eras. But it also includes men; women; Aussies (like me); Palestinians (like Dr. Maalouf, who wrote the chapter on Hagar); Californians (like Dr. Pierce, who wrote the chapter on Deborah); transplanted Americans living in Scotland (such as Ms. McKirland, who wrote on Huldah); Chicagoans (like Drs. Cohick and Peeler, who wrote about the Samaritan woman and Junia); African-American New Yorkers (like Ms. Stevens, who wrote the chapter on Vashti); an expert on Latino discipleship (like Ms. Zazueta, who wrote on Mary Magdalene); and all number of combinations. The more eyes and perspectives on the text, the better.

Belonging to Christ means becoming a member of a body with many parts. Yet pop Christianity has sold us an individualistic view of spirituality. We can have any version of the Bible we like. We can have it downloaded and read to us on our smartphones. We can "do church" online. We can worship alone. We can tithe online. We can listen to the best preachers in the comfort of our own living rooms at a time that suits us. We can even grab our two best mates and "do communion" on Saturday night before the big game. Do you see a problem with this picture? It's not that any one of these things breaks with church tradition, or even violates Scripture. Rather, it's that the combined effect can lead to an individualistic Christianity that is not biblical Christianity. The church, the body of Christ, is a community. And while we are told to pray in our closets (Matt. 6:6), we do our theology, our hermeneutics, in community.

So how do we eliminate the guesswork and arrive at a faithful interpretation of Scripture? I suggest six questions to ask every time we approach the text. These will give us a sound basis for interpretation and application.

SIX QUESTIONS WE BRING TO THE TEXT

What does the text actually say?

It is critical that the first step in biblical interpretation is knowing exactly what we are looking at. We all come to the text with baggage and preconceived ideas. Often, we've already heard sermons, memorized verses, and read devotional

books on the passage at hand. So we may think we know what it means as soon as we read it. But we must stop and ask, "What does the text actually say?"

What do I observe in and about the text?

We begin with genre. Historical narrative differs significantly from poetry, which differs significantly from apocalyptic literature. Authors use different genres and styles to convey different messages. If I want to tell my wife how much she means to me, I might use poetry to get my point across. I could write, "I would swim the seven seas for you." If I do so, I'm not lying, but she knows it's impossible, and I hate swimming. Yet the message of the poem is true. I'm saying that I love her and would do whatever I could to bring her happiness. Genre matters.

We also pay attention to the details of the passage. We consider all the words that the Spirit inspired the authors to use, and we look at how the authors have put together those words to form phrases and sentences. We're not just looking for a general vibe of the passage. We're not jumping to conclusions. We take time to notice the grammar and structure. What are the key nouns and verbs? How does the author use them in the sentence? How do the words relate to one another? We identify words that require extra study, perhaps because they are unusual or unfamiliar. We observe whether the words are being used in a literal sense (e.g., water in a lake), illustratively (e.g., lake of fire), or perhaps in a figure of speech ("come hell or high water"). We look for words that the author seems to be emphasizing, often by repetition, such as the word "sent" in the David-and-Bathsheba story.

Something else we observe is the context of the passage. Every word, sentence, and paragraph sits within a greater context. Each chapter exists within a book, and each book exists within the context of the whole Bible. Whenever we take a verse out of its context and turn it into a greeting-card saying or bumper-sticker proverb, we are in danger of ignoring the context and missing the truth.

What did this text mean to the original audience?

Next, we seek to put ourselves in the shoes of those who heard or read its words the first time. We seek to know why Moses wrote what he did to the Israelites, newly freed from Egypt and headed to Canaan. We want to understand what the Corinthians understood as they received their letters from Paul. We try to stand in the sandals of first-century persecuted believers as they heard the Gospel of Mark for the first time. This step is the heart of interpretation. What did the text mean to the original audience?

Often the text itself gives us clues. So we identify when the text was written and in what circumstances. We try to discover the author's purpose in writing. And although the Bible was written for us, we have to understand that it wasn't originally written *to* us. So discovering the author's original intended meaning helps us better understand how it applies today.

We ask, "What particular situation or need caused the author to write these things to these people?" and "What response was the author looking for from the original recipients?" Knowing the answers to these questions helps us connect the dots to similar issues or situations that we might struggle with today. For example, we don't concern ourselves with meat sacrificed to idols, as Paul did. But we do have concerns about causing weaker believers to violate their consciences—a timeless issue in Paul's situation.

To discover the author's intended meaning and how the original audience would have understood it, we look at background information. We study the text linguistically and literarily to discover how people wrote when the author wrote the text. How were certain words used, and what did they mean? What styles of writing were common? What metaphors and figures of speech were used then, and what did they mean?

We also study history and geography to understand what was going on in the specific places of the world of which the Bible speaks. Who was in political control? What was the economic situation? Which peoples held power and influence at the time? Did the topography or weather of a region affect the readers' understanding?

Recognizing that every word of Scripture was written within a cultural context to people in a cultural context, we must take culture into account when interpreting the Bible. The culture of the author and audience significantly affected their understanding of what was written. Cultural background studies include explorations of what people believed, how they thought and communicated, what they did, how they lived their daily lives, and how they worked. Such studies cover categories such as politics, religion, economics, agriculture, social and familial habits, fashion, diet, architecture and art, to name a few.

In the past few decades, especially with the influx of more women into history departments and participating in archaeological studies, emphasis has expanded from political history to include more social history. What did people wear? What did they eat? What was the average life expectancy? Because so much of the New Testament relates to the lives of non-elites, Christians seeking a better understanding of cultural backgrounds have especially benefited from this development—and at a time when we can more easily communicate findings through electronic media.

What was the point?

A key task of hermeneutics is to understand the point the author was trying to make. When Paul spoke of "coverings" in 1 Corinthians 11, we seek to find out if he was primarily concerned with fashion trends or if what someone did with his or her hair had symbolic meaning. In the same way that an American wearing a ring on the fourth finger of the left hand has meaning, what did it mean for a Corinthian to wear his or her hair a certain way? Our background studies combine to help us determine the real point of the passage. As we take all this into account,

perhaps we conclude that Paul was primarily concerned about husbands and wives showing respect to Christ and each other in the context of public worship.

What truths in this text are timelessly relevant?

Before we skip ahead to application and demand that men cut off ponytails and women wear hats to church, we ask, "What truths are timelessly relevant?" In asking this question of a passage, we are not seeking to ascertain what parts of the Bible are still relevant, as we believe the entire Word of God is relevant. What we are doing is taking the biblical truth and asking which applications from this passage are always relevant to all people. We want to know what truths apply regardless of when, where, and to whom they are applied. For example, Old Testament biblical law said a rapist had to marry his victim. Does this mean we advocate for criminal-victim marriages today? The practice, as envisioned for the original audience, was to make the one who violated a woman responsible for her lifelong care. The Bible has always stood for justice, but how that works itself out in different eras and places may change from culture to culture. The Scriptures are absolute truth; how we apply them has some fluidity.

How does the part fit the whole?

For a truth to be timeless and universal, it must be consistent with the entire teaching of Scripture. For example, the Bible is always consistent in the theological truth that husbands and wives should show respect for each other, even if the practical expression of that truth changes from one period to another. Consider that, at one time it was considered a mark of respect to rise from my seat whenever a woman entered the room. This was not always the way, and certainly is no longer practiced in the northern suburbs of South Australia. In fact, in some circles people view such practices as archaic, sexist, and disrespectful. Those of us who like the practice have to be careful that we don't disrespect the very principle of respect by clinging to applications that are no longer valid.

Instead of jumping straight to application after a quick reading of a biblical passage, we must understand the timeless truth behind a practice in order to make sure the practice lines up with that truth. Do you greet everyone with a holy kiss? Some do, but some don't. The ones who don't aren't necessarily disobedient, even though the instruction to do so appears in the imperative.

Indeed, some may object at this point by saying, "Well, I just take the Bible literally!" But the reality is this: No, you don't. Do you regularly invite strangers to use your guest room or couch (Heb. 13:2)? Have you followed Jesus's command to sell all you have to give it to the poor so that you may have treasure in heaven (Luke 12:33)? Do you follow his command to wash others' feet (John 13:14)?

No, we don't take the Bible literally in a consistent manner. But we should take the Bible as literally as it was intended to be taken. We treat metaphors as metaphors, poetry as poetry, and narrative history as narrative history. We don't

turn poetry into narrative, apocalyptic passages into scientific treatises, nor read metaphors as real life. We don't do that with any other piece of literature, nor should we do so with the Bible—special as it is.

THEY WERE SINNERS LIKE WE ARE

You would think after nearly two thousand years of studying the New Testament and even longer for the Old, we would have things worked out by now. Why isn't what our forefathers and foremothers believed good enough for us? Assuming that they had it all right, that would be a fair deduction. But did our spiritual ancestors have everything right? Did the early church even get everything right?

Faulty thinking revealed itself almost as soon as the church was born. Racism surfaced in Acts 6 with the controversy between the Hellenistic widows and the Hebrews. Did they not understand that all men and women were created equally in the image of God? It seems that the Holy Spirit inspired Luke to write the book of Acts, in part, to demonstrate clearly that the gospel message was for people of every tribe, tongue, and nation. And that was not a new message. God told the Israelites that they were to be a light to the nations (Isa. 49:6), but many of them didn't seem to get it then, either.

After the church was established, more problems arose. Paul had to get serious with the Galatian church, because they were turning away from grace and going back to legalistic Judaism. Didn't they know that salvation was by grace through faith? Theological correction of the church's biblical interpretation began early. And we've been doing so ever since, because in our humanity, we always have a way of messing things up.

The Reformation was probably the biggest reexamination of biblical interpretation in modern history. Protestant Christians affirm that a reexamination of the kind that Luther undertook was necessary and good. Because of Luther's reexamination, we have a great appreciation for salvation by grace through faith in Christ. Hadn't the church in the first fifteen centuries read Galatians? Of course they had. But somewhere along the way, the interpretation of many became faulty, which led to poor application. That was just one of the corrections that Luther brought by reexamining the biblical interpretation of the day.

Another more recent reexamination of biblical interpretation concerned slavery, segregation, and human rights. Slavery in the US was defended by some people's biblical interpretation. Yet the very reexamination of this interpretation caused people to see anew that all human beings are equal and worthy of respect, regardless of the color of their skin or the nation in which they were born. Slavery wasn't an issue fought entirely in the realm of biblical interpretation, but for a nation that held deeply religious views centered in the Bible, the interpretation of verses about slavery had great bearing on the eventual outcome.

We have always been reexamining our biblical interpretation, because we understand that every generation has its unique brands of blindness. For example, the medieval mystics might have starved themselves and deprived

themselves of too much sleep, but they also prayed much more than most of us do. Additionally, we all come to the text with preconceived ideas, so it stands to reason that our biblical interpretation has some fallibility. Instead of fearing a re-examination, we should pursue a constant reexamination in order to challenge ourselves toward growth. The alternative is to assume we have it all figured out and cling to the status quo.

There are only two possible results of reexamination—and both are benefi-cial. Reexamination either confirms that something is right and strengthens our understanding and faith, or it points out where we have been wrong and enables us to correct our course, leading us closer to conformity with Christ. We can't lose. But it might require us to change some of our views, confess our mistakes, and admit that we were wr-wr-wr-wr.... Can you say it? Wrong.

THE WOMEN IN JESUS'S GENEALOGY: MORE THAN REDEEMED SINNERS

TAMAR:
THE RIGHTEOUS PROSTITUTE

CAROLYN CUSTIS JAMES, MA

War creates moral dilemmas. In Germany during WWII, a young Jewish girl bravely faced a life-altering moral catch-22. German soldiers were rounding up Jewish friends and neighbors and transporting them to Nazi concentration camps. At any moment, she and her family could be next. Well aware that a concentration camp meant suffering and death to her entire family, she made a fateful moral decision. To rescue her family from a horrific fate, she gave herself to the Nazi soldiers. From that day on, her self-identity changed forever. She saw herself as a prostitute. The successful rescue of the family she loved came at unspeakable cost to her—leaving permanent scars of a trauma she would carry to her grave and a dark secret that, if revealed, would brand her in the eyes of others with an indelible stigma as a Nazi collaborator, an immoral woman, or both. Instead of being hailed as the selfless hero she truly was, she'd be classed as damaged goods. Faced with the moral dilemma of either losing her entire family in a Nazi death camp or prostituting herself to Nazi brutes, she chose the latter.

Bible stories also reveal moral dilemmas. Tamar, the infamous Canaanite daughter-in-law of the Old Testament patriarch Judah, faced a life-altering moral dilemma as well. But it's difficult, if not impossible, for modern readers to view her in that light because, when we read her story in Genesis 38, the word "prostitute" leaps off the page and colors everything else we read or think of her. That one word says it all. Without a pause, the judicial gavel comes crashing down with a thud, and we become incapable of seeing that she is dealing with a complicated situation. Instead, with a single blow Tamar

is tried, convicted, and sentenced with no possibility of parole. Never will I forget the awful words of condemnation that thundered from the pulpit of one pastor. "Tamar corrupted the line of Christ!"

If we know anything at all about the story of Tamar and Judah, we know it as one of the most salacious moments in the entire Old Testament. Tamar, the unscrupulous widowed daughter-in-law of the patriarch Judah, disguised herself as a prostitute in order to seduce her own father-in-law. How could the story of Tamar be anything other than a tawdry scandal?

Often pastors preaching through Genesis opt to skip over Tamar's story, which interrupts the far more interesting and better-known story about Joseph, popularized by Andrew Lloyd Webber and Tim Rice's *Joseph and the Amazing Technicolor Dreamcoat*. The gripping story of Joseph, sold by his brothers into slavery in Egypt, carries on seamlessly without her anyway, sparing the pastor from the awkward challenge of trying to explain her bewildering R-rated story. In addition to the obvious concern that such adult material is unsuitable for a general audience, pastors also face the daunting challenge of trying to salvage any useful application or word of inspiration to offer their congregations. Besides, just when suspense is heating up in the Joseph story and folks are hanging on the edge of their seats, it seems counterproductive to switch to a seemingly irrelevant story that will likely take the oxygen out of the sanctuary.

Even those who courageously wade into this perplexing narrative seem to find little more than fodder for warnings about the seductions of manipulative, vindictive women. Some think Tamar was so selfishly determined to become a mother that she was willing to stoop to anything, even prostitution, to conceive a child—a method that allegedly gave her the added benefit of getting even with her unsuspecting father-in-law for breaking his word to her. All of this makes the prospect of rescuing Tamar from her "vixen" status seem unpromising, to say the least. The evidence is stacked against her. But upon examination, the Bible actually contains significant clues that warrant a closer look, and which should raise doubts about any negative opinions of Tamar.

For starters, her descendants don't regard her as a skeleton best kept hidden in the family closet. Moments when you'd think Tamar's shady chapter of family history should remain behind closed doors are precisely the moments when they bring her out into the light. She is publically named in a beautiful wedding blessing at the marriage of Boaz and Ruth, two individuals of sterling character—hardly a fitting moment to broach the subject of a family scandal. Yet, there she is in glowing words of blessing: "Through the offspring the LORD gives you by this young woman, may your family be like that of Perez, whom Tamar bore to Judah" (Ruth 4:12, NIV). Significantly, both King David and his son Absalom named their daughters "Tamar" (2 Sam. 13:1; 14:27). In the Hebrew culture, names carried a lot of weight, for parents chose names that gave their children reasons to aspire, not as cause for shame or for them to be ridiculed. Then, of course, the apostle Matthew names Tamar (along with

four other women) in the royal genealogy of Jesus (Matt. 1:3)—a noticeable break from the customary exclusion of women from genealogies, and reason to reexamine those other women's stories too.

But by far the most compelling reason to reconsider negative opinions of Tamar is another word that shows up in her story—when none other than Judah himself describes her as "righteous" (Gen. 38:26). How can the shameful actions of Tamar be considered "righteous"?

TAMAR IN PATRIARCHAL CONTEXT

One of the biggest mistakes we make in attempting to understand biblical narratives is failing to take into account the cultural context in which they occur. Biblical stories take place within an ancient patriarchal culture that is utterly foreign to our Western, American, egalitarian culture. This puts us at a serious disadvantage when we interpret Scripture, especially when we come to stories such as Tamar's. Without insight into the customs of ancient patriarchy, we will miss, distort, or trivialize the message.

Unfortunately, the fact that patriarchy appears on virtually every page of the Bible has led to the mistaken conclusion that patriarchy (at least a kinder, gentler version) is the divinely ordained way God means for us to live. But, as I've argued elsewhere, "Patriarchy is not the Bible's message. Rather, it is the fallen cultural backdrop that sets off in the strongest relief the radical nature and potency of the Bible's gospel message. We need to understand that world and patriarchy in particular—much better than we do—if we hope to grasp the radical countercultural message of the Bible."[1]

Patriarchy creates moral dilemmas, too. Tamar's story is a key example of how far afield we've gone in understanding the Bible—and her story in particular— by failing to employ this powerful interpretive tool. Details of the ancient patriarchal culture will surface as we examine Tamar's story. For the moment, it will suffice to mention three elements of patriarchy that shape this particular story and create that dilemma for Tamar.

First, patriarchy ("father rule") invests men with priority, power, and authority over women and relies on female submission. Patriarchy essentially deprives women of agency and legal rights. Females become the property of men and are expected to submit. We will see in Tamar's story that Judah held life-and-death power over her. Without investigating the charges against her and with a blatant double standard, he immediately demands an honor-killing for *her* sexual "misconduct"—a violent response that occurred back then and still happens today in intensely patriarchal cultures whenever a female is involved (or alleged to be involved) in something that tarnishes the honor of men in her family.

Second, patriarchy invests men with power and authority over other men, with devastating consequences in both directions. Something profoundly

1. James, *Malestrom*, 31.

unhealthy happens when one man wields power over another. The patriarchs owned other men (and women) as slaves, as well as the children their slaves produced. *Primogeniture*—described by some as the linchpin of patriarchy—ranked sons by birth order. It established within the family unit a fixed male hierarchy among brothers. Primogeniture elevated a man's firstborn son over his younger brothers, making him something of a crown prince in the family and giving him authority over his younger siblings. The eldest brother also inherited twice as much of a man's estate as his other sons.

Tamar's story makes no sense unless we see how she gets caught in the crossfire of primogeniture, both within Judah's family of origin and among his sons. At the same time, it is important to note how the Bible repeatedly overturns this culturally established order[2] in the stories of the patriarchs—most often by God's decree. God chose Isaac, not Abraham's firstborn, Ishmael. Although parental favoritism played a role in Isaac's family (for Rebekah preferred Jacob, and Isaac favored Esau), God chose the younger twin Jacob, not Esau. But things got wildly out of hand when it came to Jacob's sons, for Jacob played favorites and broke primogeniture with his wives and with his sons. His favoritism shattered the family.

Third, under patriarchy a woman's goal in life was to produce sons for her husband. Doing so was her duty as a woman and her sole contribution to the family. Producing a male child was also a matter of honor to preserve her husband's family line. Family survival depended on her producing at least one son. Society determined a woman's value by counting her sons. The gold medal of womanhood was to be acclaimed as "the mother of seven sons." So it was exceedingly high praise indeed when the women of Bethlehem praised Ruth to Naomi as "better to you than seven sons" (Ruth 4:15, NIV). Such a cultural value system sheds light on the anguished desperation barren women such as Sarah, Rebekah, Rachel, and Hannah experienced, and why the postmenopausal widow Naomi was beside herself after both her sons died without either of them fathering sons. "To die without a male descendant was to be erased from history"[3]—an utter calamity in the ancient world. And the blame and shame for this deficiency fell on the widow for failing, literally, to deliver.

Although many interpreters view Tamar's actions as her personal obsession to have a baby and fulfill her womanhood, we will soon see that Tamar was motivated by something much deeper.

TAMAR THE CANAANITE

Tamar's story doesn't exist in isolation. Not only is it embedded within the ancient patriarchal culture, it is nested within layers of family history. Understanding both contexts is necessary to make sense of her story. Those other stories are also

2. For a more thorough discussion of how the Bible critiques and dismantles patriarchy, see my book (James), *Malestrom*.
3. James, *Lost Women of the Bible*, 107.

important to get a clearer sense of Judah, the man with whom she must deal. In addition, they serve to inform us that Tamar's situation as Judah's daughter-in-law was about as far from ideal as a young girl can get. Rather, from the start, the marriage arrangement that placed Tamar into Judah's dysfunctional family also put her at risk from Judah as well as from his sons.

Beyond that reality, even before Tamar entered Judah's story, she had huge strikes against her. Not only was she an outsider to the mainstream story that focused on Abraham and his descendants, she was a foreigner. Indeed, she was the worst kind of foreigner—a Canaanite (Gen. 28:1). Previous marriages in Abraham's family regarded a Canaanite woman as a serious threat to the purity of their calling. Canaanite women were considered a contaminating influence that would draw Abraham's descendants away from God. The patriarchs were dead set against their sons marrying Canaanite women.

When Isaac needed a wife, his father Abraham made his servant swear that he would "not get a wife for my son from the daughters of the Canaanites" (24:3). To avoid that undesirable outcome, Abraham sent his servant back to his God-fearing relatives to find a suitable bride (24:38). Isaac voiced similar concerns when he commanded Jacob, "Do not marry a Canaanite woman" (28:1) and sent him packing to those same relatives. So before we even read the word "prostitute" in her story, Tamar the Canaanite is already giving cause for concern.

In contrast, the name "Judah" is held in high regard throughout the Bible as the father of Israel's largest tribe and of the kingly line of David and Jesus. Consequently, it's easy to gloss over the deeply flawed Judah we encounter in the story involving Tamar. Instead, she often serves as a scapegoat for everything that happens between them. As a result, we won't understand Tamar or the significance of her actions if we don't reexamine the man who collides with her and how colliding with her affects him. Tamar is no sidebar or incidental figure in the Genesis narrative—nor even in the gripping Joseph saga. Events in this often-neglected Tamar chapter, and Tamar's role in particular, hold the key to understanding the story it seems to interrupt. So we must do some serious digging into the backstory before we're ready to talk about Tamar and the pivotal role she takes, but rarely gets credit for, in the story of God's people.

Of the family stories that surround Tamar's story, obviously Judah's is the most immediate. In turn, his story is tangled up with the surrounding story of his younger half-brother, Joseph. And of course, both brothers' stories reside inside the story of their father, Jacob. At the time of events involving Tamar, Jacob was the current family standard-bearer for the covenant promises God gave to his grandfather Abraham and father Isaac. This is the family God blessed and appointed to move forward his redemptive purposes for the whole world.

Despite the fact that at this point in the narrative Joseph owns the spotlight at the expense of Judah and his nine other brothers, God ultimately chooses Judah to be the promise-bearer for the next generation. Judah's branch of Abraham's family tree will produce King David and ultimately Jesus, the promised Messiah. So

regardless of how the focus settles on Joseph from Genesis 30 on, the Judah thread that winds its way through those final chapters in Genesis deserves careful attention.

TAMAR'S DYSFUNCTIONAL IN-LAWS

By the time Tamar enters the story, Judah is in a moral nosedive—weighed down by a boatload of dysfunctional family relationships that have left him with a throbbing father-wound and a boatload of resentment.

Judah's family got off to a terrible start when his father, Jacob, married his mother, Leah, unintentionally, instead of her younger, more attractive sister, Rachel. For seven years, Jacob worked for the right to marry Rachel. Since he arrived in Paddan Aram with essentially the shirt on his back, Jacob's labor was a variation on the bride price that he negotiated with her father, Laban. But on the long-awaited wedding night, Laban substituted Leah for Rachel. The unsuspecting Jacob didn't discover the switch until "the morning after." (It must have been very dark on their wedding night, or Jacob must have been very intoxicated.) Needless to say, Jacob wasn't pleased.

When he confronted Laban, his father-in-law pointed to primogeniture. It would be a breach of custom to marry the younger daughter off before her older sister. Undeterred, Jacob demanded the right to marry Rachel too, which he did a week later, locking himself into working seven more years for Laban and the sisters into a fierce and agonizing rivalry. Evidently, primogeniture thinking with respect to Leah stopped there, for although she was Jacob's first wife, Leah was unloved and couldn't win Jacob's love, despite the fact that she produced six sons for him. Jacob's heart belonged to Rachel, wife number two. But for Rachel, no amount of love could compensate for the miserable fact that, unlike her sister, Rachel was barren.

By volunteering their slave-girls, Bilhah and Zilpah, as surrogate wives, the warring sisters produced a grand total of twelve sons for Jacob: six by Leah, two apiece by Bilhah and Zilpah, and at long last Rachel delivered two more sons—Joseph and, finally, Benjamin. Even in this episode, we see another example of the dark side of patriarchy—the sanctioning of sexual slavery. With the birth of Joseph, patriarchal favoritism within the family escalates to a whole new level.

Jacob's flagrant favoritism of Joseph became the proverbial "last straw" for Joseph's ten older brothers, igniting jealousy and a consuming hatred for Joseph that ultimately turned to violence. The text states flatly that Jacob "loved Joseph more than any of his other sons" (37:3, NIV). Jacob's favoritism took on public physical dimensions when Jacob gave Joseph a "royal robe"—an overt sign of the preeminent place Joseph held both in his father's heart and in the family.

As a teenager, Joseph himself threw gasoline on his brothers' smoldering hatred when he unwisely (if not arrogantly) announced two dreams in which his brothers and parents bowed down to him. Seething sibling anger burst into flame, and a murder plot began to form. The story took an appalling turn when Judah assumed the lead among his brothers. Together, they seized a propitious opportunity to sell

Joseph as a slave to an approaching caravan of Ishmaelites en route to Egypt. The brothers shredded and doctored up Joseph's royal robe with the blood of a goat to deceive their father into thinking a wild beast had killed Joseph.

Jacob was inconsolable. Bereaved of Joseph, Jacob turned his love and favoritism on Benjamin, the son Rachel died delivering.

Although Judah was Jacob's fourth son, there is reason to believe he saw himself as the heir apparent to the rights of the firstborn. Judah's three older brothers had disgraced their father and disqualified themselves as honorable sons. Reuben (Jacob's firstborn) slept with Bilhah, his father's concubine. This was "a defiant act by which a son becomes 'a stench in [his] father's nostrils.'[4] . . . After the rape of their sister Dinah, Simeon and Levi (sons two and three) sought to vindicate family honor with a bloody massacre of the Shechemites, making Jacob himself 'a stench'[5] and raising the threat of retaliation among other tribes in the region."[6] If it is true that Judah felt entitled to the rights of the firstborn, then his resentment took on deeper meaning when Jacob showered affection and privilege on his youngest son, Joseph.

As an aside, it is worth noting that in all of these destructive family dynamics, Jacob himself would have benefitted from the apostle Paul's letter to the Ephesians. One can only wonder how the surrounding cultures would have marveled at Jacob's family if Jacob had sacrificially loved his wife/wives and cared as much about them as he did his own body, if he had nurtured his children (not just the firstborn or his favorite at the neglect of the others), and if he, as a slave owner, had remembered that he too had a master. Not only Jacob's story, but the stories of the other patriarchs as well, would read differently—vastly so—if they had followed culturally subversive instructions such as Paul's to the master of the Roman household (Eph. 5:25, 28; 6:4, 9).

Even so, long before Paul's input was available, the gospel of the Messiah to come was touching down in these stories and changing lives in radically unimaginable ways. Unlikely as it seems, Judah's story will bear that out. But at this point in the story, fallen patriarchal family values, favoritism, and broken relationships drive the action. The story plays out like a Shakespearean tragedy at multiple levels.

TAMAR AND THE SONS OF JUDAH

By an arranged marriage (and not by choice), Tamar landed in the wake of Judah's horribly dysfunctional family history. The pain of his father's rejection had turned Judah into a dark, hardened man. Engulfed by a deeply painful father-wound, Judah had proven he was capable of murder—a proclivity that ultimately threatened Tamar. Having instigated the sale of his own seventeen-year-old

4. Genesis 35:22; much later, when King David's son Absalom pitched a tent on the palace roof and slept with his father's concubines, it was a public act of defiance, making Absalom "a stench in [his] father's nostrils" (2 Samuel 16:21–22, NIV 1984).
5. Genesis 34:30 (NIV 1984).
6. James, *Malestrom*, 86.

brother, Joseph, into the living death of slavery, Judah had become a human trafficker. How else are we to describe his actions? In the grand family tradition (following his father Jacob's deceit of Isaac to obtain Esau's blessing and Laban's deceit resulting in Jacob's marriage to Leah), Judah was also a deceiver. He heartlessly pulled off a cover-up that brought a torrent of grief down on his father by allowing him to believe his favorite son, Joseph, was dead. It is not an impressive resume. Judah was hardly the kind of father-in-law any decent parent would wish for their daughter, especially given the powers patriarchy granted a father-in-law. As it turns out, Judah's sons weren't any better.

In the aftermath of these events, Judah leaves his family and migrates into Canaanite territory, where he forges friendships with Canaanites, marries a forbidden Canaanite, and ultimately begins acting like one. A terrible silence underscores the reality of Judah's father-wound, for there is no mention of Jacob inconsolably grieving Judah's departure or sending a search party to find and bring him home. Instead, still shattered over losing Joseph, Jacob is now lavishing his devotion on his twelfth son, Benjamin.

Judah's wife gives birth to three sons: Er, Onan, and Shelah. Tamar enters the story as the wife Judah "got" for his eldest son Er—a euphemism for an arranged marriage. Contrary to the biblical depiction of the marriage relationship where "a man leaves his father and his mother and cleaves to his wife, and they become one flesh" (2:24), in patriarchal cultures the wife is absorbed into her husband's family. She becomes their property and comes under the thumb of her husband's family.

People I've met from patriarchal cultures describe dynamics in mother-in-law/daughter-in-law relationships as extremely difficult, and express astonishment that Ruth the Moabitess didn't jump at the chance to leave her mother-in-law, Naomi. In Tamar's case, we know nothing of how things went with her mother-in-law. Judah was the in-law who wielded absolute control over her. Within patriarchy, a girl becomes marriageable when she reaches puberty, so Tamar was likely married off in her early teens. Before she ever conceived a child, God took the life of her husband Er, because he was "wicked in the LORD's sight" (38:7, NIV). We are spared the sordid details, but it is not a stretch to imagine that Tamar experienced the brunt of marriage to a wicked man.

At this point, the story moves into a strange ancient cultural custom. "According to patriarchal customs widely practiced at the time (later formalized as the levirate law under Moses),[7] the surviving brother and the deceased man's widow are honor-bound to marry and produce the missing male heir who will assume the vacant spot on the family tree."[8] Whenever I've taught the story of

7. "If [a brother] dies without a son, his widow must not marry outside the family. Her husband's brother shall ... marry her and fulfill the duty of a brother-in-law to her. The first son she bears shall carry on the name of the dead brother so the name of the dead brother will not be blotted out from Israel" (Deut. 25:5–6).
8. James, *Malestrom*, 88.

Tamar, women tell me this part of the story is "creepy." In compliance with this practice, Judah passes Tamar over to his second son, Onan, with a mandate to fulfill his duty to his dead brother.

But Onan is a wicked man too. Although he marries Tamar, it is all a sham. Instead of impregnating her, he continually uses her for his pleasure (v. 9), and when he does so, he spills his seed on the ground to prevent her from conceiving—no doubt an early form of contraception, but in this case a violation of his family duty. He feigned honor by marrying her and then repeatedly abused her in this manner. He knew full well the son Tamar conceived wouldn't be his, but his brother Er's. We may be without details of what marriage to wicked Er was like, although marriage to any wicked man is no picnic. In contrast, Onan's treatment of Tamar was overtly abusive, and the narrator gives us God's perspective on the matter.

Again, we are told of another of Judah's sons that "what [Onan] did was wicked in the LORD's sight; so the LORD put him to death also" (v. 10, NIV), leaving Judah with one remaining son who at the time was too young to marry.

TAMAR'S MORAL DILEMMA

A word of explanation is in order—not to justify Onan's actions, but to illuminate his motive and also to provide a framework for Tamar's subsequent actions. A man's responsibility to father a son for a blood brother who died without a son came at an exorbitant cost. Under simple modern inheritance laws, anyone knows the death of an heir means the surviving heirs inherit more. Under primogeniture, the gains were even higher if the deceased brother was the firstborn. Onan was acutely aware of the heavy price he'd pay if Tamar conceived a son for his brother Er.

The math is actually pretty simple. Under patriarchy, a man divided his estate among his sons, although not equally. Primogeniture designated a double share to the firstborn son. So, for example, as the father of three sons, Judah would divide his inheritance into four equal parts. Two-fourths (the double portion) went to his firstborn, Er; Judah's two younger sons would pocket one-fourth apiece.

The death of Er was a financial windfall for Judah's two surviving sons. Now Judah's estate gets sliced into three parts instead of four, with two-thirds going to Onan and one-third to Shelah—a sizeable increase for both of them. Onan's inheritance more than doubles, jumping from one-forth to two-thirds. If family honor takes precedence, and Tamar conceives a son, Onan's inheritance plummets from a full two-thirds of Judah's estate to a measly fourth—a whopping loss of nearly 50 percent of Judah's estate.

Obviously, family honor created a tremendous conflict of interest for Onan. Would he fulfill his duty to his brother, by marrying Tamar, fathering a child with her, and forfeiting Er's inheritance, which would go to their offspring? Or would he keep his winnings to himself? No one has to wonder what a financial advisor would tell him. This family duty was an enormous call to sacrifice for the good of a brother who wasn't even around

Turns out, Onan was willing to violate family honor to preserve his holdings. The price he paid for his wicked actions cost him a whole lot more than a slice of Judah's estate. After Onan's death, Judah superstitiously concluded that Tamar was the reason his sons were dying. So Judah sent her back to her father to wait until Shelah reached marriageable age, having no intention of following through with a marriage between Tamar and Shelah. Judah preferred enduring dead branches on his family tree to risking the life of his only surviving son.

A long time passed—long enough for Tamar to realize Judah had no intention of following through on his promise of a marriage to Shelah. This realization marked the tipping point for Tamar. His deception created the moral dilemma for Tamar. Would she resign herself to Judah's roadblock to the fulfillment of her duty to her dead husband? Or would she resort to other means to rescue the dying line of Er?

Remarkably, the stakes from Tamar's point of view had nothing in common with how Onan or Judah saw things. Both men were driven by self-interest at the expense of others. Suddenly, there was a member of the family who was moved by a wholly different motive. She would not be party to forsaking family duty in the name of self-preservation. She would sacrifice herself for the sake of another, if that's what it took—even for a dead man who would never know what she was willing to risk to perpetuate his branch of the family tree.

A RIGHTEOUS PROSTITUTE

Often called "the world's oldest profession," prostitution today has been more accurately recast as sex trafficking. We now know criminal elements are at work enslaving women and girls (men and boys too)—victimizing tens of millions of God's image-bearers globally and profiteering on selling their bodies again and again. No longer are prostitutes regarded as "the problem." It has become evident that the vast majority of them are victims of crime. Laws are changing to reflect this understanding so that law enforcement's practice of arresting prostitutes is stopping and instead they're going after the johns[9], pimps, and traffickers.

Sex trafficking is a humanitarian crisis of epic proportions in our twenty-first-century world. In their Pulitzer Prize-winning *New York Times* bestseller *Half the Sky*, authors Nickolas Kristof and Sheryl WuDunn identified sex trafficking as "one of the paramount human rights problems of this century."[10] Sex trafficking is not simply a problem elsewhere, but as President Jimmy Carter stated in *A Call to Action*, "It is known that teenage girls are sold by pimps and placed in brothels in all large American cities, almost invariably

9. "The label 'john' is the slang expression used to refer to men who solicit the services of prostitutes and is thought perhaps to have resulted from so many men seeking anonymity by saying their name was 'John.'" James, *Malestrom*, 213.
10. Kristof and WuDunn, *Half the Sky*, xiii.

with the local police being complicit or waiting for 'more important' things to command their attention."[11]

Prostitution is a violent and hideous thriving underworld fueled primarily by "johns"—men who seek to feed their sexual appetites both virtually through pornography, and in person at strip clubs, massage parlors, brothels, and hotels, and who are willing to pay. Sex trafficking is entirely demand-driven, and the demand for sexual services is insatiable.

When encountered in Scripture, stories such as Tamar's, Rahab's, and that of the sinful woman who wept and poured perfume on Jesus's feet give the church opportunities to raise the subject of prostitution and other forms of sexual abuse and to confront an issue to which the church cannot in good conscience turn a blind eye. We need to confront the issue, first of all, because this crisis seeps into the church. Tragically high numbers of Christian men and boys (and some women, too) are complicit—those who sit in church pews, study in seminaries, serve on elder boards, and stand behind pulpits but who nevertheless are addicted to pornography, which depends largely on exploiting trafficked women and girls.

But a second reason human trafficking is an important issue is the simple fact that, as God's image-bearers, we have a responsibility to engage an evil that destroys the lives of everyone who comes in contact with it. It even affects those of us who have the power to do something to address these atrocities, yet choose to do nothing. We are mistaken to convince ourselves that this crisis has nothing to do with us. Human trafficking is happening within our own communities—both the buying and selling of human flesh. This is not an issue the church can afford to avoid. The Bible brings it up.

So what causes a girl or a woman to become a prostitute?

A major cause is simply the reality of being born female in a world that privileges males and disadvantages females. The devaluing of girls combined with poverty is a deadly cocktail for hapless girls. Parents and other relatives are known to offload their daughters—even little girls—selling them to traffickers, sometimes in hopes of deriving income from their trafficked family member's "employment." This is patriarchy at its worst.

A thriving sex-trafficking industry means the vast majority of women and girls are *not* voluntarily involved, but are forced into prostitution—sold by relatives or ensnared by pimps. Pimps prey on vulnerable, at-risk, unhappy, and runaway girls. These girls are prime targets for pimps who spot them in malls, at Starbucks, hanging out after school, and in our neighborhoods. A pimp patiently woos, indulges, and grooms a girl into a corner from which there is no escape. Then suddenly, no more Mr. Nice Guy. He uses violence, threats against family members, and drugs to intimidate, control, and bolt and lock the door to a way out. In some cultures, a sexually violated girl brings shame on her family, so even if she somehow escapes she has no place to go.

11. Carter, *A Call to Action*, 128–29.

Is there such a person as a righteous prostitute? The writer of Hebrews seems to think so, exalting Rahab the harlot as an exemplar of faith (Heb. 11:31). Believe it or not, there are also altruistic motives for becoming a prostitute. That Jewish girl in Nazi Germany is a perfect example of self-sacrifice for the good of others. Sometimes a destitute woman sees no other alternative than prostitution to keep her children alive. It will no doubt come as a surprise to many readers that Tamar fits this category too, for family honor in Judah's family is being cast aside—a travesty that forces her to devise a dangerous scheme to pose as a prostitute to rescue the dying line of her wicked and undeserving husband, Er.

Prostitution is just one form of abuse that illuminates the enormous power differential between males and females. That differential is greatest where patriarchal values are in force. Under patriarchy, any power a woman enjoys resides in a male relative who is willing to speak for her and take action for wrongs she has suffered. Even then, the motive is often because the alleged crime violates *male* honor in the family and has little or nothing to do with vindicating her rights. She has no power of her own—no voice or agency or rights.

In the West, a breach of contract similar to what Judah was doing would be reason enough for Tamar (with or without her father's involvement) to haul him into court and fight for justice. But patriarchy fundamentally deprives women of legal rights and consequently moves justice beyond their reach. Stories like the one Jesus told about the widow badgering successfully for justice from the unjust judge undoubtedly astonished his hearers, who would find it hard to imagine a just judge, much less an unjust judge, granting a widow—i.e., a silent one—a hearing or to acknowledge that she had any legal rights. The story wouldn't have had nearly the same impact if the plaintiff had been male.

The ironic fact about prostitution is that in a strange way it simultaneously exploits and inverts the power dynamic between men and women. Patriarchy empowers and privileges men and renders women powerless. Prostitution is one of many ways that men use their power and privilege to exploit and abuse women. At the same time, the very men who feel empowered over women by pornography or prostitution are proving themselves to be utterly weak and powerless to women—a fact reinforced by the sexual addiction that ultimately overcomes and dominates them. Thankfully, many men are in the battle with women to end sex trafficking, pornography, and all other forms of violence against women and girls. But the fact remains (and Judah is Exhibit A) that, in some men, unbridled sexual passion is a self-destructive weakness where women unknowingly prevail.

Turns out, in Tamar's case, prostitution was the one way she could overcome the man who wielded total power over her. She ran a terrible risk that came with a lot of "what-ifs." What if he avoided her, and someone else approached? What if he saw through her disguise? What if her scheme backfired and she was discovered? What if nothing came from this, and she failed at her objective? What was she doing to herself? What is clear from Tamar's actions is that reckless impulsiveness was not part of her plan. She's considered all the what-ifs and taken measures to protect herself.

Tamar didn't pose as a prostitute because she was looking for a new career. She wasn't doing this because, in her heart of hearts, she was a temptress. Nor were her actions payback for a father-in-law who lied to her. Family honor compelled Tamar to act, coupled with a determination to right a wrong, for her own honor was at stake. Family duty to her dead husband was being ignored. She had only one objective in mind and was willing to risk her life to achieve it. In fact, it is fair to say that a good measure of desperation drove her to accomplish her goal through such unorthodox means.

Suddenly, Judah's once passive daughter-in-law summoned courage and took matters into her own hands. To grasp the terrifying danger of her mission, only imagine what fate awaits the young woman in today's Middle East who gets pregnant from prostitution.

TAMAR AND JUDAH THE "JOHN"

Another extraordinary irony of the Tamar/Judah story is the one-sided bias that heaps endless criticism on Tamar and not a lot (if any) on Judah. Judah is one of the leading lights in biblical history. Despite Joseph's prominence, Judah's legacy will ultimately surpass the younger brother's, for Judah is the father of Israel's leading tribe and of the line that carries forward the promises God gave to Abraham. Judah's name appears in lights in the genealogies of King David and Jesus.

As already noted, judgments of Judah's daughter-in-law are not so forgiving. Mention the name "Tamar" and eyebrows go up. It happens again and again with the so-called "vixens" of the Bible. In my book *Lost Women of the Bible*, I observed, "The belief that there's a temptress inside every woman leaps out into the open. . . . As soon as anything of a sexual nature occurs, the woman involved becomes the prime suspect. She bears more of the blame and carries the guilt a whole lot longer than the man involved. . . . It's disheartening to see just how unredemptive and one-sided our memories can be."[12]

Up to this moment in the story, Tamar accepted the passive role that patriarchy expected of her. She was taken as a wife for Er, passed on to Onan, and finally sent home to wait for Shelah.

Now, however, Tamar commands the action in the story. She knows her duty to the family and to her dead husband. The shame of Tamar's childlessness will be intensified if her husband's name dies out. Culturally she is honor-bound to fulfill this duty. Judah is standing in her way. In a decisive flurry, she sheds her widow's garments and her passivity, disguises herself as a prostitute, and stations herself in Judah's path.

Tamar's radical actions must be qualified by three important facts. First, Judah himself has become a widower and is emerging from a season of grief. Tamar's actions will not dishonor or wrong his wife. Second, with respect to levirate practices, ancient Hittite and Assyrian laws indicate that if a brother refused or didn't exist to

12. James, *Lost Women*, 104.

produce a son to perpetuate his deceased brother's name, responsibility to marry the deceased's widow fell to the dead brother's father. So, although technically fathering a child by his daughter-in-law was against Judah's will, it was a valid option.

Third, and most remarkable, is Tamar's confidence that Judah will fall for her scheme. It is a damning indictment of his character—and evidence of how far this son of Jacob has fallen—that she knew him to be that sort of a man. A possible contributing factor on that particular night is the fact that Judah had been partying—eating and drinking at the sheepshearing. The alcohol level in his bloodstream may have heightened his gullibility. It is also entirely possible that his failure to recognize Tamar is a painful reminder of just how little she mattered to him—evidence of the fact that he really didn't know her at all.

Predictably, Judah takes the bait. He approaches the mysterious prostitute, and the negotiating begins. He doesn't have money, so he promises to send her a goat in exchange for her sexual services. Like a shrewd, tough-minded business-woman, Tamar demands a pledge and drives a hard bargain, obtaining his seal and staff as security. In today's world that is roughly the equivalent of a man's ID—his driver's license (or passport) and his credit card. If Tamar becomes pregnant (which she does), she won't require a paternity test to prove Judah is the father of her child.

Later, Judah sends his Canaanite friend, Hirah, back with the promised goat and to retrieve his belongings. But the prostitute is nowhere to be found. No one in the area has seen or knows anything about a shrine prostitute. Judah fears becoming a laughingstock, so chooses to drop the matter. But he has a whole lot more to fear than laughter.

Hard as it is to believe, Judah hasn't hit bottom yet. True, his altitude is even lower than it was at the beginning of Tamar's story—that hardened, dark figure, capable of murder, a callous human trafficker, instigator of a felony, a man who knows how to cover his tracks at the cost of deceiving and devastating his elderly father. Now he's added "john" to his resume. Although his second son, Onan, willfully spilled his seed on the ground, Judah was reckless with his by soliciting a prostitute. He exhibited no sense that as a covenant grandson of Abraham, his duty before God in potentially fathering children was a sacred one. But his precipitous descent wouldn't stop until he was forced to look in the mirror and see the kind of man he had become. And the person brave enough to hold that mirror will be his daughter-in-law—a very pregnant Tamar.

TAMAR CONFRONTS JUDAH

Tamar's story reaches a hair-raising climax when someone reports to Judah that his daughter-in-law is "guilty of prostitution, and as a result she is now pregnant" (Gen. 38:24, NIV). Judah's response is abrupt, instantaneous, and horrific. "Bring her out and have her burned to death!" (v. 24, NIV). The double standard in his response is breathtaking. He condemns her for a crime he, too, has committed. Yet it is in his power, and he is determined to carry out her sentence. Now, at last, he can rid himself of Tamar.

This is when Tamar presents Judah with irrefutable evidence that he is the man by whom she is pregnant. She shows him his seal and staff—the mirror that confronts Judah with his own reflection.

In a recent radio interview, I was one of two guests discussing Tamar from the perspective of *Lost Women of the Bible*. No matter how hard I tried, I couldn't dislodge the other guest from believing Tamar was a vixen. The word "prostitute" was insurmountably hung around Tamar's neck. Strangely, Judah doesn't see her that way. His words about Tamar are so unexpected, English translators have nuanced the wording in our Bibles to "She is *more* righteous than I" (v. 26, emphasis added).

It gives the impression that Judah is suggesting they are both righteous. The difference between them is only a matter of degree. In his opinion, her righteousness score is a bit higher than his—when on the surface, at least to the uninformed Western eye (including that other radio guest), *both* are guilty of profound unrighteousness—she for playing the prostitute, he for soliciting her services. "She is more righteous than I" sounds like spiritual mumbo-jumbo or a clumsy attempt at dodging the truth about himself. That interpretation fits the Judah we have known all along, when actually his words are an emphatic vindication of Tamar and condemnation of himself.

Clearer translations render Judah's words as, "She is righteous, not I" or "She is righteous; I am not." The word "righteous" is the defining word in Tamar's story, eclipsing the label "prostitute." This vindication of Tamar comes from the chastened lips of her dark and hardened father-in-law. It is one of the most powerful moments in all of Scripture—when the prodigal takes an honest look at himself and comes to his senses.

TAMAR THE *EZER*-WARRIOR

When God created the woman, he said, "It is not good for the man to be alone. I will make an *ezer* [helper] suitable for him" (2:18). This powerful statement indicates the fact that men and women need each other. God doesn't narrow the parameters of his statement to marriage, the home, the church, or any other sphere. It is a blanket statement encompassing every arena of life. Something serious is missing if men operate in any venue without partnering with women. This sheds a glaring light on how the marginalization and oppression of women is not only disastrous for women, but also for men.

The Hebrew word *ezer*[13] (usually translated "helper") is a military word that is used most often (sixteen of twenty-one times in the Old Testament) for God as the *ezer* of his people. *Ezering* is how God's daughters uniquely image him. Every

13. *Ezer* is a military term, appearing twenty-one times in the Old Testament: twice referring to the woman (Gen. 2:18, 20); three times for military powers Israel turned to for help (Isa. 30:5; Ezek. 12:14; Dan. 11:34); the remaining sixteen occurrences refer to God as Israel's helper, each time with military imagery (Exod. 18:4; Deut. 33:7, 26, 29; Ps. 20:2; 33:20; 70:5; 89:19 (translated "strength" in the NIV); 115:9, 10, 11; 121:1–2; 124:8; 146:5; and Hos. 13:9. For a more complete discussion of the *ezer*, see James, *Half the Church*.

time the word *ezer* appears in the Old Testament, it is in a military context. God is our "sword and shield"; he is "better than horses and chariots"; he stands "sentry watch" over his people. Twice *ezer* is used to describe the woman at creation (2:18, 20). Even the Garden of Eden wasn't a safe place. Danger lurked. A powerful enemy was plotting an imminent attack. God's commands raised the threat alert to red—to "guard the garden," to "rule and subdue," and to refrain from eating fruit from dangerous trees.

From all indications, Eden was a warzone, and the *ezer* is a warrior—called to join the man in ruling and subduing God's creation, pushing back the darkness, and battling the enemy of all God's image-bearers. God summons his daughters to embrace God's heart for the world and for our brothers and to bring our wit, wisdom, and righteous determination to his mission in the world, even when it means standing up to men.

Tamar was no vixen when, honor-bound, she stood up to plummeting Judah, insisting on fulfilling her righteous duty despite the risk to herself. Tamar was an *ezer*-warrior—one of the best examples we have in the entire Bible, and Judah needed her. He hit a brick wall when Tamar stood up to him. That collision was the turning point for Judah. He became a better man because of her.

Strange as it sounds, it's hard to imagine a stronger, more exemplary *ezer*-warrior role model than Tamar, the righteous prostitute—not because she played the prostitute, but because she subverted cultural expectations of herself and stood up for what was right in God's eyes. No wonder Judah called her righteous.

God further vindicates Tamar when he blesses her with twin sons. Perez and Zerah replace each of her two dead husbands. But we cannot comprehend the powerful way God worked through Tamar's battle to rescue those two unworthy men if we think the story ends with her triumph. Which is why we leave Tamar's story and follow Judah's revised trajectory, where Tamar's influence lives on and changes the outcome of the larger family narrative.

VOLTE-FACE

Judah doesn't resurface in the Genesis narrative until four chapters later. Meanwhile, Joseph escapes Potiphar's wife (a true vixen) only to land in prison. His ability to interpret dreams lands him before Pharaoh, who releases Joseph from prison and elevates him to second in authority and power only to himself.

Judah reenters the story when Egypt and the surrounding regions, including Canaan, are in the grips of a devastating famine. In the West, we have thankfully been spared the horrors of famine, although from the comfort of our well-stocked homes we are witnesses to appalling images of famines elsewhere in the world.

God used a famine to cross Judah's path with the brother he once wanted to kill, but trafficked instead. It was a moment neither of them saw coming. But the Judah we meet in the remaining chapters of Genesis is not the same Judah who was quick to order an honor-killing of Tamar for a crime he too had committed.

By the time Judah reappears, he and nine of his brothers (all but Benjamin, Joseph's only full blood-brother) have, at their father's direction, already made one trip to Egypt for food. Joseph recognized them at the time and inquired of their father and if they had another brother. The plot thickened when Joseph set the terms for seeing him again: These Hebrew brothers will not see Egypt's second-in-command again if they come without their younger brother.

When a second trip to Egypt becomes a dire necessity, another family crisis erupts. One can only imagine the emotional angst playing out in the hearts of the brothers. Jacob is now playing favorites with Benjamin and is refusing to let him go. Jacob's grief over Joseph remains as intense as ever, and the thought of losing Benjamin too is unbearable.

Once more Judah steps into the spotlight. He reassures his father by taking full responsibility for Benjamin's safety. But that is nothing compared to what happens in Egypt. Genesis 38 may be the most annoying chapter in the Bible, but it is not possible to explain the radical change that takes place in Judah or how relationships with Joseph resolve if we forget Judah's eye-opening collision with Tamar. That encounter is not an irrelevant interruption, but is the turning point both in Judah's life and in Joseph's story.

God is at work in this family, and it is never more obvious than in the climactic scene that reunites twelve deeply divided brothers. Judah is transformed. He's frankly unrecognizable. The interview with Joseph goes better than the brothers could have hoped. He is cordial, and favors them with a feast and gifts. They leave in high spirits, only to be chased down by Joseph's men, who search their bags and discover Joseph's silver divination cup (planted by Joseph's subordinates) in Benjamin's sack. Benjamin is Joseph's only full brother and Jacob's new favorite son.

With an unhealed father-wound still throbbing, with his father, Jacob, still playing favorites and talking as though Judah, his mother Leah, and his brothers don't exist, and with Benjamin heading for the living death Judah once chose for his half-brother Joseph, Judah steps forward. He begins to speak—unaware that the ruler he is humbly addressing is Joseph, the brother he sold into slavery some twenty years ago.

What follows is a striking demonstration of God's power to produce the kind of man he intends for his sons to be. I can't improve on what Judah said. It's best to let him speak for himself: "My lord, I guaranteed to my father that I would take care of the boy. I told him, 'If I don't bring him back to you, I will bear the blame forever.' So please, my lord, *let me stay here as a slave instead of the boy*, and let the boy return with his brothers. For how can I return to my father if the boy is not with me? *I couldn't bear to see the anguish this would cause my father!*" (44:32-34, emphasis added).

Judah's speech is a radical reversal that not only reveals a radically transformed man, but is also the turning point for Joseph, who, up to this moment, has been tormenting his brothers. Sobs and hugs characterize the interaction that follows as Joseph reveals himself to his brothers.

TAMAR THE EXEMPLAR

Judah may not rise to power in the world's eyes. Joseph may always eclipse him. But the story of Tamar and Judah deserves more thoughtful attention, not simply to exonerate Tamar from the label "vixen," but because we need her brand of *ezer*-warrior courage and commitment to doing what is right for the battles in which God is calling us to engage. We need more stories of courageous women like Tamar and the young Jewish girl who faced down fear and life-threatening danger for the sake of others. Their narratives will help us courageously step up to do what God is calling us to do, regardless of the odds.

But we need Judah, too. His story fuels our hope that even the most dark and hardened human beings—those with murder in their hearts, who are willing to traffick other human beings, to exploit women, and to carry out an honor killing—are no match for the gospel.

Jesus's gospel turns everything right side up in this fallen world. His gospel exposes patriarchy for the abusive social system it is. It mobilizes a marginalized woman to act with extraordinary boldness to reveal a patriarch's hypocrisy thus leading to his renewal. Her story is not a recommendation of prostitution as a means of furthering the redemptive plan of God or in any situation, but I do see why Judah (and God's Word) declare Tamar "righteous."

God works in mysterious ways, and Tamar's story is a startling example. Far from the vixen many believe her to be, Tamar is a hero we should admire—an *ezer*-warrior who does the right thing at enormous risk to herself. Sometimes our prejudices cause us to miss the power of God's Word and avoid narratives that we desperately need in our own stories.

God works through Tamar's bold actions to rescue her dead husband from extinction and her utterly lost father-in-law from a destructive downhill slide. Her actions bring about one of the most remarkable redemptive stories in all of Scripture. Not only do we owe her an apology for ignoring what the Bible says clearly about her, we stand in her debt—for the family line she was fighting to save was the royal line that ultimately led to Jesus. God chose a marginalized Canaanite woman to put the power of his gospel on display, and to advance his redemptive purposes for Judah and for the world.

QUESTIONS FOR DISCUSSION

1. How can Tamar's righteous actions and Judah's radical U-turn in response take male/female relations to a whole new level among Christians today?

2. Have you ever been "set straight" or rescued by someone you thought was "less righteous" than you? Explain.

3. How can we live for righteousness in our relationships and circumstances?

RAHAB: WHAT WE TALK ABOUT WHEN WE TALK ABOUT RAHAB

EVA BLEEKER, MA

Rahab had me worried when I started studying her ten years ago, because I was worried about myself. A female theology student at a conservative seminary that I love and revere, I had matriculated with specific ideas about women's roles in ministry, their limitations, and their value in church. Truly, I had given no thought to the potential that my sense of self would grow or shift or freak out during my student days. When it did *all* of those things, I felt disoriented by my own anger and fear. Mixed messages flashed around my campus like heat lightning before a toad-strangling thunderstorm.

Consider the complexity of these statements: "Scripture bars women from preaching, so they shouldn't be taught to preach. Well, maybe Scripture makes provision for women to preach to other women, and heavens, some of them can really do it. So maybe they could learn to preach as long as no men students hear them learning the skill." Or "Maybe it's okay for women to preach in church as long as they are under the authority of a male senior pastor and some elders who are men." Or "Maybe when a woman talks about the Bible, it's just 'sharing.' Maybe she could limit herself to a devotional or a testimony rather than a sermon." "What about teaching? Is that different? No, forget all that because it misses the point: Women are born to have babies."

The implications of these conversations wrenched my heart, but I was too scared to participate in them or contribute anything that could be taken seriously. The vitriol that sometimes accompanied these discourses made it much, much worse. I felt like I had been prepped for surgery but, improperly anesthetized, had awakened on the operating table to hear five doctors arguing about

how to cut me open. I could hear but couldn't move, much less say, "Hey, you're talking about *me*, and I'm *right here!*"

Years after my graduation I found a handwritten note in the back pocket of a binder. It was to me, from me. During a class session, a beloved professor had encouraged us to write down something that we were wrestling with. So I wrote, "I hope that God values and loves women in the same way that he values and loves men. Because if he doesn't, I don't know what I'll do." The debates about women in the church prompted my pain and turmoil, but their source was much deeper.

During the season when I wrote that note, I felt both drawn and driven by desperation to study women in the Bible. In my independent research, I got curious about the women identified in the Matthean genealogy—Tamar, Rahab, Ruth, Bathsheba, and Mary. I had read that their inclusion was based on a commonality, namely sexual deviancy. These women were given bad-girl status (how Mary fit into this rubric was never explained). But as I studied and prayed and stumbled along, a different pattern emerged, and a professional sex worker from the ancient Near East became my hero. I grew in respect for Rahab, but she made me nervous, too.

First, Rahab shows up in a section of the Old Testament narrative that can be difficult to navigate, especially for those who hold to a literal, historical interpretation of the story. Secondly, our main character is a prostitute (wasn't she called an "innkeeper" back in the flannelgraph days?), and a story about a prostitute will likely include prostitution. Thirdly, in our time and place, the book of Joshua offends and confuses. It stretches—perhaps painfully—our understanding of God's nature and intent, especially if we insist that the "characters" were real people. My tradition esteems the Bible and grants it authority. So what does it mean when one person's interpretation points up and another's points down, yet we're all standing alone on the Word of God? Are we reading the same text? How do we disagree with people we *love*? What happens to our faith when we reject an idea we would have energetically defended ten years ago? My study of Rahab prompted these questions. Her life story couldn't answer everything, but it *really* helped.

LOCATING RAHAB

Rahab enters the story of Israel at an extraordinary moment. These Israelites have never been in Israel. They have followed a pillar of smoke and fire through the desert for forty years. They have buried an entire generation. They have experienced miracles, violence, and divine victories. With Joshua in command, the whole group has camped east of the Jordan River. And when the time comes, Joshua sends two men into Canaan to spy out the land with instructions to focus on Jericho, Rahab's hometown.

We could call Rahab the Paragon of Otherness. She embodies the opposite of the traditional values held by the Old Testament's original readers: She's female, a Canaanite (Israel's mortal enemy), a prostitute, and a resident of Jericho—the first city doomed to fall by the sword when the Israelites enter the land. She's like a death-row inmate waiting for the needle.

The spies, on the other hand, are on a personal mission from the most powerful and revered Israelite alive. God has installed Joshua, made promises to him, and anointed him to replace Moses. So we would expect the spies to be valiant, righteous representatives of both Joshua and God. The writer of Joshua, though, skews the expectations that the reader has of these characters. Everything on the surface is true, but it's incomplete.

Surprise one: flashback

You know how a TV show will give you a little flashback as a new episode begins—"Previously, on *Lost* . . .," or "Previously, on *Downton Abbey* . . ."? As chapter 2 of Joshua begins, the text notes that the two spies are sent out from Shittim (pronounced she-*team*). If you haven't read Numbers lately, the mention of Shittim might not produce an internal groan and sinking feeling in you. But an original reader would probably have thought, "Did you really have to bring that up? Things are just starting to go well. Now I'm dreading this episode."

Let's refresh. After annihilating the two formidable kings Sihon and Og (events that Rahab will mention as justification for her city cowering before the Israelite army), the Israelites nearly scuttled their future in the Promised Land. The author of Numbers notes that, while staying at Shittim, the Israelite men "began to indulge in sexual immorality with Moabite women" (Num. 25:1, NIV). These Moabites have invited them to participate in sacrifices and feasting in honor of pagan gods. The flagrant insults to God's honor and rebellion against his commands should make God's people quake. But it doesn't. And God's anger burns against them with such force that he nearly puts "an end to them in my zeal." So when Shittim gets mentioned just as the action begins in the book of Joshua, we might fight the urge to cover our faces and whisper, "I can't look." The author starts by mentioning Shittim, and before that single verse is complete, the spies are in Rahab's house (see Joshua 2:1). Do you feel the irony? The spies set out from the camp and end up at a prostitute's home *in one sentence,* with no mention of completing the task Joshua assigned to them. The text does not say these men did any spying or acquired valuable information. It does say that they were detected by the enemy.

Surprise two: language allusions

Not only do the spies sent on a task for God's people go to a prostitute's house, but the storyteller uses double entendre to emphasize the shadiness of their actions. A contemporary example might help us appreciate the details in the language. The 2000 hit movie *Remember the Titans* fictionalizes the racial integration of a Southern high school football team. The team starts winning games, and the team members gain status in their school. While walking up a staircase between classes, several girls swoon over the quarterback, who is known by his nickname, Sunshine. Another team member overhears their admiration. He tries to turn the girls away from his teammate by saying, "Sunshine is from California." They

say they know that already, but the teammate emphatically repeats the same phrase, "Sunshine is from *California!*" He means that, because of Sunshine's sexual preferences, he will not return the girls' affection. But that's not what he *says*. His meaning is concealed inside his simple statement of fact.

Joshua chapter 2 is rife with this kind of doublespeak—a perfectly "PG" meaning on the surface, with sexual innuendo and humor close to that same surface.[1] In his excellent work *The Faith of the Outsider,* Frank Anthony Spina enumerates the author's word choices in this passage that have double meaning. First, the spies "lodge" in Rahab's house. The word "lodge" can be used in a sexual or nonsexual context in Hebrew, something like the difference between "sleeping with" a teddy bear and "sleeping with" the boss. Second, when the king's men arrive, the writer uses the verb for "enter" ("where are the men that *entered* here?") and the preposition "unto" ("the men who came *unto* you"). Again the double meaning is in play, but more blatantly than before. Additionally, Rahab's name functions like the word "broad" in English, as a slang term for a potentially loose woman. The text does not explicitly charge the spies with the same sexual immorality their comrades committed at Shittim, but the writer seems to want the reader to accept the potential. Keep in mind, too, that the story has opportunity for the wordplay because the spies, rather than demonstrating stealth and skill, get caught. Without Rahab's quick thinking, they're toast.

Before moving on, the reader must consider a troubling question: Did the Israelite spies feel they had sexual license with the women of Jericho because these women were about to die anyway? Certainly, the spies knew about the divine injunction against all inhabitants of the land as it was decreed and recorded prior to their mission. Deuteronomy 20, for example, spells it out: "In the cities of the nations the LORD your God is giving you as an inheritance, do not leave alive anything that breathes. Completely destroy them—the Hittites, Amorites, Canaanites, Perizzites, Hivites and Jebusites—as the Lord your God has commanded you. Otherwise, they will teach you to follow all the detestable things they do in worshiping their gods, and you will sin against the LORD your God" (Deut. 20:16–18, NIV). This command to leave no one alive falls between the mess at Shittim and the invasion of Jericho. The spies know that Rahab, a person under the ban, will be slaughtered in combat within days. Perhaps this foreknowledge buoyed the spies' recklessness and informed the author's choices when writing about them.[2] Rahab's certainty of imminent death clearly conditions her boldness.

Surprise three: Rahab's faith and confession

At this point, Rahab shines as the hero who has outsmarted every other character. She has successfully hidden the spies who were detected by the king's men, and she has successfully sent the king's men on a fool's errand. In the next scene, she shines

1. Spina, *The Faith of the Outsider,* 52–63.
2. Fewell, *The Women's Bible Commentary,* 72.

in another way. The bawdy language ends when Rahab joins the spies where she has concealed them on the roof. Before they go to sleep, she has some things to say.

What Rahab articulates next should astonish us, beginning with her declaration, "I know the LORD is handing this land over to you" (Josh. 2:9). Rahab believes that she and her people will be dispossessed; she knows that God intends to give her homeland to the Israelites, and her people wait in terror. As proof that their fears are justified, she lists God's mighty acts already performed to bring the Israelites to her border: He made passage for them to escape Egypt—right through the Red Sea—and he gave them total victory over the powerful kings Sihon and Og, leaving them "utterly destroyed." She knows that little Jericho is a puny opponent compared to these now-dead, well-armed Amorite kings. So she and all her neighbors wait for the Israelites' attack in debilitating panic. They are "melting with fear" (vv. 10–11).

As if this weren't enough of a surprise, Rahab forms a sentence that must have disoriented the spies even further. "The LORD your God," she says, "is God in heaven above and on the earth below"[3] (v. 11, NIV). The prostitute—the one introduced to the reader with jocular tone and lewd language—has just confessed belief in Yahweh. Imagine the expressions on the spies' faces as Rahab articulates orthodox Israelite theology. Whether or not they came to her home for sex, her declaration must have shocked them. Then Rahab strikes a deal to save herself and her family.

Narrative bookends

The story about the forty years of desert wandering is bookended by several parallel events and images. At the front end, recorded in the book of Exodus, the people left Egypt through parted waters, the Red Sea. At the back end, as recorded in the book of Joshua, they entered the Promised Land through parted waters at the Jordan River. The bookends also included miraculous events—the ten plagues on the front end, and the fall of Jericho on the back end.

Perhaps the mirrored symbolism reflected in Exodus and Joshua can inform an understanding of the crimson cord in Rahab's window (2:17ff). The deal agreed upon by Rahab and the spies depends on a sign to insure her safety. Rahab must hang a red cord in the window—the cord through which she helped the spies escape. If it is not visible at the time of attack, the Israelite army will be free to kill her and everyone inside. But if the streak of red is at the opening to Rahab's home, it will ensure that those gathered inside would be safe, not unlike the lambs' blood on the doorposts of the Israelites, homes on the night of the first Passover. The symbol of safety comes with similar conditions in both

3. Spina notes that the wording of Rahab's confession in Joshua 2:11 is unusual in at least two ways. She is one of three biblical characters to use the phrase "on the earth below," the other two being Moses and Solomon. Among the three, she is the only female and the only non-Israelite.

instances. In Rahab's case, the deal applies only to those gathered within her house; anyone who goes outside forfeits his or her life, just like the instructions given before the plague on the firstborn.[4]

As Jericho literally falls, the two spies themselves rescue Rahab and her family, fulfilling their commitment to her: "Our lives for your lives."

Then what happened?

Rahab's family was indeed rescued and, for a time, they lived outside the camp. As unclean Canaanites, they inhabited the fringes of the community, literally and socially. But the writer of the book of Joshua describes Rahab living "*among* the Israelites, even to this day" (6:25, emphasis mine). If only we knew the details of that story! The outsider had become an insider. Some traditions suggest that Rahab married one of the spies.[5] And we know from Matthew's Gospel that she had at least one terrific kid, a man you can read about in the Ruth chapter of this book.

WHAT WOULD WE LOSE IF WE LOST RAHAB?

If the word choices and tone in Joshua implicate the two Hebrew spies in both potential sexual dalliance and mild stupidity while elevating Rahab to the role of unlikely heroine, what does that mean? The writer of Joshua, presumably, wrote on behalf of the Hebrew people, preserving the story for future retelling and remembrance, with the Israelite nation as the intended receivers of the story. Why include this episode? And, critically, what is the meaning of the story *without* Rahab?

Rahab's story shifts the categories for the Conquest narrative. Without her, we have a story of ethnic cleansing. Every Canaanite is under the ban. With her confession of faith included in the story, we have proof that anyone, even the most unlikely, can believe. And the one who believes shall be rescued. With Rahab in the story, we see that God inspires belief in every category of people, and that he honors that belief.

Rahab created an alliance predicated on her desire to be rescued. She joined the Israelites. She chose sides. In the Conquest story, at least on the surface, it seemed easy to sort out the good guys from the bad. Rahab's story has complicated that dichotomy with the muddied reputation of the spies and her own elevated character.

But there's another reason to reconsider the binaries in this story. When the messenger of Yahweh appears before the siege of Jericho, a most interesting exchange takes place between him and Joshua (5:13–15). Picture these two army commanders face to face. With reasonable fear, Joshua asks this warrior, standing there with sword drawn, to declare his loyalty: "Are you for us or for our enemies?" Remember, this is the Conquest. So the condemned have been named, and Joshua himself has been chosen *by God* to lead the invasion. Wouldn't we

4. Compare Exodus 12:22 with Joshua 2:17–20.
5. Bauckham, *Gospel Women,* 37.

expect the commander of the Lord's army to say, "No worries, Joshua. I'm on your side, of course." But that is *not* what he says.

Instead, the Lord's commander answers with a word: "Neither." Then he gives Joshua instructions for conquering Jericho in such a way that demonstrates that the victory belongs to God alone. This concept—that God is for God—confounds the insider/outsider themes as understood by the Israelites, and it makes room for Rahab within the community of faith.[6]

RAHAB IN MATTHEW

Canaanites in the Gospels

After dropping out of the narrative in Joshua 6, Rahab shows up again in an unlikely place: the highly stylized genealogy at the beginning of the Gospel of Matthew. Every authorial choice made in composing the list is intentional and highly nuanced, with Jesus's ancestors arranged into three groups of fourteen generations each.

The inclusion of four Old Testament women in this list, including Rahab, should stir our curiosity. Why would a Gospel writer call out the prostitute-turned-proselyte from Jericho?[7] Suddenly, old ideas about these "bad girls" come flooding back to me, and I get nervous about the status of women in the community of faith. Could there be cause to put those old fears aside?

The writer of Matthew is up to something. Don't look for Jewish shepherds at the manger in Matthew's story. Rather, foreign kings kneel to worship Jesus at his birth. Later in the narrative, a centurion—a Roman soldier—requests healing for his servant and "amazes" Jesus with his faith (Matt. 8:5–13). Jesus grants this man's request for healing-from-a-distance and tells the disciples, "I have not found anyone in Israel with such great faith" (v. 10). Did you catch that? "Not anyone in Israel." Matthew salts his narrative with the faith of *Gentiles*. "When we turn the page from Malachi to Matthew," says renowned scholar Christopher J. H. Wright, "we have landed in a totally different world. We find the same understanding of God's mission to the nations that we have seen breathing so pervasively through the Old Testament. But we also find that it has been transformed from . . . a missionary *idea* into energetic missionary *praxis*."[8] The progression of Matthew's story prepares the Jews to hear their new assignment.

Matthew is setting up his readers, the Jewish faithful, to accept cultural and racial outsiders—including the dreaded Canaanites—into the community of faith through belief, not blood. When we hit a story about a Canaanite woman

6. Fewell, *The Women's Bible Commentary*, 72.
7. Bauckham says that all four Old Testament women named in the Matthean genealogy are Gentiles and are mentioned specifically because of their non-Jew status. In Bauck-ham's view, this is the beginning of Matthew's admonition to the Jews that all nations shall partake in the blessings of Messiah (*Gospel Women*, 22). Wright shares this view exactly (*The Mission of God*, 512).
8. Wright, *The Mission of God*, 505.

interacting with Jesus (15:21–28) we might remember that this woman is not the first Canaanite that Matthew has named. Remember those women in the genealogy? The term "Canaanite" represents an old failure, detailed in the Conquest narrative. There shouldn't *be* any Canaanites, right? Matthew's choice to call this woman a Canaanite, in contrast with Mark's term "Syro-Phoenician" (Mark 7:26), calls to mind specific hopes and specific griefs for readers of his time. Richard Bauckham observes, "Jewish nationalism was not only directed at the Roman occupying power but also at the presence of pagans in the land of Israel, which they polluted with their idolatry and immoral lifestyle. The Messiah, son of David, was expected not only to overthrow the Roman imperial power but also to repossess the land for Israel and to cleanse it by slaughtering or driving out the idolatrous pagans. . . . How relevant the narratives of Joshua and Judges could appear to some first-century Palestinian Jews, awaiting the leadership of a new Joshua."[9] These specific messianic expectations—relating to the persistent existence of the Canaanites—might be in play for the disciples when they encounter this pagan woman. While her story shares many aspects of the centurion's request for healing, her interaction with Jesus raises the hackles of the disciples. After all, like Rahab, she has nothing that might give her status or honor. At least the centurion maintained his dignity while asking for Jesus's help, and he made his request on behalf of another male. This woman publicly cries out to Jesus, pleading for a powerful intervention because her daughter is demon-possessed. Jesus remains silent, and the disciples are not impressed with this woman at all. She even blocks Jesus's path with her own body, kneeling before him. With the woman on the ground and Jesus standing, the two of them engage in banter through metaphor: Jews are children, she is a dog. "It is not right to take the children's bread and toss it to the dogs," Jesus says (Matt. 15:26). "Yes it is, Lord," she answers. "Even the dogs eat the crumbs that fall from their master's table" (v. 27). Then Jesus commends her "great faith" and sends healing to her daughter (v. 28).

But why is Jesus so rude to her? Like the writer of this story, Jesus is up to something. In order to solve this puzzling interaction, we must remember who is present. "Jesus is not simply dealing with the woman, he is also interacting on a profound level with the disciples."[10] The woman's boldness and faith create a learning laboratory for the twelve.

In this story, two concepts are playing tug-of-war. On one end of the rope, we have the mission to "the lost sheep of Israel." Jesus has used this phrase already in Matthew (10:6), and he has sent the twelve disciples out preaching to only Jewish listeners. Pulling on the other end of the rope, we have all those non-Jews demonstrating faith in Christ. Matthew calls attention to the faith of multiple Gentiles and Jesus's ministry and grace toward them. Matthew seems to love this tension and highlights it as his narrative progresses. Wright explains, "Jesus's earthly ministry

9. Bauckham, *Gospel Women*, 43.
10. Bailey, *Jesus through Middle Eastern Eyes*, 219.

was launched by a movement that aimed at the restoration of *Israel*. But he himself launched a movement that aimed at the ingathering of the *nations* to the new messianic people of God. The *initial impetus* for his ministry was to call Israel back to their God. The *subsequent impact* of his ministry was a new community that called the nations to faith in the God of Israel. This double dimension of the mission of Jesus needs to be kept in mind as we read the New Testament."[11]

Jesus plays into the expectations of the disciples by rebuffing the woman as she grovels in the dust. But this woman, too, is up to something. Like Rahab, she uses a title of faith, Son of David (15:22). Like Rahab, she persists in showing her desire to receive God's blessing. And she demonstrates some brains, picking up Jesus's theological metaphor and claiming her place within it. Like Rahab, the Canaanite woman demonstrates the role of belief for incorporation into the people of God and God's acceptance of anyone who believes.

Who is this for? Why would Jesus seem to insult her, and yet grant her request? And why would Matthew choose to include the episode? Like any good writer, Matthew knows his audience. He is addressing the question, "Who can belong?"—who can access the blessings of Messiah?—and he is blowing up his readers' categories. Remember, Matthew will end his narrative with a command to go to all nations. The radical nature of the Great Commission must be felt with the Canaanites in mind, given the precedent set in this story.

Parallels between Rahab and Matthew's Canaanite woman

Rahab and the unnamed Canaanite woman in the Gospel of Matthew share a significant list of similarities. Both stories are imbedded in a time of Jewish expansion: Rahab, in the Old Testament Conquest story; the Canaanite woman, in a time of New Testament nationalism, during which the Jews resisted their pagan neighbors and longed for the coming of the Messiah. Some first-century Jews anticipated that this new Messiah would finish the task begun by Joshua, creating a connection of anticipation between Jesus and Joshua.[12] The geographical reference in Matthew to Tyre and Sidon recalls the Conquest narrative, since Joshua 13:6 notes that the Sidonians were yet to be driven out of the territory intended for Israel.[13] Both women use divine titles. Rahab calls Yahweh "the God of heaven above and the earth below." The Canaanite calls Jesus, "Son of David." Both women boldly ask for something desperately needed. Rahab asks that she and her family be spared from death; the Canaanite asks that her daughter be delivered from demon-possession. Both of these bold requests are granted. Both women embody an exception in what had been understood as a rule about Canaanites. And so, these women demonstrate God's desire to extend mercy to those who wish to belong to him. And, both women provide an

11. Wright, *The Mission of God*, 506.
12. Bauckham, *Gospel Women*, 43.
13. Ibid., 44.

object lesson for the people receiving their story. Rahab's life instructs Israelites entering the land in the Old Testament. The Canaanite woman does the same for the disciples and the nationalistic Jews in the New Testament.

THE IMPLICATIONS OF RAHAB'S STORY

Critic, journalist, and essayist Vivian Gornick makes this seasoned observation: "When writers remain ignorant of who they are at the moment of writing—that is, when they are pulled around in the essay by motives they can neither identify accurately nor struggle to resolve—the work, more often than not, will prove either false or severely limited." With Gornick's admonition in mind, I want to end where I began, with the motives and struggles that brought me to Rahab in the first place.

The implications of Rahab's story for the church's mission to outsiders are precious to me because, despite my lifelong faith in Christ, I felt (and sometimes continue to feel) like an outsider because I am a woman. I'm not claiming that Rahab's story provides a clear line between the debates of our era (preaching, etc.) and the debates of her era. I will claim two things, though. First, Rahab and her New Testament mirror-image reveal to me the power of acceptance through belief. Their stories illuminate the gospel in ways that sting my spirit into fresh, humble appreciation for my own salvation. Second, Rahab and the Canaanite woman show me that the Bible elevates some women whom I thought—was taught—were debased. I reserve the right to learn something new when I approach the Bible and resolve to stay humble when I enjoy certainty. I remain in awe of their faith, their boldness as outsiders. The treatment of their stories in Scripture helps me resolve my fears about the status of women in God's eyes.

QUESTIONS FOR DISCUSSION

1. Do you sense a connection between Rahab's legacy, the Canaanite woman in Matthew, and your own life story? If so, explain.

2. How can we make peace with ourselves and with others when our positions change?

3. In your context, who is an insider and who is an outsider?

RUTH: THE SO-CALLED SCANDAL

MARNIE LEGASPI, THM

Ruth seems an unlikely candidate for a book about vixens, considering her famous words, "For where you go I will go, and where you lodge I will lodge. Your people shall be my people, and your God my God. Where you die I will die, and there will I be buried" (Ruth 1:16–17).[1] Thousands of couples over the centuries have pledged her vow during their nuptials, making it their own declaration of undying commitment for better or worse. Her proclamation of devotion should surely garner her a different title than "vixen," shouldn't it? Why then would the woman who uttered these phrases be considered scandalous? What action could she have taken that would evoke such scrutiny into her character?

In many circles, Ruth is accused of acting as nothing more than a common harlot for initiating a marriage proposal to a man she had known for mere months. Those who accuse her insist that her choice to venture at night into Boaz's place of employment was a deliberate choice to "enchant the man" and "make herself sexually available" to him.[2] They believe, "Her daring sexual posturing is matched by her audacious appeal."[3] Her actions no longer resemble loyalty and faithfulness, but instead calculated deception. Ruth is reduced to a typical Moabite, pagan to the core, and intent on seducing a good Jewish man.

Are these allegations true? Have we misunderstood her legacy? Is our famous heroine actually a vixen?

1. Unless otherwise indicated, all Scripture in this chapter is from the English Standard Version (ESV) of the Bible.
2. Schwab, "Ruth," 1324, 1332, 1335.
3. Spina, *The Faith of the Outsider*, 131.

Setting the stage

To set the stage for the story of Ruth, it is vital to understand the period of time in which her narrative is set. More specifically, we must know the imperatives that God had commanded to obey under the Mosaic Covenant. Yahweh spoke to Moses and said of the nation, "If you will indeed obey my voice and keep my covenant, you shall be my treasured possession among all peoples, for all the earth is mine; and you shall be to me a kingdom of priests and a holy nation" (Exod. 19:5–6). Biblical scholar Charles Baylis writes, "The Mosaic Law revealed *how* they were to represent Yahweh. Unlike pagans, they were not to represent God based on what *they* reasoned . . . but they were to represent Him as He specifically revealed Himself."[4] God chose to reveal himself through a set of laws that allowed an unholy people to be set apart into a relationship with a holy God. Paramount to this list of regulations was a warning against doing actions that were right in their own eyes but were actually evil since opposed to Yahweh's commands (Deut. 12:8; Judg. 17:6, 21:25).

The days of Moses and Joshua brought prosperity and blessing to God's people, as they obediently followed Yahweh's laws and worshipped him. Upon the death of Joshua, however, generations arose who "did not know the Lord or the work that he had done for Israel. And the people of Israel did what was evil in the sight of the Lord and served the Baals. And they abandoned the Lord, the God of their fathers" (Judg. 2:10–12).

The Israelites' choice to turn away from Yahweh and worship other gods angered the Lord. The consequences for disobedience and idolatry had been clearly laid out and would ensue (Exod. 19:5–6; Deut. 28). Israel experienced defeat in battle, slavery under their enemies, and cursing upon the land as seen through famine. Theologian John Reed adequately summarizes this time by saying, "The period of the Judges was marked by weak faith and irresponsible conduct."[5] As an act of mercy, the Lord raised up judges to help rule the chaos and as a means to deliver his people. Yet the nation's stubborn, selfish behavior remained, as they continually chose idolatry and disobedience. Corruption and sin increased.

Against such a wretched backdrop, Ruth's story begins.[6] Darkness ruled the people's hearts, and if such evil were not enough, readers quickly learn of another darkness: "In the days when the judges ruled there was a famine in the land" (Ruth 1:1). Here, amid famine and immorality, we meet a Jewish man — Elimelech. He chose to take his wife, Naomi, and their two sons to the land of

4. Baylis, "Naomi in the Book of Ruth in Light of the Mosaic Covenant," 419.

5. Reed, "Ruth," in *The Bible Knowledge Commentary,* 415.

6. While the book of Ruth is named after one of the main characters, many scholars believe the narrative centers around Ruth's mother-in-law, Naomi. The story weaves around this widow who loses her family during their stay in Moab, questions her faith in Yahweh, and ultimately needs a male heir to restore her husband's name. For the purpose of this chapter, however, we will focus on the character of Ruth.

Moab, seeking reprieve from the harsh circumstances in Israel. While in Moab, their sons, Mahlon and Chilion, disobeyed one of Yahweh's law forbidding marriage to foreigners, and both wed Moabite women. The story moves quickly as tragedy strikes hard and fast: Elimelech and his sons die, leaving Naomi and both her daughters-in-law as childless, unprotected widows (vv. 3–5).

Marriage to a Moabite

Ruth's scandal begins with the "Moab" insignia found on her birth certificate. The tribe of Moab originated as descendents of Lot and the sexual relations he shared with his two daughters (Gen. 19:30–38). Incestuous beginnings for the Moabite tribe resulted in bad blood between them and the Israelites. Yahweh's Law provided explicit instructions about unacceptable interactions with Moabites, including the exclusion of these pagan people from entering the assembly of the Lord (Deut. 23:3–4).[7] The primary reason that the two tribes mentioned—Ammon and Moab—were excluded came directly from their hostility with the Israelites and the Ammonites' and Moabites' unwillingness to assist God's people as they entered the Promised Land.

In addition to excluding these peoples from the assembly, Yahweh expressed clear instructions that the Israelites were forbidden to marry women of foreign descent (Deut. 7:3). In the twenty-first century, couples find great acceptance in marrying whomever and whenever they would like. Particularly in the West, marriage between two people with differing backgrounds and ethnicities is accepted and encouraged. During the days of Moses, however, Yahweh was increasingly clear about the marriage of his people, the Israelites, to foreigners. Mosaic law forbade marriage to particular groups of people, as it resulted in wives leading husbands into idol worship (Deut. 7:4).[8] Consider Solomon, for example. Perhaps he thought he was doing a little evangelistic dating with his seven hundred wives and three hundred concubines, but in the end—disaster (1 Kings 11:1–6; Neh. 13:26). These women turned his heart away from the Lord time and time again.

Ruth inherited the reputation of her people, whether she liked it or not. Branded as an enemy of Israel, how would Ruth rise above her ethnic identity?

Ruth 1: Three strikes against her

In ancient times, a widow's primary source of sustenance came from her male relatives.[9] In a patriarchal society in which a man could find a job and rebuild his life following tragedy, a woman experienced the opposite. Women secured

7. The prophet Nehemiah references this exclusion after rebuilding the walls around Jerusalem, and as a result, the Israelites separated from themselves all those of foreign descent (Neh. 13:1–2). Also, Ezra instructed the people to divorce anyone from Moab (Ezra 9:1; 10:18–19).
8. Cf. 1 Cor. 6:14–7:1.
9. Ruth lived approximately during 1300 BC.

their place through two means: marriage and motherhood. And less than one chapter into their story, Naomi and Ruth possess neither. Theologian E. Moore writes, "In the worst case, a widow could be left to choose between slavery, prostitution or destitution."[10] Naomi sums up her status as a homeless, childless widow best when she uttered, "The LORD has brought me back empty" (Ruth 1:21). A foreigner in the strange land of Moab, having no husband and no sons, Naomi found herself in the worst circumstances possible. Where would she live? How would she eat? How would she survive?

Word arrived in Moab that the famine had finally ended in Bethlehem (v. 6). Perhaps in an attempt to return to a place of familiarity and leave behind the daily reminders of her loss, Naomi determined to return to Bethlehem (vv. 6–7). Her daughters-in-law shared her plight and began the journey with her. Along the way, Naomi urged them to leave her. She fully comprehended the lack of provision she could give them. Devoid of money, children, shelter, or even food, Naomi could offer these women no security.

Provision of grace for the widow

As she described the bleakness of their options, Naomi made reference to a provision that Yahweh had made for those such as herself. She asked her daughters-in-law, "Have I yet sons in my womb that they may become your husbands?" (1:11). The brokenhearted widow referenced a law Yahweh had designed that related to a "levirate marriage." Levitical law demanded that upon the death of one brother, the next brother in line would assume responsibility for his deceased brother's wife. The remaining brother honored his deceased brother by taking the bereft wife as his own, lying with her and producing a son, an heir, for his brother's line. The brother who did so was called the *levir*, or brother-in-law,[11] the one who consummated a marriage with his sister-in-law.[12] Had either of Naomi's sons lived, they would have been responsible to lay with the deceased brother's widow and produce an heir.

As Naomi explained, Ruth and Orpah would need to wait for her to marry again, become pregnant (twice!), wait for her new sons to come of age, and then marry them. Naomi offered nothing but a life of burden in light of this reality; thus, she released Ruth and Orpah of all obligations to remain with her. She urged them to return to their parents' homes, blessed each of them, and prayed for their future security (vv. 8–9). Initially, both women refused to leave her. Yet as Naomi insisted, one daughter in-law, Orpah, finally agreed to her plea, kissed her goodbye, and returned to Moab.

With Orpah gone, Naomi and Ruth stood face-to-face. Ruth faced a choice. Watching Orpah walk away, she knew the road back to Moab led to

10. Moore, "Ruth 2: Ancient Near Eastern Background," 688.
11. BDB, 386.
12. HALOT, 383.

predictability and the possibility of protection and rest in her mother's home.[13] Ruth glanced at Naomi and the Bethlehem road behind her. Discomfort, uncertainty, adversity and life as an outsider awaited her. Yet the determined character of Ruth is unmistakable in her next action. Her words were powerful. Unwavering. Courageous. Ruth vowed, "For where you go I will go, and where you lodge I will lodge. Your people shall be my people, and your God my God. Where you die I will die . . ." (1:16–17).

Ruth was fully aware she was choosing to uproot her life, live as an outsider, and endure disdain as an enemy of Israel. As a Moabite woman, she was forbidden to participate in the normal gatherings of God's people. Yet, as her words suggest, this prohibition did not bar her from participating in a relationship with Yahweh. Of this, an expert in the ancient Near East, Eugene Merrill writes, "Disbarment from the assembly was not synonymous with exclusion from the covenant community itself, as the one example of Ruth the Moabite makes clear."[14] And we will see that while Ruth's birth certificate read "Moab," she unashamedly chose Yahweh and what life would bring as one of his followers.

Her vow committed her to the following:

- *Loyalty in location:* Regardless of where Naomi would find herself geographically, Ruth committed to being with her.
- *Loyalty in lodging:* Regardless of the accommodations in which Naomi would find herself—stable, cave, or home—Ruth committed to be with her.
- *Loyalty in people:* Ruth denounced her nationality and chose never to return to her own family or homeland.
- *Loyalty in religion:* Ruth rejected the pagan deities of her birth and chose Naomi's God, the God of Israel.
- *Loyalty in death:* Ruth desired to be buried with Naomi at the end of her life and desired that only death separate them.

Ruth's determination to denounce these crucial components of her life proved her commitment to Naomi and loyalty to Yahweh. Ruth chose sacrifice. And as President Woodrow Wilson once said, "Loyalty means nothing unless it has at its heart the absolute principal of self-sacrifice." [15]

Ruth's oath left Naomi speechless. Perhaps she welcomed the companionship or simply lacked the energy to fight Ruth. Regardless, Naomi clung to the determination of her daughter-in-law, and these two widows become a team.

13. Acceptance back into their father's home was not guaranteed. In a patriarchal shamebased society, the death of one's spouse and the return to one's father's home brought shame for him. Naomi offered her hope for rest and security in the home of their fathers, but she understood there was no promise of either.

14. Merrill, *Deuteronomy*, Vol. 4, 309.

15. Address at Citizenship Convention, Washington, July 13, 1916.

A Bethlehem homecoming

My father grew up in the middle of Perham, Maine, population 386. This farming town was nestled in the hills of northern Maine and consisted of a one-room schoolhouse, a post office doubling as a general store, and the little white church in the wildwood. Whether Wendell's tractor broke down in the back forty, Clayton's Holstein got loose, or Miss Glenna came down with a fever, everyone knew. Bethlehem was probably a lot like that.

Imagine Naomi's apprehension in returning to a town that she left so long ago and the gossip that would ensue upon her arrival with no husband and a Moabite daughter-in-law. Bethlehem was a small place where everyone knew everyone's name and business, just like Perham. Naomi had plenty of time to ponder the repercussions of allowing Ruth to follow her as they made the thirty-to sixty-mile trek across the arid desert, carrying all their belongings.[16] A decade earlier Naomi had departed with a full quiver, and now she was returning with an enemy of Israel. What would her kinsmen say?

Bethlehem buzzed with the arrival of the two widows and the clear absence of their men. Shocked and amazed, the women asked, "Is this Naomi?" The hopeful wife who had departed so long ago returned a broken and bitter widow. Her response to their inquisition exposed her crumbling faith as she cried, "Do not call me Naomi; call me Mara ["bitter"], for the Almighty has dealt very bitterly with me. I went away full, and the LORD has brought me back empty" (1:20–21).

As we often do amid extreme heartache, Naomi blamed Yahweh for her calamity. The pain of her brokenness blinded her to Yahweh's care of her through the young woman standing beside her. While her feeling of emptiness was certainly not unmerited, it masked the beginnings of Yahweh's provision to once again raise her up through the young Moabite woman who had just pledged all allegiance and support to her for as long as they both should live.

Naomi was broken. Yet in reading her story, the reader has hope. We who have eyes to see notice that Yahweh is working, just as he promised. We see Ruth rising above her pagan, adversarial status with determined faith, even when everyone around her is marked by weak faith. Ruth will prove her commitment to Naomi, regardless of what that might look like—even if it involves a midnight rendezvous with a man.

Ruth 2: Proving the Bethlehemites wrong

The pair of widows arrived in Bethlehem at the beginning of barley harvest (1:22).[17] As widows with no male heir, Naomi and Ruth returned to Bethlehem

16. The journey from Moab to Bethlehem would have been roughly thirty to sixty miles (50–100 km), the variance depending on which route they chose.
17. Barley harvest in ancient Israel took place in early spring. Leviticus 23:5–14 commands that the first grain be brought to Yahweh's temple. The extremes of famine and barley harvest become the two bookends for chapter 1.

with the clothes on their backs and what possessions they could carry. Ruth wasted no time trying to assure some kind of security for herself and Naomi. She knew that if anything, she could work for their supper. Her subtle, yet firm resolve offered a polite request to her bitter mother-in-law: "Let me go to the field and glean among the ears of grain after him in whose sight I shall find favor" (2:2).

Ruth recognized that as an outsider she would be mistrusted, despite Yahweh's provision for the sojourner. Of this theologian Daniel Block writes, "The Mosaic law displayed particular compassion for the alien, the orphan, and the widow by prescribing that harvesters deliberately leave the grain in the corners of their fields for these economically vulnerable classes (Lev. 19:9–10; 23:22; Deut. 24:19)."[18] Ruth qualified as a gleaner on two accounts—as an alien and as a widow. Ruth desired merely to follow after the harvesters, among the other poor, and glean the leftovers for Naomi and herself.

Setting out from home, Ruth "happened to come to the part of the field belonging to Boaz" (2:3). As an introduction to this man, the author tells the reader two facts. First, he is a relative of Naomi's deceased husband, Elimelech; and second, he is considered to be a "worthy man" (2:1). The literal translation of his name means, "liveliness"[19] and "swiftness."[20] Many feel his name indicates the valor and strength of his character and faith in Yahweh.[21]

An additional aspect about Boaz, gleaned from the text, is his possible age. He addresses Ruth as "my daughter" (vv. 8, 3:10–11), a name Naomi uses of her as well, indicating he and Naomi are of the same generation. Also, he appears to fear God. Jump forward to where the author describes Boaz coming to the fields to assess the day's events. His loyalty to keeping Yahweh's covenant is immediately demonstrated based upon his greeting to his workers: "The LORD be with you" (2:4).

As Boaz surveys his fields, his eyes rest on an unfamiliar face. He asks his foreman about the stranger among them, and the foreman explains, "She is the young Moabite woman, who came back with Naomi from the country of Moab" (2:6). Her identities as a Moabite and as Naomi's daughter-in-law have preceded her. Bethlehemites missed nothing of Naomi's plight as she walked her childless, foreign daughter-in-law through town. Oh, the gossip mill that must have traveled through Bethlehem because of her! Yet, based upon Boaz's quick permission for Ruth to glean in his fields, the gossip mill seems to be producing honorable recommendations.

The text offers no details about precisely how long Ruth was married to Mahlon, nor how long after his death she and Naomi started their journey back

18. Block, *Judges, Ruth,* 652.
19. HALOT, 142.
20. BDB, 126.
21. The term "mighty man of valor" is also used of Gideon and Jephthah (Judg. 6:12; 11:1).

to Bethlehem. But no matter how long the time, the grief in losing a spouse never totally fades. Whether the marriage was arranged or one rooted in love, the void remains. In a male-centered society such as this, in which Ruth's social and physical security rested on a husband, her secure future ended abruptly. An immigrant, from a despised ancestry, Ruth needed a miracle.

Boaz summoned Ruth for a meeting. Imagine for a moment the emotions soaring through her as a widow and foreigner standing face-to-face with the powerful owner of this field. Fear must have overcome her as she wondered if she'd done something wrong. Would he banish her from his fields? Where else might she glean? How would she provide food for her mother-in-law?

Faced with either banishment from the field or mercy at his hand, Ruth received the unexpected. Boaz offered her praise and blessing for her choices (v. 11). He took an almost protective role with her, instructing her to remain gleaning in his fields and to follow closely behind his female servants (v. 8).[22] Boaz gave explicit instructions to his male workers not to harass or harm her, clearly protecting her from inappropriate treatment, including sexual harassment (v. 9). Last, Boaz desired that Ruth drink water from the water he provided his workers, including her as one of his own trusted workers (v. 9).

While most scholars believe Boaz's actions radiate kindness, grace, and charity, others find the beginnings of Ruth's sexual scandal. Scholar George Schwab believes Boaz's four commands to contain "four sexually suggestive overtones."[23] Schwab goes so far as to suggest that Boaz's command to "drink from his well" does not in fact mean water, but rather alludes to the proverb, "Drink water from your own cistern, flowing water from your own well. . . . rejoice in the wife of your youth . . . be intoxicated always in her love" (Prov. 5:15–19).

Interpreting Boaz's commands as flirtatious advances toward a Moabite widow he had known for ten minutes is a grave disservice to Boaz's character, as established by the biblical author. Instead of reading sexual meaning into his words, we must interpret Boaz's actions as a deliberate choice to act completely counterculturally. Daniel Block offers an opposite perspective regarding Boaz's offer of water: "In a cultural context in which normally foreigners would draw [water] for Israelites, and women would draw [water] for men (Gen. 24:10–20), Boaz's authorization of Ruth to drink from water his men had drawn is indeed extraordinary."[24] Boaz went above and beyond what society expected of him as a noble man, and humbled himself to mirror the gracious love of Yahweh.

Overwhelmed by Boaz's actions toward her, Ruth "fell on her face, bowing to the ground" (Ruth 2:10). That is, Ruth honored Boaz and communicated her

22. Boaz's four-part commands are as follows: remain here (v. 8); follow behind the female servants (v. 8); do not worry (v. 9), and drink freely (v. 9).
23. Schwab, "Ruth," 1324.
24. Block, *Judges, Ruth,* 660.

respect and expression of gratitude toward him as she bowed, face and nose to the ground.[25] Her bodily response to Boaz revealed her understanding of what worship looked like for a Yahweh-follower.[26] And her verbal expression indicated her acute awareness of her position and Boaz's grace toward her. She asked, "Why have I found favor in your eyes, that you should take notice of me, since I am a foreigner?" (v. 10). In other words, "Why are you being gracious to me?" Ruth, the Moabite widow, encountered a man who showed her an undeserved kindness, and it left her shocked.

Rather than dismissing her questions, as was his right considering his status, Boaz answered her kindly. His answer was simple: Your reputation precedes you (v. 11). Ruth was known as a woman of undying loyalty to her mother-in-law and unwavering courage to leave her homeland.[27] While many considered her choice irrational and even downright crazy, Boaz praised her. In response she said, "I have found favor in your eyes, my lord, for you have comforted me and spoken kindly to your servant, though I am not one" (v. 13). Although as a widow and a woman Ruth held an inferior position in this society, Boaz threw culture to the wind, and Ruth knew it.

Before Ruth returned to Naomi that night, Boaz embarked on the unthinkable and invited her to dine with him (v. 14). Meals in the ancient Near East were not merely a ritual to satisfy a growling stomach. Meals took place as a means of celebration and hospitality, and they also served to create political and social treaties, and even served religious purposes.[28] Those whom one invited to dine received a statement of acceptance. Boaz bestowed this upon Ruth with his invitation. At the conclusion of the meal, Boaz's generosity resulted in instructions to his workers to deliberately drop handfuls of barley in Ruth's path so she would have abundant provision (v. 16), and a goodie bag to take home. With each act of kindness, Ruth remained unaware that this man was a kinsman of her deceased husband. She had ironically and providentially happened upon the field of the one man who could actually assist these widows in their calamity.

Ruth returned to Naomi that evening with one ephah of grain, equivalent to about eleven two-liter soda bottles. Such a haul represents an extraordinary accomplishment for one day's labor, and an indication that Boaz's harvesters followed his instructions by leaving plenty behind for her to gather.

25. Abigail behaves the same way when she greets King David (1 Sam. 25:23).
26. Bowing face down was commonly done in response to royalty or deities (Cf. Judg. 2:12, 17, 19; 7:15). Gideon is also seen worshipping Yahweh in the same manner after Yahweh comes to him in a dream before defeating Midian (Judg. 7:15).
27. Ruth's actions to leave her father and mother shadow that of Abraham when he left his home for an unknown Promised Land (Gen. 12:1–4).
28. Cf. Gen. 18:1–8, 43:33–34; Exod. 24:11, 32:5–6; Ps. 23:5; Isa. 21:5; Amos 6:7; Matt. 22:1–14.

The kinsman-redeemer

Picture the scene that follows. Ruth returns from her day in the fields, sweat on her brow, dust on her garments and laden with enough food for days. Perhaps she finds Naomi miserable and quiet in the corner of wherever they had found to lay their heads. Trying to coax Naomi out of her pit of bitterness, Ruth lays the day's bounty at her feet, and chats about the day's events—the field of grain, the women she followed behind, the conversation with the field owner, the invitation to dine at his table and drink from his well, and the goodness of Yahweh on their lives.

Imagine Naomi's shock when in quiet naivety Ruth simply says, "The man's name with whom I worked today is Boaz" (2:19). As his name escapes Ruth's lips, Naomi's eyes sparkle. Her back straightens. Her spirit visibly lifts. For the first time, Naomi offers praise to Yahweh for his provision (v. 20).

As Ruth recounts her day, Naomi says, "The man [Boaz] is a close relative of ours, one of our redeemers" (v. 20). Naomi explains Boaz's connection with her family, and you can almost see the pieces starting to fit together. When a woman in Naomi's day experienced tragedy, her family was responsible to care for her in her darkest hours. Remember her reference to Yahweh's levirate marriage law in the opening scenes of this story? She told both her daughters-in-law, "Have I yet sons in my womb that they may become your husbands?" (1:11). While the levirate law obligated the brother in-law—the *levir*—to marry the brother's widow, in the case of Ruth no brother-in-law existed.[29] Yahweh's Law, however, had a built-in family care policy, even if no *levir* lived.

Naomi names Boaz, not their *levir,* but by a more accurate name—their *go'el.* The *go'el* functioned as one who restored family wholeness. By definition, this relative "acted as kinsman or did the part of next of kin, in taking the kinsman's widow."[30] Another way to accurately describe the *go'el* would be to call him the kinsman-redeemer. This kinsman-redeemer is associated with a custom that "involves a circle of close relatives . . . beyond the brother-in-law and concerns needs beyond the provision of an heir."[31] His duties could include purchasing back any property that family members might have had to sell, buying back a family member sold into slavery due to hardship, and even avenging the murder of any family member by killing his or her murderer (Lev. 25:23–49).

If my husband lived and married in Ruth's day and I found myself a destitute widow, by law his eight (no, that's not a typo) brothers would be responsible for me. God forbid that death would fall upon every one of them; but if that

29. The book of Ruth contains the only narrative within Scripture that highlights the role of the kinsman-redeemer as the central motif. It remains unique in this regard, highlighting the unique practices/laws of the Israelites.
30. BDB, 145.
31. Hubbard, *Dictionary of the Old Testament,* 379.

happened, his uncles would be next in line to care for me. In the story of Ruth, Boaz would act as the *go'el,* not the *levir.* With all of Naomi's sons deceased, a *go'el* redeemer was the women's only hope.

Ruth 3: The threshing-floor controversy

During a three-month stay in southern India, I followed my host family village to village as they sought a bride for my hostess's brother. Each morning they faithfully read the newspaper for ads placed by families seeking to marry their sons and daughters. This old-school Match.com came complete with descriptions of the betrothed's schooling, religious association, and dowry demands. After finding a couple of possible matches for the brother, the family arranged meetings.

We travelled from home to home, where the father, mother, and other family members of the potential bride were introduced. After a short time, the potential bride emerged in her finest clothes, serving tea. She remained quiet and reserved, answering questions politely. Soon after tea, the patriarchs of each respective family left the room to discuss more details. After each visit, a thorough analysis of the experience, family, woman, and benefits ensued. Compatibility and necessity dictated marriage.

As we unpack what transpires in chapter 3 of Ruth's scandal, remember that our perspectives on marriage have a twenty-first-century spin. We have reduced love to twelve bridesmaids and groomsmen, cocktail parties, exotic destinations, and a sweetheart-cut rock on the ring finger. We expect candlelight, a bed of roses, and a photographer to capture minute expressions during the romance. Many around the globe, however, participate in arranged marriages—often for convenience, strategic alliance between families, inheritance, or necessity, but rarely love. Such was Ruth's situation.

The next component of Ruth's story opens in dialogue between mother-in-law and daughter-in-law. Once the latter has established herself through two harvest seasons with Boaz's workers,[32] Naomi seeks to find permanent security for her in this land that is foreign to her. In conversation with Ruth, Naomi goes into great detail about how she and Ruth will move forward in securing her status through their kinsman, Boaz. Naomi offers instruction; and it is these very instructions that lie at the heart of why the story of Ruth is sometimes labeled as scandalous.

Naomi's plan

Naomi lays out a five-point plan in which she tells Ruth, "Wash therefore and anoint yourself, and put on your cloak and go down to the threshing floor,

32. The biblical text indicates Ruth worked in the fields for both barley and wheat harvests (2:23). Barley harvest typically took place from late April or early May and preceded the wheat harvest by about two weeks (Exod. 9:31–32). See Brand et al., eds., "Barley Harvest," 172.

but do not make yourself known to the man until he has finished eating and drinking. But when he lies down, observe the place where he lies. Then go and uncover his feet and lie down, and he will tell you what to do" (3:3–4).[33]

Let's consider her plan and its implications for Ruth:

Wash and anoint yourself. Let's be honest: No woman would ever dream of meeting a man she hopes to marry smelling like she just left a YMCA cardio-burn class, her hair in disarray, and her clothes dripping with sweat. Rather, we take a little extra time to pull out the lavender-scented body wash and dab some Ralph Lauren behind our ears. Naomi's instructions to bathe and apply perfume are realistic, considering Ruth's labor in the fields. More specifically, these preparations are actions taken by a bride in preparation for a wedding.

Adorn yourself. What does Naomi mean when she tells Ruth to put on her cloak? Would Boaz even notice her clothing, considering she would approach him after dark? Two opinions emerge. First, many believe that Naomi asked Ruth to adorn wedding attire, symbolizing that Ruth's period of mourning had ceased.[34] Second, others believe Naomi did nothing more than make sure Ruth took a cloak of sorts with her so as to keep from chilling in the evening air (Exod. 22:25–27).[35] Whether Naomi instructs her to remove her mourning clothes or simply instructs her to bring a garment used by the poor as a blanket for warmth at night, she instructs Ruth to make a statement with her attire.

Uncover his feet and lie down. Naomi's final two instructions remain the most controversial of all; they're what most bring Ruth's character into question. The Hebrew words in this passage have multiple interpretations. The words in question are as follows:

- **To uncover:**[36] The root of this word can have a sexual understanding. One might throw back a duvet and find the person to be naked underneath

33. Within this chapter, Naomi errs on a few levels regarding her instructions to Ruth. These mistakes include the following: referring to Boaz as a "relative," a term more fitting of a friend, rather than the legal term for someone who could redeem or rectify legal problems; sending Ruth in the middle of the night, rather than during the day among a plethora of witnesses; requesting Ruth speak to Boaz after he had drunken wine and could be a tad buzzed. Naomi's relationship with Yahweh is crumbling, which could explain such errors in judgment.

34. King David is seen doing this when he removes his clothes of mourning to establish this period of time is over (2 Sam. 12:20). See also Genesis 38:14, 19, when widows' garments are removed.

35. The word Naomi uses here is the generic word for an outer garment, *śimlâ.*

36. The terms "to uncover" and "feet" are often linked. See footnote 37 on "feet," for additional texts where this combination of words is used.

(i.e., uncover someone's nakedness). The term is also used as a euphemism for exposing someone's private parts, as seen in Yahweh's Law found in Leviticus.[37]

- **Feet:** The Hebrew noun for foot (*regel*) can also serve as a euphemism for male genitalia. It sometimes appears in narratives in which someone is using the bathroom.[38] Interestingly, however, Naomi's command does not include this term (*regel*), but *margelôt,* which means "place of the feet."[39]

- **To lie:** The verb meaning "to lie" is often used to denote sexual relations, as in the case of Jacob and Leah (Gen. 30:15–16).[40] The common phrases for sexual intercourse, however, tend to be "he lay with her," "he went in to her," or "he knew her," as can be seen in the final chapter of Ruth's story when intercourse actually occurs (4:13).

The mystery surrounding these commands should be obvious. Their possible double meanings can raise a question: What exactly did Naomi intend for Ruth to do? Naomi's instructions exude longing for her season of calamity to be over. And some interpret her actions as a "delicate and dangerous scheme, charged with sexual overtones."[41] But before we explore the possible interpretations, let's follow Ruth as she walks in obedience to the threshing floor.

What will Boaz do?

Ruth courageously ventures into the night. She weaves her way through the streets of Bethlehem, finally reaching the threshing floor. She waits and watches for Boaz to finish his evening meal and drink and then lie down for the night. Perhaps she hid behind a pile of grain, waiting for the right moment. Biblical scholar Ron Allen speaks of her quest: "What a powerful act of faith it was, that journey into the darkness."[42] The reward would be great, but Ruth had no way of knowing that yet. She felt only the risk.

As Boaz drifted off, Ruth quietly emerged and uncovered his feet, just as Naomi instructed. As anyone would do in the middle of the night when suddenly awakened, Boaz asked, "Who are you?" (3:9).

37. Cf. Lev. 18:6–19; 20:11, 17–21; Ezek. 22:10.
38. King Eglon of Moab took care of his business and "covered his feet" (literal Hebrew translation; Judg. 3:24). Similarly, King Saul goes into a cave to relieve himself (1 Sam. 24:3). Additional texts where *regel* is used include Song of Solomon 5:3, Isaiah 7:20, and Ezekiel 16:25. Texts for "uncover" include Ezekiel 16:37, 23:29 and Leviticus 20:11–21.
39. HALOT, 631.
40. See also, 2 Sam.11:11; Gen. 19:32–33; Lev. 20:11–13, 18, 20; and Deut. 15:22, 22:25, 27:20–23.
41. Block, *Judges, Ruth,* 685.
42. Ron Allen, unpublished article "On the Threshing Floor," February 2, 2016, 8.

Ruth responded with, "I am Ruth, your servant. Spread your wings over your servant, for you are a redeemer" (v. 9).

In these two sentences, Ruth makes a powerful shift from her mother-in-law's commands and begins to take matters into her own hands. Rather than waiting for Boaz to speak first and explain the next course of action, as Naomi had said, Ruth makes a bold move. Her direct request for protection and security (i.e., spread your wings) has left no question as to why she has come. Carolyn Custis James writes, "Ruth's boldness jars the respectable Boaz out of his religious comfort zone and leads him to a more radical, self-sacrificing life of faith—a life that breaks the rules of conventional religion—just as Jesus, their descendant, will do generations later."[43] While her respect for Naomi remains, Ruth's understanding of Yahweh's law shines.

Ruth asks Boaz to fulfill his covenant obligation to the family of Elimelech by naming him with his rightful title, go'el or redeemer. Daniel Block observes, "Naomi . . . identifies Boaz as the kinsman obligated to perform redemption duties for a widow, Ruth . . . classifies him as one qualified to fulfill the role."[44] Not only does Ruth name Boaz as her go'el, but she also reminds him of his own prayer for her to find blessing under Yahweh's wings.[45] Ruth intentionally points out Boaz as the very one capable of conveying God's love.

Interpreting Ruth's actions

Boaz has two possible interpretations for Ruth's actions: either to view her as making a sexual advance like a common prostitute or as acting in virtuous obedience. Which will he choose?

A sexual advance? Naomi's instructions came with great risk that Ruth would be mistaken for a prostitute considering the time of day, Boaz's full day of field-labor, and his full belly. Naomi chose to send Ruth to confront Boaz at the threshing floor in the darkness of night rather than in a public arena during the day. Scholar Harry Harm writes, "Night is considered to be a time for sinful, not for righteous deeds."[46] The prophet Hosea even links threshing floors with forbidden sexual escapades (Hos. 9:1). Would Boaz be coherent enough to interpret her actions as virtuous?

Jewish scholar Haim Chertok thinks not. He observes, "Except for Joseph, no other biblical man of valor occurs . . . who is a champion of sexual restraint. What does Naomi hope will happen?"[47] Likewise, Schwab takes this interpretation to an erotic level saying, "How far up his legs was Naomi counseling the oiled and alluring Ruth to uncover?"[48]

43. James, *The Gospel of Ruth*, 136.
44. Block, *Judges, Ruth*, 692.
45. See Boaz's prayer for Ruth in Ruth 2:12.
46. Harm, "The Function of Double Entendre in Ruth Three," 19–20.
47. Chertok, "The Book of Ruth—Complexities within Simplicity," 291.
48. Schwab, "Ruth," 1332.

An overtly sexual interpretation of Naomi's directions seems to read far more into the text than is intended, despite scholars' attempts to find symbolic impregnation even in her return home at the end of the night.[49] First, there is no suggestion in Naomi's tone or intention that either verb used (to "uncover" and to "lie") be interpreted solely sexually. No matter how depressed Naomi might have been, it is unlikely that she would have encouraged her daughter-in-law to immoral action. As a reminder, marriage customs were different in the ancient Near East. Courtship, dating, living together—none of these options existed. Parents arranged each component of the union. In the case of Ruth, her parents lived far away in Moab. And Boaz's parents were most likely deceased. Although Naomi's instructions might seem oddly dangerous, her actions could simply be interpreted as that of a mother arranging a marriage for her daughter.

While trying to understand the term "foot" (*margelôt*) and its proper meaning, a better clue can be found if we look at the only other place outside this context where it is used—in Daniel 10:6. In this passage, the term is used to describe the actual arms and legs of a statue Daniel sees in a vision. The term "foot" (*margelôt*) references the limbs of the statue. Block concludes, "Accordingly, it seems Naomi is advising Ruth to uncover Boaz's lower limbs, probably exclusive of his genitals, and then go and lie down herself."[50] Moreover, uncovering Boaz's legs in the middle of the night would likely cause him to become cold and awaken on his own.

While Naomi's instructions seem to place Ruth in a precarious situation, we must remember her state of mind and desperate need to provide long-range security for Ruth. All factors included, an entirely sexual advance seems improbable.

Virtuous obedience. A second interpretation follows a more true-to-the-text approach, in that Boaz could have viewed Ruth's actions consistently with how the author has portrayed her thus far in the story: humble, obedient, driven, and determined to honor her mother-in-law.

The threshing floor scene is delicate, dangerous, and yes, possibly even scandalous. Those who interpret Ruth's actions as solely sexually, however, fail to see the bigger clues within the entire story. Naomi's instruction to meet Boaz in the middle of the night allowed Boaz the opportunity to reject Ruth's proposal without the embarrassment or shame of the town watching. Remember, Boaz and Ruth held different statuses within the culture. A nighttime conversation allowed her to retain her dignity and her reputation, should Boaz send her away. The darkness of night actually functioned as the safest place for Ruth's proposal to occur—especially in a community in which everyone knew everyone else's business, and a person of low status could not properly approach a landowner, especially one of the opposite sex, to have a conversation.

49. Ibid., 1337: "Ruth returns home *symbolically* inseminated, her midriff being pregnant with Boaz's seed."
50. Block, *Judges, Ruth,* 686.

Additionally, the threshing floor was not as secluded as one might think, but rather a "communal installation" where men and women would stay at night in order to protect their grain.[51] Biblical scholar J. Vernon McGee writes, "There was not much privacy connected with such circumstances, but it was the custom of the day and was not considered immodest or even questionable."[52] While this event did take place at night, it is highly probable that others were also sleeping nearby, providing little privacy for intimacy.

The thrust of the scandalous accusations rest within the meanings of "feet" and "uncover." These terms tend to be linked together within biblical texts, as mentioned above. Ron Allen explains the possible etymology of the phrase to "cover one's feet": "The 'covering of one's feet' might be explained as lowering one's robe so that the feet are covered while squatting over a bowl, either a toilet or a chamber pot."[53] Additionally, Allen explains, each passage where these words occur together holds the possibility that the characters involved went into a cave or cool room to take a nap. In these instances, "to cover their feet" could simply suggest they arranged their robes so as to literally cover their feet to not catch a chill in a damp cave. In uncovering Boaz, then, Ruth then would be doing the opposite—removing Boaz's robe around his feet to perhaps cause him to be chilled and wake up.

Finally, if Ruth were prostituting herself to the fullest degree, how could Boaz bless Ruth for her actions as he does? Boaz's immediate response to Ruth includes a notation of her virtue, not of her unscrupulous character. He says to her, "May you be blessed by the LORD, my daughter" (3:10). Ron Allen writes, "The explicit Yahwistic language, the language of faith, piety and rectitude, is overwhelming."[54] Boaz's praise of Ruth seems to echo her courage, despite the odds, to care for her mother-in-law, while obeying Yahweh and his commands. From the beginning, Ruth rises off the pages of Scripture as a woman of virtue and honor.

Centuries before the events described here happened, another man offered the same kind of praise to a woman. Tamar found herself in a similar situation as Ruth, widowed and childless—except that Tamar's father-in-law, Judah, refused to order his son to marry his widowed daughter-in-law and produce an heir. Tamar, left with few choices, chose to disguise herself as a prostitute, sleep with her father-in-law, and as a result became pregnant. Months later, her swollen belly revealed her actions. Judah confronted her in outrage, and when she presented him with his own signet ring and staff (as proof of the child's paternity), Judah made a telling remark: "She is more righteous than I" (Gen. 38:26).

Ruth's actions, whether to her mother-in-law or Boaz, mirror God's love for his people. The word for "love" used within the book of Ruth is *hesed*. This

51. Boraas, "Floor," 292.
52. McGee, *Ruth,* 38.
53. Allen, "On the Threshing Floor," 3. See also footnote 37.
54. Ibid., 11.

type of love depicts God's faithful, committed love, which is rooted in loyalty to his people. Ruth and Boaz alike mirror this love throughout the book. Ron Allen writes, "By positioning herself at the place of his feet (recall the word, *margelôt*), she was asking for protection, for position, for *ḥesed*."[55] For the author of the story to say this woman's actions mirror the loyal love of Yahweh and then call her nothing more than a prostitute is absurd. We must not be distracted by feet, but rather focus on the character of this chosen outcast. As Schwab acknowledged, Freud would say, "*Zuweilen sind Füße nur Füße* ("sometimes feet are only feet")."[56]

Ruth 4: Hope discovered

As the final chapter to Ruth's story opens, we find Boaz making good on his promise to discuss Ruth's proposal with the nearest kinsman-redeemer (3:11–13, 4:1–10). The character and ingenuity of Boaz shine within these first verses. Boaz addressed the unnamed man (*ploni almoni*, aka Mr. So-and-So) and told him of an available parcel of land which belonged to their relative Elimelech. "The designation of the property as the deceased Elimelech's allotment (4:3) highlights the Mosaic emphasis on the land as an inheritance from the Lord that was to remain within the family (Lev. 25:25)."[57] Mr. So-and-So quickly agreed to redeem this land. After all, who would pass up additional property to add to one's wealth? But the response of Mr. So-and-So—the author avoids mention of his name—shows his desire only for wealth and prosperity, not full reverence for the law, as we'll see with what happens next.

Boaz countered his agreement with an additional clause, saying, "The day you buy the field from the hand of Naomi, you also acquire Ruth the Moabite, the widow of the dead, in order to perpetuate the name of the dead in his inheritance" (Ruth 4:5). It is important to note that the law does not require the *go'el* to perform the duties of the *levir*. Why then does Boaz link these two? Scholar Ron Hubbard believes that two assumptions drive Boaz's action: "a belief that land is inalienable (i.e., it must remain in family hands) and a social expectation (or custom) that close family (e.g., a *gō'ēl*) uphold that value."[58]

Upon hearing this new condition, Mr. So-and-So wasted no time saying, "No, thank you!" This man is certainly not ignorant to the laws of *go'el*. He understood that if he were to marry Ruth, the first son conceived through their union would be considered the deceased Mahlon's heir. Jewish scholar Dvora Weisberg notes, "Women view levirate unions as opportunities to ensure family continuity and provide widows with security. Men, in contrast, see levirate unions as a threat to their understanding of paternity and their desire to protect

55. Allen, "On the Threshing Floor," 11.
56. Schwab, "Ruth," 1337.
57. Moore, "Ruth 2: Ancient Near Eastern Background," 692.
58. Hubbard, "Kinsman-Redeemer and Levirate," 381.

their own interests."[59] Mr. So-and-So would benefit financially from the land, but it appears he would lose greatly with his own family should he "inherit" Ruth along with it. For these reasons, he relinquished all his rights to Elimelech's land and to Ruth through the exchange of a shoe. He transferred all rights to this parcel of land and the widow Ruth to Boaz.[60]

The witnesses at the city gate must have been waiting with bated breath for the conclusion of this scene, as they immediately pronounced blessings on Boaz: "May the LORD make the woman, who is coming into your house, like Rachel and Leah, who together built up the house of Israel" (4:11). Their blessing continued as they reminded the people listening of another woman whose similar actions resulted in a declaration of righteousness: "May your house be like the house of Perez, whom Tamar bore to Judah, because of the offspring that the LORD will give you by this young woman" (v.12).

The connection Ruth shares with Tamar is one many of us might miss. But needing someone to fulfill the levirate marriage responsibilities, they both chose to act when the men who should have shown *hesed* remained passive. These women's esteem of Yahweh's law must be commended, not criticized. Biblical theologian Frank Spina observes, "Like Tamar before her, Ruth the outsider has acted to save her own future, Naomi's future, Boaz's future, and Israel's future. And from the point of view of the Christian story, Israel's future and the world's future go hand in hand (Gen. 12:1–3)."[61] The Bethlehemite witnesses rightly focus their attention on the result of Ruth's actions. They desire Ruth to build up the house of Boaz, just as Rachel and Leah grew the house of Israel. Ruth walked in obedience, as Yahweh aligned her with an honorable and decent man. The result is astonishing.

Genealogy turned cool

Many can recall that time their parents pulled down the dusty slide projector and clicked through every family photo of Great-Great-Uncle Tom and his fourteen siblings. Our minds wandered as the folks described in detail how Great-Aunt Susie, twice removed, wound up on a tree farm in Alaska. Genealogies can be mind-numbing. And because our brains often go into neutral when we encounter family trees, we are tempted to do the same at this point in Ruth's story—which ends with a genealogy. This seems odd as the finale for a work driven by narrative. Stick with it though. This is a genealogy worth sitting through—and it helps if we give the list a context.

Ruth—a woman whose incestuous family legacy includes the enemies of the children of Israel—chooses to leave her pagan homeland with no promise of security or acceptance in the new land of her mother-in-law, Naomi. She comes as a childless destitute widow, the lowest rank a woman could bear. Ruth chooses

59. Weisberg, "The Widow of Our Discontent," 405–6.
60. Moore, "Ruth 2: Ancient Near Eastern Background," 692; cf. Deut. 25:8–10.
61. Spina, *The Faith of the Outsider*, 136.

to show loyal obedience to her mother-in-law, even when Naomi instructs her to visit a man above her social rank in the middle of the night. This young woman, who risks everything to follow Yahweh in loyal obedience, obtains a seat of honor that most women could only dream of.

Boaz and Ruth unite in marriage, and Ruth conceives. After a possible ten years of marriage to Mahlon with no pregnancy, Ruth's womb is opened by the Lord so she can bear a son (1:4; 4:13). The miraculous conception is significant. The women of Bethlehem break out in praise for Naomi's answered prayers. A woman whose home echoed with emptiness now has rooms that ring with the cries and giggles of a little boy. This son, who serves as a kind of redeemer to her, has restored the prospects of security in her old age. Naomi's joy is complete, as she takes him and becomes his nurse.

The son born to Naomi, by Ruth and Boaz, was named Obed. We read that this child grows to be a man and eventually become a father himself: "Obed fathered Jesse, and Jesse fathered David" (4:22). Fast-forward a few hundred years, connect the branches on the family tree and you'll discover that Ruth becomes the great-great-great-great-great-great-great grandmother of Jesus Christ, the ultimate Redeemer of a broken, chaotic world (Matt. 1:5, 16).

While most genealogies can produce a good nap, this one wakes God's people to the reality of divine mercy. From the union of Ruth and Boaz, the kinsman-redeemer, comes the line of Jesus Christ. Despite the darkness that ruled in the hearts of God's people during the era in which Ruth and Boaz lived, the hand of Yahweh secured his plan for the ultimate Redeemer.

What do we make of it all?
In four short chapters, the author of Ruth weaves a narrative of an immigrant woman who rises above every obstacle thrown at her. In contrast to the chosen Israelites within this story, she, the foreign Moabite Gentile, exhibits more understanding of Yahweh's law than they. Her faith in Yahweh shines through her courageous choices that include devotion to her mother-in-law and loyalty to Yahweh's commands. Biblical scholar Charles Baylis remarks, "To care for a poor widow in a foreign land without any hope of personal benefit seems impossible to Naomi. Yet Ruth wanted to emulate the Lord's mercy to the hopeless."[62] She accomplished her goal, despite the scandalous implications.

What's in a name?
While Ruth's actions may appear shocking and even disgraceful, the author chooses to name this narrative after the heroine of the book, Ruth. Names within this book—including the withholding of one—are integral to the telling of this story, and Ruth is given many titles. Each offers a distinction in

62. Baylis, "Naomi in the Book of Ruth in Light of the Mosaic Covenant," 431.

her role and status at that particular time.[63] First introduced as a *Moabite wife,* Ruth becomes an established character for the narrative (1:4). Her name then takes on a familial shift, *daughter-in-law* (1:6; 2:20; 4:15).[64] Upon Naomi's sojourn back to Bethlehem, the one who called herself "bitter" begins to refer to Ruth no longer as her daughter-in-law, but her *daughter* (1:12, 13; 2:2; 3:1, 16, 18), symbolizing Naomi's possible acceptance of Ruth as a biological child, as she will have no more children of her own. As the story unfolds, Ruth continues to be referenced as a *Moabite woman* (2:6; 4:5, 10), but then chooses to name herself. During her first conversation with Boaz, Ruth calls herself *servant,* the term used of the servant with the lowest rank (2:13), and by the time she approaches Boaz on the threshing floor, she progresses to use *servant* again, but this time with the meaning *handmaiden* (3:9). The author concludes by naming her the *widow of Mahlon* (4:10) and finally, *wife* (v. 13). The narrative ends with the elders of Bethlehem offering Yahweh's blessing upon her life, like that of Rachel and Leah. A woman, once a destitute outcast, becomes so esteemed that she is counted among the matriarchs of the Israelites.

The significance of Ruth's transition from an unknown Gentile to the eventual grandmother to King David is astounding. The narrative of Ruth opens by ridding the story of all male characters except two—Boaz, and Mr. So-and-So, the nearer-kinsman. The author does so not to elevate females, but to establish the significance of these two characters within the biblical narrative of redemption. God delights in weaving the unexpected underdog into his story. Who better to ensure the line of Christ than an enemy of Israel, a Moabite widow?

Carolyn Custis James writes, "A woman's high calling as God's image bearer renders her *incapable* of insignificance, no matter what has gone wrong in her life or how much she has lost. Even if her community shoves her aside, turns a deaf ear to the sound of her voice, or regards her as invisible—even if she is forced into a passive role in her community—she remains vital to God's purposes and is a solid contributor anyway. She cannot be stopped."[65] Ruth faced each of these and despite the death of her husband and Naomi's wavering faith, she proved herself a beautiful picture of God's loyal love to his people.

63. The meaning of names in the book include: Elimehlech, "my God is King"; Mahlon, "Sickly"; Chillon, "Failing"; Naomi, "My Pleasantness"; Mara (what Naomi chooses to call herself on her return from Moab), "Bitterness"; Orpah, "Neck"; Ruth, "Friendship"; Boaz, "Swift Strength"; Obed, "He who serves." All definitions found in HALOT.

64. The name *daughter-in-law* will arise a couple of times: first when Ruth leaves with Naomi for Bethlehem (1:6), next as a title of blessing by Naomi after meeting Boaz (2:22) and lastly by the women of Bethlehem as they rejoice and bless Naomi on the birth of a grandson (4:15).

65. James, *The Gospel of Ruth*, 66.

Ruth's faith

There is no indication in the text that Elimelech and his family turned to worshipping the gods of Moab. Despite their sojourn to pagan Moab, it is a fair assumption that their faith remained, regardless of how weak it might have been. As they recited the Torah, celebrated feasts, and practiced Levitical law, how much of their faith became real for Ruth? Did she see the difference between her lifeless statues and their vibrant God? Their testimony of Yahweh's works schooled her, day in and day out, on their belief system.

On the road from Moab, Ruth faced a choice. Perhaps the words of Yahweh, which echoed in Naomi's home, began to echo in her own heart: "Now therefore fear the LORD and serve him in sincerity and in faithfulness. Put away the gods that your father served beyond the River and in Egypt, and serve the LORD. . . . choose this day whom you will serve" (Josh. 24:14–15). In that dusty, humid moment there really was only one choice for her—Yahweh.

Centuries later, another duo walked onto the streets of Bethlehem in search of a place to reside. Weary and desperate for someone to show them kindness, they found a humble stable. That night a teenage girl gave birth to the Son of God, Jesus Christ. Thirty-three years after that night, a real scandal occurred as the Son of God hung upon a rugged tree a few miles from those Bethlehem streets. Isaiah 60:16 reads, "I, the LORD, am your Savior and your Redeemer, the Mighty One of Jacob." Our Redeemer, our *go'el,* hung crucified to atone for the sins of his people. His resurrection brought power over death and provided our ultimate redemption.

Ruth chose to go against every cultural norm to engage a man above her status, alone, at night. These accusations are true. If her actions equate to scandal, then so be it. However, Ruth's motivation rested not in deception, selfishness, or foolishness. Her growing faith in the God of Israel radiates through each of her choices.

Most of us have seen the radical, exuberant faith of a new follower of Jesus. The new convert's joy saturates each component of life. Each encounter with an old friend in the produce aisle serves as an opportunity to shout Jesus's love and grace from the rooftops. Ruth is no different; yet in a deeply patriarchal society, her "WWJD bracelet" has to look a bit different.

Ruth demonstrates astonishing courage in her obedience on the threshing floor. Motivated by more than a foolish or selfish heart, Ruth rises off the pages of Scripture as a beacon of God's loyal love during some of the darkest days of Israel's history. Allen writes, "Perhaps no other character in the Hebrew Bible is as remarkable in her constancy of a *hesed* life than the woman from Moab. For one to picture her as a slovenly woman, a slattern, seems not only wrong, but such a view undermines the spiritual thrust of the book."[66] As an immigrant, widow, and Gentile, her gutsy boldness on the threshing floor exhibits a willingness to risk everything for Yahweh's commands. Does this make her a vixen? If so, then may we all be counted as such.

66. Allen, "On the Threshing Floor," 7–8.

QUESTIONS FOR DISCUSSION

1. Describe a time in your life that you were misrepresented. How did you respond?

2. How has God redeemed your "misrepresented" moments?

3. In what areas of your life can you act boldly for the sake of the gospel?

CHAPTER 4

BATHSHEBA: VIXEN OR VICTIM?

SARAH BOWLER, THM

I spent several months in seminary brainstorming possible thesis topics—all of which went into a well-organized Word document to be saved for further mulling. Since I would need to put in countless hours of research and writing, I wanted a subject that would keep my interest. Researchers don't want to get halfway through their thesis work and realize they'd rather be scrubbing the bathtub, right?

I narrowed down my list of topics to two biblical characters and ultimately decided on Bathsheba. Her story surprised me, and I became convinced that Bathsheba's story has many applications for today. I started with the notion that the details about Bathsheba's responsibility remained ambiguous, and thus we should be careful with assumptions about her character. But the more I delved into the biblical text, the more I realized her agency in the story wasn't so enigmatic.

As I talked about my thesis research with my friends and colleagues, some comments and questions kept coming up. One of the top three questions people asked me was, "Why was Bathsheba bathing naked on top of a roof?"

Many who hold to the viewpoint that Bathsheba acted immorally make their case by claiming she bathed in a seductive or immodest manner near the palace. Yet, this idea overlooks several valid points. For instance, the participle "bathing" does not necessarily mean Bathsheba stood outside completely naked. The Hebrew word used here has a variety of meanings, including everything from washing one's whole body to washing only one's hands, feet, or face. So, it is possible that Bathsheba washed only part of herself, and David saw a pretty face that he liked and desired to see more.[1]

1. David E. Garland and Diana R. Garland, in "Bathsheba's Story: Surviving Abuse and

Chart 4.1: What We Often Suggest—What the Evidence Suggests

What We Often Suggest:	What the Evidence Suggests:
Bathsheba bathed on top of a roof.	Textual and cultural studies indicate she was most likely in an enclosed courtyard.
Bathsheba bathed naked.	The Hebrew word translated "bathed" is ambiguous. She could have been washing her hands or her feet only (while fully clothed).
Bathsheba's immodesty caused a king to stumble.	David was a "peeping Tom."
Bathsheba willingly came to the palace.	David sent messengers (plural) to fetch her.
Bathsheba had an affair with King David.	The text suggests David raped Bathsheba.

Second, the text states that David saw Bathsheba from his vantage point on the palace roof. The text also indicates that Bathsheba and Uriah's dwelling was lower than the palace, as David says to Uriah, "Go down to your house and wash your feet" (2 Sam. 11:8, ESV). In verses 9–13, the phrase "go down" appears four more times. So Bathsheba presumably was in an enclosed courtyard with little to no reason for her to guard herself against a peeping Tom.[2]

It could also be that cultural etiquette of that time dictated people "looked out but not down, so as to preserve the privacy of others."[3] In contexts where people lack indoor plumbing, various cultural allowances must be allowed. In support of this, Katherine Doob Sakenfeld suggests a thought that occurred to her when she visited Manila: "Walking through a garden area early one morning, I encountered a man bathing. He was in a partially secluded area, but it was

Loss," also suggest that there is no reason to suppose Bathsheba was fully naked: "If she were in public view, she would have washed without disrobing. There is no reason even to assume that she was naked. Public nudity was not acceptable in this ancient Jewish culture, but instead was considered shameful. There is no foundation for assuming she was some kind of exhibitionist." *Flawed Families of the Bible,* 156.

2. Archaeological data shows that the type of enclosed courtyard described was common for inhabitants during the Iron Age. For more information, see Mazar, *Archaeology of the Land of the Bible 10,000–586 B.C.E.,* 486; Borowski, *Daily Life in Biblical Times,* 16–20. Also, archaeologist Eilat Mazar suggests that David's palace was built outside the city walls with a commanding view of everything in the valley below. See *Preliminary Report 2005* and "Did I Find King David's Palace?" 16–27.

3. Sakenfeld, *Just Wives?* 72.

the only place he had; clearly it was my responsibility in that context to keep moving, not stare, in effect pretend to see nothing. So also Bathsheba may have been in the most private place available to her for bathing."[4]

The point remains that Scripture does not suggest Bathsheba intentionally bathed in David's view, and even if she had, the choice to sin still belonged to David. He could have looked away, but he chose to give in to temptation. As Joyce Baldwin states, "The glance becomes the gaze."[5]

But why do the details of one story really matter? Does our view of Bathsheba affect how we live out our Christian faith? I believe it does. A true understanding of her tale holds crucial ramifications for how Christians respond to a world filled with abuse and saturated with misunderstandings about sexual misconduct.

As I researched, I found current examples in which Christian writers and editors failed to be empathetic toward victims as they reported stories. Even sadder, some spiritual leaders rape or sexually abuse young women, and many of the victims still receive partial blame in situations where a spiritual leader is fully at fault.

It really hit home for me after a pastor's kid I had discipled several years ago started reading some my blog posts about Bathsheba. She got back in touch with me to say: "I just wanted to say thank you. I was raped two years ago Friday on a date in my home. I had three ministry leaders who I held on a pedestal put full blame on me. . . . Thank you for taking my side. I can never thank you enough for not blaming the victim."

How we interpret biblical narratives affects how we interpret events around us today. When we say phrases such as "David had an affair" or "Bathsheba bathed naked on a roof," we overlook the fact that Bathsheba was an innocent victim. We may also forget the "modern-day Bathshebas" who exist today. I long for the day when believers eradicate the line of thinking in which the victim shares partial blame for a perpetrator's sin. One step toward that end is sharing the "true" Bathsheba story.

DEFINITIONS OF RAPE

Before advancing further, the definition of rape must be considered. What constitutes rape? Further, how does the definition of rape differ between Israelite thought and modern thought? Was Bathsheba really raped?

The organization RAINN (Rape, Abuse, and Incest National Network) lists three keys to determining if a sexual act is consensual: (1) Are the participants old enough to consent? (2) Do both people have the capacity to consent? and (3) Did both participants agree to take part?[6] If any of these questions cannot be answered in the affirmative, then rape has occurred, whether or not it took place through the use of physical force.

4. Ibid.
5. Baldwin, *1 and 2 Samuel*, 232.
6. RAINN, "Was I Raped?"

The Hebrew language, though, has no direct equivalent for the English word "rape." This does not mean that translators should never use the term "rape" in English translations, but it does highlight the need to look carefully at the surrounding context.

Journal author Alexander Izuchukwu Abasili points out, "In the Hebrew bible, the concept of coerced sexual relationships is not as wide and all embracing as the contemporary conception of rape. The Hebrew bible does not emphasize the role of psychological, emotional and political coercion in rape, instead it stresses the vital role of physical force or violence."[7]

Social laws listed in Deuteronomy 22:23–27 illustrate this point concerning physical force with two examples. In the first hypothetical case, the text mentions an engaged woman having sexual intercourse with another man "in the city." In the second hypothetical case, a man lies with an engaged woman "in the open country." In the first example, both people are stoned to death. However, in the second example only the man is punished by stoning because, presumably, "he met her in the open country, and though the betrothed young woman cried for help there was no one to rescue her" (v. 27, ESV).

Strictly speaking Bathsheba was in a city, but that doesn't mean she wasn't vulnerable.

Davidson comments, "The whole narrative flow here suggests Bathsheba's vulnerability once she is inside the palace, yes, even before."[8] If Bathsheba cried out, no one would dare enter the king's chamber to stop him. In that sense, there was little difference between a man raping a woman in the country and a king raping a woman in his palace chambers.

Regardless of one's interpretation, the text still portrays Bathsheba as a victim and David as the perpetrator of a crime. Further, the biblical text suggests that Bathsheba did not agree to the sexual encounter with David and that, given David's position of power, she was not in a position to choose. So, from a modern perspective, David did indeed use his position of power to rape Bathsheba. Since the story is conveyed to listeners who better understand modern definitions of rape than biblical definitions, it seems best to describe the story as one of rape by one who holds power over another.

The danger of using other terminology in place of the term "rape" is twofold. First, doing so fails to convey the full enormity of David's sin and violation of Bathsheba to modern listeners, perhaps even tacitly suggesting that she is partly at fault.

Second, it means that listeners who have realized the victimization of Bathsheba must also be aware of ancient emphases of rape and the accompanying lexical ambiguities in order to avoid confusion over the absence of the term. Hence, it's best to stick with a modern definition for rape rather than dabble

7. Abasili, "Was It Rape?" 4–5.
8. Davidson, "Did King David Rape Bathsheba?" 88.

with ancient Israelite thought on the matter. Thus, we conclude that David used his position of power to, in modern parlance, rape Bathsheba.

THE SETTING AND CHARACTERS

Bathsheba's first encounter with David occurs within a section of short stories or scenes in the book of 2 Samuel. Chapters 9–20 make up a unit of 2 Samuel known as the Court History of David, and within that section chapters 10–12 make up a distinct literary unit. This is evidenced by the Hebrew phrase (the ESV translates this in 10:1 as "after this") found at the beginning of 10:1 and 13:1 and used to introduce a new narrative sequence.[9]

Chapter 10 begins with the death of King Nahash of Ammon, Jerusalem's neighboring territory on the east side of the Jordan River. It appears that Nahash, who had been an enemy of Saul, was an ally of David and had possibly made a peace treaty with David. David sought to remain on friendly terms with the Ammonites and sent a delegation of men to express condolences.[10]

Nahash's son Hanun listened to advisors who suggested David's men had come to spy out the land. In response, Hanun had the delegates' garments cut off at the waist and half of their beards shaved (10:4). Arnold writes that this degrading action toward David's men served as an informal "declaration of war."[11]

Next, the Ammonites hired help from the Syrians to battle Israel, but when the commander, Joab, and the Israelite army prevailed in the first battle, the Syrians fled, necessitating that the Ammonites retreat as well (v. 14). The Ammonites, however, did not give up. They gathered more Syrian allies and regrouped for a second battle.

This time David marched against the Syrians with his troops, and his troops prevailed again. When the Ammonite allies saw the great success, they "made peace with Israel and became subject to them. So the Syrians were afraid to save the Ammonites anymore" (v. 19, ESV).

Chapter 11 begins with David sending Joab to finish the conquest of the Ammonites. Some commentators suggest that the opening phrase "in the spring of the year" (better translated "the return of the year") indicates David strategically timed this to coincide with the one-year anniversary of when the Ammonites had marched against Israel.[12]

Despite this well-timed military campaign, David remained at home while his troops fought, and thus begins the peak point of this narrative section and the downfall of David[13] marked by the Lord's displeasure with him.

9. Youngblood, "1, 2 Samuel," 422.
10. Arnold, *1 and 2 Samuel*, 519–20.
11. Ibid., 521.
12. Ibid., 523; McCarter, *II Samuel*, 284–85; Fokkelman, *Narrative Art and Poetry*, Vol. 1, 51.
13. After David's sin against Bathsheba and Uriah, the prophet Nathan pronounced judgment on David in 2 Samuel 12:10–12.

Uriah the Hittite

The first mention of Uriah (11:3) classifies him as a Hittite. This designation, however, proves ambiguous for modern readers. Some believe it refers to any non-Israelite. Elaborating on this possibility, Uriah Yong-Hwan Kim, a professor at Hartford Seminary, suggests, "I think it functions the way the term 'Asia' is used in the US. No specific place is meant by 'Asia.' It refers to an enormous region outside of the US, 'somewhere' in the east. Anyone who looks like a person from that region, regardless of his or her national or ethnic origin, is called an Asian."[14]

It is also possible Uriah belonged to the clan of Jebusites[15] who had assimilated themselves among the people of Jerusalem. When King David chose Jerusalem for his capital city, it appears that he permitted the Jebusites to remain and appointed some to high positions in his regime; supposedly, this included Uriah.[16]

Second Samuel 23:8–39 and 1 Chronicles 11:10–47 both list Uriah as a member of David's "Mighty Men," an elite group of his best fighting men. Some members were loyal companions of David when he fled from King Saul. Others, such as Uriah, likely joined forces with David after he made Jerusalem his capital during his reign as king.

Archaeologist Eilat Mazar suggests that the name "Uriah" may have been a title designating him as a ruler among the Jebusites in a similar manner as the Hurrian title "the Araunah" designated the king of the Jebusites (cf. 1 Chron. 11:4–8).[17] However, most commentators believe the name "Uriah" is Hebraic, meaning "Yahweh is my light."[18]

Kim says of this Uriah, "He may have been a member of a ruling family in Jerusalem when the Jebusites controlled the city, but he managed to differentiate himself from the Jebusites. He is a faithful Yahwist with a Yahwistic name, but he is not claimed by the Israelites. Instead, he is labeled as 'the Hittite,' a non-Israelite."[19] Kim suggests that the Israelites had trouble completely accepting Uriah as one of their own: "When Uriah was 'wanted,' the Israelites claimed him as their own by placing him in their army and by differentiating him from the Jebusites. But when Uriah was 'unwanted,' they abandoned him with other non-Israelites and branded him as 'the Hittite.'"[20]

However, it seems better to follow Baldwin's interpretation posed in a question format: "The reader notes that he is not a member of Israel's covenant

14. Kim, "Uriah the Hittite," 75.
15. Ibid., 76.
16. Mazar, *Preliminary Report 2005*, 44–5.
17. Ibid.
18. McCarter and Anderson both describe Uriah's name as being a "good Yahwistic name." McCarter sees this as evidence that Uriah was born in Israel (*II Samuel*, 285). Anderson suggests that Uriah was either born in Israel or changed his name at some point in his life (*2 Samuel*, 153).
19. Kim, "Uriah the Hittite," 76.
20. Ibid.

community. What sort of person will he prove to be?"[21] As the narrative progresses, readers will quickly note that Uriah the Hittite stands in sharp contrast to David. A foreigner shows greater adherence to the laws of Yahweh than does the king of Yahweh's chosen people.

Bathsheba

Bathsheba's name may mean "daughter of Sheba," "daughter of oath," or perhaps even "daughter born on the seventh day."[22] She is identified both by her husband's name ("the wife of Uriah the Hittite") and her father's name ("daughter of Eliam") (2 Sam. 11:3). According to the Talmud, Bathsheba's grandfather was Ahithophel, one of King David's advisors.[23] Second Samuel gives further information of interest when it refers to an "Eliam son of Ahithophel" in David's list of mighty men (23:34). If this person is the same Eliam, then both Bathsheba's husband and father served as members of David's elite fighting group.

Both McCarter[24] and Anderson[25] point out the unusualness of Bathsheba's double identification and suggest it shows that the significance of her patronymic relationship surpassed the significance of her marriage relationship. This could be the case, particularly if indeed her father was one of David's mighty men and her grandfather was Ahithophel, who served as advisor.

Kim suggests another plausible explanation. Without the addition of Bathsheba's familial background, her national identity would remain ambiguous. Stating the name of her father pinpoints Bathsheba as an Israelite rather than as a foreigner like Uriah.[26]

As a final possibility, the messenger(s) who gave David Bathsheba's double identification might have done so as a subtle warning. In modern English it might sound something like this: "Hey, just so you know, Bathsheba is married to Uriah, one of your best soldiers. Oh, and also, her father is Eliam, another one of your elite warriors. And don't forget, Eliam's father Ahithophel is one of your chief advisors."

THE STORY

While his troops battled the Ammonites, David found himself one particular afternoon walking along the roof of his palace. From his vantage point, he saw a woman "bathing." Her great beauty captivated him and he inquired as to her identity.

One of David's servants replied, "Is not this Bathsheba, the daughter of Eliam, the wife of Uriah the Hittite?" (11:3, ESV). Yet David chose to ignore the implications of the acquired information as he fetched her to his chambers: "So David sent messengers and took her, and she came to him, and he lay with her.

21. Baldwin, *1 and 2 Samuel*, 232.
22. Anderson, *2 Samuel*, 153; HALOT.
23. McCarter makes reference to the Talmud, citing Sanhedrin 69B, 101a; *II Samuel*, 285.
24. Ibid.
25. Anderson, *2 Samuel*, 153.
26. Kim, "Uriah the Hittite," 77.

(Now she had been purifying herself from her uncleanness.) Then she returned to her house" (v. 4, ESV).

After their illicit encounter, Bathsheba sent word that she was pregnant. David attempted to solve this problem by summoning Uriah from the battlefield for a report on the war. In an effort to get Uriah to sleep in his own home that evening, David urged him, "Go down to your house and wash your feet" (v. 8, ESV).[27]

If Uriah had gone along with David's plan, no one would have been able to prove David was the father of Bathsheba's baby. Uriah, however, spent the night near the door of the palace among the king's servants. In frustration, David summoned Uriah before him again and asked him why he did not go down to his own house.

Uriah replied, "The ark and Israel and Judah dwell in booths, and my lord Joab and the servants of my lord are camping in the open field. Shall I then go to my house, to eat and to drink and to lie with my wife? As you live, and as your soul lives, I will not do this thing" (v. 11, ESV).

David asked Uriah to stay another day in Jerusalem before returning to the troops and invited him to dine with him for dinner. David offered Uriah enough wine to make him drunk and loosen his inhibitions, but Uriah still did not go down to his own home. One commentator points out, "So, on the one hand was the king of Israel, unfaithful and disloyal; deliberately and willfully he engaged in adultery with the spouse of one of his warriors. On the other hand was that very warrior, besotted Uriah, emerging more faithful to Yahweh, liege, and comrades, than was the sober and scheming David."[28]

The next day David sent Uriah back to the battlefield with a letter for his military commander Joab. David wanted the troops to withdraw from Uriah in the heat of battle, leaving him surrounded by enemy soldiers. Even if Joab had been able to have all the soldiers, except Uriah, withdraw at the same time, it seems unlikely that Uriah would not have noticed and followed his retreating comrades. So, in order to carry out David's desire for Uriah's death, Joab sacrificed other soldiers as well.[29]

Uriah's death left David free to play the noble man and marry Uriah's widow. David's cover-up temporarily got him out of trouble, but God was displeased and sent the prophet Nathan to confront David. Nathan told a story about a rich man who stole a lamb from his poor neighbor. When David grew vexed over the rich man's actions, Nathan announced, "You are the man!" (12:7, ESV). David finally admitted his sin but still faced painful consequences, including the death of Bathsheba's child.

27. Fokkelman points out that the phrase "wash your feet" functions here as a metonymy and could thus be translated as "take leave with all its pleasures," *Narrative Art and Poetry*, vol. 1, 53.
28. Kuruvilla, "Pericopal Theology," 277.
29. Chisholm, *1 and 2 Samuel*, 235.

Later Bathsheba conceived again and bore David another son, Solomon. After his birth, Bathsheba's name does not appear until David lies on his deathbed. Following the prophet Nathan's advice, Bathsheba approaches David and informs him that his son by Haggith, Adonijah, is making plans to appoint himself king. She urges David to appoint a successor to the throne before Adonijah steals the kingship. David thus appoints Solomon as the next king (1 Kings 1).

Afterward, Adonijah approaches Bathsheba with a petition. The text makes the tension between them apparent, as Bathsheba asks him, "Do you come peacefully?" (1 Kings 2:13). When he answers in the affirmative, she listens to his request. He wants her to petition her son Solomon to give Adonijah David's concubine Abishag as wife.

Bathsheba agrees, but her next move is open to interpretation. Marrying a former king's concubine was generally perceived as a ploy to gain royal authority, and it seems unlikely that Bathsheba would not know this. She knew all too well the cunning ploys that people in power may pull.

Bathsheba makes good on her word, and she petitions Solomon to give Abishag to Adonijah, but one must wonder if she did so as a way of alerting him to his half-brother's supposed treachery. Her tone of voice may have indicated to Solomon that she did not expect him to grant her request or hinted that he should get rid of his brother.[30]

Klein says of Bathsheba, "Although she asks Solomon not to refuse her, her presentation of Adonijah's case assures that Solomon *will refuse*, thus eliminating a potential rival for the throne and a potential danger to her and her son's position."[31]

As likely expected, King Solomon's response lacks any favor toward his half-brother. He asks his mother, "And why do you ask Abishag the Shunammite for Adonijah? Ask for him the kingdom also, for he is my older brother, and on his side are Abiathar the priest and Joab the son of Zeruiah" (2:22, ESV). Then King Solomon has Adonijah put to death.

No other direct mention of Bathsheba is given, though some scholars believe she might be the woman who taught the oracle of Proverbs 31 to her son. Additionally, the Gospel of Matthew references Bathsheba in the genealogy of Christ as "the wife of Uriah" (Matt. 1:6), though her name is not specifically mentioned.

The narrative sequence of 2 Samuel 10–12 highlights one of King David's darkest points and God's great displeasure over David's sin. Though God does not depose David from the throne, David's actions parallel Saul's in his downward spiral before losing his kingdom. David's actions parallel those of Samson too, who also experienced grievous consequences.

30. Sakenfeld, *Just Wives?* 76–77.
31. Klein, *From Deborah to Esther,* 70–71. Bailey also suggests that Bathsheba had a goal of bearing a child in *David in Love and War,* 70.

Uriah represents a marked moral contrast between himself and King David. One would not expect a foreigner to show more deference toward the God of Israel than does Israel's own king. Yet Uriah's actions prove righteous, while David shows no respect for Yahweh or his fellow man.

As chapter 11 begins, Bathsheba finds herself without a voice and the victim of King David's sexual lust. She suffers consequences for the sin of another, including the loss of a child. Later in life she gains a more influential voice and helps secure the throne for her son.

Sakenfeld makes three noteworthy observations about the end of Bathsheba's story:

> First, she is no longer silent. She speaks in the royal presence first of her husband David, then of her son Solomon, and she is treated deferentially. Second, despite her new outspokenness, the narrator is still interested in the king and succession to the throne; he does not give us access to Bathsheba's thoughts as she decided whether and how to comply with requests made of her, and Bathsheba disappears each time as soon as her part is finished. Finally, she is still portrayed as a relatively dependent and less powerful person than the men around her. In each instance she acts in accord with what a man has asked her to do and say. She appears only when responding to the concerns and wishes of others. In sum, Bathsheba the queen mother has power, but she does not function as an independent agent.[32]

The reader is reminded that Bathsheba still acts within the regulations and requests of the men in her life. The prophet Nathan enlists her to go to King David. Adonijah asks her to petition Solomon. Her actions are at the request of others and for the primary benefit of others. The men around her have more social power.

The fact that the text demonstrates Bathsheba's positive influence later in her life, however, shows Bathsheba to be a woman of good character and suggests that she was not held responsible for her earlier sexual encounter with David. If she had seduced David, it is unlikely that the prophet Nathan would have sought after her help or that King David would have valued her advice. Even Adonijah considered her influential. Finally, her son Solomon honored her in court (1 Kings 2:19).

A CLOSER LOOK AT THE BIBLICAL TEXT

What did the author intend and what did the original hearers think when they heard the story of David and Bathsheba? Taking a look at the language elements of the narrative will dismantle some of the false assumptions modern readers bring to the story, and help shed light on the narrative accounts involving Bathsheba.

32. Sakenfeld, Just Wives? 77.

Hebrew narrative: the scene

In Hebrew storytelling, some narratives divide the action into scenes. Jacob Licht writes, "Each scene presents the happenings of a particular place and time, concentrating the attention of the audience on the deeds and the words spoken."[33]

Adele Berlin describes scenes in narratives with the analogy of film frames, saying, "The stories in the Bible are like the frames from which films are made. Each one exists separately, and they are combined in a certain order to make the greater narrative, but an individual frame has no life of its own outside of the film as a whole."[34]

The narrator chooses each element of the story with careful intention. Thus details left untold are also decided upon with great deliberation. Reading through the narrative of David and Bathsheba, readers will find that each part of the narration plays a specific role in the story.

Hebrew narrative: dialogue

Dialogue is crucial to the development of Hebrew narratives, so much so that Alter writes, "Everything in the world of biblical narrative ultimately gravitates toward dialogue—perhaps . . . because to the ancient Hebrew writers speech seemed the essential human faculty: by exercising the capacity of speech man demonstrated, however imperfectly, that he was made in the image of God."[35] Certainly dialogue forms a crucial portion of the narrative, essential to dramatizing for the reader what must be seen and heard rather than merely summarized.

Alter proposes, "In any given narrative event, and especially at the beginning of any new story, the point at which dialogue first emerges will be worthy of special attention, and in most instances, the initial words spoken by a personage will be revelatory, perhaps more in manner than in matter, constituting an important moment in the exposition of character."[36] In the David-and-Bathsheba narrative, the first bit of dialogue is, "And David sent and inquired about the woman. And one said, 'Is not this Bathsheba, the daughter of Eliam, the wife of Uriah the Hittite?" (2 Sam. 11:3, ESV).[37]

This identity question seems to function as a way of pointing out how David should treat Bathsheba by highlighting her societal role.[38] It introduces to the reader the question of what David will do with his acquired information. The

33. Licht, *Storytelling in the Bible*, 29.
34. Berlin, *Poetics and Interpretation of Biblical Narrative*, 125.
35. Alter, *The Art of Biblical Narrative*, 226.
36. Ibid., 93.
37. Youngblood suggests that the phrase "Is not this Bathsheba?" is possibly an intentional echo of the earlier phrase "Isn't this David?" found in 1 Samuel 21:11; 29:3, 5 (Youngblood, "1, 2 Samuel", 430).
38. Other examples of this include Boaz's inquiry about Ruth's identity (Ruth 2:5); Nabal's negative response to David (1 Sam. 25:10); Eliezer's inquiry as to Rebekah's identity (Gen. 24:23); and Jacob's dialogue concerning his relatives in Haran (Gen. 29).

details of the messengers' response "might arouse relief in the reader at first," as the expected response is that David will not take his neighbor's wife, particularly the wife and daughter of some of his closest comrades,[39] but the details "eventually serve only to highlight the premeditated event of David's next action."[40]

David saw a beautiful woman. After inquiring about her, he found out her identity as a woman married to one of his mighty men. His negative choice marked a key turning point in his life. Notably, the narrative emphasizes David's choice in the matter without any consideration of Bathsheba's feelings. As king, David had the power to dispatch messengers to inquire about her identity, and he used his power to objectify Bathsheba, thereby nullifying her identity.

Another point of interest concerning dialogue comes in the narrator's choice of quoted dialogue between Uriah and David. When David summoned Uriah home to inquire as to the state of the battle, the text does not state Uriah's response. This suggests that Uriah's response was not important to David or to the furthering of the narrative. The narrator described the story from David's point of view only, and "by contrast, direct speech is used for what really matters to David."[41]

Hebrew narrative: characterization

Characterization data may come from the author's description or lack of description, response of other characters, characters' names and epithets, self-characterization, recorded thoughts, speech, actions, contrast with another character, or even by their "extent of development."[42]

In the David-and-Bathsheba story, Uriah the Hittite stands in contrast to King David. Literarily speaking, Uriah serves as a foil to David. While David remains at his palace forcing Bathsheba into his bed, Uriah fights loyally against the Ammonites. When David summons him home for a brief time, Uriah finds it dishonorable to sleep in his own house with his wife while his comrades sleep outdoors on the battlefield. Kuruvilla aptly describes the contrast: "The loyal, abstinent, and self-sacrificing soldier is requisitioned as a foil for the disloyal, indulgent, and selfish king."[43] In other words, David, who has been the admired hero up until this point of the book, becomes the bad guy in the story. The narrator purposefully writes the account in such a way as to highlight the actions of David as evil, which prepares for the main focal point of God's displeasure with King David as noted previously.

A brief analysis of characterization with the help of Adele Berlin's approach reveals helpful information pertaining to Bathsheba's role. Though the text gives information about David and Uriah's character, little is said about Bathsheba.

39. As mentioned earlier, David's messenger may have used Bathsheba's double identification as a subtle warning.
40. Arnold, *1 and 2 Samuel,* 527.
41. Baldwin, *1 and 2 Samuel,* 232.
42. Chisholm, *From Exegesis to Exposition,* 152.
43. Kuruvilla, "Pericopal Theology," 277.

She does not play the role of a main character, or even a secondary character, but is viewed as something different altogether. Berlin discusses the typical literary distinction between flat characters and round characters. Flat characters are "built around a single quality or trait."[44] Round characters are "much more complex, manifesting a multitude of traits, and appearing as 'real people.'"[45] Berlin, however, prefers to use different literary labels and adds an additional category for a total of three character categories: (1) the full-fledged character (round character), (2) the type (flat character), and (3) the agent (functionary). She also points out that a biblical character may fall into a particular category in one narrative account and in a different category in another story.[46]

In the case of Bathsheba, one finds her portrayed as a "passive object,"[47] or as a functioning "agent." The narrator subordinated her character and gave no reference to her point of view. The text does mention that she mourned Uriah's death and that of her child, but no other emotion is revealed. This mention of Bathsheba's grief over Uriah's death and that of her child further serves as an indictment against David for causing her grief, and provides another suggestive example of her innocence. If she had tried to seduce David or even helped conspire with David concerning Uriah's murder, it seems unlikely she would have exhibited such grief, as described by the word "lament" (v. 11:26), a verb depicting deep sorrow and mourning.[48]

In contrast, the reader learns much about David's emotions. Desire overcame him. Later, frustration filled him when he could not get Uriah to return home for an evening. Nathan's confrontation led to David's anger at the rich man in the story—and then shame, when he recognized his own sin. Finally, David mourned his child's illness.

It is also interesting to note that Bathsheba's proper name is absent from most of the story. It occurs once when a messenger says to David, "Is not this Bathsheba, the daughter of Eliam, the wife of Uriah the Hittite?" (v. 3, ESV). Its next occurrence is not till after the baby has died, where the text says, "Then David comforted his wife, Bathsheba, and went in to her and lay with her, and she bore a son, and he called his name Solomon" (12:24, ESV). The absence of name assigned to Bathsheba further depicts her as an object of David's lust rather than as a person to whom he gives proper respect and identity, and it additionally suggests she has no share in David's guilt.

The rest of the narrative refers to Bathsheba with impersonal phrases such as "a woman bathing" (11:2, ESV), "the woman was very beautiful" (v. 2, ESV), "inquired about the woman" (v. 3, ESV), "the woman conceived" (v. 5, ESV), "lie

44. Berlin, *Poetics and Interpretation of Biblical Narrative*, 23.
45. Ibid.
46. Ibid.
47. Ibid., 26.
48. Cf. Gen 50:10; 1 Sam. 25:1; 2 Sam. 3:31; 28:3; 1 Kings 13:30; 14:13, 18; Jer. 16:6; 22:18; 34:5.

with my wife" (v. 11, ESV), "the wife of Uriah" (v. 26, ESV), "his wife to be your wife" (12:9, ESV), and "the child that Uriah's wife bore to David" (v. 15, ESV), as well as various forms of feminine pronouns scattered throughout the account.

The narrator portrays Bathsheba as a "complete non-person" who is "not even a minor character, but simply part of the plot."[49] She is an agent performing a function integral to the story's plot. This does not make her responsible for David's iniquity. As Berlin puts it, "She is not an equal party to the adultery, but only the means whereby it was achieved."[50]

Later, when Bathsheba appears again (1 Kings 1–2), she becomes a central character in the story of securing Solomon's kingship as successor to David. Berlin references her as a "full-fledged" literary character.[51] Whereas in the earlier account her voice was limited, here Bathsheba finally has a greater voice.

Hebrew text: disjunctive clauses

In Hebrew narratives, clauses typically follow a set pattern: conjunction + verb + subject. Occasionally, the sequence will be interrupted by a nonstandard construction such as *waw* plus a nonverb at the start of a new clause commonly referred to as a disjunctive clause. Since this breaks into the normal pattern, it draws attention to the specific clause and in narratives often adds a "dramatic dimension."[52] Such is the case in 2 Samuel 11, demonstrated by the use of disjunctive clauses in the first four verses.

The first disjunctive occurs at the end of verse 1: "But David remained at Jerusalem." The phrase serves as a contrastive element to the preceding statement. Chisholm points out, "The construction draws attention to the fact that David seems to be in the wrong place at the wrong time."[53]

The second disjunctive occurs in verse 2. There the text says, "And the woman was very beautiful," which serves as parenthetical background information about her. The emphasis on this "adds more tension to the narrative by making it clear that David is now faced with sexual temptation."[54]

The third disjunctive occurs in verse 4, which says, "She had been purifying herself." This serves as more parenthetical information. Many commentators assume that Bathsheba was purifying herself from her menstrual impurity, though that assertion is debatable.[55] But if indeed Bathsheba had been purifying herself

49. Berlin, *Poetics and Interpretation of Biblical Narrative*, 26.
50. Ibid.
51. Ibid.
52. Chisholm, *From Exegesis to Exposition*, 119–28.
53. Ibid., 128.
54. Ibid.
55. For example, Frymer-Kensky asserts that it is an error to see this purification phrase as referring back to Bathsheba's earlier bath as it is anachronistically based on later rabbinic law and has two flaws: (1) The matter of timing—in rabbinic law women would immerse themselves in a *mikvah* one week after the menstrual flow ceased, which put

from her menstrual uncleanness, then as Chisholm states, "This statement makes it clear that David's liaison with Bathsheba takes place at a time when she is especially ripe for conception. This is not 'safe sex.' David is playing with fire. Will he get burned?"[56]

Regardless of one's interpretation of the third disjunctive clause, the point remains that these three disjunctive clauses help to highlight David's primary role of responsibility in the story. David was in the wrong place at the wrong time, not Bathsheba. David faced sexual temptation, not Bathsheba, nor does it appear that she purposefully enticed him. Finally, David, not Bathsheba, faced the decision of what to do. In contrast to David, it appears she purified herself in accordance with rituals laws, while he sought illicit sexual activity.

Hebrew text: verbal clauses

A look at verse 4 reveals four main verbal clauses that describe David's brief sexual encounter with Bathsheba: "David sent messengers," "took her," "she came to him," and "he lay with her." Each clause contains separate *qal wayyiqtol* phrases, which represent a temporal or logical sequence.[57] David initiated the process by sending messengers and consequently each action resulted from the previous.

In the first clause ("David sent messengers"), David is the subject and the messengers are the object. Interestingly, the verb "send" occurs twenty-three times within 2 Samuel 10–12, and in most of the occurrences it refers to an action done by David.[58] The narrator may have used this verb intentionally to demonstrate a power motif.

Abasili sees a likely connection between the power motif with the verb "send" and the opening description. He writes, "The narrator portrays David on the roof of the king's house as the lord of all that he surveys with the power to

the conclusion of their purification near their fertile period. However, in the biblical period, uncleanness lasted only seven days total, with the conclusion of the uncleanness not occurring near a woman's typical period of fertility. (2) There is no indication in the Bible that women washed themselves after menstruation, though Scripture is careful to mention other occurrences of ritual bathing (*Reading the Women of the Bible,* [New York: Schocken Books, 2002], 149). For further discussion on this topic, see Chankin-Gould et al., "The Sanctified 'Adulteress,'"339–52. Chankin-Gould suggests that this refers to Bathsheba purifying herself after her illicit encounter with David rather than a reference back to her original bath. The purification reflects positively on Bathsheba, who is later proven by the author of Kings to be a clean, sanctified, and legitimate mother of Israel.

56. Chisholm, *From Exegesis to Exposition*, 128.

57. Chisholm refers to this as a sequential or consequential *wayyiqtol* function (Ibid., 120–21).

58. Nine instances refer to someone other than David as the sender: When King Hanun sends David's soldiers back to him (2 Sam. 10:4), when the Ammonites send for Syrian aid (v. 6), when Hadadezer sent out the Syrians (v. 16), when Bathsheba sent word that she was pregnant (11:5), when Joab sent battle news to David (vv. 18, 22; 12:27), and when the Lord sent Nathan to David (12:1, 25). For two similar discussions on this, see Kuruvilla, "Pericopal Theology," 276; Abasili, "Was It Rape?" 1–15.

'send for' what he sees."[59] David was the one in charge of the kingdom, and thus everyone was obligated to do his bidding.

David is again the subject in both the second and fourth verbal clauses ("took her" and "he lay with her"), though this time the object of his taking is Bathsheba. His messengers retrieved her, but the messengers are not the subject of the verb "took." The Hebrew syntactically links David with the verb "took," making the king the primary one responsible. This detail "underlines David's lordship of the situation."[60]

The third verbal clause ("she came to him") has Bathsheba as the subject. The primary thing of note here is that Bathsheba came without being dragged and suggests that David did not use physical force in the bedroom. Abasili views Bathsheba as sharing in a small part of culpability for not resisting, but he comments, "The great power difference between David and Bathsheba supports the interpretation that Bathsheba, rather than physically resisting the king, opted for a passive attitude. She saw herself in a situation in which her only option was to submit to the king's sexual passion."[61]

Randall C. Bailey, however, sees Bathsheba as "a willing and equal partner" in their sexual union. First, it appears to him that Bathsheba's actions paralleled David's actions. Second, he suggests that a *hiph'il* verb form for "came" would have indicated Bathsheba was "caused to act," but instead a *qal* form was used.[62]

His view, though, seems to read too much into the text. Much of the rest of the narrative points to David as the primary one responsible, as discussed previously. Further, the biblical author specifically mentions "the thing that David had done displeased the LORD" (11:27, ESV). Finally, when Nathan confronts David (chapter 12), the prophet lays the blame entirely on David.

It is also worth pointing out that the phrase "she came to him" does not necessarily indicate that she knew why she was summoned. She had no reason to suspect foul intent on his part or that he had been spying on her while she bathed. Perhaps she thought he had a message for her from the battlefield about her husband, Uriah. Even if she suspected David's intentions were less than honorable, however, few women would dare to resist a summons to court when multiple messengers arrive. A king may summon and take what he chooses, as underscored in the text by the use of more than one messenger.

Hebrew text: key words

One important word, "took," probably has the meaning of "fetch" or "summon" in this context.[63] Davidson points out that this "clearly involves psychological

59. Abasili, "Was It Rape?" 9.
60. Ibid., 10; compare with a similar usage of the verb in Genesis 20:2, where King Abimelech sent and took Sarah as a wife.
61. Ibid., 11.
62. Bailey, *David in Love and War*, 88.
63. HALOT.

power pressure on the part of David and not voluntary collusion on the part of Bathsheba."[64] The verb *laqah* is the same one used to describe how David took women for his harem earlier (1 Sam. 25:39–40; 2 Sam. 3:15; 5:13). As Chisholm notes, "David's taking Bathsheba is the culmination of a disturbing trend."[65]

Arnold also suggests that *laqah* harks back to the time when Samuel warned the Israelites that kings "are takers" (1 Sam. 8:11–18).[66] Chisholm states that the word "takers" also alludes to the Samuel narratives' earlier characters who selfishly took what belonged to others. Eli's sons demanded meat from those who brought temple sacrifices (2:16). Samuel's sons "took bribes" (8:3). Samuel described to the Israelites how the kings of the neighboring nations took sons, daughters, crops, servants, and livestock (1 Sam. 11–16). Ironically, David's own action of taking Bathsheba resembles the description Samuel gave of a "hypothetical foreign-looking king."[67]

Hebrew text: singular pronouns

When the prophet Nathan discusses David's sin (2 Sam. 12:7–9, ESV), he uses the masculine second-person pronoun "you" to point toward David as the responsible party: "Nathan said to David, "You are the man! Thus says the LORD, the God of Israel, 'I anointed you king over Israel, and I delivered you out of the hand of Saul. And I gave you your master's house and your master's wives into your arms and gave you the house of Israel and of Judah. And if this were too little, I would add to you as much more. Why have you despised the word of the LORD, to do what is evil in his sight? You have struck down Uriah the Hittite with the sword and have taken his wife to be your wife and have killed him with the sword of the Ammonites.'"

Additionally, as Nathan announces the consequences for David's actions (vv. 10–12, ESV), he again uses second-person masculine pronouns: "'Now therefore the sword shall never depart from your house, because you have despised me and have taken the wife of Uriah the Hittite to be your wife.' Thus says the LORD, 'Behold, I will raise up evil against you out of your own house. And I will take your wives before your eyes and give them to your neighbor, and he shall lie with your wives in the sight of this sun. For you did it secretly, but I will do this thing before all Israel and before the sun.'"

If the Lord had desired to indict Bathsheba, he could have done so through his prophet Nathan.[68] The Lord specifically indicted David only, however, as evidenced both by the text in verses 7 through 9, as well as in the implications of Nathan's story about the man who stole his neighbor's ewe lamb. The little

64. Davidson, "Did King David Rape Bathsheba?" 88.
65. Chisholm, *1 and 2 Samuel*, 234.
66. Arnold, *1 and 2 Samuel*, 527.
67. Chisholm, *1 and 2 Samuel*, 234.
68. Note other instances in Scripture where pairs were charged with sin, rather than just the male figure, such as with Adam and Eve (Gen. 3) and Ananias and Sapphira (Acts 5).

lamb did nothing wrong. It was the rich man in the account only who sinned in stealing and devouring the lamb.

IMPLICATIONS FOR MINISTRY

In contemplating Bathsheba's lack of responsibility, many current observations and applications call for attention. Practically speaking, some countries today have laws in place to protect minors from sexual abuse. For example, as mentioned earlier, the organization RAINN stipulates boundaries concerning a person's age, capacity to consent, and agreement to an act.[69] Yet, despite protective legislation, abuse and suppression of voices still occurs. Some Christian leaders abuse their power in sexual relationships. Others continue to put part of the blame on victims instead of the abusers, perhaps even more so in cases in which the abuser is in a leadership position. What might be done to change this and give victims a greater voice?

Rachel Marie Stone's perspective

Rachel Marie Stone, a blogger, author, and editor for *Christianity Today*, wrote an article for *Prism Magazine* discussing the damage done to victims by those in positions of power, particularly spiritual leaders. In the story of David and Bathsheba, few people would say that David did not sin, but many people also include Bathsheba as a sinner or even a seducer. In her research, Stone has discovered that all too often people similarly put the primary blame, at least in part, in the wrong place—namely, on the victims'.[70]

Stone interviewed a representative of The Hope of Survivors, an organization dedicated to bringing support, hope, and healing to victims of pastoral sexual abuse. Samantha Nelson suggested to Stone that while seminaries warn pastors about the dangers of "predatory women," few emphasize the danger of the abuse of power.[71]

Nelson also added, "We see a lot of predatory pastors. It's more often the case than not that a pastor will have abused more than one person. Sometimes there's a young, inexperienced pastor who crosses a line, but generally we see a lot of repeat offenders who pick out vulnerable people and groom them for abuse."[72]

Survivors of pastoral abuse often find themselves angry with the church and suspicious of all spiritual leaders. This anger comes in part due to a lack of understanding and compassion toward them from faith communities, as well as the misuse of biblical stories such as that of David and Bathsheba.[73]

The biblical narrative does not suggest that David was a predator who groomed Bathsheba for his own sexual appetite. Furthermore, neither the

69. RAINN, "Was I Raped?"
70. Stone, "Saving Bathsheba."
71. Ibid., 27.
72. Ibid., 27–28.
73. Ibid., 29.

current day office of pastor nor the church existed yet. However, David still held a position of authority over a theocratic nation, and he used his power to victimize a person with far less social power.

Stone suggests, "It appears that what made David's sin possible was secrecy, and what brought forth his confession of guilt was the threat of exposure. For the sake of justice—and for the sake of healing—faith communities must acknowledge that compassionate attention and full apologies are needed."[74]

Rape culture in the church

Blogger Heather Celoria, in an article adapted for the blog *The Junia Project*, brings additional thoughts to the table in her post "A Cautionary Tale about Rape Culture in the Church and #TakeDownThatPost." Celoria referenced an article posted in June 2014 in *Leadership Journal* from a pastor convicted of felony against a student in his youth group. The article received backlash across several social media platforms, including blogs, Twitter, and Facebook, and resulted in massive use of the hashtag "#TakeDownThatPost."[75]

Celoria describes one of the main problems with the article: "The author described the statutory rape for which he is currently incarcerated as an extramarital relationship and implied mutual consent and responsibility by the victim. Reading between the lines, it seems the victim was in middle school at most when the abuse began. In almost romantic terms, the convicted felon describes as a slippery slope into sin what is, in fact, textbook predatory grooming."[76]

Celoria went on to describe the predator's lack of empathy observed for the victim and the use of pronouns suggesting mutual consent. She concluded that "at no point in the article are the words 'rape,' 'abuse,' 'child abuse,' or 'sexual abuse' mentioned."[77] The fault did not rest with only the convicted felon, however. Celoria pointed out the failure of the editors as well: "Not only does the writer fail to see the reality of his crime since he frames it as an affair, the editors failed to recognize the whitewashing of child sexual abuse in the article. They published the piece along with the tags 'accountability, adultery, character, failure, mistakes, self-examination, sex, temptation' showing a total lack of understanding and discernment in regard to sexual predation, child abuse, and rape-culture mentality."[78]

Eventually the editors revised the article, taking out much of the troublesome language; however, it took several days for them to comprehend the issues and make the changes. Further, the fact that this became a problem at all suggests Christians still have a long way to go in recognizing the nature of sexual abuse by leaders. Part of the answer begins with better education about biblical narratives

74. Ibid.
75. Celoria, "A Cautionary Tale about Rape Culture in the Church and #TakeDownThat-Post."
76. Ibid.
77. Ibid.
78. Ibid.

such as that of David and Bathsheba. When Christians describe the story of David and Bathsheba as an "affair," this language does not remain enclosed in the classroom dialogue of biblical narratives. It cannot help but make its way out into descriptions of current stories and events as well.

CONCLUSION

Bathsheba's story, and the various responses to it, ought to prompt careful thought. The repercussions of allowing negative stereotypes of her character to continue are real. Rather than viewing her as a scapegoat for David's sin, we ought to call the situation what it is: rape of a subordinate by a man in power.

As stated earlier, my own perspective on Bathsheba's story changed. But there was something else I found surprising—some of my friends changed their perspectives, too. With the wide variety of viewpoints among evangelicals, I didn't expect this. Yet a few carefully phrased comments and replies did just that.

After one particularly engaging conversation, a mentor commented, "I never thought about this before, but I wonder if Bathsheba knew that David murdered her husband. How awful it must feel to be married to the person who murdered your first husband." Bathsheba's victimization hit home for her.

This all encourages me. Why? Because sometimes all it takes for the major truth of a narrative to hit the heart is a few glimpses of smaller truths within the story. Sometimes all it takes to change the culture is for a few people to start the chain of thinking that eradicates the belief that victims share partial blame for a perpetrator's sin. Sometimes all it takes is a few believers lifting up those victimized in order to give them a greater voice in their faith communities.

QUESTIONS FOR DISCUSSION

1. In what ways have you heard Bathsheba's story portrayed through messages at church, Christian materials, or secular sources? Did reading this chapter change any of your previous ideas about Bathsheba?

2. Do you agree or disagree with the assertion that failing to acknowledge victims of abuse in the Bible has parallels with the church's failures toward victims today? Why or why not?

3. How might Bathsheba's story offer comfort for victims of abuse today?

THE VIRGIN MARY: RECLAIMING OUR RESPECT

TIMOTHY RALSTON, PHD

Among the men and women in the Old and New Testaments, the Virgin Mary occupies a most prominent position. She appears in more contexts and with greater discussion than any other woman in the Bible. At the same time, however, Christian treatments of her vary widely.

Historically, Christians have given the Virgin Mary a position of high honor. She was the human mother of the Savior of the world. Theologically, she has served as a model for individual and corporate Christian experience. When Jesus gradually became isolated from human experience in early debates and theological formulations, Mary grew in popularity as the face of heaven's empathy and the model of Christian virtue. By the seventh century, Mary had become so prominent that the *Qur'an* (incorrectly) identified her as one of the three members of the Christian Trinity (along with the Father and the Son).[1] Her portraits have dominated Christian art. Visions of her and miracles attributed to her have abounded.[2] Since 1967, the Ecumenical Society of the Blessed Virgin Mary (ESBVM) has facilitated an ongoing international dialogue between Roman Catholic, Orthodox, Anglican, Lutheran, Methodist, Reformed, and Anabaptist scholars over the Virgin Mary's role in Christian

1. *Qur'an 5:116.* Tragically, this misrepresentation of the Trinity in the "inerrant" Qur'an creates a barrier to Christian-Muslim dialogue and toward understanding of the actual nature of the Christian Trinity and its implications.
2. A chronological list of these phenomena is available at www.miraclehunter.com.

theology, life, and worship. A recent author even referred to her as "the world's most powerful woman."[3]

Other Christians avoid her. Why? The answer forms a complex web of misunderstanding and prejudice. When the Protestant Reformation drove a wedge between the Roman Catholic Church and its various groups intent on its reformation, the Virgin Mary and traditions surrounding her became casualties. These traditions were thought contrary to the theological formulations of the reformers. Her prominence was thought to obscure the person and work of Jesus. At the same time in the Americas, early Roman Catholic evangelistic strategies among the indigenous peoples produced syncretism in which Mary figured prominently. As a result, some struggle to speak of the Virgin Mary without wondering if they are contributing to these problems. Some may avoid her simply because she's a woman and just not as exciting as the warriors, prophets, and apostles who regularly populate Bible stories with larger-than-life exploits and miraculous happenings. Stories about calamity and conquest always sell better than examples of character.

Let's also acknowledge the obvious recent challenges. On the one hand, evangelical Christianity has emphasized the recovery of "biblical manhood." To focus on the imitation of a woman—even one as remarkable as the Virgin Mary—might be seen as undermining the goal of this movement. At the same time, radical feminists have attacked traditional views of the text and its male, patriarchal understanding, such that the study of the Virgin Mary becomes a cultural minefield. Consequently, despite the large amount of biblical material in which the Virgin Mary appears, modern Bible study guides often ignore her. Apart from her appearance in a Christmas nativity, modern Christians know little else about her.

This situation is ironic for people who value Bible knowledge. The Virgin Mary is mentioned by name twelve times in the Gospel of Luke, five times in the Gospel of Matthew, once in the Gospel of Mark, once in the Gospel of John, and once in the book of Acts. She also appears in a number of other narratives without mention of her name, sometimes assuming a prominent role in the story. Overall, Mary is the fourth most described person in the New Testament, after Jesus and the apostles Paul and Peter. To neglect Mary is to ignore a very significant New Testament figure.

Because Mary's life has been treated by four different New Testament writers, putting her story together becomes more complicated than merely collating verses. Each writer has used her in a slightly different way for his story. Each Gospel's portrait should be developed independently to reveal its unique nuance. Secondly, the Gospels were written and circulated over many years. At least one Gospel writer affirms his dependence upon previously known material (e.g., Luke 1:1–2), and between the Gospels there are clear signs of literary dependence. This means that earlier material likely had an influence on how later material was used. Similarly, later audiences would have had more information

3. Orth, "How the Virgin Mary Became the World's Most Powerful Woman".

about Mary to inform their understanding than earlier audiences. Therefore, the Gospel material concerning Mary should be treated in the chronological order in which the Gospels were written, starting with the earliest. This builds a framework within which the growing portrait can be constructed. By the conclusion, a timeline of Mary's life can be reconstructed, within which individual Gospel observations can be properly integrated and understood.

A biblical portrait of the Virgin Mary reveals a remarkable woman by any human measure. She displays deep spiritual commitment, remarkable biblical insight, and thoughtful personal reflection. Her passionate understanding and unwavering support of her son's messianic mission motivated her to make deep sacrifices at each stage of life, an example of Christian devotion unequalled in the New Testament. Not knowing the Mary of the New Testament is like attending a dinner party without meeting the hostess. She sets a high bar for everyone who professes to follow Jesus Christ.

THE INDIVIDUAL PORTRAITS (IN CHRONOLOGICAL ORDER)

The first and likely the oldest statement in the New Testament concerning Mary comes from the apostle Paul. In his letter to the Galatians, he notes that "when the fullness of time came, God sent forth His son, born of a woman, born under the Law" (Gal. 4:4).[4] Although Mary is not mentioned by name, Paul offers us his high valuation of her as the necessary human agent for Jesus's incarnation. Without her, Jesus could not demonstrate the prerequisite for both justification (the full satisfaction of God's justice) and resurrection (the demonstration of its completion with the extension of its benefits)—that prerequisite being his full participation in our human nature. Paul's passing reference indicates that Mary had already assumed a significant place in the theology of the earliest believers.

The order of the Gospels

As stated earlier, the first issue is the chronological order in which the biblical sources for a study of Mary were written. The ancient church understood Matthew to be the first written synoptic Gospel.[5] (Modern biblical criticism typically

4. Paul wrote to the Galatians on the eve of the Jerusalem Council (convened c. AD 49), according to the "south Galatian" theory. Paul's Galatian letter offers his defense for including Gentile (non-Jewish) converts without requiring Jewish circumcision. This same issue was reviewed by the apostles at the Jerusalem Council after Paul's first journey, and a decree was issued affirming Paul's understanding (Acts 15:1–35). If this decree had already been issued, why didn't Paul refer to it in his letter dealing with the very same issue? This (along with other considerations) favors the "south Galatian theory" and the dating of AD 49 for the epistle.

5. Markan posteriority (Mark as the last of the synoptic Gospels to be written) was the common position among the early church. For example, Irenaeus, Bishop of Lyons, *Contra Haereses* (c. AD 180) asserts that Mark is the last of the synoptic Gospels: "After Peter's and Paul's deaths, Mark, the interpreter of Peter, himself also handed down

prefers Mark because of its brevity).[6] Luke's statement that he himself had access to others' accounts (Luke 1:1–2) and Mark's alternating use of material from Matthew and Luke confirms that Mark employed them when writing. Because John's Gospel stands independently of the synoptics and shows significant Old Testament theological reflection on Jesus's ministry and miracles, it's thought that this Gospel comes late in his ministry, perhaps after his incarceration and visions on Patmos. This study, therefore, assumes that the New Testament Gospels were written in the chronological order of Matthew, Luke-Acts, Mark, and John. With this order in mind, it's possible to see a developing, coherent portrait of Mary among the Gospel writers.

Matthew's portrait: A divine instrument

Matthew's portrait of Mary is the earliest in the Gospel accounts. Her role in Matthew's story seems somewhat passive, serving only as the virgin mother of the promised Messiah. She first appears as the last of five women (Tamar, Rahab, Ruth, Bathsheba, Mary) included in the opening genealogy (Matt. 1:16). Each of these women faced great personal challenges which revealed their integrity and confidence in the God of Israel, which resulted in their gracious inclusion in the messianic line. By association with these women, Mary implicitly shares their qualities. Like them, she faces a great personal challenge with integrity and confidence in God.

The story immediately moves to Joseph and the discovery of Mary's pregnancy.[7] Although Joseph appears as the central figure in the subsequent stories, Mary's implied virtues are reinforced in the story of Joseph's dilemma concerning her disposition. It opens with the affirmation that her pregnancy is "by the Holy Spirit,"

to us in writing the things preached by Peter." Similarly, *The Anti-Marcionite Prologue* (c. AD 160) writes that "Mark . . . was Peter's interpreter. After the death of Peter, Mark wrote down this same Gospel while in Italy." Perhaps the earliest testimony is provided by Papias, Bishop of Hierapolis (c. AD 140; preserved in Eusebius, *Ecclesiastical History* 3:39:15–16), who claims to be quoting the "elder" [i.e., the apostle John (c. AD 80)]: "Mark, who was Peter's interpreter, wrote accurately, though not in order, all that he remembered of the things said or done by the Lord." Since Luke writes while Paul is still alive in Rome (Acts 28:30–31), Mark's Gospel must be written after Luke's.

6. Markan priority (Mark as the first written Gospel) was initially taught by nineteenth-century German biblical scholars, who applied to the New Testament the growing scientific hypothesis that all systems become more complex over time. This led them to conclude that because Mark's was the shortest Gospel, and contained no sermons, it must be the earliest. Consequently, they asserted that Matthew and Luke used Mark as a source for their Gospels. The major objections to this view are: (1) clear statements to the contrary by the early church; (2) the proliferation of hypothetical pre-Markan sources; (3) the inability to explain the alternating literary use by Mark of Matthew and Luke.

7. According to Luke, Mary left to see Elizabeth immediately after the angel appeared to announce her conception (Luke 1:26, 39), and returned three months later (1:56). Joseph was confronted with Mary's pregnancy after she returned to Nazareth at least three months pregnant.

an explicit Old Testament prophecy of her virginity,[8] and Joseph's preservation of her virginity until Jesus's birth (Matt. 1:18–25).[9] Mary is obviously a woman of great virtue, akin to those noted earlier within the messianic line.

But wouldn't Mary's family and friends have considered her pregnancy evidence of immorality? Wouldn't they have thought her child was illegitimate? There is no clear indication anywhere within the New Testament that Mary was considered to have behaved immorally or that Jesus was illegitimate (i.e., "born of fornication").[10] A recent study suggests otherwise.[11] Jewish society during this period considered betrothal to be a legal arrangement, binding both parties to mutual fidelity before the actual wedding event. Rabbinic teaching after the New Testament also allowed for pre-wedding sexual intercourse between bride and groom (if it occurred within her father's house).[12] It's reasonable to assume, then, that there were pre-wedding pregnancies with no social or religious stigma, as long as the child was thought to be the groom's. Matthew is clear that Joseph discovered Mary's pregnancy "before they came together" (i.e., had a sexual relationship). Confronted with Mary's pregnancy, Joseph concluded that she had committed "adultery" and violated their betrothal agreement. He was entitled to divorce her publicly but decided instead to do it "secretly" (λάθρᾳ) to avoid causing Mary shame. Assured of Mary's virginity, however, Joseph continued the betrothal and wed Mary. From the other Gospels it's clear that Joseph assumed a father's role for Jesus's circumcision, presentation to the Lord, and discipling in the traditions of Judaism. Many years later, people called Jesus "Joseph's son" (Luke 4:22). And as Joseph had hoped, Mary suffered no "shame"—no ostracism from family, community, or religious leaders for her pregnancy.[13] Similarly, there is no reason to believe that Jesus's enemies ever accused him of illegitimacy.

For the remainder of Matthew's infancy narratives, Mary appears only as a single character with her son in the formula: "the child and his mother." (Of

8. Matthew quotes Isaiah 7:14 from the Septuagint, which translates the Hebrew "chaste young woman" (הָעַלְמָה) with the more explicit "virgin" (ἡ παρθένος).

9. Matthew states that Joseph maintained Mary's virginity "until she gave birth" (Matt. 1:25). The use of "until" (ἕως) with the aorist indicative "gave birth" (ἔτεκεν) represents a typical idiom to denote the *terminus ad quem* of an event in past time. See Robertson, *A Manual Grammar*, 975. That is, Matthew's statement indicates that Joseph's action ended with Jesus's birth, suggesting that her virginal condition also ended at this point.

10. Some commentators speculate that the Jewish leaders are making a veiled reference to his illegitimacy when they respond, "We are not born of fornication" (John 8:41), but this is unlikely on contextual grounds.

11. See Cohick, *Women in the World of the Earliest Christians*, 152–56.

12. *B. Yevam 69b–70a.*

13. According to *ben Sirach* 23:22–25, the consequences of immorality included long-term social ostracism. Mary suffered no social ostracism. She regularly joined the Nazareth group that journeyed to Jerusalem for the feasts. She played a significant role in the wedding at Cana. Apparently her community didn't consider her pre-wedding pregnancy evidence of immorality.

course, a breastfeeding newborn is virtually one with its mother, and in modern medical circles is referred to as a "maternal-infant dyad." Matthew's "single character" may originate as much from maternal reality as narrative design.) Mary is united with Jesus in the Magi's visit (Matt. 2:11), Joseph's dream to flee from Herod (v. 13), the family's flight to Egypt (v. 14), Joseph's vision to return to Israel (v. 20), and the family's resettlement in Galilee (vv. 21–23),[14] reinforcing her role as the divine instrument in the messianic fulfillment.

In Matthew's account, Mary appears only in two other contexts. In Matthew 12:46–50, she comes with several of Jesus's "brothers" to speak with him. Matthew offers no explicit motive for their visit.[15] Her visit provides Jesus with an opportunity to redefine family relationships as created by obedience to God's will. Similarly, in Matthew 13:55, the people of Nazareth incredulously identify Jesus's family by name: Mary as Jesus's mother, along with Joseph and Jesus's four "brothers" (James, Joseph, Simon, and Judas) and more than one unnamed sister. In both of Matthew's passages, it's unclear whether the males associated with Mary are her biological children (i.e., conceived with Joseph subsequent to Jesus's birth), Joseph's sons and daughters from an earlier marriage, or simply male and female relatives. There are no legitimate lexical, grammatical, or theological reasons, however, to assume that they are anything other than Mary's biological children.[16] Consequently, Matthew's portrait of the Virgin Mary presents her as a remarkable example of godliness who served as God's human instrument under his direction and protection to accomplish his redemptive purpose.

Luke's portrait: an exemplary disciple

Luke comes late to the Gospel story, most likely having been the last of the New Testament writers to meet the Virgin Mary.[17] Despite this, he has contributed the most to our knowledge and appreciation of Mary as a person.

14. Although Matthew does not state where the betrothal occurred, Luke notes that Joseph and Mary were living in Nazareth (Luke 2:4). When they returned from Egypt (Matt. 1:21–23), however, Matthew implies that they had planned to resettle in Judea (v. 22), perhaps even in Bethlehem, but instead returned to Nazareth (v. 23).

15. In an apparent parallel account, Mark offers an explicit reason for Mary's action. See the discussion of Mark 3:20–21, which precedes the parallel account in 3:31–35.

16. Since Matthew's statement indicates that Mary's virginal condition ended with Jesus's birth (1:25), it's reasonable to assume that other Gospel references to Jesus's brothers and sisters denote the other biological children of Mary and Joseph born after Jesus.

17. Luke first appears with the apostle Paul as a missionary companion on his second journey. In Acts, Luke reveals the periods of his association with Paul through the use of "we." Called by Paul "the beloved physician" (Col. 4:14), Luke's Greek name and travel record suggest he is either a Hellenistic Jew or a Gentile whose family comes from Antioch (one of the medical training centers in the Roman Empire), or from Philippi (a city founded by retired Roman legionnaires). The other Gospel authors likely knew Mary first: Matthew and John were Jesus's disciples; Mark was closely associated with Peter (and possibly related to Barnabas, as well as being Paul's companion on his first journey). Luke could have met Mary only much later.

Paul's "beloved physician" became privy to the details of interest to a doctor—the matters of conception, birth, and childhood—as well as personal insights into Mary's state of mind. In this unique material, Luke develops the themes of promise and fulfillment that are central to Luke-Acts. Whereas Matthew uses Joseph as the key parental figure in the nativity stories, Luke makes Mary the prominent parent. Luke consistently portrays Mary as deliberate and thoughtful, a determined and persistent woman possessing deep spirituality tempered with a rich biblical understanding.

The annunciation

Luke introduces Mary to his readers with the annunciation (Luke 1:26–38). He notes her small-town Galilee origins, describes her betrothed status, and strongly emphasizes her virginity (vv. 26–27). Luke offers no indication of Mary's age, but cultural custom suggests that she was in early to middle adolescence, past thirteen years old when she entered adulthood but likely no older than fifteen or sixteen years old. A further clue may come from this detail: Following the annunciation, Mary immediately travels south to visit Elizabeth, who lives in an unnamed town in Judah's "hill-country" (v. 39). The "hill country" lies south of Jerusalem, some 80 to 110 miles (130 to 180 kilometers) from Nazareth. Assuming Mary followed Jewish practice, she would have avoided traveling through Samaria, a detour which would have added more miles. Even if Mary had a male escort for such a long overland journey, one would expect that Mary was a little older than the minimum age of thirteen years to make such a trip. So her age is likely somewhere from mid- to late teenage years (somewhere between fifteen and sixteen years old).

Despite her youth, the angel greeted her as "highly favored" (v. 28). This term (κεχαριτωμένος) describes Mary as the recipient of a special favor (grace), namely the privilege of serving as mother of the Messiah, rather than one in possession of a prerequisite quality of grace.[18] At the same time, the angel states that Mary has "found favor" (εὗρες χάριν) with God (v. 30). This idiom is used in the Old Testament to describe a positive disposition toward someone, often based in that individual's prior performance or quality of character. In this case, the latter would be preferred since Mary's exemplary qualities quickly become evident in her typical response to these experiences: She ponders the idiom's significance (v. 29; cf. 2:19, 51). Mary is a thoughtful and deliberate young woman, whose resolve is not easily shaken.

Now Mary and the angel engage in a dialogue. In the first movement, Mary receives the news of her coming pregnancy and birth (vv. 30–34). Her response,

18. BADG, 1081. This can be clearly seen in its only other New Testament occurrence when Paul speaks of the salvation "bestowed" by God on all believers (Eph. 1:16). Unfortunately, the Latin Vulgate rendered this as "full of grace" (*gratia plene*), suggesting that Mary possessed a superlative "grace" which qualified her to serve as the mother of the Messiah.

a simple question, contrasts sharply with the question Zacharias, Elizabeth's husband, poses to the angel. Zacharias's use of "know" displays his incredulity at the announcement, despite its holy context and supernatural visitor (v. 18). Mary similarly uses the same word ("know") to indicate the absence of any sexual intimacy that would facilitate conception (v. 34). Yet she does so in a way that confirms Luke's earlier assertion of her virginity. Mary demonstrates that she believes the angel's announcement, but she is curious about the means by which conception will happen.

In the second movement, the angel answers Mary's question and provides her with a "sign" (vv. 35–38). The angel explains that her conception will be a supernatural event superintended by God himself. Then the angel offers her a confirming "sign." Biblically, a "sign" was not to persuade the skeptic, but to confirm the certainty of God's promise and to reinforce the faith of those to whom the promise was made. Those who received a sign were expected to check it out as an aid to their obedience. Since Mary has already expressed her acceptance of the angel's announcement, the angel gives her a "sign": Elizabeth is pregnant, despite her being long past childbearing age and previously unable to conceive.

Mary responds to the angel's announcement with a remarkable self-identification: "Behold, [I am] the slave of the Lord" (v. 38). Her use of "slave" recalls the Old Testament servant Isaiah, who submitted to God's will and represented his purpose. Despite human misunderstanding and opposition, the slave looked to God for the vindication of his identity and message. He was a living testament to God's faithfulness. Mary affirms her identity as the servant with a second statement: "May it be to me according to your word." Taken together, these two statements reveal a very intelligent and biblically cultured young woman with a deep confidence in the God who is commissioning her.

The visit to Elizabeth

Since the angel has given Mary the "sign" of Elizabeth's pregnancy, Mary again demonstrates her confidence in God's word to her by immediately heading off to visit her relative. She intends to witness the sign that God has provided (vv. 39–46). When Mary arrives, Elizabeth's outburst makes three strong statements concerning Mary:

1. Mary is "blessed among women" (v. 42).

2. Mary is "the Mother of my Lord" (v. 43). Typically, first-century Jews avoided the possibility of breaking the commandment concerning "not taking God's name in vain" by substituting the common noun, Lord, for both the word "God" and for God's name. If we pair this custom with the earlier descriptions of Mary's child, we find a strong suggestion that Elizabeth meant her statement to mean "Mother of my God."

3. Mary's confidence in God's promise concerning her pregnancy is confirmed (v. 45). Mary's visit to Elizabeth to see God's sign is itself evidence that Mary has believed from the beginning.

Mary's response to Elizabeth's greeting is a thanksgiving psalm known as the Magnificat. In the Old Testament, hymns were ascribed only to three women: Miriam, Moses's sister who celebrated God's conquest of Egypt after the crossing of the Red Sea (Exod. 15:20–21); Deborah, unique as the only woman prophet/judge in Israel (Judg. 5:1–31); and Hannah, mother of the prophet Samuel, the last judge and maker of kings (1 Sam. 2:1–10). Luke's inclusion of this material ascribed to Mary implies that she belongs among these great women of the Old Testament.

A casual reader might assume that Mary composed this hymn spontaneously. Luke states only that she uttered it at this moment. Earlier Luke noted that Elizabeth lived some distance from Nazareth, and we've already seen that Mary was prone to reflection. During the trip south lasting several days, Mary had many hours to think and to compose a poetic response to the annunciation. Therefore, there's no reason to assume that Mary composed it spontaneously, or to ascribe its authorship to anyone else.

The hymn is a masterpiece of composition.[19] Its Greek style resembles the Septuagint (Greek version of the Old Testament), like much of Luke's narrative. There is evidence in the New Testament that the Septuagint was among the versions of the Old Testament read in the synagogues of Galilee.[20] Therefore, it's reasonable to assume Mary would have known and copied the Septuagint's style of expression.[21] The hymn structure displays compositional skill. It follows the traditional Old Testament "Thanksgiving Hymn": a call to praise, followed by the cause for praise (in which clear reasons for offering praise are provided). The hymn has two strophes: verses 46–49 and verses 50–55. The second strophe is arranged as a chiasm:

A "powerful humbled" (v. 52a)
 B "lowly lifted" (v. 52b)
 B' "hungry filled" (v. 53a)
A' "rich sent away empty" (v. 53b)

19. Because the hymn displays sophisticated compositional characteristics, some modern biblical scholars have expressed skepticism that such a work could be authored by a young Jewish woman. They prefer to attribute it to Luke, Elizabeth, or even a broader Jewish/Jewish-Christian community. For a discussion of the various options, see Bock, *Luke Volume 1: 1:1–9:50*, 142–47.

20. For example, Jesus's reading of Isaiah 61 in the Nazareth synagogue (Luke 4:18–19) appears to be from a Septuagint version of that text.

21. An analogy would be someone very familiar with the 1611 King James Version who prays or composes a poem using the same kind of language.

enclosed within references to God's covenant faithfulness (vv. 50, 54–55). The hymn's themes draw heavily on Old Testament patterns of praise and address, employing Old Testament language and allusions that extoll God's covenant faithfulness ("remembrance") established in the past, active in the present, and extending into the future.[22] Mary shows us that she is a skilled theologian, possessing a broad awareness of the Old Testament, which she weaves into a single synthetic statement. In doing so, Mary reveals a remarkable awareness of the Old Testament and employs her knowledge skillfully for both the form and content of her hymn. She created it as an individual, but her use of corporate themes has transformed her song into a voice for all who would accept Jesus's messianic claim.

The nativity

Luke carefully locates Jesus's birth within its sociopolitical context under less-than-favorable conditions created by the demands of a Roman census (Luke 2:1–4). He emphasizes Mary's virginity by designating her as "the one betrothed to him [Joseph]" (τῇ ἐμνηστευμένῃ αὐτῷ) yet who was also "with child" (v. 5).

22. Some of these Old Testament allusions have been suggested as follows:

vv. 46–47 The opening two verses mirror Habakkuk 3:18. The parallelism of "soul . . . spirit" occurs frequently in the Old Testament as a synonym for the writer (e.g., Job 12:10; Ps. 77:3-4; Isa. 26:9).

v. 47 In the Old Testament God often appears as the eschatological "savior" of his people (e.g., Ps. 25:5; Isa. 12:2; Mic. 7:7). Similarly, "magnify . . . exult" (μεγα-λύνει . . . ἠγαλλίασεν) typically appear as the rejoicing that accompanies the fulfillment of God's eschatological promises to his people.

v. 49 While the title "mighty One" (ὁ δυνατός) has no exact Old Testament parallel, God is described as "mighty to save" (Zeph. 3:17) and a "mighty warrior" (Isa. 42:13). God is often praised for his great power, particularly when he displays his faithfulness to deliver his covenant people from their oppressors (e.g., Deut. 10:21; 34:11; Ps. 44:4–8; 89:8–10; 111:2, 9). Similarly, "great things" in the Old Testament describe God's saving intervention, epitomized in the exodus from Egypt (e.g., Ps. 71:19; Deut. 10:21; 11:7). The coda closes with "Holy is his name," the psalmist's summative expression for God's unique character (Ps. 111:9).

v. 50 God's "mercy" is the New Testament rendering of the Hebrew "covenant loyalty" (*hesed*). In language that echoes Psalm 103:17, Mary affirms the consistent Old Testament portrait of God as the one who will keep his covenant promises forever, especially to those who "fear" (remain faithful to) him.

v. 51 Mary expands on God's faithfulness with a description of his "mighty arm," a common Old Testament metaphor for God's power exercised on behalf of the righteous (e.g., Deut. 4:34; Ps 44:3; 89:13; 118:15).

vv. 52–53 Mary's list of God's blessings follows a similar pattern to Psalm 103:2–6 and includes themes similar to those in the psalms: "brought down rulers" (Ps 68:1; 89:10; 147:6); "exalted the humble" (Ps. 147:6; cf. 1 Sam. 2:7).

v. 54 The last half of the verse is reminiscent of Isa. 41:8–9 (LXX).

v. 55 The language of the verse conflates 2 Samuel 22:51 and Micah 7:20. For a more detailed discussions of the Old Testament character of Mary's hymn, see Bock, *Luke* I:147–62.

Luke's matter-of-fact description of Mary's giving birth and providing for her newborn under these difficult conditions contributes to a reader's appreciation of Mary's competence. Then her thoughtful reaction to the visit of the shepherds and their story of the angelic host (vv. 8–17) again emphasizes Mary's reflective nature (v. 19). She labors to arrange these events into a coherent understanding of the mission of her son.

The temple visit

After Jesus's birth, Mary's piety comes into sharper focus. Luke notes that Mary and Joseph acted "according to the Law" (vv. 23, 24) and "performed everything according to the Law of the Lord" (v. 39). This included the circumcision of Jesus on the eighth day (v. 21), and on the thirty-third day his presentation to the Lord in the temple and the offering of the timely sacrifices for Mary's purification (vv. 22–24). Luke also notes that the entire family attended the Passover festival in Jerusalem every year (v. 41). This is remarkable, since attendance was required only of adult males.[23] Mary's presence with her husband and son suggests a deep concern for her spiritual responsibility as a faithful Israelite. Further incentive may have been added by her knowledge that her child was "the Son of the Most High" (1:32) who "will suddenly come to His Temple" (Mal. 3:1).

After their Passover visit to the temple during Jesus's twelfth year, Mary and Joseph with the rest of their family began the journey home. When Mary and Joseph discover Jesus's absence on the first day of their journey home, they began an unsuccessful search for him among the pilgrims and then back in Jerusalem (Luke 2:44–45). After three days' unsuccessful search "everywhere," Jesus's parents found him engaged in discussion with the religious leaders in the temple (v. 46). It's interesting that Mary acted as spokesperson for both parents when she rebuked her son for his lack of consideration (v. 48). Jesus's reply that they should have looked first for him in the temple—the place from which Messiah would exercise his office (v. 49)—assumed they had clearly understood his messianic destiny, and confused both parents (v. 50). Mary's reaction is now typical: She reflects on the event, obviously trying "to put it all together" (v. 51). Once again, Mary appears as a spiritually motivated, intelligent, and highly reflective young woman. In this incident, however, Mary reveals she has not fully understood how her son will fulfill his messianic mission.

After the ascension

Lest Luke's readers leave with the temple scene as their last image of the Blessed Virgin, he offers one final glimpse. He names Mary (along with Jesus's

23. Women were exempted from the obligation to attend the annual festivals, both implicitly by the Old Testament prescription for males to attend (Exod. 23:17; Deut. 16:16) and explicitly by the first-century AD rabbinic teaching that exempted females from the obligation (*m. Hagigah 1:1*).

"brothers") among the first community of Jesus's disciples after his ascension (Acts 1:14), a group of about 120 people (v. 15). Mary began her journey with full confidence in God's work through her. She completes her story with the same confidence now extended to God's Son. Her diligent search for coherence in all that she encounters concerning her child is rewarded. Her journey from the annunciation to the ascension is complete.

In summary, Luke presents Mary as an intelligent, spiritually disciplined young woman, well-versed in Old Testament themes and expectations. Her unswerving allegiance to God equips her to assume a supernatural appointment as his agent, buttressed by an unshakable confidence in his provision and vindication. Although at the time of each event she doesn't necessarily understand fully all of the implications of Jesus's identity, she consistently puts forth the mental effort necessary to determine its significance.

Mark's portrait: a humble disciple

As the last of the synoptic Gospels, Mark says the least about Mary. This also means it's likely that many in Mark's audience had access to both Matthew and Luke and had already formed an appreciation of Mary. People hearing Mark's treatment of Mary would be integrating his perspective with their prior understandings and would be suspicious of interpretations of her actions which were inconsistent with that portrait.

Mary appears only twice in Mark, both instances occuring in passages parallel with Matthew. She is named once (Mark 6:3; see Matt. 13:55) when the "home town" (Nazareth) crowd notes that Jesus's mother and siblings possess no credentials by which Jesus can claim to be a teacher. Apparently, Jesus's family had little wealth, social standing, or privilege to commend it. In an earlier story, Mary is designated only as Jesus's mother (Mark 3:31–35; parallel to Matt. 12:46–50). In this passage, his family's appearance provides Jesus an opportunity to redefine kingdom relationships. But Mark adds a unique and potentially troubling detail (Mark 3:21): Jesus's family believes the crowd's enthusiasm has stressed Jesus to the breaking point so that he is "beside himself" (ἐξέστη). They plan an intervention to "take control of him" (κρατῆσαι αὐτόν). At the very least, this indicates his family's concern.

But is such a perspective evidence of Mary's unbelief? Because it's immediately followed by a description of Jesus's rejection, commentators often take the family's action as evidence of Mary's unbelief at this point in Jesus's ministry. But a picture of unbelief doesn't fit with all we've learned about Mary to this point from Matthew and Luke (and certainly not with John's Gospel, either).

Mark's motive for the family's intervention holds the answer. Jesus's family is concerned that the pressure of the crowd's demands has caused Jesus to become "beside himself" (ἐξέστη, second aorist of ἐξίστημι, standing alone as an intransitive verb). This word we translate as the phrase "beside himself" describes someone who is confused or has lost something, including one's spiritual and/or

mental balance, one's path, or something else.[24] This "loss of way" can be described as "becoming distracted or diverted" or even "being transformed," an example of use being wine that has "lost its way" to "become soured" (i.e., vinegar).[25] In this broader understanding of their assessment, Mary's concern is that the excessive demands of the crowd have distracted and diverted Jesus from his larger messianic responsibilities. Her son, she believes, is in danger of losing his way.

Mary's intervention reflects Mark's broader theme of messianic misunderstanding and the messanic secret: Since populist messianic ideas threatened to eclipse the true nature of Jesus's ministry, the Lord urges his followers not to identify him as the Messiah. Apparently at this point, Mary also struggles with misunderstanding how Jesus is to conduct his ministry and fulfill his messianic destiny. Her misunderstanding would have the same consequence for Jesus's true ministry as the unbelief of his enemies, and Mark juxtaposes it against their unbelief.

Once admonished by Jesus, Mary and the family disappear from the narrative, along with these concerns. Therefore, Mary should be commended for taking action that shows the depth of her concern for her son's welfare, under the stress imposed by the enthusiastic response. She should also be commended for her humility, and for a willingness to accept her son's messiahship ministry as other than what she had heretofore understood.[26]

John's portrait: a messianic advocate

The apostle John's record of Jesus's life was likely the last of the four Gospels to be written. While John followed the same chronological order, he omitted the institution of the Lord's Supper and offered much more development of a few key events in Jesus's life and ministry against the backdrop of Old Testament theology. John's presentation assumes that his readers already know much of the story. Therefore, Mary's person and actions in John's Gospel must be seen against the audience's greater preunderstanding of events. Although she appears only three times in John's Gospel, she is never identified by name but only as Jesus's mother or in direct address as "woman."[27]

The wedding at Cana

The first reference to Jesus's family appears in Philip's words to Nathaniel: "Jesus of Nazareth, the son of Joseph" (John 1:45). Shortly after this, the text describes is a wedding in Cana "and the mother of Jesus was there" (2:1) as well as Jesus

24. BAGD, 276.
25. Liddell and Scott, *A Grek-English Lexicon*, 595.
26. Obviously, this understanding fits better with Mary's earlier ambitions for Jesus at Cana (as reported by John) and with her consistent example of devotion to her son (as reported in both Luke and John).
27. John likely uses this designation to distinguish Jesus's mother from other Marys in his narrative (as in John 19:25). One was Mary's own sister, "the wife of Clopas" (who also might have been present at the wedding in Cana).

and his disciples as invited guests (v. 2).[28] When the wine runs out, Mary brings the problem to Jesus's attention (v. 3). Jesus responds that "the time" is not right (v. 4).[29] Undeterred by Jesus's inaction, but encouraged by his response, Mary immediately instructed the servants to obey Jesus's orders (v. 5). Subsequently, Jesus turns six large stone pots filled with water for ceremonial cleansings into vintage wine for the wedding (vv. 6–10).

The Old Testament characterizes the messianic age as a remarriage between God and Israel (e.g., Isa. 54:4–6; 62:1–5), a "wedding feast" in which God will provide the best victuals. This would include, of course, "fine, aged wine" (25:6). Consequently, the "wedding feast" is an image for the anticipated messianic reign, in which "choice" wine will flow abundantly. It was natural for Jesus to use "wedding feast" to describe his kingdom (e.g., Matt. 9:14–17; 22:1–14; 25:1–13; Mark 2:19–22; similarly, Luke 22:15–30). Therefore, Jesus's miraculous provision of an abundant supply[30] of good wine at a wedding is offered by John as evidence ("sign") of Jesus's messianic identity, which manifested his "glory" (John 2:11; cf. 1:14).[31]

Jesus's clearly identified messianic identity and mission forms the context for Mary's actions. Her statement to Jesus, "They have no wine" (v. 3) offers her son an opportunity to manifest his messianic identity. This would be consistent with the portrait of Mary elsewhere in the Gospels: "she" understood her son to be "the Messiah," and she was passionate to advance his mission (as she understood it). Mary showed she was a believer committed to her son's mission. John confirmed this conclusion by a brief comment after the wedding (vv. 11, 12). Mary follows Jesus and his disciples when they move to Capernaum, the town

28. Although Jesus is explicitly described as "invited" (ἐκλήθη) to the wedding, John notes only that Mary "was there" (ἦν … ἐκεῖ). This contrast suggests Mary was present because of a relationship with one or both wedding parties to assist with the feast. It may also explain how Mary knew about the lack of wine and why she took steps to resolve it. See Lenski, *The Interpretation of St. John's Gospel,* 185.

29. The tone of Jesus's first response ("what have you to do with me?") is ambiguous. But his use of "woman" was not pejorative, since he also used it to address Mary, affectionately from the cross (John 19:26). Jesus appears to be telling his mother to leave the matter alone.

30. John is specific about the amount of wine: Each stone water pot (λίθιναι ὑδρίαι) held twenty to thirty gallons (ἀνὰ μετρητὰς δύο ἢ τρεῖς). If we assume that a standard serving of wine is about four ounces, Jesus created somewhere between 3,840 and 5,760 servings of wine (or as modern 750 ml. bottles, between 150 and 230 bottles)! Now Cana in Jesus's time was such a small village that modern archaeologists have been unable to identify its location. Providing such an abundance of excellent wine for such a small wedding would certainly have fulfilled Mary's messianic expectations.

31. The preceding stories also set up the messianic context for the wedding. At Jesus's baptism (John 1:28), John publicly identified him as the promised Messiah (vv. 29–34). This was repeated by Andrew (v. 41), Philip (v. 45), and Nathaniel (v. 49). The wedding occurred on "the third day" after Jesus's baptism (2:1), which suggests the decisive nature of the Cana event. Finally, Jesus's response, "My hour is not yet come" (v. 4), confirmed that Mary's request had messianic implications.

Jesus used as his base of operations in Galilee.[32] Mary's commitment to Jesus's messianic destiny motivates her to abandon the town in which she had grown up, been married, raised her family, and buried her husband, leaving behind all of the social fabric in which her life and prosperity are grounded. Like the true disciple Jesus often sought, Mary has left everything to follow him. At this point in John's Gospel, all reference to Jesus's family ceases until the crucifixion.

The crucifixion

John is the only Gospel in which Mary is said to be a witness to Jesus's crucifixion (19:25–27). We know that Mary accompanied Joseph and Jesus to Jerusalem every year for the Passover (Luke 2:41). Mary now lived in Capernaum with Jesus and his disciples, and John notes in one instance that other family members ("brothers") attended the Feast of Booths (7:10; cf. 5:1). It's reasonable to assume, therefore, that Mary continued to accompany Jesus when he attended the Passover (John 2:23 [cf. 4:45]; 6:4; 11:56).

John has finished describing Jesus's arrest, his trials, Peter's denials, Jesus's public rejection by the Jews, and his crucifixion by the Roman soldiers. The next sentence offers a heart-wrenching example of three[33] women's devotion that contrasts sharply with the failure of the male disciples. The last time we saw the Virgin Mary, she was her son's strongest advocate. At the wedding she seized the moment, providing him with an opportunity to demonstrate his messianic destiny. Now she kept vigil as she watched him die.

Where is Joseph? The last time Joseph appeared alive was the family's visit to the temple when Jesus was thirteen years old (Luke 2:41–52). After the Cana incident, Mary moves from Nazareth to Capernaum (John 2:12)—an unusual situation if her husband is still alive. Later, when Mary attempts an intervention, Joseph is absent (Matt. 12:46–50; Mark 3:20–21, 31–35). The last reference to Joseph is his nameless identification of Jesus by the Jews as "the carpenter's son"

32. John's comment explains how Mary was able to intervene so quickly when she saw the Capernaum crowds overwhelming Jesus and the disciples (Matt. 12:46–50; Mark 3:20–35). While John says that the group stayed in Capernaum "for a few days" (v. 12), among the Gospels this move represented Jesus's establishment of Capernaum as his center of ministry in Galilee.

33. Translators debate whether John lists three or four women. To designate four, a Greek reader would expect to see καὶ ["and"] between each name. Since καὶ appears only twice in the list and is missing between "her [Mary's] sister" and "Mary the wife of Clopas," grammatically it's more natural to assume that Mary's unnamed sister is then identified by name with the addition of "wife of Clopas." How likely is it, however, for two sisters in one family to have the same name? One solution suggests that "sister" has the broader sense of "relative." The similar lists in Matthew (Matt. 27:56) and Mark (Mark 15:40) include more than two women named Mary (without mentioning the mother of Jesus): Mary Magdalene, Mary the mother of James and John (also identified as the sons of Zebedee), and Mary the mother of James and Joseph. So many women named Mary. Perhaps one of these women is also the wife of Clopas?

(Matt. 13:55). Taken together, the impression is that Joseph died prior to Jesus's baptism. In a world of day-labor without savings accounts, insurance, or welfare, Joseph's death would have left Mary destitute, dependent on her children or extended family.

From the cross, Jesus saw his mother standing with her relative (also named Mary) and Mary Magdalene (John 19:25). Jesus asks his mother to consider the apostle John her son (v. 26). This means his mother must look to John for her welfare. Conversely, Jesus asks John to consider Mary as his own mother. Jesus intends that John will ensure Mary's welfare. As Jesus dies, he assures his mother of his care for her, that her needs would be met, and her world would go on. According to Christian tradition, Mary's final years are spent in Ephesus, where John serves as bishop, and where she eventually dies under his care.

In two snapshots, John shows us a Mary who remains a devoted disciple of her son and advocate for his messianic destiny. Her spiritual dedication is an amazing model of the radical commitment Jesus taught for all his followers, a commitment that suffers the horrors of her son's crucifixion—and the "sword" that must have pierced her own soul at the sight (Luke 2:35).

Summary of the New Testament survey

The New Testament authors weave a growing image of Mary as God's exemplary servant and faithful disciple. The apostle Paul points out that she was a critical and timely participant in the incarnation. Matthew emphasizes Mary's role as God's divine instrument and adds qualities of virtue and godliness, equating her with Old Testament women whom God vindicated for their faith in his covenant. Luke provides more detail about God's sovereign choice, but also increases our appreciation for her godliness, spiritual commitment, and intelligence as she skillfully weaves her Old Testament understanding of God into an enduring poetic statement, even as she grapples with Jesus's destiny. Her unswerving belief in him finds its climax when she is numbered among his first post-ascension followers. To this portrait, Mark adds an important detail to correct a possible misconstruing of her Capernaum intervention as unbelief. John deepens the colors of Mary's passion for her son's destiny, her radical commitment to follow him, and her persistence despite the pain that this will (temporarily) create. When these portraits are taken together, Mary emerges as perhaps the greatest example of discipleship in the New Testament.

Collating all of the sources, it's possible to construct a chronology of Mary's life:

- Mary was betrothed to Joseph (Matthew).
- The angel Gabriel visited Mary to announce her pregnancy (Luke).
- Mary immediately journeyed south to visit Elizabeth (Luke).
- Three months later, Mary returned to Nazareth (Luke).
- Joseph discovered Mary's pregnancy and, having received God's assurance of her virtue, married her and kept her a virgin (Matthew).

- Mary accompanied Joseph to Bethlehem to fulfill the census requirement (Luke).
- Mary gave birth to her firstborn, a son, in a stable and received visiting shepherds (Luke).
- Mary and Joseph circumcised their eight-day-old son and named him "Jesus" (Luke).
- Mary and Joseph visited the temple in Jerusalem with Jesus thirty-three days after Jesus's birth to fulfill the Law's requirements for his dedication and Mary's purification (Luke).[34]
- The Magi visited the family in Bethlehem and departed (Matthew).
- Mary and Joseph fled to Egypt with Jesus after being warned by God in a dream of King Herod's murderous intent (Matthew).
- The family returned to Galilee and resettled in Nazareth (Matthew).
- The family annually attended the Passover in Jerusalem (Luke).
- Mary and Joseph were confronted with Jesus's messianic identity when he was twelve years old (Luke).
- (Joseph died.)
- Mary encouraged Jesus to provide wine for a wedding in Cana as a messianic sign (John).
- Mary followed Jesus from her hometown of Nazareth to his ministry base in Capernaum (John).
- Mary attempted to rescue Jesus from the Capernaum crowds, which she thought were distracting him from his messianic mission (Matthew, Mark).

34. Mary and Joseph are typically portrayed as poor, a conclusion based on Mary's offering for her purification thirty-three days after Jesus's birth (Luke 2:22-24). Luke quotes from the Old Testament law concerning purification (Lev. 12:1–8) and draws special attention to the substance of the offering as the concession for poorer Israelites (two turtledoves or young pigeons), rather than the "normative" offering (a yearling lamb and a pigeon). Luke expects his readers to infer both the family's low economic status and their piety.

 Joseph's profession didn't change this situation. He was a carpenter (Matt. 13:55), and by Jewish custom, professions were established prior to betrothal. He had time to establish himself financially, and the family's poverty several months after the wedding suggests he earned only "day-labor" wages.

 What effect did the Magi's gifts have on the family's financial situation? These gifts were most likely received after Mary's temple visit for her purification (when her offerings indicated her poverty). After the Magi's visit, the holy family had enough money for the food and accommodations needed for a multi-day journey to Egypt, a stay in Egypt of several weeks or even months, and the return to Nazareth. Perhaps the Magi's gifts were instrumental in facilitating their escape from Herod. Then upon their resettlement in Nazareth, Mary and Joseph had sufficient funds for the entire family's annual multi-day pilgrimage to Jerusalem for the Passover celebrations. The Torah stipulated that this regular expense was to be paid out of an individual's "second tithe," so that it was required only of the males (Deut. 14:22–27). Assuming Joseph's profession didn't provide sufficiently for the whole family to undertake this expense, the Magi's gifts may have made their annual trips possible as well.

- (Mary accompanied Jesus and his disciples to Jerusalem to attend the annual feasts.)
- Mary, having accompanied Jesus to Jerusalem for the last Passover, witnessed his crucifixion and was committed by Jesus into the apostle John's care (John).
- After the ascension, Mary remained in Jerusalem with the apostles as one of Jesus's first followers (Acts).
- (Mary accompanied John to Ephesus where she died.)

THE MODERN MARGINALIZATION OF MARY

From the New Testament portrait of Mary, it's easy to see why early Christians quickly valued her as much for her example as a follower of Jesus as for her unique role in redemption. They quickly began to associate her with Old Testament images and events. One prominent image was the burning bush on Mount Sinai. The Old Testament consistently described God as "a consuming fire" (Deut. 4:24; 9:3; Exod. 24:17; Isa. 33:14). According to Exodus, the bush from which God spoke burned but was not destroyed by the flame. By analogy, God had dwelled within Mary's womb, and miraculously Mary was not consumed by God's presence within her. The association of these two stories appears in the name given to the ancient monastery at the base of Mt. Sinai, "The Monastery of Mary in the Burning Bush."[35] The association went further. Since also God dwells within each individual believer and within the church corporate, Mary's experience is a pattern for all believers—and the Virgin Mary is a symbol of the church.

Another analogy was created between the ark of the [first] covenant and Mary as the ark of the [new] covenant. Both were earthly dwelling places of God. Both were "overshadowed" [ἐπισκιάσει] by God (God's glory over the tabernacle/temple and the Holy Spirit over Mary [Luke 1:35]). Both contained the Word of God (the written Law and the incarnate Word). Both were received with expressions of great joy (David's dance and Elizabeth's song). As the ark of the covenant remained in the house of Obed-Edom for three months after its return to Israel (2 Sam. 6:11), so Mary remained three months with Elizabeth. Finally, the loss of the Old Testament ark during the exile made way for the appearance of Mary as the New Testament ark. In Christian thought, the Virgin Mary became the ark of the new covenant.

Other long-standing Christian traditions surround Mary: her title "Mother of God," her perpetual virginity, her immaculate conception, her bodily assumption, and her status as co-redemptrix. All these traditions lay claim to ancient roots and offer biblical or theological justification for their existence. But these traditions go further than many Protestants are willing to concede; thus, they

35. The monastery has become more popularly known as St. Catherine's Monastery because it houses the relics of a famous martyr, St. Catherine, which were discovered on a nearby mountain.

often reject both the traditions and those who hold to them. If we understand how Mary was presented in the New Testament, it's easy to appreciate the high regard in which she was held by the early church, how early Christian thought contributed to each tradition's development, and what that tradition actually asserts. With a better understanding of these traditions, we can be less critical of those who hold them.

"Mother of God" and the *theotokos*

Two different expressions—"Mother of God" and "the *theotokos*" express one idea. That is, that Jesus was both fully human and fully divine. Consider "Mother of God." The expression appears once in the New Testament. In Luke's narrative, Mary's child is supernatural in origin and given titles equating him to God (Luke 1:32–33, 35). When Elizabeth greets Mary as "the mother of my Lord" (v. 43), as mentioned earlier, her statement carries the fuller sense: "the Mother of [my] God." The second term, *theotokos*, was created by early Christians from two Greek words: *theos* ("God") and *tikto* (meaning "to bear" or "to give birth") and was given to Mary as "the bearer of God." Both terms denote one thing: Mary was the human agent through whom the infinite God took on a fully human nature. While these titles are given to Mary, they are meant only to describe the incarnation of Jesus Christ. They don't attribute anything about deity to Mary or about Jesus's origins as God.

These terms appear in the early liturgies of James (second century AD) and of Mari and Addai (third century AD), then appear widely in the writings of the church fathers, both East and West, during the third and fourth centuries AD. When the Third Ecumenical Council (Ephesus) was called in AD 431 to deal with the Nestorian view of Christ (i.e., Jesus was neither fully God nor fully human, but something else), its members decided that the one person, Jesus, must possess both divine and human natures in all of their fullness ("the hypostatic union"). Thus, the titles, *theotokos* and "mother of God," were decreed to be shorthand affirmations of this orthodox view of Jesus Christ. A millennium later, these titles were affirmed by the Protestant Reformers in England and Germany. Today both designations for Mary appear in Anglican and Lutheran service books. As the Lutheran theologian Karl Barth said, "The description of Mary as 'Mother of God' was and is sensible, permissible, and necessary as an auxiliary Christological proposition."[36]

The perpetual virginity of Mary

The perpetual virginity of Mary teaches that Mary was a virgin before, during, and after giving birth to Jesus until her death. The New Testament strongly asserts Mary's virginity at the time of Jesus's conception (Luke 1:34) and birth (Matt. 1:18, 24–25), but then the disagreement begins. Some take Matthew's

36. Barth, *Church Dogmatics*, I:288.

statement that Joseph "kept her a virgin until" (v. 25) to mean that their mutual celibacy ended with ("until") Jesus's birth.[37] Others prefer to see Matthew's statement concerning their marital celibacy as a lifelong, *perpetual* condition ("through"). Apart from this single text, the New Testament offers no other comments on Mary's virginity after Jesus's birth.

In the second century AD, *The Protoevangelium of James*, an apocryphal work, taught that Mary remained a virgin after Jesus's birth, and that the New Testament references to Jesus's brothers and sisters were Joseph's children from a previous marriage (or simply a broad reference to "relatives").[38] Subsequently Mary's *perpetual* virginity became widely taught and was eventually affirmed by the ecumenical councils,[39] enshrined in liturgical statements of both Eastern and Western churches, and held by some leaders of the Protestant Reformation (apart from the Reformed tradition which rejected it for lack of clear New Testament corroboration).

This teaching may seem strange to a modern audience raised in the shadow of the sexual revolution (and often disconnected from church history). The church fathers taught a different sexual ethic. They generally held marriage in high regard and agreed that sexual intercourse was necessary for procreative purposes to fulfill God's command, "be fruitful and multiply and fill the earth" (Gen. 1:28). Some also taught that humanity had fulfilled God's command to "fill the earth," rendering sex within marriage unnecessary. They confirmed this by Jesus's statement that in the resurrected [ideal, heavenly] life Christians would "neither marry nor are given in marriage but are like the angels in heaven" (Matt. 22:30). The church fathers also valued the apostle Paul's instruction that celibacy was a preferred state for all Christians (1 Cor. 7:1, 7, 27, 29, 32, 34). Therefore, early fathers thought that the ideal state for Christians was chaste singleness. Similarly, the ideal Christian marriage was a celibate companionship of brother and sister in Christ within which sexual activity might be necessary, but only as a concession to human weakness.[40]

In this context, Mary's perpetual virginity was their consistent application of Scripture in light of her obvious virtue and her exemplary status for devout Christians. By the end of the twentieth century, churches were forced to re-examine the biblical texts dealing with human sexuality. The result was a recovery of the sacred character of sexual intimacy within marriage (apart from its reproductive role) and a reduction in importance for Mary's perpetual virginity.

37. See footnote 9. Based on Matthew's statement concerning the *terminus ad quem* of Mary's virginity, it is reasonable to assume that New Testament references to Jesus's brothers and sisters likely denote other biological children born to Mary and Joseph.
38. *Protoevangelium of James*, XIX–XX.
39. The term "ever virgin" (αειπάρθενος) is attributed to Epiphanius of Salamis (*Ancoratus*, 119.5) c. AD 374 and was well known by the Second Ecumenical Council of Constantinople (AD 553).
40. For the most concise summary of the argument, see Augustine of Hippo, "On the Good of Marriage," IX.9; XVII.19.

Christians who hold Mary's perpetual virginity value the tradition, but do not require it as an article of faith.

The immaculate conception of Mary

The tradition concerning the immaculate conception of Mary states that Mary was conceived and born to Anna (her mother) and Joachim (her father) through natural biological processes,[41] God preserved Mary from the transmission and subsequent "stain" (Latin *macula*) of original sin. She was "immaculate."[42] This teaching first emerged in the *Protoevangelium of James*. Because this work contains numerous parallels with the story of the birth and childhood of Samuel (1 Sam. 1:1–2:21), some think that Anna's story (Mary's mother) was borrowed from (or confused with) Hannah's story (Samuel's mother). The story appeared in two later works, the *Gospel of the Nativity of Mary* (c. fifth century AD) and *The Gospel of Pseudo-Matthew* (c. AD 600–625).[43] Early church fathers strengthened the story's importance by appeal to the necessity of *both* Mary's and Jesus's purification at the temple (Luke 2:22–24), which implied Mary's "pre-purified" human nature.

This view of Mary was widely taught, but it never assumed doctrinal orthodoxy in the church, and many Christian traditions do not teach it as dogma. In Roman Catholicism, however, Pope Pius IX pronounced it *ex cathedra* to be Roman Catholic Church doctrine in 1854, one of only two such doctrinal pronouncements.

The bodily assumption of Mary

The concept of "bodily assumption" isn't foreign to the Scriptures. Enoch walked with God and "God took him" (Gen. 5:24). Elijah went bodily to heaven before death in a flaming chariot (2 Kings 2:11). By the first century AD, the record of Moses's death and burial (Deut. 34:5–6) also included the heavenly assumption of his corpse.[44] Coincidentally, these last two figures appeared with Jesus at his transfiguration, suggesting to the ancients a common assumption experience for them all (prefiguring Jesus's own bodily

41. In 1677, Pope Benedict XIV (*De Festis*, II, 9) explicitly condemned the view that Mary, like Jesus, was "virgin born."

42. The Council of Trent (1545–1563) subsequently declared that Mary was also free from personal sin. The church has consistently asserted, however, that her sinlessness must not be taken to mean that she did not require a Savior.

43. It is also known as *The Infancy Gospel of Matthew*, and by its full title as *The Book about the Origin of the Blessed Mary and the Childhood of the Savior*.

44. Moses's bodily assumption developed from the biblical statement concerning the dispute between the archangel and Satan over Moses's corpse (Jude 1:9). The only existing text of *The Assumption of Moses* (also known as *The Testament of Moses*), a pre-first-century AD Jewish work (existing in a single sixth-century AD Latin copy), was cited favorably by prominent ancient writers such as Gelasius (vv. 2, 21, 17) and Origen (*De principiis*, III, 2, 1) in their discussion of the Jude reference.

assumption). The apostle Paul taught that all Christians will experience a bodily assumption—either the transformation of the living or the resurrection of the dead (1 Thess. 4:13–17). With these examples and knowing Mary's biblical status as an exemplary disciple, early Christians had no problem extending the biblical idea of bodily assumption to the Virgin Mary.

The bodily-assumption tradition first appears in *The Book of Mary's Repose* (fourth century AD) and the "Six Books" dormition narratives (fifth to sixth centuries AD). It became widely accepted after the seventh century (although it was never among the issues discussed by the first five ecumenical councils). The bodily-assumption tradition exists in two forms. Eastern Christians who refer to the event as "the dormition" (Latin) or *Koimesis* (Greek) for "falling asleep" universally believe Mary died and three days later her empty tomb was evidence of her bodily resurrection and assumption to heaven.[45] Among Western Christians, some believe that she was resurrected after death and assumed to heaven (like the Eastern Church), while others hold that she was assumed to heaven bodily without dying. Other key details of the story also vary between the early accounts.[46]

For most Christians who believe in this tradition, it's not dogma, and they don't allow it to generate disputes. Unfortunately for Roman Catholics, in 1950 Pope Pius XII declared the bodily assumption of Mary to be dogma of the Roman Catholic Church (while ignoring such questions as when and where it occurred, and even whether it followed or preceded her death), making it a tradition that divides.[47]

Mary as co-redemptrix

The title of *co-redemptrix* is one of a series of Latin titles for Mary that attempt to recognize her crucial role in the incarnation whereby the work of redemption through Jesus Christ became possible.[48] Mary provided the

45. Ware, *Festal Menaion*, 64. Mary has already experienced the resurrection that all believers anticipate when Jesus returns.

46. For example, in one version of the story, Mary's bodily assumption occurred in Jerusalem three years after Jesus's resurrection; a competing version has her bodily assumption occur many years later in Ephesus. Consequently, Pope Gelasius I (AD 492–496), in his "Gelasian Decree" (*Decretum Gelasianum*), declared some of these versions apocryphal.

47. Pope Pius XII defended the bodily assumption with three biblical arguments. First, in 1 Corinthians 15 Paul indicates that the woman's seed crushing Satan (Gen. 3:15) was fulfilled at Jesus's ascension. Since woman shares in the serpent's enmity, she must also share in that victory by bodily ascension, too. Second, Psalm 132, commemorating the ark of the covenant's return to Jerusalem, prays for the elevation of the ark to a heavenly resting place under the new covenant (Ps. 132:8). Since the fathers equated Mary with the ark of the covenant, this would be fulfilled by Mary's bodily assumption. Third, Mary is identified as the woman in heaven clothed with the sun (Rev. 12:1–2).

48. Other terms include *mediatrix, auxiliatrix, adjutrix,* but often nuanced toward an emphasis of one aspect of her role in human redemption. See Macquarrie, *Mary for All Christians*, 98–100.

means to give life to Jesus Christ, shared all facets of his earthly life, and even suffered when he suffered according to the prophecy "A sword will pierce even your own soul" (Luke 2:35). But these titles are not intended to encroach upon, add, or diminish the unique dignity and efficacy of Jesus Christ's work as Redeemer and Mediator in any way. Mary herself was always understood to need the redemption offered by her son, Jesus Christ, and was never allowed to share an equal role in his redemptive work. Unfortunately, given the popular excesses of devotion to Mary, the meaning of these titles has often been misconstrued.

The concept appeared in the works of Irenaeus (third century AD), continued into the scholastic discussion of the Middle Ages, and peaked in the fifteenth century. In the first half of the twentieth century, interest in Mary increased along with attempts to have her role enshrined as dogma. Since Vatican II failed to offer a formal definition for the concept, or to elevate it as formal dogma, interest has generally receded. The term remains in use today as an elevation of Mary (and women in general) and a source of misunderstanding.

Because these traditions are most apparent in Western Christianity among Roman Catholics, evangelical Protestants struggle to study Mary without at the same time feeling they are supporting Roman Catholic theology and tradition. Cut off from history, they also cut themselves off from Mary.

CONCLUSION

Mary is the fourth-most described person in the New Testament. Her portrait has the advantage of corroboration and development across six New Testament books written by five separate authors, and, as her portrait is revealed, we see growing depth of field and color without contradiction or conflict in the testimony. Mary serves as God's unique instrument for the incarnation of the second person of the eternal Trinity. Listed among some of the great women of faith in the Old Testament, she validates her position as an exemplary servant of Yahweh. She possesses impeccable virtue in the most difficult of circumstances. She consistently offers us an image of deep spiritual commitment, remarkable discipline, biblical awareness, and practical competence. She even surprises us with her curiosity, intelligence, and skillful artistry.

Mary challenges us with her radical attitude toward discipleship, giving up everything for the sake of making her son preeminent. Although she may not have always understood the nuances of Jesus's mission, she courageously took every opportunity before her to advance his cause. She stands apart as perhaps the greatest example of discipleship in the New Testament.

It's time for Christians who espouse the priority of the Scriptures to reclaim the Bible's testimony concerning one of its most prominent figures.

QUESTIONS FOR DISCUSSION

1. What limits do you think we place on Mary's role as an example of following Jesus?

2. Why do you think we place these limits on Mary's example?

3. Which of Mary's characteristics most challenges you to be a better disciple?

A SURVEY OF SEXUALIZED, VILIFIED, AND MARGINALIZED WOMEN OF THE BIBLE

BEGINNINGS

EVE:
THE MOTHER OF ALL SEDUCERS?

GLENN KREIDER, PHD

In John Milton's classic 1667 poem *Paradise Lost*, book 9 tells of the appearance of the serpent in the garden of Eden, the temptation of the man and woman to eat the forbidden fruit, and the horrifying consequences of the fall. According to Milton, the serpent comes to the woman when she is alone:

> Beyond his hope, Eve separate he spies,
> Veiled in a cloud of fragrance, where she stood.[1]

She succumbs to the temptation of the serpent and eats from the tree. When she does, she immediately experiences the effects of sin and ponders how she can entice Adam to join her in eating. Her words drip with deception, dishonesty, and duplicity as she seduces her husband:

> Hast thou not wondered, Adam, at my stay?
> Thee I have missed, and thought it long, deprived
> Thy presence; agony of love till now
> Not felt, nor shall be twice; for never more
> Mean I to try, what rash untried I sought,
> The pain of absence from thy sight. But strange
> Hath been the cause, and wonderful to hear:
> This tree is not, as we are told, a tree

1. Milton, *Paradise Lost,* 9.424–25.

> Of danger tasted, nor to evil unknown
> Opening the way, but of divine effect
> To open eyes, and make them Gods who taste;
> And hath been tasted such: The serpent wise,
> Or not restrained as we, or not obeying,
> Hath eaten of the fruit; and is become,
> Not dead, as we are threatened, but thenceforth
> Endued with human voice and human sense,
> Reasoning to admiration; and with me
> Persuasively hath so prevailed, that I
> Have also tasted, and have also found
> The effects to correspond; opener mine eyes,
> Dim erst, dilated spirits, ampler heart,
> And growing up to Godhead; which for thee
> Chiefly I sought, without thee can despise.
> For bliss, as thou hast part, to me is bliss;
> Tedious, unshared with thee, and odious soon.
> Thou therefore also taste, that equal lot
> May join us, equal joy, as equal love;
> Lest, thou not tasting, different degree
> Disjoin us, and I then too late renounce
> Deity for thee, when Fate will not permit.[2]

Adam's response to Eve's seduction is to reflect on what God has said, on his love for his wife and the tragedy of losing her, on the beauty of the fruit, and on her seductive words; he chooses to eat. Milton concludes,

> She gave him of that fair enticing fruit
> With liberal hand: he scrupled not to eat,
> Against his better knowledge; not deceived,
> But fondly overcome with female charm.[3]

Milton speculates beyond the limited details of the canonical account in Genesis 3, yet his description of the event reflects a long history of interpretation and adds an authoritative voice to that interpretation that extends into our day.[4] In

2. Ibid., 9.856–85.
3. Ibid., 9.996–99.
4. Morris ("John Milton and the Reception of Eve") writes, "At the climax of Milton's story Eve considers concealing the fruit she has taken from the forbidden tree so that she can be superior to Adam, but she changes her mind because she might actually die, leaving Adam free to marry another (9.816–832). Adam, however, chooses to eat the fruit because he cannot imagine life without Eve (9.908–926). . . . Milton's portrayal of Eve is pervasive in Western culture."

Milton's tale, Eve is deceived and then becomes the willing instrument of the serpent to deceive her husband. The seduced becomes the seducer.

EVE: SEDUCED OR SEDUCER?

In the third chapter of the book of Genesis, briefly and without much detail, Moses portrays a tragic tale of temptation, deception, and rebellion—tragedy in Eden.[5] Milton's account, on the other hand, adds details not found in the canonical version of the story, which results in the woman being seen as a seductress and temptress of her husband. The origin of Milton's version appears to be an early Jewish pseudepigraphic work, *The Apocalypse of Moses*.[6]

In "Eve's Account of Her Fall" found in this work, Eve tells her "children and children's children . . . how the enemy deceived us" (15:1).[7] She explains that she and Adam were guarding paradise; as divided by God between them, Adam had the east and the north and all the male creatures, while she was given the female creatures and the territory to the west and south (15:2). The devil spoke to the serpent and sent him to talk to her. When the serpent asked about her tasks, she explained that God had instructed her and Adam to guard paradise and to eat of all the plants except one (17:1–5). The serpent encouraged her to eat of the tree in the middle of the garden; she refused out of fear (18:1–6). The serpent tried again, saying, "I have changed my mind, and I will not give thee to eat until thou swear to me to give also to your husband" (19:1). This time Eve agreed, swearing "by the throne of the Master, and by the Cherubim and the Tree of Life, I will give also to my husband to eat" (19:2). After she ate and her eyes were opened, she knew she was naked and wept in sorrow. The serpent left her without a word, and she made herself a "girdle and it was from the very same plant of which I had eaten" (20:5). Eve then called out to her husband, "Adam, Adam, where art thou? Rise up, come to me and I will show thee a great secret" (21:1–2). She continues the explanation to her children:

> When your father came, I spake to him words of transgression [which have brought us down from our great glory]. For, when he came, I opened my mouth and the devil was speaking, and I began to exhort him and said, "Come hither, my lord Adam, hearken to me and eat of the fruit of the tree of which God told us not to eat of it, and thou shalt be as a God." And your father answered and said, "I fear lest

5. See Storms, *Tragedy in Eden*. After Genesis 3:20 and 4:1, Eve does not appear in the biblical text except in 2 Corinthians 11:3 and 1 Timothy 2:14. In the two Pauline texts, she is used as an example of one who was deceived. Paul's warnings seem to treat her as a victim of deception.
6. Wells, "Introduction," 2:127, dates this Jewish work "not earlier than the first century A.D. or later than the fourth century" and probably earlier rather than later. It is also known as *The Life of Adam and Eve.*
7. *Apocalypse of Moses*, 2:145–49.

God be wroth with me." And I said to him, "Fear not, for as soon as thou hast eaten thou shalt know good and evil." And speedily I persuaded him, and he ate and straightway his eyes were opened and he too knew his nakedness. And to me he saith, "O wicked woman! What have I done to thee that thou has deprived me of the glory of God?" (21:2–6).[8]

In this version, Eve is seduced by the devil speaking through the serpent that comes to her when she is alone. Having succumbed to the temptation, she plots to seduce her husband, to entice him to join her in her rebellion against the Creator.

Although this is not the story Moses tells, many people have read the Genesis fall narrative in a similar way.[9] In this story of the fall, the serpent attacks the weaker human while the male, the head and leader of humanity, is absent. The devil, thus, perverts and corrupts God's order for creation. She is deceived by his wiles, eats of the tree of the knowledge of good and evil, experiences the effects of the sin, and then devises a scheme by which she can seduce her husband. He falls for her evil plot, is judged by God for listening to his wife, and is warned not to be so easily deceived again. This version of the story usually includes, at least implicitly, a warning to women not to be like Eve and to men not to fall for women's seductive scheming. The result is to pit men against women, to train both to see each other as adversaries, and to warn both that the other is untrustworthy, unreliable, duplicitous, and dangerous. Is it any wonder that throughout human history, and maybe particularly Christian history, the relationship between men and women is characterized by distrust, disunity, disloyalty, discord, and dissension?

8. For a survey of first-century Jewish writings on Eve as seductress see Hanson, *Studies in the Pastoral Epistles*, 65–77. For a survey of patristic voices which blame Eve for seducing Adam (including Irenaeus, Tertullian, John Chrysostom, Gregory Nazianzen, and Augustine), as well as medieval voices, see Phipps, "Eve and Pandora Contrasted," 42–47.

9. I have vivid childhood memories of sermons that warned men of the seductiveness of women and warned women not to be like Eve. Undergirding this teaching was the story of Eve's having seduced Adam in the garden, of the temptation narrative as typical of how women continue to destroy men. See Witcombe, "Eve and the Identity of Women": "Throughout the Christian period, the story of Eve has provided men with the reason why they should restrain and restrict the social, sexual, religious, political, and economic freedom of women. It has also given men the justification to hold women responsible for all the misfortunes suffered by mankind. All women are like Eve, and their only chance of redemption is to become like the Virgin Mary, another patriarchal fantasy, who represents absolute obedience and purity. The story of Eve and its many misogynistic interpretations have over the centuries defined the image of woman in Western civilization." McColley, in "Shapes of Things Divine: Eve and Myth in *Paradise Lost*," 47–48, observes that in literature and visual arts, "Eve is typically portrayed as either vacuously innocent or attractively wicked; in either case, her primary function is to tempt Adam."

Here is an example of a sermon that tells this narrative:

> As a rule men have more brute strength than women and so they can rape and abuse and threaten and sit around and snap their finger. It's fashionable to say those sorts of things today. But it's just as true that women are sinners. We are in God's image, male and female; and we are depraved, male and female. Women may not have as much brute strength as men, but she knows ways to subdue him. She can very often run circles around him with her words and where her words fail, she knows the weakness of his lust.[10]

The preacher continues,

> If you have any doubts about the power of sinful woman to control sinful man, just reflect for a moment on the number one marketing force in the world—the female body. She can sell anything because she knows the universal weakness of man and how to control him with it. The exploitation of women by sinful men is conspicuous because it is often harsh and violent. But a moment's reflection will show you that the exploitation of men by sinful women is just as pervasive in our society. The difference is that our sinful society sanctions the one perversity and not the other.[11]

That women's bodies have been used in advertising is true, but the way such marketing functions is more complex than this preacher implies. In an article that examines the images of Eve in fashion magazines, Shelly Colette observes,

> By and large, advertising does not actively create need and desire; rather, it redirects preexisting needs and desires. It is not so much a snake in the garden as it is a mirror of our own cultural values. Advertisements are understandable to us because they exist within a symbolic structure that already has cultural meaning and value. Not only do existing symbolic structures inform the content of any advertising text, but the text itself in turn influences the meanings attending the larger symbolic structure.[12]

She concludes, "These advertising images do not tell the full story of Adam and Eve's transgression. Rather, the snapshots highlight one particular event within a complex mythological narrative, and the reader is left to reconstruct the full

10. John Piper, "Manhood and Womanhood: Conflict after the Fall." It is chilling how cavalier the reference to rape and abuse is in this sermon.
11. Ibid.
12. Colette, "Eroticizing Eve," 10.

story from a single depiction of a solitary event. This event is most often a scene of seduction, either the moment of Eve's seduction by the Serpent or Eve in the act of seducing Adam."[13]

The canonical story should be the basis by which the other stories are interpreted and any speculation should be evaluated by the authority of God's inspired Word. Further, whatever one might conjecture about the conversation between the serpent and the woman, the aftermath of eating of the fruit has an impact on the male and female together. Phyllis Trible explains, "The contrast between woman and man fades after their acts of disobedience. They are one in the new knowledge of their nakedness (Gen. 3:7). They are one in hearing and in hiding. They flee from the sound of the Lord God in the Garden (v. 8)."[14]

THE BIBLICAL STORY OF EVE

The biblical story of creation
The biblical story of creation is told twice, in the first two chapters of the book of Genesis.[15] Of particular interest for our purposes is the account of the creation of humanity. Both narratives emphasize that God is the Creator of the first humans, the ancestors of all other human beings, but their descriptions of creation are not the same.

The first account of creation
In the first creation account (Gen. 1:26–30), the man and the woman are created, presumably, at the same time and by the same means by which God created the heavens and the earth, the land and the seas, the plants and the animals, through his word. Yet the language God uses of this act of creation is different from that used of the rest of creation. According to the narrator, "Then God said, 'Let us make man in our image, after our likeness. And let them have dominion over the fish of the sea and over the birds of the heavens and over the livestock and over all the earth and over every creeping thing that creeps on the earth.' So God created man in his own image, in the image of God he created him; male and female he created them" (1:26–27).[16] The other days of creation are introduced

13. Ibid., 10–11. Mary Hunt, in "Eve's Legacy," observes, "The image of Eve is still a powerful reminder of innocent times when women and men roamed a mythic garden in search of knowledge. But society's all-time scapegoat has become the model, and excuse, for woman-as-temptress, seductress or marriage-breaker. In Western Christian thought, Eve was summarily replaced by Mary, the virgin most pure, who would not have eaten the apple if she had been starving to death. Over the centuries, she came to stand for willful Eve's 'other' side: woman as obedient, docile, submissive, modest, quiet."

14. Trible, "Eve and Adam," 79.

15. It is beyond the scope of this issue to deal with how biblical scholars have interpreted these two stories. For an introduction to some of the issues involved, see Reynolds, ed., *Three Views on Creation and Evolution*.

16. Unless otherwise noted, biblical citations are from the English Standard Version. Some

by the phrase, "God said, 'Let there be'" or something similar (1:3, 6, 9, 11, 14, 20, 24) but the creation of the humans is introduced by "Let us make" (1:26). This self-deliberation indicates a greater degree of personal and intimate creation than the rest of God's work.[17]

Both the male and the female are created together and, more significantly, they receive the same name (Adam), the same blessing, and the same function. As divine imagers, humans represent and reveal God to the rest of creation and rule over the world that God made.[18] God also pronounces a blessing upon the two humans, a blessing that is identical to the one pronounced on creatures earlier, with one significant addition. To the living things in the water and the seas created on the fifth day, God had announced a blessing: "Be fruitful and multiply and fill the waters in the seas, and let the birds multiply on the earth" (v. 22). To the divine imagers, God also declares a blessing: "Be fruitful and multiply and fill the earth and subdue it, and have dominion over the fish of the sea and over the birds of the heavens and over every living thing that moves on the earth" (v. 28). To the humans, God grants dominion over the rest of creation, a clear statement of the hierarchy in the creation order, and this dominion surely includes being mediators of blessing to the creatures that God has already blessed. In other words, dominion is not domination and destruction but compassionate care for those creatures and the environments in which they live. God's intention for his imagers is that they be mediators of blessing to blessed creatures. That the dietary provision for all living creatures is "green plants" (v. 30) and not animal flesh is indicative of this as well as providing evidence that sin, which results in death of living things, is not part of this creation.[19]

The second account of creation

In the second account of creation (Gen. 2), the narrator tells the story of the creation of humanity differently. The male and female are created by a different

versions, such as NET and NIV (2011), translate "Adam/man" in these verses as "mankind." Since the historicity of Adam is so important to New Testament theology, especially seen in the Pauline contrast between the first Adam and the second Adam and since all humans are descended from this first Adam, I prefer the ESV translation here. On the diversity of evangelical views on Adam, see Caneday and Barrett, eds., *Four Views on the Historical Adam*. For an excellent defense of the historicity of Adam, see Collins, *Did Adam and Eve Really Exist?*

17. Christians might be tempted to see evidence of the Trinity in this language. Surely it hints at plurality, although it would be too much to argue that the Trinity was revealed in Genesis 1. The Trinity is revealed in the coming of Jesus. Alister E. McGrath in *Christian Theology: An Introduction*, 235, explains, "The distinctively Christian doctrine of God took shape in response to a question about the identity of Jesus Christ. The development of the doctrine of the Trinity is best seen as organically related to the evolution of Christology."

18. For a further explanation of image as representation, revelation, and rule, see my (Kreider) *God with Us*, 54–55.

19. Death is a consequence of sin (Rom. 6:23).

means than in Genesis 1, and the formation of the two is separated in time.[20] The LORD God "formed the man of dust from the ground and breathed into his nostrils the breath [Spirit] of life, and the man became a living creature" (v. 7).[21] The man was placed in the garden and given the task of caring for it. The LORD God also commanded him to eat of the trees of the garden, "but of the tree of the knowledge of good and evil you shall not eat, for in the day that you eat of it you shall surely die" (v. 17). The woman was not yet created; "It is not good that the man should be alone; I will make him a helper fit for him" (v. 18). The man's dominion over the animals is disclosed when he gives them names. Ancient Near East scholar Eugene Merrill asserts that in the ancient Near East naming indicates dominion or authority. He writes, "When Yahweh brought the animals to Adam 'to see what he would name them,' He was in effect transferring from Himself to Adam the dominion for which man was created. This of course is perfectly in line with the objects of human dominion listed in the pivotal text of Genesis 1:26: fish, birds, livestock, and 'all the creatures that move along the ground.'"[22] After the man gave names to all the animals, the LORD God made a woman from "one of his ribs . . . and brought her to the man" (vv. 21–22). Merrill succinctly explains, "No idea of superiority/inferiority with respect to the sexes can be found here. That woman was taken from man no more implies the inferiority of woman to man than the taking of man from the ground ('ādām from 'ădāmāh) implies the inferiority of man to the ground."[23] When the man saw the woman he said, "This at last is bone of my bones and flesh of my flesh; she shall be called Woman, because she was taken out of Man" (v. 23).

It is not uncommon for commentators to interpret this statement as indicating a divine hierarchy of man over woman since he named her, as he had named the animals.[24] This is unlikely for several reasons. First, such an interpretation is

20. Mathews, *Genesis 1:1–11:26*, vol. 1A, 220, summarizes a widely held view that the order of creation in this chapter implies a hierarchy of man over woman: "The participant structure of Genesis 2–3 shows implicitly the hierarchy of creation: God, the man, woman, and animal (serpent). But this was reversed in the fall: the woman listens to the serpent, the man listens to the woman, and no one listens to God."

21. Note that the narrator uses a different name for God in this chapter than in the previous one. This is one of many differences between the two accounts.

22. Merrill, *A Biblical Theology of the Old Testament*, 15. Sometimes cited as a counter-example, Hagar naming God in Genesis 16 is, rather, an example of God's humility; the Almighty God allows an Egyptian slave woman to give him a name. See my (Kreider) discussion in *God with Us*, 47–49.

23. Merrill, "Theology of the Pentateuch," 19. He continues, "Nor does the term 'helper' connote subordination. This is clear from the context in which the need is for man, like the animals, to have a mate, a partner who would complement or correspond to him. . . . It is, moreover, important to note that the Hebrew term for 'helper,' ('ezer), is frequently used of the Lord Himself as man's Helper (Deut. 33:7; Ps. 33:20; 115:9–11; 146:5; Hos. 13:9). A helper, then, is not necessarily dominant or subordinate but one who meets a need in the life and experience of someone else" (19–20). See also James, *Half the Church*.

24. Schreiner, "Women in Ministry," 206–7.

not consistent with the narrative in the first chapter, in which both male and female are named "Adam." Further, in Genesis 5 the narrator reiterates this point: "When God created man, he made him in the likeness of God. Male and female he created them, and he blessed them and named them Man [Adam] when they were created" (Gen. 5:1–2). Second, the man does not name the woman in Genesis 2; he calls her what she is. The passive construction, "she shall be called Woman," does not indicate that he gave her a name.[25] Further, "woman" (*ishah*) is not her name. He is man (*ish*) and she is woman (*ishah*).[26] What they share in common is their "*ish*-ness"—they are both human. But they are not the same; he is male and she is female.[27] And that is the narrator's point, that there is unity and diversity; they are one but different. They are equal, but not the same.

Although there are significant differences, what these two creation accounts have in common is that God is the Creator, he made humans in his image and likeness and gave them dominion over the living creatures that God had made, and that male and female are equal in essence and function.[28] The hierarchy of God over humans, created in his image and likeness, and their dominion over the rest of creation is seen in both accounts. Created as the divine representatives, Adam (male and female) will serve God together as they care for creation. But everything is about to change, and none of those changes is positive.

The fall of humanity and the curse of creation

The serpent, more crafty than the other creatures God had made, approached the man and the woman in Eden.[29] Although the narrator emphasizes the role of the woman and the serpent in the conversation, the man was also present. One indication of this is that the second person pronouns in Genesis 3:1–5 are plural.[30] Perhaps more importantly, when the woman ate of the fruit she gave some to her husband "who was with her, and he ate" (v. 6). The implication seems to be that he was with her the entire time.[31]

25. Trible concludes, "*Woman* itself is not a name. It is a common noun; it is not a proper noun. It designates gender; it does not specify person." "Eve and Adam," 77–78.
26. These terms are gender-specific; *ish* is masculine and *ishah* is feminine.
27. Lois A. Tverberg, in "*Ish* and *Ishah*—Together Fully Human," writes that when the woman is created, "only at that point is Adam called *ish*, a man. The Hebrew word *ishah* hints at her origins from within the *ish*, something that we can mimic in English, with the words 'man' and 'woman.'"
28. Of course, they each have a different function in reproduction (Gen. 1:28).
29. Mathews, *Genesis 1–11:26*, 234, correctly explains, "Many modern interpreters, however, fail to recognize that the serpent's trickery is ultimately the voice of Satan. Although the snake is never identified as Satan in the Old Testament, more than the principle of evil must have been intended by the serpent's presence. . . . In accord with the traditional opinion, the snake is more than a literal snake; rather it is Satan's personal presence in the garden."
30. Mathews, *Genesis 1–11:26*, 238, explains: "'You' at each place in 3:1–5 is plural and thus suggests his [Adam's] presence."
31. Higgins, in "The Myth of Eve," 646, suggests five arguments in support of Adam being

Why does this matter? A great deal of discussion of this text has focused on the conversation between the serpent and the woman and has assumed that the man was absent. One common view is that the serpent attacked God's plan by going after the woman when the man was absent.[32] Closely related is the belief that she was the weaker of the two, the more vulnerable, the more easily deceived, and an easier mark for the adversary.[33] This makes her particularly guilty of the fall and minimizes his responsibility; after all, she deceived him. If, on the other hand, the two of them were willing co-conspirators in the act of rebellion against God, they were then both responsible.

The serpent asks, "Did God actually say, 'You shall not eat of any tree in the garden'?" (Gen. 3:1). The woman explains that God had said, "We may eat of the fruit of the trees in the garden, but God said, 'You shall not eat of the fruit of the tree that is in the midst of the garden, neither shall you touch it, lest you die'" (v. 3). Although it appears from Genesis 2 that she had not heard these words from God himself, this is an accurate paraphrase of the instructions, with one slight omission. The serpent calls attention to that when he contradicts what God said. God had said that if they ate from the fruit of the tree, "you shall surely die" (2:17). The serpent said, "You will not surely die" (3:4).

To this point, there is no deception, little subtlety, and no ambiguity. There is a clear contradiction: Either God is telling the truth, or the serpent is. God said eating of the tree would bring death ("you shall surely die"), and the serpent denies that death will occur ("you will not surely die"). If the conversation ended here, the man and the woman would have a simple choice between God and

present. (1) "From the moment God presents Eve to Adam (Gen 2:22f.), the text never mentions her leaving. The supposition then is that they were together all the time." (2) "The serpent speaks about 'you' in the plural, and Eve answers in terms of 'we.'" (3) "In some ancient versions, Gen 3:6b ends: 'she gave some to her husband and *they* ate,' which could mean that he was waiting there through the temptation to join her in eating at the end." (4) "Gen 3:7 says, 'And the eyes of them both were opened.' Since, strictly speaking, Eve's eyes should have been opened at the moment 'she took and she ate,'" this might indicate they ate together. (5) "The most serious argument for Adam's presence is in the Hebrew 3:6b: literally, 'and-she-gave also-to-her-husband with-her.'"

32. As in Milton and the *Apocalypse of Moses*, as discussed above.

33. Mark Driscoll, in *On Church Leadership*, 48, interprets 1 Timothy 2:12–14 this way: "Without blushing, Paul is simply stating that when it comes to leading in the church, women are unfit because they are more gullible and easier to deceive than men. While many irate women have disagreed with his assessment through the years, it does appear from this that such women who fail to trust his instruction and follow his teaching are much like their mother Eve and are well-intended but ill-informed."

See also Piper and Grudem, *Recovering Biblical Manhood and Womanhood*, 72–73: "First Timothy 2:14 says, 'Adam was not the one deceived; it was the woman who was deceived and became a sinner.' Paul gives this as one of the reasons he does not permit women 'to teach or have authority over a man.' Historically this has usually been taken to mean that women are more gullible or deceivable than men and therefore less fit for the doctrinal oversight of the church. This may be true."

the serpent. But the serpent is not finished. He continues, "For God knows that when you eat of it your eyes will be opened, and you will be like God, knowing good and evil" (v. 5). Herein lies the deception. According to the serpent, eating the fruit of the tree of the knowledge of good and evil will give them knowledge; they will be like God. In their creation they were already "like God"; they had been created in his image (1:26).[34] They do not need to eat the fruit to be like God. Further, the serpent justifies their rebellion against God's command by implying that eating will result in something better than they already have as divine imagers.[35] Ironically, what the serpent promised comes true: The man and the woman do become "like God" when they eat of the fruit. In the words of their Creator, "Behold, the man has become like one of us in knowing good and evil" (3:22). Being "like God" in this way has not been good for us.

The narrator summarizes the thought process Eve went through as she made her decision: "So when the woman saw that the tree was good for food, and that it was a delight to the eyes, and that the tree was to be desired to make one wise, she took some of its fruit and ate" (v. 6a). The narrator tells us nothing of Adam's thought process; he merely says, "She also gave some to her husband who was with her, and he ate" (v. 6b).[36] Commentators differ on the interpretation of the statement that he was "with her." John Calvin, for example, asserts: "From these words, some conjecture that Adam was present when his wife was tempted and persuaded by the serpent. This is not believable. Yet it might be that he soon joined her and that, even before the woman tasted the fruit of the tree, she related the conversation she'd had with the serpent and entangled him with the same fallacies by which she herself had been deceived."[37] The Calvinist pastor-theologian John Piper is similarly confident of the other view:

34. Sailhamer, "Genesis," 86.
35. According to John Piper in "Affirming the Goodness of Manhood and Womanhood in All of Life," the temptation was to rebel against the divine order of man over woman: "Satan's subtlety is that he knew the created order God had ordained for the good of the family, and he deliberately defied it by ignoring the man and taking up his dealings with the woman. Satan put her in the position of spokesman and leader and defender. And at that moment both the man and the woman slipped from their innocence and let themselves be drawn into a pattern of relating that to this day is destructive." There is nothing in the text that implies this.
36. "Although 'with her' does not in itself demand that he is present since the serpent speaks 'to the woman,' nevertheless, the action of the verse implies that Adam is a witness to the dialogue." Mathews, *Genesis 1–11:26*, 238.
37. Calvin, *Genesis*, 43. John MacArthur takes a similar position: "Now all of a sudden Adam's here. Where has he been when we needed him? Well, I'll tell you one thing, he wasn't there during the temptation. How do I know that? Because it says in 1 Timothy 2:14 that Adam was not deceived. He wasn't there during the deception. Satan pulled her out from under her protector. But Adam appears from where, we don't know. But again 1 Timothy 2:14 says he wasn't deceived, so he wasn't there through this whole process of deception. Or else if he had been there he would have been in the conversation, believe me. But it just says she gave to her husband with her and he ate." MacArthur, "The Fall of Man."

> The second thing to notice is that Adam is evidently with Eve while
> Satan is talking to her. When we come to verse 6 and the woman is
> about to eat of the forbidden fruit, the verse says (most literally from
> the NASB), "When the woman saw that the tree was good for food,
> and that it was a delight to the eyes, and that the tree was desirable to
> make one wise, she took from its fruit and ate; and she gave also to
> her husband with her [NIV: who was with her] and he ate." It does
> not say that she went to get him. It does not say that he arrived on the
> scene after the serpent was gone. It moves directly from the words of
> temptation to the act of eating and says that the man was with her.[38]

Another Calvinist pastor, Matt Chandler, uses Adam's presence to criticize men
in his congregation for their passivity:

> In Genesis 1 and 2, you have Eve walking in the garden. Her dumb,
> passive husband is with her. He is an idiot. I am not saying all men are
> idiots. I'm saying passive men are idiots. Ultimately, they walk into the
> garden. The serpent starts lying to Eve and presents the lie that to this day
> we all buy into. "Did God say you could have the fruit on that tree?" . . .
> By the way, Adam is right there. . . . His wife is being lied to. Everything
> is at stake, and that moron is staring into the clouds. So Eve sees it's
> pleasing to the eye and good for food, she takes it, and she eats it. She
> hands it to her husband. There are no questions out of this moron.[39]

Adam was with her when she spoke to the serpent. Adam was with her when she
ate. Adam was with her when he ate. But there is nothing in this text that implies
that she deceived or seduced him to eat.[40] Religion scholar Jean Higgins draws
this helpful conclusion: "But in simple interpretation, there is a logical risk in
reading 'she gave some to her husband' as the equivalent of tempting and leading
into sin. According to such logic, God too would be tempter and cause for sin,
for God 'gave' Adam his wife; and God 'gave' Adam the garden to keep with the
forbidden tree in the middle of it."[41]

Immediately upon eating the fruit, their eyes were opened and they were
exposed in their nakedness so they covered themselves with fig leaves (3:7). God
appeared in the garden and, when they heard him, they hid (v. 8). Kenneth

38. Piper, "Affirming the Goodness of Manhood and Womanhood in All of Life."
39. Chandler, "Recovering Redemption: The Genesis: Creation and Fall."
40. Higgins, "The Myth of Eve," 639–47, provides a helpful survey of the literature on
 Genesis 3:6, from Tertullian through Gerhard von Rad, demonstrating the widespread
 nature of the claim that Eve functioned as a temptress or seductress.
41. Higgins, "The Myth of Eve," 642. She later comments, "Now one may grant poets and novel-
 ists the freedom to fill in the gaps from their own imaginations, but most of the authors we
 have been quoting thought of themselves as seriously explaining the word of God" (644).

Mathews writes, "It was part of the sad deception that the man and woman who wanted so much to be 'like God,' rather than obtaining the stature of deity, are afraid even to commune with him."[42]

When God called out to "Adam" (v. 9), the man answered.[43] He blamed the woman. The woman blamed the serpent. God judges all three of them. The serpent is cursed (vv. 14–15). The woman receives multiplied pain in child-bearing and conflict with her husband (v. 16).[44] God rebukes the man "because you have listened to the voice of your wife and have eaten of the tree of which I commanded you, 'You shall not eat of it'" (v. 17).[45] Surely, the problem could not be that Adam had listened to his wife.[46] The problem is that he listened to the serpent.[47] Since he was present during the conversation and since he listened

42. Mathews, *Genesis 1–11:26*, 239.

43. That the male answered does not indicate that God was speaking to him. Perhaps the call was to "Adam," male and female (cf. Gen. 1:26–28, 5:1–2).

44. The similar language in the conversation between God and Cain in the next chapter probably indicates that, because of the fall, the conflict between the wife and husband will be like that between Cain and sin: "Sin is crouching at the door. Its desire is for you, but you must rule over it" (Gen. 4:7, HCSB). Merrill explains, "The Hebrew construction of the verse reflects poetic parallelism in which the first line of the couplet carries the same meaning as the second. The second ('and he will rule over you') requires that the 'desire' of the woman for her husband also convey the idea of domination. The word translated 'desire' (*teĕšugāh*) occurs also in Genesis 4:7, which says that sin 'desired to have you [Cain], but you must master it.' Interestingly the same Hebrew verb translated 'master' (*māšal*) here was translated 'rule' in Genesis 3:16. This suggests that the woman will turn to the man for her dominion and that his rule over her will come to pass. As a rule, then, the headship of the man will be the pattern as long as the fallen world of history remains." Merrill, "Theology of the Pentateuch," 21.

45. Higgins argues that the language God uses is grounded in the excuse Adam had given: "Why is the woman mentioned in this verse? Because of the self-defense Adam has just offered. When God asked him, 'Have you eaten of the tree which I commanded you not to eat?', Adam excused himself by blaming the woman: 'The woman, whom thou gavest me to be with me, gave me and I ate' (3:12). God's reply picks up this defense: 'Well, then, since [you say your excuse is your wife gave it to you, implying that] you listened to the voice of your wife [as if that, or anything else, could be more important than listening to the voice of your God] and ate of the tree which I commanded you not to eat Here is your punishment.'" Higgins, "The Myth of Eve," 645.

46. For a contrary view, see Ortlund, Jr., "Male-Female Equality and Male Headship," 110: "'Because you listened to your wife and ate from the tree. . . . Adam sinned at two levels. At one level, he defied the plain and simple command of 2:17. That is obvious. But God goes deeper. At another level, Adam sinned by 'listening to his wife.' He abandoned his headship. According to God's assessment, this moral failure in Adam led to his ruination."

47. According to John Piper, "God's reprimand is not merely a reprimand that Adam ate the forbidden fruit but also that he forsook his responsibility to be the leader and the moral guardian of the home. Satan's subtlety is that he knew the created order God had ordained for the good of the family, and he deliberately defied it by ignoring the man and taking up his dealings with the woman. Satan put her in the position of spokesman and leader and defender. And at that moment both the man and the woman slipped from their innocence and let themselves be drawn into a pattern of relating that to this day is destructive." Piper, "Affirming the Goodness of Manhood and Womanhood in All of Life."

to the serpent and since he ate of the tree, and since he rebelled against God in doing so, he is culpable for his own sin.

A common view of the divine response to the humans here, especially among evangelical interpreters, is found in Mathews: "God first addresses the man, who evidently bears the greater responsibility, then the woman and the serpent. This inverts the order of the participants in the act (serpent, woman, and man) and indicates God's chief interest in the state of the human couple. It is not until the man points to Eve that God addresses her; it is the first time in the Edenic narrative that Eve and God converse."[48] On the other hand, it is possible that the order is literary, not hierarchical. In the narrative, there is a clear chiastic structure; what is not clear is that the chiasm is evidence of a hierarchical authoritative structure.

After the rebuke and the reminder of Adam's culpability, God then pronounces judgment on him. The rebuke is primarily directed to the male, but the judgment applies to male and female: "Cursed is the ground because of you; in pain you shall eat of it all the days of your life; thorns and thistles it shall bring forth for you; and you shall eat the plants of the field. By the sweat of your face you shall eat bread, till you return to the ground, for out of it you were taken; for you are dust, and to dust you shall return" (vv. 17–19). Several observations appear obvious.[49] The curse on the ground affects men and woman equally. Female farmers face the same struggle as male farmers; thorns and thistles proliferate, while edible crops require extensive agricultural skill and care. Also, both men and women die and return to the dust. Both are from the dust, and to dust both return.[50] One final hint that men and women together are in view here is that God repeats a dietary restriction. Rather than eating from the trees of the garden (cf. Gen. 2:16), the man and woman will eat "the plants of the field" (3:18; cf. 1:29–30). Of course, their expulsion from the garden makes eating from the garden trees impossible, but the narrator's use of language from Genesis 1 where "Adam" explicitly refers to male and female might be significant.

When God finishes his judgment oracle, the narrator tells us, "The man called his wife's name Eve, because she was the mother of all living" (v. 3:20). At first glance, and many Bible scholars take it thusly, this statement might indicate

48. Mathews, *Genesis 1–11:26*, 240.
49. But see Mathews, *Genesis 1–11:26*, 252: "The final word is directed against the man (vv. 17–19). Adam's penalty also fit his crime since his appointed role was intimately related to the ground from which he was made and which he was charged to cultivate (2:7, 15). Now the 'ground' is decreed under divine 'curse' on his account (see 3:14 discussion). The man will suffer (1) lifelong, toilsome labor (vv. 17–18) and finally (2) death, which is described as the reversal of the creation process (v. 19 with 2:7). Although the woman will die too (2:17), the death oracle is not pronounced against her since she is the source of life and therefore living hope for the human couple. It is the man who bears the greater blame for his conduct and is the direct recipient of God's death sentence."
50. With the exception of Enoch (Gen. 5:24) and Elijah (2 Kings 2:11), and the generation that is glorified without death (1 Cor. 15:50–55), every human being faces the same end, the grave.

the man's faith that God will provide for them, that death will not have the last word, and that the adversary will not defeat God's plan. This is the view Mathews defends: "She is the 'mother of all living,' for all human life will have its source in her body. This assumes a prodigious posterity, and it is a tribute to Adam's faith in the prospect that God had revealed (vv. 15–16). Adam had learned, albeit through the most calamitous lesson, to accept God's word in faithful obedience. Another implication of Adam's naming the woman is his exercise of responsible headship (cf. 2:23)."[51] In that interpretation, the name "Eve" is the key. Another view, and I think it more likely, recognizes the role of naming in the context. In Genesis 1, God names the elements of his creation, except he does not name the plants and animals on the earth. He names the imagers "Adam"; male and female receive the same name (Gen. 1:26-28; cf. 5:1–2). In chapter 2, God names the rivers (2:10–14) and the tree of life and the tree of the knowledge of good and evil (v. 9) and the man names the animals (vv. 19–20). The man does not name his wife.[52] But now, after the fall and the pronouncement of judgment, the man names his wife. He, in effect, changes her name from Adam, given to her by her Creator, to the name Eve, as if he has authority or dominion over her.[53]

The naming of Eve seems to be the man's way of taking authority over her, of placing her under him, of demonstrating the reality of enmity between men and women. As Mathews notes, Johannes Oecolampadius (1482–1531), the reformer in Basel,

> "read Adam's naming of the woman as an expression of his postlapsarian dominion over her. . . . [He] argued that Adam's naming of the woman was an expression not of his faith but of his recognition that in a fallen world he would rule over her. As he had earlier imposed names upon the animals, so after sin he also named the woman: 'You may be sure that Adam gave the name to the woman after sin and in this way showed himself to be lord and head of the woman, she who before sin was a partner of equal worth. To impose a name on someone is a sign of dominion. Above, he imposed names on the animals but not on his wife.'"[54] This first act of a human after the fall, the man naming his wife, is indicative of, and perhaps the source of, the pattern of male dominance over woman.[55]

51. Mathews, *Genesis 1–11:26*, 254.
52. She already has a name. Like him, her name is Adam.
53. In naming her, he treats her like he has treated the animals. That God is silent in the midst of this act in no way implies his endorsement of it.
54. Mattox, "Eve in Early Reformation Exegesis," 203–4. The quotation is from Mattox, *An Exposition of Genesis [1–3]*, 194-95.
55. Ironically, Mathews, *Genesis 1–11:26*, 221, correctly observes the significance of the naming and appears to try to soften the significance: "Although naming indicates authority in the Old Testament, the narrative of Eve's creation as a whole takes steps to

This new relationship of the man and woman was not God's design. This is not God's plan. God's will is expressed in Genesis 1 and Genesis 2. Adam, male and female, were created to fill the earth with other divine imagers, care for God's creation, bless the creatures that God had already blessed, help one another, and thus make the presence of God visible on the earth. After the fall, rather than helping one another, they instead blame one another, fight one another, and struggle to survive in a fallen world until they return to the ground in death. What was intended to be a blessing to all creation of their cooperation and partnership has become a curse marked by conflict, suffering, pain, and ultimately, death.

But, thanks be to God, this is not the end of the story. They did not die in the day they ate of the tree (cf. Gen. 2:17). They lived for hundreds of years: Adam lived 930 years, and then he died (5:5).[56] The first death in the fallen world was not the death of the guilty. Instead, an animal died so that God could make garments of skin to cover their nakedness (3:21).[57] The innocent died instead of the guilty; substitutionary atonement through the shedding of blood is the only way that an unrighteous person can be made righteous (Heb. 9:22). The divine imagers, blessed by God and designed to be mediators of blessing to the creatures God had blessed, are now mediators of curse. Animals died, and continue to die, because of human sin. All creation shares the hope of humans. Creation's redemption is tied to human redemption. Creation waits for the completion of the work of redemption, the resurrection of the dead. Paul expresses this clearly in his letter to the Romans: "Creation was subjected to futility, not willingly, but because of him who subjected it, in hope that the creation itself will be set free from its bondage to corruption and obtain the freedom of the glory of the children of God. For we know that the whole creation has been groaning together in the pains of childbirth until now. And not only the creation, but we ourselves, who have the firstfruits of the Spirit, groan inwardly as we wait eagerly for adoption as sons, the redemption of our bodies" (Rom. 8:20–23).

Eve in the New Testament

In the New Testament, Eve appears two times, both in the writings of the apostle Paul. In 2 Corinthians 11, the apostle Paul expresses his love and "jealousy" for the Corinthian believers, that they would remain faithful to Christ. He expresses his fear: "But I am afraid that as the serpent deceived Eve by his

show that the woman is not subject to the man in the same sense that the animals are subject to him. Rather, the text presents them as partners who together exercise rule, fulfilling the mandate of 1:28 by exercising their appropriate sexual functions and respective intrahuman roles."

56. The narrator does not tell us when the woman died. Possibly they died together.

57. Perhaps two animals died, one for each of them, since "the Lord God made for Adam and his wife garments of skins and clothed them" (Gen 3:21). It seems significant that the narrator does not use the name Eve but rather refers to her as the man's wife.

cunning, your thoughts will be led astray from a sincere and pure devotion to Christ" (v. 3). Similarly, in 1 Timothy 2:12–14, he expresses his conviction: "I do not permit a woman to teach or to exercise authority over a man; rather, she is to remain quiet. For Adam was formed first, then Eve; and Adam was not deceived, but the woman was deceived and became a transgressor." In neither of these texts is there any hint that the woman, Eve, having been deceived, is the deceiver of her husband. In short, any argument that Eve, and her daughters, are seducers of men lacks biblical support. There is no intimation in the fall narrative in Genesis or Paul's language in the New Testament that Eve is somehow responsible for deceiving or seducing Adam.

THE DIFFERENCE IT MAKES

It is dangerous to speculate where Scripture is silent, especially when the speculation results in a demeaning attitude toward, and perhaps even mistreatment of, human beings. The Scriptures are clear that both man and woman were created in the image of God, and that the fall did not change that. The Scriptures are clear that both man and woman received the same name "Adam," and the change in the woman's name from "Adam" to "Eve" occurred after the fall. Distinguishing male and female is necessary in some circumstances, but a hierarchy of worth or value based on that distinction cannot be defended from the Scriptures. The Scriptures are clear that man and woman received the same responsibility from God, to care for creation. And the fall did not change that. The task of imagers remains; we are to care for creation, to be mediators of blessing to creatures that God has blessed.[58] And there is nothing in the account of the fall in Genesis 3 that implies Eve is the seducer of her husband.

No one wins in the blame game. To blame Eve, and by implication, all women, for the fall results in a suspicious or skeptical attitude toward women and a wariness, or perhaps even rejection, of their contributions to the church and society. It also results in the perpetuation of pride and arrogance of men. Surely there are men who are easily deceived, and by other men. What is gained by advocating and institutionalizing gender bias? What is to be gained by viewing one another as adversaries or enemies?

Recognizing the shared responsibility of the first man and woman for the fall unites men and women in culpability, and it also unites us in the work of redemption. What we share in common is much more significant than what divides us. We need one another to reproduce, but we also need one another to serve God effectively, to worship him holistically, to grow in godliness efficiently, to care for creation proficiently, and to fulfill the Great Commission completely.

In the garden, the serpent attacked the plan of God for men and women; the serpent's goal was to destroy God's plan for his creation. The adversary continues

58. See Kreider, "The Flood Is as Bad as It Gets," 162–77, for a discussion of our responsibility to care for creation.

to try to destroy what God has created good. Our adversary is not other humans, but the forces of evil. Paul states this clearly: "For we do not wrestle against flesh and blood, but against the rulers, against the authorities, against the cosmic powers over this present darkness, against the spiritual forces of evil in the heavenly places" (Eph. 6:12). Our goal as Christians should be to view other humans, especially the opposite sex, as fellow members of the family of God rather than objects to be conquered or feared. Blaming Eve for the fall, and all her daughters by extension, makes healthy family relationships difficult to achieve.

We serve a God of justice; to blame one sex for seduction when both the man and the woman were culpable is unjust. It is ironic that the woman is blamed for being easily deceived by the serpent and then also blamed for being as seductive as the serpent in a fallen world. So which is it? Is she gullible and thus not trustworthy to stand against the adversary or is she the seducing one, responsible for destroying men? It would seem that it would be hard to be both at the same time.

Finally, as long as there is conflict between men and women and that conflict is rooted in gender differences, it will be hard for us to live out the command of our Lord Jesus Christ: "A new commandment I give to you, that you love one another: just as I have loved you, you also are to love one another. By this all people will know that you are my disciples, if you have love for one another" (John 13:34–35). It is hard to love one that is feared. It is hard to love one who is seen as duplicitous and deceitful. It is hard to love one who is perceived to be the seductress. And it is hard for her to love those who see her that way.

QUESTIONS FOR DISCUSSION

1. Why do you think the "Eve as seductress" narrative is so widely believed?

2. In what specific ways does the seductress perspective manifest itself?

3. In what specific ways could you be an instrument of change, to redeem Eve's reputation?

ERA OF PATRIARCHS

SARAH: TAKING THINGS INTO HER OWN HANDS OR SEEKING TO LOVE?

EUGENE MERRILL, PHD

SARAH: HER NAME AND ITS MEANING

The name "Sarah" occurs first in Genesis 17:15, where Abraham renames his wife from an original "Sarai."[1] The latter form first appears in Genesis 11:29, where Sarai is identified as the wife of Abraham, and subsequently in Genesis 11:31; 12:5, 11, 17; and 16:1, 8. The original name most likely bears the meaning "princess" (though this is not universally accepted), but the Hebrew form שַׂר (sar) clearly has this meaning.[2] When Abraham changed the spelling in accordance with divine directive (17:15), he did not change the meaning, but simply rendered it in Northwest Semitic (Canaanite), as opposed to the Akkadian dialect of Upper Mesopotamia, from whence he and Sarah had come (see discussion below).

Abraham's doing so was in line with the changes under which Abraham himself was undergoing in his move—at God's command—after Ur, from Haran to Canaan (12:1–5). In fact, his own name had been changed from Abram to Abraham, that is, from "exalted [or noble] father" to "father of a multitude" (17:5).[3] He was to generate a vast people that would be the means of blessing

1. The -ay ending is typical of names attested to in Mari, an important city in NW Mesopotamia. See Huffman, *Amorite Personal Names in the Mari Texts,* 135. GKC describes it as "an old feminine termination," citing Sarai as an example. See 80l, 224.
2. HALOT, 1354.
3. This name in a few variations is also known from contemporary sources. See Cassuto, *A Commentary on the Book of Genesis,* 267; de Vaux, *The Early History of Israel,* 196–98. He states: "This name is . . . really Akkadian" (197).

the whole earth with the message of salvation (12:1–3). How fitting that Sarah should now be *Princess*, for she would be the mother of kings who would rule the nations (17:16).

SARAH'S ANCESTRY AND FAMILY

As noted above, Sarah was from Ur and with Abraham settled in the region of Haran, an important crossroads city on the Upper Habur River, a major tributary of the mighty Euphrates.[4] She, with her husband, would have become known to the people of Lower Mesopotamia as a "westerner," that is, identified with the Amorites of the Bible. Abraham and Sarah must have learned Amorite, a subdialect of the language family known as Akkadian, in the many years they lived in the region.[5]

The trek of Abraham that continued on from Haran was in response to his call by God to "go to the land that I will show you" (12:1). Abraham's father, Terah, went also, perhaps persuaded by the obedience of his son to Yahweh, although the stop in Haran suggests perhaps that Terah was not far from the idolatry from which Abraham had been delivered. The major deity in the pantheon of gods worshiped in Ur was the moon god, Sin ("Nannar" to the earlier Sumerians). The other principal center of moon worship was Haran, thus accounting perhaps for Terah's desire to stay there, which he did until his death.[6]

Of more relevance to Sarah, it appears certain that she was a native of Ur; however, nothing is revealed in the narrative of her parentage and line of descent except for the possibility that she was the daughter of Abraham's brother Nahor.[7] She appears on the scene for the first time with no introduction beyond the fact that she became Abraham's wife before the migration to Haran (11:29–30). As Abraham's wife, Sarah naturally became a daughter-in-law to Abraham's father Terah (v. 31) as well as a daughter of her husband's brother Nahor (not to be confused with Abraham's grandfather by the same name [vv. 22–23]). She also ended up as the aunt of Lot, a nephew to Abraham (vv. 27, 31). What Sarah

4. The name "Haran" (Akkadian *ḫurrānu*) in fact means "crossroads."

5. Abraham, as a native of Ur, near the Persian Gulf and more than five hundred miles from Haran, was at home in standard Akkadian, the official language of the so-called Akkadian Empire of 2000 BC. In addition, Abraham no doubt also had mastered the Sumerian, non-Semitic tongue of the predecessors of the Semites of Mesopotamia, namely, the Sumerians. Now he and Sarah adopted the dialect of the Amorite peoples among whom they now lived.

6. Ringgren, *Religions of the Ancient Near East*, 56–57. One should note also that the name "Terah" is itself indicative of the religious tradition of Terah and, for that matter, of Abraham as well. It is possibly a derivative of the word in Hebrew for "moon."

7. Abraham identifies Sarah as his sister because they have the same "father" but different mothers (Gen. 20:12). However, the term can also mean, more broadly, "blood relation," the nuance that seems to fit best here (HALOT, 31). See Hamilton, אָחוֹת, NIDOTTE, 351–53; H. Ringgren, אָח, TDOT, 191.

lacked by way of recorded ancestry is more than made up for by her progeny, a succession of generations that climaxed with the Messiah himself, Jesus Christ (Matt. 1:1–16; Luke 3:23–34).

More immediately, Sarah became the mother of Isaac (Gen. 21:1–3), grandmother of Jacob (= Israel; 25:24–26), great-grandmother of Judah (29:35), and thus a distant "grandmother" to Jesus himself.[8] Centuries later, Isaiah recognized and celebrated this lineage:

> Listen to me, you who pursue righteousness
> and who seek the LORD:
> Look to the rock from which you were cut
> and to the quarry from which you were hewn;
> Look to Abraham, your father,
> and to Sarah, who gave you birth.
> —Isaiah 51:1–2

SARAH'S ROLE WITHIN THE PATRIARCHAL WORLD AND ITS CULTURE[9]

The biblical texts, augmented by helpful documents from numerous sites of the ancient Near East, project a reasonably full panoply of information about the role of women in the Eastern Mediterranean world at the end of the third millennium and beginning of the second from Upper Mesopotamia to Egypt, including Canaan, of course. This was the period of the Old Testament patriarchs, commencing with the birth of Abraham in c. 2166 BC to the death of Jacob, c. 1860.[10] Beyond question, it was a patriarchal world in which women's roles were limited by social custom in general and by women's own familial situations in particular. It must be said, however, that women were considered broadly as not mere properties to be bought and sold, or to be treated with disdain or even abuse. Indeed, they enjoyed great societal respect for the most part, and their protection was generally assured by tribal and community legal safeguards. Indeed, women even played pivotal roles in family decision making from time to time.[11]

8. For an outstanding work on biblical genealogies, see Dawson, *Genealogies of the Bible* (forthcoming).

9. A three-volume work edited by Edwin M. Yamauchi and Marvin R. Wilson titled *Dictionary of Daily Life in Biblical and Post-Biblical Antiquity* is rich with articles devoted to adoption, childbirth and children, dwellings, infanticide and exposure, inheritance, and marriage, among a great many others of a more tangential nature. Other helpful resources are *Everyday Life in Bible Times*, 56–106; and King and Stagers' *Life in Biblical Israel*, 49–61.

10. See the chronological table in Merrill, *Kingdom of Priests*, 2nd ed., 47–48; Merrill, "Chronology," *Dictionary of the Old Testament: Pentateuch*, 118–120.

11. Most of these issues are dealt with clearly and sympathetically by Bradley, "Women in Hebrew and Ancient Near Eastern Law," 1–46.

The biblical portrayal of Sarah in her limited world will receive attention first, and then it will be measured against the standards of the larger world as seen in various secular literatures. The best way to understand her life and times is to track her movements through the various mini-narratives where she is seen to be or do certain things at certain times.

Sarah in the biblical accounts

The first of the biblical accounts simply makes reference to the fact that Terah, Sarah's father-in-law, exercised his patriarchal authority by moving his entire family to Haran from Ur—even his grown sons and their wives—all of whom were subject to his decision making (Gen. 11:29–32). Sarah has no voice in all these movements—at least none that is recorded. She compliantly picks up and moves as her father-in-law and husband direct. Her barrenness, however, is explicitly noted as an important motif, as indeed such barrenness was all through biblical history. For a wife not to bear children was an embarrassment, if not almost a scandal. It was, at the least, a sign of a lack of favor in the Lord's eyes.[12]

Sarah next appears on the scene with Abraham as they journey together to Egypt to purchase food in the face of a famine that has struck Canaan but, as usual, has not affected Egypt because of that country's reliance on the dependably ever-flowing Nile River (12:10–20). Why Abraham takes Sarah along is not at all clear, for he went with fear and trepidation at the possibility that Sarah's great beauty would be so attractive that his very life would be in danger, and thus Sarah could be taken by another man to be his wife. His fear is well-founded, for some Egyptians inform Pharaoh of the beautiful Canaanite woman who has come among them, and he acts quickly to add her to his harem.[13] Only by employment of the unscrupulous lie that Sarah is his sister can Abraham save his neck and be delivered from harm, but at the expense of leaving Sarah to suffer her own fate. Yet God has another plan for both the deceiver and his wife. Before Abraham returns to Canaan with all the largess Pharaoh has heaped on him because of his having acquired Sarah as a wife through Abraham's supposed goodwill, Pharaoh's house and family suffer plagues. Pharaoh correctly interprets these plagues to be God's judgment on him for taking another man's wife, even though in ignorance.

12. Other noteworthy examples are Rebecca (Gen. 25:21), Rachel (29:31), Hannah (1 Sam. 1:2), and Elizabeth (Luke 1:7).

13. In the ancient Near East, it was common for rulers to amass large harems as one measure of their greatness and as a means of cementing relations among neighboring nations by intermarriage of their sons and daughters (de Vaux, *Ancient Israel: Its Life and Institutions*, Vol. 1, 115–17). The most famous example in the Bible is, of course, Solomon, of whom it is said that he had "700 princesses and 300 concubines" (1 Kings 11:3). Ironically, one of these wives was a daughter of an Egyptian pharaoh, possibly Siamun of Dynasty 21.

Sadly, the same ruse is put to use a few years later when Abraham, on an undisclosed mission to the Negeb, cajoles Sarah to apparently lie to Abimelech, the sheikh of the region of Gerar, and to pass Abraham himself off as her brother, as he had in Egypt to Pharaoh (20:1–18). Surprisingly, she consents, at least if Abimelech is to be believed (v. 5). This time both Abraham and Sarah are spared further disgrace and harm by a divine intervention in the shape of a dream, warning Abimelech to leave the woman alone and even to spare the life of the scoundrel Abraham who, more surprisingly and despite all his foibles, is called a prophet by Yahweh himself (v. 7).[14] Why Sarah collaborates in the plan can be explained best by understanding the authoritative role played by the husband over his wife in such a time and such a situation.[15]

To return to the earlier narrative, the issue now is not so much the general well-being of the couple, but their inability to produce a son who can fulfill the promise of a people and nation. At least three times God has made that covenant commitment, but nothing seems to be coming of it. Freshly upon Abraham's entering Canaan, Yahweh has said to Abraham, "To your seed I will give this land" (12:7), a promise reiterated in virtually the same words in Genesis 13:15. This time it is said that Abraham's seed will be innumerable, like the very dust of the ground (13:16). Later still, Yahweh has underscored the abundance of the offspring by comparing it to the numbers of the stars in the skies (15:5). Finally, Yahweh has pledged, "I will greatly multiply you" (17:2, 6); "[you] will be father of many nations" (15:5, 16; 17:4, 5, 6, 16); "kings will come out of you" (v. 6, 16).

The problem from Sarah's standpoint especially is that she has reached the age past which she could conceive a child (17:17; 18:11). She attributes her barrenness to Yahweh's having made her sterile (16:2), but the promise of God is real to her nonetheless. In her first recorded utterances, Sarah proposes to Abraham a solution common to her culture, namely, to have a child by a surrogate—in this case her slave-girl, Hagar, whom Sarah likely had acquired in Egypt (16:1–6; cf. 12:16). At length, Hagar bore a son, Ishmael, who seemed at the time to be the long-awaited heir to Abraham and the embodiment of the promise made to him and Sarah of a multitudinous progeny.

The utter folly of attempting to achieve a divine objective by human means became most evident in the ensuing conflict between barren Sarah

14. The designation "prophet"(נָבִיא) does not indicate here that Abraham is a prophet akin to the great writing prophets of later Israel, beginning with Samuel (1 Sam. 9:9). Rather, it focuses only on one function of such a prophet, namely, his task and ministry of intercession between humans and God (cf. 1 Sam. 7:5; 8:6; 12:17–19).

15. The most common term for "husband" in the Hebrew Bible is "lord" (בַּעַל), a reflection of this ancient notion of the husband's dictatorial headship. William T. Koopmans, בעל, NIDOTTE 1:683.

and fertile Hagar. The humiliation of the wife of the great patriarch when she considered that a lowly slave had become her husband's lover and had given to him what she could not was unbearable. More than that, the slave had become "uppity," viewing her mistress now with contempt.[16] Sarah's response was predictable and understandable: She spoke of this to her husband, using the same slanderous verb (וָאֵקַל) to repeat the manner in which Hagar now reckoned her. Given permission by Abraham to do with Hagar whatever she wished, Sarah began to mistreat[17] her to the point that Hagar ran away to the desert (Gen. 16:6–7).

In the flow of the narrative, for more than a decade Sarah remains mute until the day she and Abraham "entertained angels unaware." The setting is their tent home at Mamre, in the entry to which Abraham is resting in the shade from the heat of the day (18:1). Three strangers appear, and as they near the tent, Abraham, in accord with ancient (and still modern) practices of Middle Eastern hospitality, rises up, bows in a welcoming gesture, and invites his visitors to sit while water is fetched for them to wash their feet. Food is then proffered, consisting of bread, which Abraham asks Sarah to bake as quickly as possible. As for Abraham, he selects a choice calf from the herd, ordering his servant to prepare it with all the trimmings. Only then do the visitors inquire as to where the patriarch's wife was to be found. Before she could be called, one of the men speaks the most unexpected and profoundly confusing words imaginable: Within that very year Sarah will give birth to a son (v. 10)! Overhearing this absurdity, Sarah laughs (וַתִּצְחַק) to herself, whereupon Yahweh asks Abraham why she has reacted in this manner.

The first mention of any oral communication at all by Sarah is in the form of her incredulous laughter at the very idea she could bear a child at her advanced age (v. 12). She next speaks to herself (v. 12) and then at last utters words aloud—words of denial that she has laughed at the prospect of childbirth (v. 15). Is there in her response only a lack of faith, or is Sarah's utterance a sign of discontent and frustration directed at both her husband and her God? Do we see a woman who at last is unafraid to take her stand in a male-dominated world and to ask questions and register complaints? Abraham is unaware that Sarah has laughed until Yahweh tells him so and asks him why. Can this insinuate that Abraham has not done enough to encourage Sarah? Does he share in her disbelief that God can and will fulfill his promises? Yahweh's further word is a probing theological question that he and all believers must answer, perhaps many times: "Is anything too marvelous[18] for Yahweh"? (v. 14).

16. The text reads literally, "Her mistress was considered a person of no standing (Heb תֵּקַל,—'she made her to be a lightweight'] in her [Hagar's] opinion" (12:4).
17. The verb here (וַתְּעַנֶּהָ) means to oppress severely or to greatly humiliate.
18. The Hebrew verb here (הֲיִפָּלֵא) is in a passive form, suggesting anything done by Yahweh is thus not a "natural" phenomenon. "Miracle" is an appropriate synonym.

At long last, but at the time prophesied by the strange "men" at the tent door, Sarah conceives at the age of ninety (17:17; 18:10; 21:1). Recalling how she had laughed in derision at the promise of a son, she now names the new-born "[everyone] will laugh" (יִצְחָק) in her joy.

Yet joy turns to sorrow and frustration a few years later when Ishmael, the son of Sarah's slave Hagar, then about seventeen years old, makes the youngster Isaac's life miserable by his incessant taunting and teasing[19] of the child (21:9).[20] This time, Sarah's demands for Hagar's expulsion have more justification, given the abuse suffered by her baby son. So Abraham sends Hagar away once more, albeit reluctantly and with a few provisions, this time never to return (21:14). His hesitation in doing it is allayed by God's permission, even encouragement, in letting Hagar and her son depart, for her descendants through Ishmael would themselves someday be a great people (vv. 12–13).[21]

Some thirty years after the events of the previous narrative, Sarah dies at the age of 127 years (23:1–2). Isaac, the son of the promise, is not yet married, and therefore Sarah dies without being able to witness the continuation of the salvific line of which she is the mother. After she has been interred in a tomb purchased by Abraham for that specific purpose, Isaac marries Rebekah, a cousin from the Mesopotamian city of Nahor (Akkadian *Naḫuru*). Sarah's significance as the matriarch of the Abraham clan is seen in Isaac's installation of his new bride in Sarah's tent, thus proclaiming to all that Rebekah now fills that role (24:67).

Nothing more is said of Sarah in Genesis except for the fact that Abraham, having reached the age of 175, is buried with her in the cave of Machpelah (25:7–10). As for the remainder of the Christian canon, Sarah is referred to in Isaiah as "the mother of Israel the nation" (Isa. 51:2); in Romans as "the mother of the promise" (Rom. 9:9); in Hebrews as "the mother of faith" (Heb. 11:11); and in 1 Peter as the model wife who submits to her husband (1 Peter 3:6).

The speeches and silences of Sarah

Ofttimes one speaks through silence as eloquently as through speech. It is instructive to see how this works out in the Genesis narratives where Sarah does each. What can be learned about her in either case? The following chart displays the instances of Sarah's response to words and actions.

19. It is worth noting that the term used to describe Ishmael's verbal abuse of Isaac is מְצַחֵק, the participle of the verb from which "Isaac" also comes (יִצְחָק). This hints at the repetitive nature of Ishmael's mockery.
20. Careful attention to chronological data in various texts (Gen. 16:16; 17:1; 21:6) indicates that Ishmael was an unruly teenager who found delight in harassing a three-year-old.
21. These peoples would principally be the Arabs, who indeed, trace their ancestry to Ishmael (Maalouf, *Arabs in the Shadow of Israel*, 44–79).

Chart 7.1: The Speeches by Sarah in Genesis

References	Speaker or Actor	Sarah's Responses	Significance of Response
16:2	None	Tells Abraham to bear a son by Hagar	Matriarchal behavior
16:5	Hagar	Complains to Abraham	Matriarchal or egalitarian behavior
18:12	The Angel of Yahweh	Laughs	Unable to believe God
18:15	The Angel of Yahweh	Denies her laughter	Disbelief exposed
20:5	Abimelech	Remains silent	Seemingly unaware of Abimelech's claim
21:6–7	Birth of Isaac	Laughs and has restored belief	Admits wrongdoing
21:10	Ishmael	Complains to Abraham	Jealousy motivated by protection of her child

Chart 7.2: The Four Unexpected Silences of Sarah in Genesis

References	Speaker or Actor	Sarah's Responses	Significance of Response
12:5	Abraham	Silence	Apparent cooperation with decision to move
12:11–13	Abraham	Silence	Apparent cooperation with plan to deceive
17:15	Yahweh	Silence	Name change
20:2	Abraham	Silence	Apparent cooperation with plan to deceive

Interpretation of the data of charts 1 and 2.

Several cultural, sociological, and theological points can be made regarding the information gleaned from these texts and their subject matter:

- On two occasions, Sarah exercises a kind of matriarchal or egalitarian[22] standing.
- Twice she displays a lack of faith or a spirit of unbelief.
- One time, she gives vent to jealous (motivated by maternal protection).
- One time, she admits her lack of faith.
- One time, she submits to moving to Canaan.
- One time, she submits to a change of her name.
- Two times, she apparently cooperates with Abraham in a plan of deception.

Observations:

1. Despite common understandings of patriarchal domination in ancient Israel, Sarah exhibits on occasion what seem to be exceptions to this preconception in situations that involve her slave.

2. Two other times a more egalitarian relationship appears to be the case, namely, Sarah's apparent cooperation with Abraham in deceiving first Pharaoh and then Abimelech of Gerar as to their husband-wife relationship.

3. Sarah displays a rather petulant and jealous attitude with regard to Hagar and her husband's sexual trysts with the slave woman. Sarah first suggested the ploy, and then blamed Abraham for its outcome.

4. With reference to her faith, Sarah finds it difficult to believe the promises of God that she will bear a son. On the other hand, when the birth actually comes to pass, she expresses satisfaction and confesses that her faith had been wanting.

5. Notions of outright matriarchy or even egalitarianism are offset in Sarah's case by a lack of recorded resistance to making the long and treacherous journey from Ur to Canaan, and by her silent acceptance of a name change. In fact these examples, at least, bespeak a position of utmost abject subservience of wife to husband—that is, a classic example of male authority of the patriarchal mode.[23]

SARAH'S INTERPERSONAL RELATIONSHIPS

One way of acquiring a great deal of insight into someone's personality, temperament, and motives is by examining his or her relationships with others. The following survey of those relationships includes only those instances in which this kind of information about Sarah is readily garnered from the texts themselves, and not from modern psychological analyses that have little or no validity when applied

22. I'm using the word "egalitarian" in this chapter in its usual literary sense.
23. Matthews, "Family Relationships," *Dictionary of the Old Testament: Pentateuch,* 293–94.

to persons of such a different cultural and historical world (such as the eastern Mediterranean four thousand years ago).

Sarah and Abraham

The first and most obvious example is the Abraham-Sarah relationship—the closest kind of relationship in any society, that is, in marriage. The two were genealogically closely related, Abraham being the son of Terah, son of Nahor, and Sarah the daughter of Nahor, son of Terah. This made Abraham and Sarah brother and sister in the broader Semitic sense. Thus, Abraham's insistence that Sarah identify herself as his sister was not a complete fabrication (12:13, 19; 20:2, 5, 12).

As we have noted, the marriage was rather rocky throughout the recorded story. Abraham had been called to go to Canaan, a far-off land much inferior in culture and technological advantages as compared with the Sumero-Akkadian land from which they had come. The adjustment from clay brick dwellings to tents must have added to the fears and uncertainties that Sarah surely experienced. Her husband had responded to a call from Yahweh that he should go to the new land and there sire a people who would someday fill the earth with descendants. But Abraham, though a man of faith, seemed always prone to working things out his own way, often to Sarah's detriment. Twice he was willing to lie to rulers who coveted his wife, legitimately giving up to them the only means whereby the covenant could be fulfilled (which God later specifies; see 17:16–19). Abraham was not the only partner in the covenant—so was Sarah! But her barrenness was a cause of great consternation to her, as it was to Abraham. So great was her burden, she became willing to "borrow" Hagar's womb in order to bring about the line of descent.

After the difficulties associated with living in a foreign land among people of a foreign tongue, Sarah was treated to even more hardship by Abraham's restlessness. From Shechem to the Canaan hill country (12:8) and on to Egypt they went, and then from Egypt to Bethel to Hebron they returned (13:18). Tired of the travels and the futile attempts to become pregnant with the promised child, Sarah made a suggestion to her husband that must have caused them both a great deal of anxiety. Though children by proxy was not a foreign idea to Sarah, for her to have to resort to this was an embarrassment and an assault on her self-image as a woman. This explains her desperation to have a child by some means or other, her jealousy when the surrogate bears a son and changes in her demeanor toward Sarah, and her demand that the woman and her baby be banished to the desert—all seeming to work at cross-purposes.

Abraham was no less desperate and disappointed, but in the midst of his darkest hour, Yahweh spoke the promise that Sarah would give birth to the long-awaited son of the promise, though she was now ninety years old, well beyond the time the biological clock made such things possible (17:16–19). To make it doubly sure, Yahweh, disguised as an angelic stranger, visited the devastated couple and made such a grandiose reiteration of the promise that

Sarah could not help but laugh at the very idea of a near-centenarian becoming pregnant (18:12). But become pregnant she did, and gave birth to Isaac, the laughing-stock (21:1, 6, 9). All now went well in the marriage, for Yahweh had accomplished in their relationship all he said he would do and more.

Sarah and foreign rulers

Very little can be said about Sarah's relationship to foreign rulers, for not a single word is recorded of any conversation Sarah had with anyone in the times she was taken by Pharaoh, and then the sheikh of Gerar, to be their wife. It seems she offered no resistance, spoke no words of disapproval to Abraham, and said nothing to her would-be masters. All one can conclude from the scanty evidence of the texts is that Sarah entered submissively, and perhaps even at times willingly, into these relationships. However, this was not to be. In both instances Yahweh intervened in plagues and dreams and warned the pagan rulers of the severe consequences that would ensue if Sarah was not returned to her husband (12:17; 20:3).

Sarah and the slave

In a classic contrast, Sarah dealt with pharaohs and paupers, sheikhs and slaves, the latter in each case personified in Hagar.[24] The Egyptian appears first in the narrative as Sarah's "slave-girl" (שִׁפְחָה; Gen. 16:1 and subsequently through 16:16 and 21:9–17; 25:12). Hagar had likely been acquired as such when Abraham had first journeyed to Egypt in a famine time (12:16). Sarah's attitude and behavior toward Hagar oscillated from her being a person of convenience (16:2) to being a rival (v. 4) and an oppressed object of her scorn (v. 6). Is this indicative of Sarah's attitude in general about status and class distinctions, or is it applicable to this strange case alone? Unfortunately, not enough is known of Sarah's contacts with other persons like Hagar to draw any fair conclusions. One can say, however, that such discriminations were common in the ancient Near East as a whole, as will be seen presently.

Sarah and God

Last, but surely not least, is Sarah's interaction with Yahweh, her God. Direct interactions take place between Yahweh and Abraham about Sarah's place in his redemptive plan, but direct encounters between Yahweh and Sarah are rare and then not exactly direct. In fact, the only pericope where the text says this happens is in connection with Yahweh's visit in angelic or human form to Abraham's tent at Mamre (18:1–15). All that happened then by way of encounter was Sarah's eavesdropping on the conversation between Yahweh and Abraham, the absurd content of which made her laugh (v. 12). Now, to be sure, neither Abraham

24. Her name, by a slight but perhaps deliberate shift in vocalization (הָגָר>הַגֵּר), could be a play on גֵּר, "stranger, wanderer, sojourner."

nor Sarah understood the visitor to be Yahweh, so perhaps her reaction can be explained in that light. In any event, it is ironic that Yahweh appeared to the despised Egyptian slave-woman Hagar more intimately and extensively than he did to Sarah (16:7–14; 21:17–21).

BIBLICAL LAWS, CUSTOMS, AND TRADITIONS CONCERNING SARAH, AND THEIR REFLECTION IN DOCUMENTS FROM THE ANCIENT NEAR EAST

The term "ancient Near East" is not self-explanatory because of geographical, chronological, and other considerations. Generally speaking, ancient (from our standpoint) can mean anything from the beginning of human history to the Christian era. To scholars working in the field, however, "ancient" implies for its *terminus ad quem* the beginning of documented history, which is approximately 3200 BC for Egypt, Mesopotamia, Anatolia, and other smaller civilizations in the orbit of "Near East." The *terminus a quo* for the region is between the beginning and ending of the Iron Age (1200–300 BC), depending on the particular culture being addressed.

"Near East" (= in modern times "Middle East") pertains at various times to a region from Iberia in the west to Afghanistan in the east and from Urartu (biblical Ararat) in the north to Nubia (modern Sudan) in the south. The focus of the term for biblical studies is limited to modern-day parts of Iran, Iraq, Syria, central and eastern Turkey, Cyprus, Libya, Egypt, Sudan, Ethiopia, Saudi Arabia, Jordan, Israel, and Lebanon. The interface with the Old Testament (in particular, with the Sarah narratives) begins c. 2200 BC and ends c. 1800 BC.[25]

A slight problem appears to exist with regard to the patriarchal customs and those of the larger environment, and that is that the texts describing the latter are, for the most part, later than the Old Testament dates for the patriarchs, in some cases much later. However, it is well known that cultural traditions are notably conservative, often changing little over a millennium or more. This being the case, the parallels cannot *ipso facto* be rendered either meaningless or directly relevant to the circumstances of personal and societal life embedded in the biblical narratives. These will now be investigated on a case-by-case basis.

Having viewed Sarah in the narrow confines of Canaan for the most part and having given attention to the Bible's descriptions of beliefs, attitudes, and behaviors in that region, many of them strange and foreign to modern sensibilities, we must now direct our attention toward the larger world of which Canaan

25. Sarah's dates are approximately 2156 to 2029 BC, but details of ancient Near Eastern customs and cultural practices would, of course, have begun earlier in some instances and outlived her in others. For Sarah's dates and others of the period, see Merrill, *Kingdom of Priests*, 2nd ed., 44–48. The 1800 date marks approximately the date of Joseph's death, thus bringing an end to what is generally described as "the age of the patriarchs."

was a tiny part.[26] This is necessary because it can no longer be maintained that the eastern Mediterranean world was isolated from the great empires, especially those to the east and south. Commerce, military conquest, and other reasons for international travel had knitted the entire Middle East together by 2000 BC.

As a result of the increasing familiarity among the nations with each other, there naturally followed exchange not only of goods, but of ideas, customs, traditions, and religious concepts. Bodies of laws had begun to be codified in Mesopotamia as early as 2200. Mythical texts having to do with creation, floods, and other traditions devoted to the question of origins, space and time, and the workings of the gods had also been composed. These had also been faithfully transmitted, translated, and made available to all parts of the literate world. To suppose that such texts and traditions were unknown to the biblical patriarchs is to invite skepticism of the worst kind. Particularly is this true given that the Bible locates the original home of Abraham and other patriarchs in Lower Mesopotamia, the "cradle of civilization."[27]

The scheme to be followed here is an attention to the forward movement of the narrative of Genesis combined with interruptions of relevant ancillary secular texts when a given biblical custom or tradition makes its first appearance.

Life in the late Bronze Age: Egypt and Lower Mesopotamia

Lower Mesopotamia in the Late Bronze era was populated primarily by Sumerians and Semites, the former being the earliest documentable settlers there, including in Ur. The contributions of the Sumerians are too numerous to list here, but among them were (1) the engineering of a network of canals designed to take maximum advantage of the great Tigris-Euphrates river system as a resource for irrigation of crops;[28] (2) a highly developed urbanism represented by a number of independent or semi-independent city-states, again including Ur;[29] and (3) the origin of a truly functional written form of the agglutinative Sumerian language.[30] The tablets date to c. 3200 BC, one thousand years before Abraham, who likely was literate and conversant in

26. Canaan at its largest extent in Abraham's time (the latter Early Bronze and early Middle Bronze eras, c. 2100–2000 BC) was minuscule compared to the farthest reaches of the Sumero-Akkadian, Egyptian, and Levantine kingdoms and empires. The best estimate is that Canaan occupied no more than 2 percent of the land mass of the known world of the Middle Bronze Age (c. 2000–1550 BC). See Schlegel, *Satellite Bible Atlas*, 2–1.

27. The term is usually attributed first to Edmund Spenser, the English poet, in AD 1590.

28. For a helpful description of the canal networks of the period and their foundational importance for the rise of the Sumerian economy and even urbanization, see Oppenheim, *Ancient Mesopotamia*, pp. 38–42.

29. A vivid account of the grandeur of Ur in the days of Abraham is by its principal excavator, Leonard Woolley; see *Ur of the Chaldees: A Record of Seven Years of Excavation,* 112–147.

30. The earliest cuneiform tablets in Sumerian were discovered in Tell Ubaid (=Uruk), just fifty miles NW of Ur. See Falkenstein, *Das Sumerische*, 6–60; Schmandt-Besserat, "How Writing Came About," 1–5.

both Sumerian and Akkadian, the early Semitic language introduced primarily by Sargon the Great of Akkad (2360–2305). Moreover, life in Ur was at a surprisingly technological high level, including plumbing, a sewage system, and multistoried buildings. All this Abraham and Sarah left, for the distant and virtually unknown backwater of Canaan.

Life in Egypt was in turmoil at the turn of the twentieth century BC, an era known to moderns as the First Intermediate Period. The glorious days of the Old Kingdom and the pyramid builders of Dynasties 4 and 5 were over for a host of reasons, and Egypt had entered into a sort of dark ages of nearly two centuries (c. 2200–2000 BC).[31] The biblical chronology suggests that this was the time Abraham and Sarah traveled to Egypt and when Sarah, it seems, nearly ended up as a permanent member of Pharaoh's harem.[32]

The harem in the ANE: Egypt

In Sarah's case, it is entirely possible she could have become part of a harem, even though some scholars argue that the evidence for such an institution is not greatly abundant from Egyptian texts prior to the New Kingdom.[33] On the other hand, the so-called "Autobiography of Weni" of Dynasty 6 (c. 2330–2165 BC) records that the author acted "in the name of the king for the royal harem" and "never before had one like me heard a secret of the king's harem; but his majesty made me hear it, because I was worthy in his majesty's heart."[34] Even so, Sarah could have been just another wife added to the many that most kings of the period acquired, usually daughters of rulers of surrounding nations the king had conquered or with whom he wished to establish or maintain good relations.[35] This would suggest that Abraham was, in the eyes of the pharaoh, not just a minor chieftain of a sandy desert, but a man of wealth and prestige, able on occasion to raise a military force of some significance (14:14).

Barry J. Kemp describes the institution of the harem in the New Kingdom period (ca. 1580–1150 BC) as a "semi-independent institution with its own officials." It was housed in a structure apart from the main royal palace (a so-called "harem palace"), but it was also part of the greater palace complex.[36] As much as a pharaoh might enjoy the pleasures of a harem, harems were frequently environments in which plots were hatched. The following lines from a court-docket illustrate this in the reign of Rameses III (1198–1166 BC):

31. Kuhrt, *The Ancient Near East*, 154–61.
32. Merrill, *Kingdom of Priests,* 51.
33. Kuhrt, *The Ancient Near East*, 149; Toivari-Viitala, "Marriage and Divorce," in Frood and Willeke Wendrich, eds. *UCLA Encyclopedia of Egyptology*, 1–17.
34. Lichtheim, ed. *Ancient Egyptian Literature,* 19.
35. Kuhrt, *op. cit.,* 167.
36. Kemp, *Ancient Egypt,* 218.

The great criminal Paibakemon . . . was brought in concerning the collusion that he had formed with Tiye and the women of the harem. He had made common cause with them; he had begun to bring their words outside to their mothers and their brothers who were there, saying, "Gather people and incite enemies to make rebellion against their Lord."[37]

The same intrigue was at work in the much earlier period of Hatshepsut (1503–1483 BC) who, although a female herself, was the target of betrayal of the harem women. Wells points out that "the palace apartments where the 'other women' lived with the children sired by their king was always a hotbed of intrigue."[38]

The harem is also attested to in the early patriarchal period (c. 2400 BC) at Ebla nearly one thousand years earlier, more contemporary with Abraham; and in the very area where he had settled first in Haran, the institution of the harem is attested to in the Ebla tablets in which the harem women are called DAM EN, "women of the king."[39] Several centuries later, the Hittite evidence for such a practice is abundant. In that society the women are "the shut-in ones," suggesting access to them by the king alone.[40] Much later than even that is the example in the Neo-Assyrian era of the harem of Esarhaddon (680–669), who himself was born of a harem wife of King Sennacherib.[41]

Surrogate motherhood: Mesopotamia

The term "surrogate," by its simplest definition, means "a person appointed to act in place of another."[42] In Sarah's situation, as already noted, the appointed person was the Egyptian slave-girl Hagar, and the "other" whose place Hagar took was Sarah, the wife of the great sheik Abraham. Hagar bore a son by Abraham, but only as a "borrowed" womb in terms of her claims and rights to motherhood. The legal mother was Sarah, since the slave acted on her behalf only.[43]

Ancient Near Eastern texts devoted to such a practice are lacking as late as 2000 BC, but plentiful not long after the best dates for the patriarchs. The most

37. Ritner, "The Turin Judicial Papyrus," COS, 3:27.
38. Wells, *Hatshepsut*, 174.
39. Sasson, ed., *Civilizations of the Ancient Near East*, Vol. II, 1224.
40. Ibid., 537.
41. Ibid., 949.
42. *Webster's Dictionary*, 886.
43. Such an arrangement might seem strange to the modern Western mind, but the traditional surrogacy of this generation is remarkably similar to that of four thousand years ago. The major differences are (1) the surrogate mother today enters into a legal arrangement with a couple, surrendering all rights to the child to be conceived and serving for a fee of some sort; and (2) modern genetic science has made it possible for the sperm of a "donor" to be transferred into a woman's womb in place of that of her infertile husband's. In this case, the donor is the surrogate, being the "father" in a biological sense, but only a means to an end in a legal sense.

famous of these is the so-called "Code of Hammurabi," compiled and composed at the directive of this great king of the Old Babylonian period (c. 1792–1750 BC). In the section on marriage and family, Law 144 (out of some 282) states, "If a man has married a priestess[44] and that priestess has given a slave-girl to her husband and she has then brought sons into the world, (if) that man sets his face to marry a lay-sister, they shall not allow that man (to do this); he shall not marry a lay-sister."[45] Law 145 is more in line with Sarah's predicament: "If the man has married a priestess, and she has provided him with sons and so he sets his face to marry a lay-sister (and) take her into his house; that lay-sister shall not then make herself equal to the priestess."[46]

Law 146 is still more pertinent. "If a man has married a priestess and she has given a slave-girl to her husband and she bears sons, (if) thereafter that slave-girl goes about making herself equal to her mistress, because she has borne sons, her mistress shall not sell her; she may put the mark (of a slave) on her and may count her with the slave-girls."[47]

The parallels of these examples to the Genesis narratives are striking indeed. Other texts also exist demonstrating the same cultural norms. A most distasteful case appears in the "Lipit-Ishtar Law Code," a collection in Sumerian from the city-state Isin dated c. 1875 BC. Law 27 reads: "If a man's wife has not borne him children, (but) a harlot (from) the public square has borne him children, he shall provide grain, oil, and clothing for that harlot; the children which the harlot has borne him shall be his heirs, and as long as his wife lives, the harlot shall not live in the house with his wife."[48]

Other early texts providing parallels to Sarah's apparently (to us) extreme course of action come from eighteenth-century Alalakh (Tell Atçana), an important site in the remote northwest of Syria, very close to the Mediterranean. The first of these is fragmentary, but the relevant lines read as follows:

> If Naidu has not given birth to an heir, then the daughter of her brother, Iwavvura, shall be given (to Irihalpa). If Tatadu (?) gives birth first for Irihalpa, and afterwards Naidu gives birth, then the older (?) woman shall not be given anything.[49]

44. The Akkadian term translated "priestess" here (LUKUR, a Sumerian logogram for Akkadian) refers to a "woman dedicated to a god, usually unmarried, not allowed to have children." The Chicago Assyrian Dictionary, N1, 63. Another technical term for such a woman is "hierodule," temple slave. The fact that Hagar is not identified as such a slave does not nullify the view that the marriage is of the pattern of a surrogacy as understood at Nuzi (see below). In fact, she could not have been a hierodule, since she married and had a child.
45. Driver and Miles, eds., *The Babylonian Laws*, 57.
46. Ibid.
47. Ibid.
48. ANET, 160.
49. Sasson, Vol. 3, 252.

The second, even more elusive, reads thus:

> Zanzuri, Idat[ti(?)] has taken for a wife. Two hundred shekels of silver and thirty shekels of gold he has given as a bride price. [I]f she does not give birth after seven years, he (Idat[til]) may take a second wife.

Much later from Nuzu/i (Yorgan Tepe), located forty miles southeast of Asshur near the Great Zab River in Iraq, a rich trove of court dockets was found detailing various marriage customs from the Late Bronze (Middle Assyrian) period. Granted, this is four hundred or more years later than Abraham's time, but the texts no doubt preserve customs of long standing. Speiser cites a text that reads: "If Gilimninu bears children, Shennima shall not take another wife. But if Gilimninu fails to bear children, Gilimninu shall get for Shennima a woman from the Lullu country as concubine. In that case Gilimninu herself shall have authority over the offspring."[50]

But shortcuts like this could not work in Sarah and Abraham's case, because God's plan was that the womb of Sarah herself would incubate the beginning of all the good things that would follow (17:15, 19; 18:10, 14; 21:2; cf. Heb. 11:11). In the secular sources nothing is said of the intervention of deity by promise of conception or of miraculous birth such as that occasioned by Sarah's age and consequent inability to conceive naturally. In this situation, the biblical account is to be understood as not just a remarkable turn of events but as a profoundly important theological lesson designed to encourage Abraham, Sarah, and all subsequent links in the redemptive plan to trust Yahweh God for the immediate and remote outcomes. Whatever one may want to make of Abraham and Sarah's faith and its genuineness, they resorted to devices well known from patriarchal times and even earlier.[51]

Pseudo-adoption of a covenant son[52]
Related to the matter of Sarah's barrenness, but apparently without Sarah's involvement, was Abraham's acquisition of a "son" while traveling through and staying for a while in Damascus. This is not even hinted at in the main narrative of the journey itself (Gen. 12:5). In fact, Sarah's inability to bear the son of the covenant promises seems also concealed by the narrator (with the exception of the proleptic insertion of Genesis 11:30 that "Sarai was infertile") until the first reference to Damascus and the adopted son (15:2).[53] The omission of the

50. Speiser, *Genesis*. AB 1, 120, citing HSS 5 (1929), No. 67.
51. That Sarah, like Abraham, was an individual of deep faith, notwithstanding their seeming equivocations throughout the narratives, is clear from the NT witness: "By faith Sarah herself received power to conceive, even when she was past the age, since she considered him faithful who had promised" (Heb. 11:11, ESV).
52. Yamauchi and Wilson, *Dictionary*, Vol. I., s.v. "Adoption," 12–14.
53. The descriptor "infertile"(עֲקָרָה) derives from the rather violent-sounding verb meaning "tear out, uproot" and the like (עָקַר) (HALOT, 874). The notion that this is prolep-

"adopted son" façade is strange, indeed, given the impression to this point that Sarah for some time appears to be well able to be a wife and mother, as the lateness of the resort to adoption employed by Abraham implies.

Numbered among the Nuzi tablets are several that speak of "adoption" for all kinds of situations where family, business, and legal matters were concerned. For example, if a man had no male heir, he could adopt a friend as a fictitious son, no matter the age or social standing of the adoptee. A familiar example involves an individual named Zigi, who allows his own son Shennima (see above) to be adopted by Shurihil, who has no heir. As for Shurihil, "as far as Shennima is concerned, all these lands, his earnings, whatever their description, one portion of it all to Shennima he has given. If Shurihil has a son of his own, firstborn he shall be; a double share he shall take. Shennima shall then be second and according to his allotment his inheritance share he shall take. As long as Shurihil is alive, Shennima shall serve him. When Shurihil dies, Shennima shall be heir."[54]

The reference to "Eliezer of Damascus" as "one born in [Abraham's] house" seems to refer to "inheritance adoption" as well. Sarah cannot produce an heir so Abraham, in desperation, accommodates himself to the custom of fictitious adoption that prevailed throughout much of the world, especially in his homeland in Mesopotamia whence he had recently come. The text reads most literally, "Lord God, what can (?) you give me since I keep on being[55] childless? On the other hand, Eliezer might perhaps be available since Abraham calls him "heir of my house" (בֶּן-מֶשֶׁק בֵּיתִי), i.e., "of everything I have" (15:2).[56] With what seems to be a claim of adoption-ship, Abraham wonders aloud if this might not be God's way of getting both God and himself out of a difficult dilemma.

tic—meant primarily as a literary device to alert the reader to the problem of barrenness that would jeopardize the promise to Abraham—does not strip the story of the factuality of the story or of Abraham's knowledge of that fact from the beginning. Rather, it remains that the purpose of the observation that the notice of barrenness is where it is in the text was to alert the reader (or hearer) of problems to come. See Mathews, *Genesis 11:27–50:26*, 102. Even if this interpretation is incorrect, the fundamental fact remains that Sarah could not have children.

54. Arnold and Beyer, eds., *Readings from the Ancient Near East*, 72.

55. The Hebrew form הֹלֵךְ is a participle of the verb הָלַךְ, "walk," suggesting here a continuous or characteristic way of life. Abraham is childless, and has always been so to that point. This intensifies the predicament in which he finds himself and Sarah.

56. The expression בֶּן הֹלֵךְ occurs one other time (Eccl. 2:7), but there it likely refers to sons born to indentured slaves. Here it seems clearly to be idiomatic for heir. In that sense it is fair to assume that adoption is in view in this situation, since Abraham has complained that he has no son to be an heir. See Westermann, *Genesis 12–36*, 219–20. For a strong argument for adoption *a la* Nuzi, see von Rad, *Genesis*, 178–79. See also above discussion; with an ingenious pun the author goes on to note that Eliezer, the בֶּן מֶשֶׁק, was from דַּמֶּשֶׂק; i.e., Damascus.

Sarah's death and continued influence

After a long and somewhat troubled and difficult life, Sarah died, but even in death was the subject of complication, because arrangements had not been made for her burial (23:1–4). Ironically, Abraham dealt with the pagan world once more, and once more he dragged Sarah, though deceased, into it with him. The couple had lived then in Hebron, but apparently as landless strangers among the "Hittites" (or "Hethites"; vv. 3, 5, 7, 10, 16, 18, 20).[57] Recognizing Abraham as a significant citizen and "godly [or 'powerful'] leader" (נְשִׂיא אֱלֹהִים), Ephron, who owned a choice burial ground that included a cave, sold it to Abraham after some considerable dickering (vv. 4–16). It became thereafter the family cemetery where Abraham himself was laid to rest (25:9–10) as were Isaac (35:37–38) and Jacob (49:29–32; 50:13).

SARAH: A VINDICATED VIXEN?

In light of all that has been seen and said in this survey of Sarah's life at its various intersections, what objective and reasonable assessments can be proposed? Was she a manipulative, scheming, and imperious vixen—or a woman of God who made her mistakes, to be sure, but who sincerely sought to walk in his ways and pursue his covenant plan for her life? What can men and women of today learn from the narratives in which she plays a leading role? The following observations about this woman of the ancient past and her place in sacred history propose to answer these questions and others about how one should learn to live, love, and labor for the glory of God in the age we occupy four thousand years later.

1. Sarah lived in a patriarchal world in which women's places were firmly established by societal and religious traditions that greatly hindered their aspirations and capabilities in virtually all aspects of life. It is true she was favored by her marriage to a man of influence and wealth, and she came from a city unusual in its time for its cultural and material splendor. She was torn loose from that place, however, because of her husband's sense of a call to go to a distant land, the name of which even he did not know. She learned to adapt to the life of a nomad, living in tents and moving from place to place to find foraging for the animals essential to the nomadic style. She did find respite from her wandering for a time by the decision to settle in Haran, a much smaller and less prestigious place than Ur, but nonetheless a place where she could enjoy again the relative ease and comfort of urbanism.

57. These most likely were not the same as the Hittites of Anatolia and of much later times. The name Heth (חֵת) is very similar to the term "Hittite" (חִתִּי), but the one whom Abraham engaged was clearly a descendant of the Hittites referred to in the genealogy in Genesis 10:15, who are said to be indigenous Canaanites. It is best here to understand the identification of these Hittites thusly.

All that ended when her father-in-law died, and her husband again moved on to the west in pursuit of a "call." There is no record of complaint from Sarah, no intimation of her resistance to the disruptions in her life. One might suppose that the "call" was hers as well as his. At long last the caravan of hundreds of persons and thousands of livestock arrived in a land unlike anything Sarah had ever seen—hills and valleys, abundant pasture-lands, bountiful rain that gave birth to exotic fruits and vegetables previously unknown to her. There were no great rivers like the Tigris and Euphrates, but bordering Canaan to the west was a mighty ocean, the "Great Sea" made famous in the itinerary texts of Sarah's illustrious Semitic forebears, Sargon and Naram-Sin. But once in Canaan the wandering never ceased, though there were intermittent times of respite in places with strange names like Shechem, Bethel, Hebron, Gerar, and Beer-Sheba.

Surely most painful to Sarah must have been the two times she was pawned off by her husband as his sister, not his wife, and all because he wanted to save his own neck. But through all this, the narrator speaks not once of her complaint—a remarkable tribute to Sarah indeed! Yet, this is not all the story.

2. Not to be overlooked is the fact that Abraham had received a vision from the Lord—a revelation he must have shared with Sarah at the very beginning, because she figured prominently in its message. Abraham was to be the father of a nation of people that would be a means of blessing all the sinful world, and its rulers would be kings (12:1–3; 17:6, 16). A king must, of course, have a queen, and that was the role Sarah was to assume, a fact so momentous that her very name meant "princess." Sarah, then, was indispensable to the working out of this divine plan. One can only imagine her perplexity at the announcement that she would be the mother of a nation, since it was well known that she was sterile, unable to mother even the second generation to say nothing of the hundreds of generations that would follow. How could anyone reconcile the sure promises of God with a biological impossibility? Was her faith (or lack of it) so deep that it need not or could not be expressed? The author of Hebrews seems to know the answer: "By faith Sarah was made able to conceive when she was past age, since she trusted that He who had promised was faithful" (Heb. 11:11). It seems, then, that Sarah's faith was below the surface, but nonetheless there.

3. A counterpoint to the claim of Sarah's faith must also be examined, though perhaps not answered. How is it that she was willing to offer Abraham a way out of his theological dilemma of childlessness by suggesting that he use Sarah's slave-girl, Hagar, as a means of propagating his seed? Did she love her husband so much that she was willing to swallow her pride and let the

lowly Egyptian take her place as Abraham's lover? Or did Sarah reconcile in her own mind the possibility that her faith in Yahweh's promise need not be worked out through her directly, but by another means, namely, by surrogacy? This strategy would, of course, fail in every respect because (1) it was well known she was barren; (2) her reaction to the birth of Hagar's son was anything but charitable, nor could it have been otherwise; and (3) later, God made clear that the messianic son would be a fruit of her own womb.

4. Finally, a redemptive note should be sounded *vis-à-vis* Sarah's various attitudes and actions—a note that can perhaps be a way of unraveling the twisted threads and manifold aspects of her complicated life, and of ours as well. Nothing in the account suggests that Sarah acted out of mere self-interest at the expense of others. In fact, one marvels at her compliance to the leading of her husband as he moved from place to place. She attempts to enhance his situation in the presence of both Pharaoh and Abimelech by her seeming willingness to be taken by them if Abraham can go free. It is late in the story before Sarah even makes the slightest reference to her greatest physical and emotional problem—her barrenness, and even then it is in the interest of her husband that she speaks of her willingness to step aside and urge Abraham to have a child by her Egyptian slave. Such self-denial is rare in biblical literature and rare indeed in modern life, even within the Christian community.

On two occasions, however, Sarah's edginess is evident, the two episodes resulting in Hagar's expulsion from the home and family. However, in each instance Sarah did not initiate the confrontation but reacted to it. The first encounter resulted from Hagar's overt air of superiority to Sarah, since Hagar was a successful mother, and Sarah was not a mother at all. This was in a culture in which such a display of disregard of the norms of mistress-slave relationships could have resulted in death for the woman of lower caste. Thus, Sarah's restraint should be seen as a remarkable display of grace and not vindictiveness. The second flare-up that led to a second expulsion seems to set Sarah in a darker mode than before, but a close reading of the narrative suggests that her primary concern was not for herself but for her young son Isaac, who was suffering at the hands of Ishmael, his elder half-brother. Of course, Sarah resented Hagar's insolence, as any woman might in a polygamist culture where jockeying for the favor of the common husband must have been rampant. But this may not have been the central motivation for her plea to her husband to ban Hagar and her son Ishmael to the desert.

CONCLUSION: WAS SARAH A VIXEN?

By Webster's definition of "vixen" ("a shrewish, ill-tempered woman") Sarah is exonerated. Her attitudes and behavior were far from exhibiting pristine purity, but even so, she was a fit person to be "every-woman" (and -man). The final tribute

paid her in the Word of God, after all, is, "by faith Sarah herself received power to conceive, even when she was past the age, since she considered him faithful who had promised" (Heb. 11:11, ESV). What finer encomium could one want?

QUESTIONS FOR DISCUSSION

1. What are some of Sarah's strengths and weaknesses?

2. What are some ways that Sarah both suffered and exercised agency within a patriarchal culture?

3. Peter tells wives that they have become like Sarah if they do what is right, without "being frightened by any fear" (1 Peter 3:6, NASB). What are some fears that Sarah surely faced?

HAGAR: GOD NAMES ADAM, HAGAR NAMES GOD[1]

TONY MAALOUF, PHD

Many have made the observation that "familiarity breeds contempt." Sadly, the truth of this statement often applies to our reading of Scripture. I saw an example of this recently. A friend who pastors a California church expressed how he considers discipleship of Muslim-background believers the most thrilling part of his work. He told me, "They read the Gospel accounts with zero prior knowledge of anything that takes place in them. As a result, they get thrilled with the simplest details about Christ that we often take for granted." This friend then told me that when he was reading about Jesus's confrontation with the religious leaders in Jerusalem, one of his listeners joyfully shouted, "Here you go! Good for you, Jesus!" as this man saw how Christ silenced opponents with his probing answers.

I wish sometimes that we would approach the Bible in that fresh way too. In particular, such an approach might help us read the story of Hagar with that type of innocence rather than presuppositions that too often frame our understanding of the biblical text. Wouldn't we marvel at the privilege of the Lord appearing to Hagar (and ironically not to Sarah, as recorded in Genesis 16), as Hagar fled to the wilderness away from her misery? Wouldn't we stand in awe when the Lord reveals himself to her as "the God who Listens," naming her unborn son *Ishmael* (meaning, "God listens"; Gen. 16:11)? Wouldn't we shout, "Good for you, Hagar!" as the Lord covenants to multiply her descendants

1. For a full treatment of the Hagar/Ishmael narrative throughout the Bible, see my work, Maalouf, *Arabs in the Shadow of Israel.*

beyond numbering, despite the fact that she is just a lowly slave woman (v. 10)? The list of pleasant surprises could go on and on.

Although loaded with teaching on God's grace toward fallen humanity, the Hagar narrative is rarely preached from evangelical pulpits. When preachers do tell Hagar's story, it is often only to disparage her "infamous" liaison with Abraham (v. 3) that resulted in the "unfortunate" birth of Ishmael (vv. 4–6, 15), whose line supposedly brought only "trouble" to Israel (v. 12). Consequently, we miss the gems embedded in this narrative, since we fall short of digging in it deeply enough, or we approach it with lenses tarnished with negative stereotypes and faulty theological presuppositions. In what follows, I will try to reflect on the often-ignored aspects of Hagar's character and experience. Theologically, such a perspective allows readers to see how God elevated the so-called "unchosen" lowly, making them recipients of his blessings. At the same time, God also elects by his grace failing humans to administer his purposes in redemptive history as a channel of those blessings. Consequently, this essay does not embellish the weaknesses of the saintly patriarchal couple, Sarah and Abraham, but exalts the Lord, who was able to turn them into "songs in the night" in the life of Hagar and her son (Job 35:10).

HAGAR'S HUMBLE INTRODUCTION (16:1–3)

Being a bond-slave

At the outset of the Hagar/Ishmael narrative in Genesis 16, the focus clearly shifts from Abraham to Sarah. While the writer introduces Sarah in her egalitarian relationship to Abraham (v. 1a) as his wife who was supposed to bear "to him," Hagar is introduced in a subordinate relationship to Sarah as her Egyptian slave-girl (v. 1b). How Hagar became part of the patriarchal family is unclear from the text. We know only that she was an Egyptian slave whom Sarah acquired. While evidence indicates that the first slaves in the ancient Near East were mostly foreign war captives, sources of slavery varied soon after that. Poverty-stricken people sold themselves into slavery to survive; those unable to repay debts sold themselves into slavery; and poor parents, unable to provide for their families, sold their minor children.[2] Rabbinical tradition in its attempt to exalt the patriarchs conjectured that Hagar was the daughter of Pharaoh.[3] But it would be much more likely that Hagar's poverty-stricken parents offered her for sale, and that Abraham and Sarah acquired her during their earlier sojourn in Egypt (12:10–20). As for the meaning of the name "Hagar," it is enough to know that it is a proper name; no more is needed to understand the plot.[4]

2. Mendelsohn, "Slavery in the Ancient Near East," 76.
3. See Freedman, trans., *Midrash Rabbah,* 380.
4. Thus also, Westermann, *Genesis 12–36,* 238; and Wenham, *Genesis 16–50,* Vol. 2, 6.

Socially, a slave in the ancient Near East was "merely a thing belonging to his master with regard to whom he had only duties and no rights whatsoever."[5] The slave, male or female, was just "a piece of property, chattel that could be bought, sold, pledged, deposited, and traded."[6] One might think Hagar could consider herself fortunate to live in the service of a benevolent mistress like Sarah. Yet it seems that, in light of the "misery" to which she became subject as the story unfolds (16:11), Hagar was vulnerable to exploitation in the same way as were other contemporary slaves. Against this background of exploitation, we must understand the sympathy of an impartial God toward Hagar, and his later promises to her and her descendants (16:9–12; 17:20).

Ancient laws revealed in texts spread over two millennia allowed a barren woman to give her maidservant to her husband as a surrogate wife in order to secure children for herself.[7] Jacob's wives, Rachel and Leah (30:4–6, 17–18) practiced this custom. As a result, four of Israel's tribes were born through maidservants. Although God allowed (2 Sam. 12:8) and regulated polygamous relationships under the Mosaic Law (Exod. 21:10; Deut. 21:15–17), such relationships almost always brought complications, such as the exploitation seen in Hagar's story.

Being a tool

The above details put Sarah's demand (Gen. 16:2) into a contemporary-customs perspective. Since Hagar was considered Sarah's property to use as she wished, Sarah addressed Abraham, instructing him (imperative mood, v. 2b) to "go in to" her maidservant; that is, Sarah gave Hagar "to him" as a surrogate "wife" (v. 3). Contrary to popular thought, Sarah did not initiate her demand with a spirit of rebellion to counter God's hand. Rather, she was trying to determine God's will for her (v. 2) based on her unfortunate circumstances and God's partial revelation about the promised seed (16:1). In fact, Abraham's promised seed was not specified to be from Sarah until Ishmael was thirteen years old (16:15; 17:1, 15–17). Against what many are predisposed to think about Hagar's spiritual and moral condition, Sarah's picking Hagar to secure a line for Abraham's inheritance reflects positively on her character.

Being a wife-concubine

After recording that Sarah "took" her slave-girl and "gave" her to Abraham, the focus of the author shifts to Hagar (v. 3). Hagar's social status changes from that of "a slave" to that of "a wife," though not in the primary sense. Formerly, she

5. Dandamayev, "Slavery: Ancient Near East," in *The Anchor Bible Dictionary*, 58.
6. See Alexander and Violet, "The Marketing of People," 145.
7. See Pritchard, ed., ANET, 170; Gordon, "Biblical Customs and the Nuzu Tablets," 3; also Speiser, "New Kirkuk Documents Relating to Family Laws,"; Lewy, "On Some Institutions of the Old Assyrian Empire,"; Grayson and Van Seters, "The Childless Wife in Assyria and the Stories of Genesis".

was Sarah's maid (Heb. *shifkha*); now she becomes Abraham's wife (Heb. *ishah*). Rabbinical interpretations considered that Abraham took Hagar "*to be his wife*, not his concubine. . . . She was to enjoy the full rights of a wife" [emphasis original].[8] Therefore, Hagar's status ranks higher than that of a mere concubine (Heb. *pilegesh*) resembling other concubines in Israel's later history.[9] In the text, Hagar is called *ishah*, literally meaning "a woman," or "a wife" when in relation to a man. Ancient texts imply that the children of such slave women were considered legal heirs of the father's estate, unlike the children of concubines (*pilegesh*) in the later history of Israel.[10]

A comparison of the roles and privileges of a concubine and a wife shows that the two terms were distinct and not interchangeable in later Hebrew narrative (cf. 2 Sam. 5:13; 19:4; 1 Kgs. 11:3; 2 Chron. 11:21).[11] Yet in the patriarchal period the two words were indeed used interchangeably. Thus Abraham's secondary wives (Hagar and Keturah) are referred to as *pilegesh* and *ishah* (cf. Gen. 16:3; 25:1; 25:6; 1 Chron. 1:32). These two words are used together to refer to a category different from that of a wife, yet unlike that of concubine; this middle-class category may be called a "concubine-wife."[12]

With an elevation in status, Hagar had a corresponding change in attitude and behavior, as could be expected.[13] Trible describes the effect of this change: "In making Hagar Abram's wife, not concubine, Sarah has unwittingly diminished her own status in relationship to this servant. But she still retains full control over Abram."[14]

HAGAR'S UNFORTUNATE MATERNAL PRIDE (16:4–6)

Prompted by a change of status

Abraham passively follows Sarah's instructions to take Hagar as a secondary wife. Abraham's apathy is evident as we see him as a "silent, acquiescent, and minor figure in a drama between two women."[15] As a result of her new relationship with Abraham, Hagar conceives, and not only so, but "she saw" that she had conceived (16:4).[16] The change in her social status results in a role change as well, for she boasts in the fact that she is bearing the patriarch's firstborn and

8. See Kasher, "Genesis," in *Encyclopedia of Biblical Interpretation*, Vol. 2, 216–19; and Freedman, *Midrash Rabba: Genesis*, 381.
9. See Hamilton, *The Book of Genesis: Chapters 1–17*, 445.
10. See Cruveilhier, "Le Droit de la femme dans la Genèse et dans le receuil de Lois Assyriennes," 365.
11. See Hamilton, *The Book of Genesis: Chapters 1–17*, 445–46.
12. Ibid., 446.
13. Thus also Janzen, "Hagar in Paul's Eyes and in the Eyes of Yahweh (Genesis 16)," 13, 15.
14. Trible, "The Other Woman: A Literary and Theological Study of the Hagar Story," 223.
15. Ibid.
16. So Janzen, "Hagar in Paul's Eyes," 5.

heir. And with Hagar's increased self-esteem, an inevitable devaluation of her mistress develops,[17] as Hagar is put in a place of rivalry with her. According to Westermann, "The narrator is not describing a gross violation of law and custom by Hagar, but a conflict which was almost unavoidable, which in any case was the natural outcome of the situation, and which recurred again and again."[18]

The action of Hagar is often inaccurately portrayed as "looking on her mistress with contempt,"[19] thus suggesting an attitude of hostility. Unfortunately, the NIV Study Bible generalizes this misinterpretation further in its comments on verse 12c by stating, "the hostility between Sarah and Hagar (see vv. 4–6) was passed on to their descendants (see 25:18)," which is unsubstantiated both in biblical and secular history.[20]

The original Hebrew literally translates, "and Sarah became little in her eyes," where the subject of the verb *became little* is Sarah rather than Hagar. An old Targum correctly translates the expression, "the honor of her mistress was of little value in her sight."[21] Thus, the literal translation of the original would be, "and her mistress became little in her eyes," that is, decreased in status in comparison with her previous position, revealing an attitude of maternal pride on Hagar's part rather than an attitude of proactive hatred or contempt.[22]

Vilifying Hagar can even go much further in this verse, as some have suggested that there should be a connection between Genesis 12 and 16. In chapter 12, the author records that God promised to curse those who curse Abraham (12:3).[23] Hagar's eventual loss of the blessing, they claim, is in direct connection to this promise.[24] Yet, while it is true that those who disdain Abraham bring themselves under God's curse (cf. 12:3), "there is no evidence that Hagar is looked on this way in this story."[25] In fact, if anything, the two theophanies Hagar enjoys in the presence of God later on (16:7–13; 21:17–20), and the blessings uttered over her son Ishmael (17:18), show that the opposite is quite the case. Hagar and her son eventually leave Abraham's home, not because of a divine curse on them, but because God has a different plan for their blessing from that of Sarah's son, Isaac (21:13). Add to that the fact that the verb form of "dishonor" in 12:3 differs from the one used in 16:4, each suggesting a different

17. See Sarna, *The JPS Torah Commentary: Genesis*, 119; Wenham, *Genesis 16–50*, 8.
18. See Westermann, *Genesis 12–36: A Commentary*, 240.
19. Thus the NRSV. See *The Complete Parallel Bible, Containing the Old and New Testaments with the Apocryphal/Deuterocanonical Books, NRSV, REB, NAB, NJB* (New York: Oxford University Press, 1993).
20. See *The NIV Study Bible, New International Version*, 30; the modern conflict of the Middle East does not reflect a pattern sustained in biblical and secular history. See full treatment of Ishmael in biblical history in Maalouf, *Arabs in the Shadow of Israel.*
21. See McNamara, *Targum Neofiti 1*, Vol. 1A, 98.
22. Thus also, Janzen, "Hagar," 5; and Hackett in *Gender and Difference in Ancient Israel*, 12.
23. See Janzen, "Hagar," 6.
24. So Coats, "The Curse in God's Blessing," 31–41.
25. See Wenham, *Genesis 16–50*, 8.

meaning.[26] Scholars' speculation shows how in biblical interpretation our assumptions may determine to a certain extent what we are inclined to see in the text and how to go about finding evidence to back our perspective.

Provoking Sarah to anger

Yet the change in the status and in the nature of the relationship between Hagar and Sarah invites the matriarch to a prompt reaction. Several details reflect Sarah's anger. First, Sarah turns to Abraham instead of Hagar to blame him for the side-effects of the scheme that she herself has orchestrated. Sarah addresses him saying, "my wrong is on you" (literal rendering of v. 5). As head of the patriarchal family, Abraham has the authority to effect changes in the ensuing situation. His possible pampering of Hagar as mother of his firstborn might have exacerbated the tension.

Second, Sarah is dismayed by the elevated position of Hagar, which leaves her devalued in her maid's eyes. Thus Sarah magnifies the problem. Her calling Hagar's pride "wrong" (Heb. *khamas*) is "but the subjective reaction of the one offended,"[27] since the term is seldom used in reference to a woman's action.[28] Sarah's anger may be justified in that while she has turned to Hagar for help, the solicited help is turning out to be costly for Sarah's privileged status. Yet one cannot think of any example involving human exploitation that does not have consequences.

A third aspect of Sarah's anger is displayed in the final address to Abraham. Having told Abraham of Hagar's haughty attitude toward her, Sarah invites the Lord's judgment between her and her husband. Thus she holds Abraham responsible for allowing their marriage to be shaken, requesting from him prompt action.

Facing harsh subjection

Abraham places the matter back in the angry Sarah's hands by saying, "behold your maid is in your hand" (v. 6). Abraham quickly dismisses his marital relationship to Hagar by calling her "your maid." By putting Hagar back under Sarah's authority, the patriarch admits that Hagar's servant-mistress relationship to Sarah will again supersede Hagar's relationship to him as "wife" (v. 3). Abraham prefers to play a passive role, doubtless because of the delicacy of the situation, being caught in the tension between the two women.[29] Therefore, Abraham grants Sarah the freedom to do to Hagar whatever she sees fit. Kidner comments on the situation saying, "Each of the three characters display the untruth that is part of sin, in false pride (v. 4), false blame (v. 5), false neutrality (v. 6); but Sarah's mask soon slipped (v. 6b), to show the hatred behind the talk of justice."[30]

26. Shehadeh, "Ishmael in Relation to the Promises to Abraham," 68–69.
27. See Westermann, *Genesis 12–36: A Commentary*, 240.
28. See Haag, "*khamas*" in *Theological Dictionary of the Old Testament*, 4:481.
29. See also Gunkel, *Genesis*, 192.
30. See Kidner, *Genesis*, 126.

As Sarah was belittled "in the eyes of her" maid, she is to do to Hagar what is good "in your [Sarah's] eyes" (v. 5). Thus the narrator uses the "eyes" reference to point to the reversal. It was Sarah's opportunity to deal with the new condition as it pleased her. Feeling that her privileged status as Abraham's wife was endangered, Sarah was ready, as von Rad expresses it, to "strike back."[31] In her attempt to invert the consequences of her proposal to Abraham, Sarah afflicted Hagar. The Hebrew verb used to refer to Sarah's treatment of Hagar stems from the Hebrew root 'anah; the form suggests the idea of bringing someone under control and dominion by means of harsh treatment that may involve physical abuse.[32] The word will later be used in the book of Exodus to refer to the Egyptians' oppression of the Israelites (Exod. 1:11–12). In connection with that, Yahweh uses the term when predicting the Egyptian servitude of Israel (Gen. 15:13). Hagar finds her way out of this oppression.

Hagar's flight (Heb. barah) out of oppression (Heb. 'anah), will later be paralleled by the Israelites' flight (barah) to the wilderness out of the Egyptians' oppression ('anah) (Exod. 14:5). The difference will be that the roles are inverted. In Egypt, the Israelites are oppressed; here, Sarah is the one who is afflicting the Egyptian woman.[33] Rabbinical tradition held that, "Sarah sinned in afflicting her, so did Abraham in permitting it."[34] The reference to the oppression of Israel in Genesis (15:13) and in Exodus (1:11–12) "frame Sarah's and Abraham's treatment of Hagar and invite the reader to compare their treatment of this Egyptian maid with Egypt's later treatment of the Hebrews."[35] The end of this first scene (Gen. 16:1–6) is quite sad, as "Hagar lost her home; Sarah, her maid; and Abraham, his second wife and the son she is carrying."[36]

HAGAR'S WILDERNESS BLESSINGS (16:7–12)

Fleeing the severity of her mistress, Hagar ends up in the wilderness. There she receives special divine revelation and attention. It is shameful that we often fail to appreciate the impartiality of God in this context. We also fail to empathize with the vulnerable one in her plight. Such is not the case with God, who is occupied with even the trivial details of the lives of those he created after his own image (cf. Matt. 5:45). Certainly God loves Sarah and has a mighty role for her, but it is evident that God loves Hagar as well, and will reveal his plan for her in history. Thus the Lord came to the rescue of the afflicted fugitive

31. See G. von Rad, *Das Erste buch Moses,* 191.
32. See BDB, 776. So Janzen, "Hagar," 7; Hamilton, *The Book of Genesis: Chapters 1–17,* 448; Trible, "The Other Woman," 225; Wenham, *Genesis 16–50,* 9; also, Sarna, *The JPS Torah Commentary: Genesis,* 112.
33. See Hamilton, *The Book of Genesis: Chapters 1–17,* 448; Janzen, "Hagar," 7; Trible, "The Other Woman," 225; and Wenham, *Genesis 16–50,* 9.
34. See Kasher, "Genesis," in *Encyclopedia of Biblical Interpretation,* 2:218.
35. Janzen, "Hagar," 7.
36. Wenham, *Genesis 16–50,* 9.

in the wilderness. A slave-girl pregnant with Abraham's firstborn finds herself vulnerable in a perilous wilderness fleeing the subjection of her mistress. The slave's only protection and provision used to come from the household of her masters. Ironically, after her union with Abraham, marriage—which normally provides security and love for a woman—became a starting point for Hagar to lose everything. Fleeing became her only way out of abuse, yet with no aim or provision, no protection or security. Sin, which is humanity's failure to measure up to God's standards, always leads to complications that only God in his sovereignty is able to resolve—yet not without including consequences.

Surprised by a divine encounter

In the middle of Hagar's despair, the narrator tells his readers, "the Angel of the Lord found her by a well of water in the wilderness" (v. 7). The text gets more specific in pointing to the well "on the way of Shur." Nahum Sarna's comments here offer an objective and insightful perspective: "As between Sarah and Hagar, there is no doubt," he says, "as to where the sympathies of the divine narrator lie. God, the guardian of the weak and the suffering, reveals himself to the lowly Egyptian maidservant, bringing her a message of hope and comfort."[37] The use of the verb "find" (Hebrew, *matza'*) in the Hebrew Bible brings perspective here. In all parallel situations where the subject of the verb "find" is God and the direct object is impersonal, the reference is normally to "God's discovery of sin or evil in somebody" (Gen. 44:16; Ps. 10:15; 17:3; Jer. 2:34; 23:11).[38] However, when the direct object is a person with God as the subject, the verb *matza'* ("to find") "carries a technical meaning going well beyond connotations of the English verb: it includes elements of encounter and of divine election (cf. Deut. 32:10; Ps. 89:20; Hos. 12:5)."[39] This remark supports the rabbinic conclusion that "Hagar was one of the nine righteous women proselytes of the Bible."[40] She is actually the first one in the history of Israel!

Furthermore, the motif of divine appointment and potential marriage "at the well" makes the preceding conclusion even more likely. Well scenery in Scripture reappears later in Genesis (21:19). The author records how God intervenes on behalf of Isaac, providing him with Rebecca at the well of water (24:12–27, 42–48). Moses also met his appointed wife at the well (Exod. 2:15–21). And in the New Testament, Christ holds his meeting with the Samaritan woman at the well of Jacob and introduces himself to her as the giver of living water (John 4). The mention of "the Angel of Yahweh" finding Hagar by the well of water may be a deliberate allusion by the inspired writer to the special attention that God gives to this used and abused woman.[41]

37. See Sarna, *The JPS Torah Commentary: Genesis*, 120.
38. So Hamilton, *The Book of Genesis: Chapters 1–17*, 451.
39. See McEvenue, "Comparison of Narrative Styles in the Hagar Stories," 69.
40. See Kasher, "Genesis," in *Encyclopedia of Biblical Interpretation*, 2:219.
41. For a fuller discussion of the motif of the well in the Bible, see Fishbane, "The Well of Living Water: A Biblical Motif and Its Ancient Transformations".

"The Angel of the Lord" here is most likely a reference to a theophany, since the Angel declares himself to be the one who will multiply Hagar's seed, a blessing that only the Lord could provide (Gen. 16:10). Also, verse 13 says that Hagar gave "the Lord who spoke with her" a name, "El Roi," and she also gave the well a name, "the well of the Living One who sees" (v. 14), thus suggesting that she had encountered the Lord Himself. Later in the story, it is God who hears the voice of the child (21:17), yet it is the Angel of God who calls Hagar from heaven, thus the same person is implied by this interchange. Finally, "the Angel of the Lord" swears by Himself, being the Lord of Abraham (22:16). Thus "the Angel of Yahweh" is very likely a reference to the Lord himself, probably a bodily appearance of the preincarnate Christ.[42]

In any case, Hagar is obviously the object of special divine favor, revelation, and comfort. Biblical references to Shur (Gen. 20:1; 25:18; Exod. 15:22; 1 Sam. 15:7; 27:8), where the divine meeting takes place, point to a location on the southern border of Canaan. It is likely that Hagar traveled quite a distance and became exhausted before her encounter with the Angel of the Lord.

Redirecting Hagar's wandering path

What a lovely surprise for Hagar to hear someone calling her by her name in the wilderness (Gen. 16:8)! This implies God's personal knowledge of her situation and a potential personal relationship. Hagar is quickly reminded, however, of her status as the servant of Sarah. Up until this point, no one in the narrative has referred to her by her name. She has always been spoken of as the slave, even by her own husband, Abraham. Yet the Lord sees her affliction, listens to her distress, and comes to her comfort.

At first, the Angel asks Hagar where she is coming from and where she is going (v. 8). Her short answer reflects her humility by admitting she is a runaway slave, and her aimlessness by failing to supply any direction for her escape. Her short answer, though, sheds light on Hagar's condition. First, she admits to the Angel that she is a slave, having no freedom. Furthermore, she says that she is running away, meaning that she has no power for confrontation. By failing to provide a direction to her flight, she indirectly implies that she has no compensation for being used, with no plan for her future. It is against these three conditions that the Lord will later reverse her situation, through the life of her son (vv. 11–12).

The Angel of the Lord directed Hagar to go back to her mistress and submit herself again "under her hand" (v. 9). The imperative verb "submit" used in this request has the same Hebrew root (*'anah*) as for the verb used in reference to Sarah's *affliction* of Hagar. The difference resides in the middle reflexive voice

42. See Hamilton, *The Book of Genesis: Chapters 1–17*, 450–51; Skinner, *A Critical and Exegetical Commentary on Genesis*, 286-87; and Delitzsch, *A New Commentary on Genesis*, 2:18–21. For a fuller discussion of the options see the excursus of Westermann, *Genesis 12–36*, 242–44; also Lagrange, "L'ange de Iahvé," 217.

yielding a meaning of "subjecting oneself voluntarily."[43] That is, the Angel exhorted Hagar—strange as it may seem—to go back and subject herself again to her mistress, apparently under the same conditions. Most likely, Hagar's return was still necessary, since she had to be cared for by the patriarchal family; it would have been unethical for Sarah and Abraham to refuse to bear the consequences of their choices. Furthermore, Abraham's firstborn had to be born in his house, reared in the godly patriarchal family (18:19), and circumcised in Abraham's home (17:22ff.), before heading eventually to his divinely appointed land. In Jacob's terms, "Hagar's submission was not asked because God approved of her oppression; it was necessary for his plans."[44]

However, God coupled compensation with his instruction that Hagar return to slavery. And such a theme of enabling the called servant to endure reappeared throughout redemption history. God's revelation of his glory to Moses compelled a return to Egypt to face Pharaoh; a divine vision on Mount Horeb enabled depressed Elijah to face Jezebel; and glorious visions of God enabled the apostle Paul to endure multiple adversities.

Likewise, meeting the Lord face-to-face and hearing promises of blessings from him were enough to empower this young bond-slave to accept her circumstances and subject herself voluntarily to her mistress. This may be the reason why, after Hagar's encounter with the Lord and her subsequent return to her mistress, the narrator does not relate any flaw in Hagar's behavior. In fact, Hagar is silent until she leaves Abraham's home again. The slave ends up later being dismissed from Abraham's house not for any wrong she has done herself (Gen. 21), but because of the natural tension over inheritance rights that surface between Ishmael and Isaac, as perceived later by Sarah. Having been the recipient of a special revelation from "the God who sees" her and listens to her, Hagar could much more easily accept her circumstances.[45] An often-overlooked aspect of Hagar's surrender to the Lord is that she did not question the Angel's command, but instead chose to obey him and return immediately to her mistress Sarah, after exalting the One who had spoken with her (v. 13).

Promising a numberless progeny

After directing Hagar to return to Sarah, the Angel of the Lord gave Hagar a message of comfort that helped her endure her circumstances. He promised to multiply her seed (v. 10). In doing so, God gave the slave a promise parallel to the promises given to the patriarchs (cf. 17:2; 22:17; 26:24), though they might have lacked "the covenant context."[46] Thus, Hagar became the only woman in the Bible to whom God gave such a promise of multiplied seed. If one is inclined

43. This is the *Hithpaʿel* stem; see BDB, 776.
44. See Jacob, *The First Book of the Bible, Genesis*, 107.
45. See Tsevat's comments on verse 9 in Matitiahu Tsevat, *The Meaning of the Book of Job*, 60.
46. So Trible, "The Other Woman," 228.

to see an inclusion of Hagar's seed in the promise given to Abraham concerning his own numberless seed, the promise to Hagar was a development of one aspect of the Abrahamic covenant. If, on the contrary, there was no reference to the Ishmaelite line or to the Keturahite line (Gen. 25:1–6) in the initial Abrahamic promises, the promise to Hagar was to be an independent pledge. In either case, Hagar stood as a recipient of divine blessing bestowed only on the righteous and those who received favor in God's sight (Ps. 37:28).

Divine naming for Hagar's son

Having decreed the numberless multitude of Hagar's descendants, the Angel of the Lord went on to announce to Hagar, "Behold you are pregnant, and you will bear a son" (Gen. 16:11). Hagar already knew she was pregnant (v. 4). Yet the newness of the Angel's declaration related to the specifics of the child she was bearing. Hagar would have a "son," and she would call him "Ishmael," meaning, "God listens."[47] A rabbinical tradition says: "Four were named before they were born, viz., Isaac, Ishmael, Josiah and Solomon. Ishmael we see in our text. This applies to the righteous."[48] The reason the Angel gave for naming him "Ishmael" was that Yahweh had listened to Hagar and paid attention to her affliction. Luther wrote that Hagar and her descendants should have been proud of this beautiful name that neither Isaac nor Jacob received. In fact, the name spoke of the Lord's sympathy toward Hagar and Ishmael in their unfavored status.[49]

Interestingly enough, Hagar received the first birth annunciation from heaven in the history of Israel. Raymond Brown draws a comparison between the various annunciations of birth in the Bible, seeing in them common features. This comparison shows that the announcement of Ishmael's birth by the Angel of the Lord and the name God bestowed on him reflected divine grace that put Ishmael in the company of the saints.[50] Thus God counterbalances manmade social classes by granting the lowly—Hagar, in this case—divine favor.

Listening that reverses slavery conditions

God's naming of Hagar's son as "God Hears" (*Ishmael*) was meant to remind her—every time she called his name—of God's attention to his children facing hardship. His revelation to her that he had listened to her affliction (v. 11) became effective in reversing her slavery conditions in the life of her son (v. 12).

The motif of affliction under slavery appears again in Israel's experience under the Egyptians (see Exod. 1–2). As recorded there, God "heard" the groaning of the "sons of Israel" under bondage (2:23–24). His "hearing" of their cries

47. See HALOT, 2:447; and BDB, 1035.
48. See Kasher, "Genesis," in *Encyclopedia of Biblical Interpretation*, 2: 221.
49. See Luther, *Luther's Commentary on Genesis*, Vol.1, 284.
50. See Brown, *The Birth of the Messiah*, 156.

was an active one, and he immediately called Moses to reverse Israel's situation and set the people free (3:1–4:31).

God's "hearing" of Hagar's affliction was active, as would be his "hearing" of the Israelites' groaning. This is why Yahweh's action to reverse Hagar's circumstances of slavery was only started at the prediction of the childbirth of Ishmael (16:11). This reversal of slavery-related circumstances was primarily embedded in the Ishmael oracles delineated in verse 12. Only after hearing that would Hagar be able to go back to endure the slavery she had run away from, awaiting the time appointed by God for the fulfillment of his promises.

Sadly, Genesis 16:12 is the most misunderstood in the whole chapter. A forecast is given that Hagar's son will be a "wild donkey of a man" (Heb. *peré adam*). This prediction makes him a lover of freedom like a wild donkey (*peré*) in the desert. While many view the prediction negatively, the wild donkey image harmonizes well with the context of God's comforting of Hagar in the wilderness and listening to her misery under slavery. The use of animal bynames is customary in nomadic culture; five of Jacob's children later received animal bynames (Gen. 49).

The type of animal determines whether the imagery is meant as a blessing or a curse. Within Bedouin culture and biblical context, the wild donkey is an envied and praised creature, as it is untamable and roams free in the desert (cf. Job 39:5–8; Jer. 2:24; Hos. 8:9). Thus the oracle described the free nomadic lifestyle that would distinguish Ishmael and his line (Gen. 16:12a), with all the struggle it involved for survival in the wilderness (v. 12b). Thus an *enslaved* and *powerless* Hagar, fleeing from affliction under Sarah (v. 6), received a promise of a son who would, in contrast, be *free* and *strong* as a nomad, surviving through power struggle in the wilderness. And indeed, a cycle of nomadic struggle under the direct care of God resulted in the survival of Bedouin tribes related to Abraham from Hagar's time until today.

Additionally, of Ishmael it was said that he would dwell "in the presence" (*al-pené*) of all his brethren (v. 12c). The literal nuance of this term implied geographical proximity. The motif of Hagar's conditions being reversed under slavery applied to this part of the verse as well. In the first section, the enslaved and powerless Hagar was promised a son who would be free and surviving, though through wilderness power struggle. Here uncompensated Hagar, fleeing "from the presence" (*mi-pené*) of Sarah is promised a son who will dwell "in the presence" (*al-pené*) of all his brethren (v. 12c). This proximity to the circle of Abrahamic blessing is a great potential for faith in Yahweh, in the day when Israel walks with the Lord (Jer. 12:16)! However, when Israel moves away from the Lord, it may mean for Ishmael's line further alienation from the Lord and potential rivalry over Abrahamic blessings.

Unfortunately, the Hebrew expression *al-pené*, meaning "in the presence," has been the subject of negative translations, possibly influenced by the inclination to vilify Hagar and her descendants. Thus the NIV portrays Ishmael as

dwelling "in hostility with all his brethren." Yet such a rendering is inconsistent toward the context of "listening" and comfort of the Ishmael oracles. This unwarranted interpretation goes against all early and modern Jewish translations of the term,[51] and it may feed racial antagonism today, both in the Arab-Israeli context and in the rising tension between Islam and the West.

NAMING GOD *EL ROI* (16:13–14)

Marveling at her encounter with the Angel of the Lord and comforted in the promises Hagar heard from him, she realized her privilege. As she listened to the promises, Hagar recognized that she was in the presence of God.[52] Consequently, she became a great theologian, as Hagar called the name of the Lord who had spoken to her, "you are a God of seeing" (*ata 'el ro'i*, v. 13).

It is not quite clear whether the reader should take "Roi" as "a God *who sees*," or "a God *who may be seen*." But ambiguity makes room for both possibilities.[53] At any rate Hagar, the slave woman, stands out as the only person in the Bible to confer a name on deity. People often name family members, things, and sites, "but never . . . one's God, with the exception of Hagar."[54] It is not that God was nameless; rather, for Hagar he had become a personal God. It was as if by naming him "the God who sees," Hagar was saying, "the one who came to my aid in my distress," he is the "God who sees me" (v. 13).[55] She said this to explain why she had given the Lord this name.

Hagar may have wondered both how she came to meet the One who looked after her and how she survived seeing God.[56] Maybe she felt delighted at viewing the back of the Lord, that is, the glory of the God who saw her.[57] Certainly she recognized her privilege as one exalted and comforted by the Lord's presence. Thus she called the well "the well of the Living One who sees me" (v. 14), which the narrator located between Kadesh and Bered.

This moment of naming marked a definite turning point in Hagar's life. The text suggests that she went back to Abraham's house (v. 15). Her son had to be born not in the wilderness, nor in Egypt, but in the house of Abraham his father, where the child had to be brought up until the appointed time. Thus Abraham, at the age of eighty-six years, ended up appropriating the child that Hagar bore to him by naming him "Ishmael" (vv. 15b–16). And the text does

51. See the translation of Genesis 16:12 in Sperber, ed., *The Pentateuch According to Targum Onkelos,* volume 1, in The Bible in Aramaic Based on Old Manuscripts and Printed Texts; *The Torah: The Five Books of Moses: A New Translation of the Holy Scriptures according to the Masoretic Text.*
52. See Tsevat, *The Meaning of the Book of Job,* 65.
53. Thus also Sarna, *The JPS Torah Commentary: Genesis,* 121.
54. See Hamilton, *The Book of Genesis: Chapters 1–17,* 455.
55. Thus Westermann, *Genesis 12–36: A Commentary,* 247.
56. See Booij, "Hagar's Words in Genesis 16:13b," 1–7.
57. As in Exodus 33:23.

not record Hagar speaking again until the end of the Ishmael narrative and the exit to the wilderness.

Listening to the details of her encounter with deity—together with promises that parallel, seed-wise, the Abrahamic Covenant—the patriarchal couple must have thought that Ishmael might be after all the promised seed. In fact, such a possibility is what Sarah envisioned when she made her proposition to Abraham. Here the tension is eased by divine intervention—at least for a while. The lack of further revelation at this point caused Abraham to appropriate his son as legitimate and name him "Ishmael." Hagar was vindicated. For the time being, healing of broken hearts and relationships came from divine initiative, intercepting the wandering path of Hagar, sending her back to the circle of blessing full of hope in the God who Sees, and Listens (16:11, 13).

HAGAR'S EXIT TO THE WILDERNESS (21:14–21)

Prompted by Sarah's vindication

It is interesting to note that the Lord waited until Ishmael was thirteen years old (17:15–16, 25) to promise Sarah a son. For Ishmael had to be raised in a godly fashion by Abraham (18:19) and be put under the Abrahamic covenant through circumcision to benefit from the blessings of that covenant (17:23–25). Ishmael even received great promises from the Lord as an answer to Abraham's prayer for him (vv. 18–20). Once the boy was about seventeen, he departed with his mother, Hagar, to the destination God had set for him (21:8).

But returning to the chronology, the Lord finally opened Sarah's womb, and—when she was ninety years old (17:17)—he gave her a son whom she called Isaac (21:1–3), saying "the Lord has made a laughter for me" (v. 6). Everyone laughed and rejoiced as the Lord vindicated Sarah after a long wait. Most likely around the age of three years, according to ancient Near Eastern customs, baby Isaac was weaned, and they made for him a great celebration (21:8). As Isaac passed the dangerous period of early childhood years and his future became surer, his mother Sarah started reflecting on her earlier move of giving Hagar to Abraham (16:1–6). Sarah became resolved that she did not want Abraham's estate to be split between her son and "the son of this slave woman" (21:10).

The birth of Isaac led to an automatic distancing again between Sarah and Hagar. Before Isaac's birth, Ishmael was the only son Sarah could legally claim. Yet once Isaac was born, Ishmael became merely "the son of this slave woman." Sarah had been awaiting an opportune moment to disclose what was on her heart and settle an old account with her slave. This moment came when Sarah saw Ishmael "joking" (Heb. *metsakheq*) during the weaning party (v. 9).

What Sarah saw need not have been a grave moral failure on Ishmael's part. The Greek Septuagint indicates that Sarah saw Ishmael "playing," adding to the

Hebrew text, "with Isaac her son."[58] The term rendered here as *playing* occurs only once more in the Hebrew Bible (in the absolute form in Genesis 19:14). There, Lot appeared as "joking" (*metsakheq*) in the eyes of his sons-in-law. As a typical Semitic mother, Sarah was looking for the welfare of Isaac. As long as her son suffered social threat, she could not rest. Most likely Sarah had premeditated her demand, and upon seeing Ishmael playing or joking on equal footing with her three-year-old, she had her verdict decided: Ishmael must go. She told of the motivation that had driven her demand: "The son of this slave woman shall not inherit with my son Isaac" (21:10).

The New Testament reference to Ishmael's "persecution" of Isaac (Gal. 4:29) should not affect our understanding of the term *metsakheq*. A closer look at Galatians 4:21–31 shows that the apostle Paul was not talking about physical persecution, but social nuisance reflecting Sarah's futuristic insight, which foresaw Ishmael pursuing an inheritance that belonged to Isaac.[59] Furthermore, Paul inverted the historical order in his use of the Hagar-Sarah allegory (Gal. 4:21–31). He used Sarah, who historically was responsible for the Jewish line, as representing the Gentiles free in Christ. While Hagar, who historically stood behind the line of many Arabs, he used to represent the Jews under the Law embodied in the experience of the Judaizers.[60] But we should not let a common misunderstanding of the Hagar allegory in Galatians dictate our interpretation of the Genesis account.

From a legal perspective, it seems that Sarah found backing for her demand in a contemporary text, which stipulated that "the father may grant freedom to the slave woman and the children she has borne to him, in which case they forfeit their share of the paternal property."[61] Since the text put the decision in that regard in the hand of the father, Sarah asked Abraham to implement that scenario.

In light of the severity of Sarah's demand and regardless of the seriousness of Abraham's concern for his firstborn (21:11), God saw it better for Hagar and Ishmael to live under his care in the wilderness than to remain in Abraham's house. Nevertheless, Ishmael was included in the blessings of the Abrahamic covenant (17:23–25), and God had and has a special plan for Ishmael's line in secular history that differs from his plan for Isaac (21:13). This vision is the primary reason for God's summoning Abraham to listen to Sarah's voice, and not because he wished to curse Ishmael, as it may seem to the casual reader.

Implemented by concerned Abraham

The biblical text says, "Early in the morning Abraham took bread and a skin of water and gave them to Hagar putting them on her shoulder and the child

58. See Brenton, *The Septuagint with Apocrypha, Greek and English*, 24.
59. See the full treatment of Galatians 4:29 in Maalouf, *Arabs in the Shadow of Israel*, 100–104.
60. Ibid.
61. See Sarna, *The JPS Torah Commentary: Genesis*, 147.

and sent her away" (21:14). This last sentence does not mean that Abraham literally put Ishmael on Hagar's shoulder, as the boy was a teenager by then.[62] The concern of Abraham is indicated both by the reference to his provision and his early rise, so as to avoid the heat of the day, and also by the fact that "he dismissed her" (Heb. *shlkh*), which is a verb less strong than Sarah's demand of casting her out (*grš*).[63] This difference of nuance may also imply a dismissal with blessing.[64]

Having left Abraham's house, Hagar and Ishmael wandered in the wilderness of Beersheba in a place likely located at the southern border of Israel as indicated in the formula "from Dan to Beersheba" (Judg. 20:1; 1 Sam. 3:20; etc.). Her tears and sad circumstances possibly contributed to Hagar's loss of direction. To make matters worse, she ran out of water (21:15a) and ended up casting her son under a tree (v. 15b). Her action indicates exhaustion. Since Ishmael was at death's door, casting him under a tree would at least allow her son to "die in the shade."[65]

How can anyone read this story carefully without being filled with compassion for this homeless single mother and her dying son? Hagar withdraws herself from the scene of agony and utters a sad prayer: "Let me not see the death of the child" (v. 16). Hagar in a sense "utters one of the first prayers in the Bible."[66] She sat "far enough away to be able to let her tears run freely."[67] Naturally speaking, there was no more hope for Abraham's firstborn, and a fading one for his slave-wife. Ironically, this maidservant had been set free against her will, only to face death in the wilderness of Beersheba. She had left her slavery within the circle of blessing to become sovereign in a land of thorns and thistles. Only a display of God's redemptive work could rescue Hagar and her son. Only a divine irruption in time could change the course of events.

Intercepted by a God who listens

Having promised repeatedly to make Ishmael a great nation (Gen. 16:10–11; 17:20; 21:13), God could not let Hagar and Ishmael perish in the wilderness. But since the shadow of death allows salvation's light to shine brighter, God heard from heaven the agony of the dying child (21:17a). When Hagar was unable to bear the cries of her son, God heard him "where he was" (v. 17c). This indicates that Ishmael (*God Hears*) was not forsaken or forgotten by God.

62. A rabbinical tradition notes: "This, however, teaches that Sarah cast an evil eye on him, whereupon he was seized with feverish pains." See Freedman and Simon, eds., *Midrash Rabbah*, vol. 1, 472.
63. See also Jacob, *The First Book of the Bible, Genesis*, 138; also Hamilton, *The Book of Genesis*, 82.
64. So Westermann, *Genesis 12–36: A Commentary*, 341.
65. Ibid.
66. See Hamilton, *The Book of Genesis*, 83.
67. See Jacob, *The First Book of the Bible, Genesis*, 138.

In fact, Ishmael's name indicated the contrary. Thus God called to Hagar from heaven and exhorted her to lift up her son with a strong hand. The Lord also reassured her of the great future that awaited the lad (v. 18). Since the Hagar/Ishmael narrative began, this is the only place where Hagar is referred to by her name without qualification. Prior to this, when the Lord spoke to her (16:7–8), he called her name and immediately reminded her of her social status as Sarah's slave. In that encounter, God encouraged Hagar to go back to her mistress, as Ishmael had to be born and reared in Abraham's house. But in the present scene, God addresses the former slave purely by her name, "Hagar." No more qualification. Finally, though not without great suffering, she is free.

The LORD opened the eyes of the emancipated slave to see the well of water (21:19a). Fortunately, Hagar's wilderness is always coupled with a well that illustrates divine grace extended to the outsider. Back in her previous encounter, the well was where she met the Angel of the Lord (16:7). Here she did not see his provision. Possibly the gloominess of the situation and the tears that filled her eyes kept her from seeing the well, even though it was always there. Thus, with divine intervention and assurance, Hagar hurried to fill the skin of water and give it to her child (21:19). And God's intervention went beyond providing water for survival.

Despite its intense moments, the Hagar/Ishmael narrative ends on a happy note. The narrator notes the presence of God with Ishmael to prosper his life: "And God was with the lad, so he grew up, and dwelt in the desert, and became a bow hunter" (21:20). A rabbinical tradition comments on the phrase "with him," saying that it "means with him, his ass-drivers, and his camel-drivers and his household."[68] A logical inference is that Ishmael walked with the Lord.

Hagar the Egyptian secures an Egyptian wife for her son (21:21). It seems that the freed slave finally has returned to visit her native land. As a resourceful mother, she looks after Ishmael's welfare. Most likely she reunited with her family; and as someone who had twice experienced the tangible presence of God, she must have become the first Egyptian witness to Yahweh. Her son also was a living witness to God's listening grace, as he embodied the listening that the Lord extended to his mother (16:11–12). Both mother and son settled in Paran, a land that became known for the gracious presence of God (Hab. 3:3, 7).

The account of Hagar is, after all, a beautiful story of the divine redemption of human failure. It is a story of God's coming to the rescue of the marginalized and the social outcast. We see in it the thorny road from bondage to freedom—a road that yet abounds with the fragrance of the gracious dealings of a "God who Listens" and a "God who Sees" his children wherever they are and whoever they may be.

68. See Freedman and Simon, *Midrash Rabbah,* vol. 1, 474.

QUESTIONS FOR DISCUSSION

1. What does Hagar's story reveal about the character of God?

2. How does Hagar's story help us better understand Jewish/Arab relations today and how Christians should view them?

3. Which of Hagar's characteristics challenges you to be a better disciple?

ERA OF JUDGES

DEBORAH: ONLY WHEN A GOOD MAN IS HARD TO FIND?

RON PIERCE, PHD

Unwarranted criticisms of Deborah's remarkable leadership, honored in Judges 4–5, have been common throughout history and persist. Wayne Grudem provides a notable contemporary example when he asserts regarding this passage, "Something is abnormal, something is wrong—there are no men to function as judge!"[1] Others further diminish the significance of Deborah's ministry by speculating that her work is done only in private[2] or that she is actually submitting to Barak's leadership by calling him.[3] Rabbinical scholars branded her an arrogant woman who is punished by God.[4]

Through a careful reading of the story and song of Deborah and Barak, this essay will argue that the Spirit of God intends to communicate exactly the opposite. Deborah may more accurately be described as a "woman of valor" (like the "woman of noble character" or "excellence" [Heb. *eshet hayil*] in Prov. 12:4;

1. Grudem, *Evangelical Feminism & Biblical Truth*, 134. Grudem's evident surprise at Deborah's function in this text runs counter to the work of Myers, *Discovering Eve*; updated as *Rediscovering Eve: Ancient Israelite Women in Context*. Myers argues that women in ancient Israel played important roles in their culture in judicial and legal affairs, as well as religious observance. See the application of Myers's earlier work to the Deborah story and song by Ackerman, "Digging Up Deborah: Recent Hebrew Bible Scholarship on Gender and the Contribution of Archaeology."
2. Schreiner, "The Valuable Ministries of Women in the Context of Male Leadership" in Piper and Grudem, *Recovering Biblical Manhood and Womanhood*, 216.
3. Finley, "The Ministry of Women in the Old Testament," 81.
4. Bronner, *From Eve to Esther*, 170–74. For a brief history of interpretations of Deborah and Jael, see Yee, "By the Hand of a Woman," 117–24.

31:10; Ruth 3:11),[5] as she responds to God's calling in her life under the most difficult of circumstances. Likewise, Barak is better understood as a person of faith, because he honors God in this account by following Deborah's leadership (cf. Heb. 11:32). Even Jael—the other courageous woman in this account—is called "most blessed of women" by the biblical poet (5:24). Indeed, this is a biblical text to be celebrated—not qualified or lamented.

The larger pericope under consideration divides naturally into a prose battle account (Judg. 4) and a poetic victory hymn (Judg. 5)—both regarding the military crisis with the Canaanite army at Hazor and the subsequent deliverance of Israel by Yahweh through the prophet and judge Deborah, her military general Barak, and Sisera's unlikely nemesis: the Kenite woman Jael.

DEBORAH'S STORY: A WOMAN OF VALOR AT A TIME OF CRISIS (JUDGES 4)

The story's setting (4:1–3)

The biblical author paints a brief yet foreboding historical, geographical, and theological backdrop to this narrative. This backdrop consists of a distressingly repetitive pattern of spiritual corruption among God's people, the resultant divine judgment that leads Israel into military oppression by other local tribal groups, and Israel's plea for deliverance that causes Yahweh to send a deliverer to bring peace until the next repetition of this sad cycle begins.[6] As the first of four[7] longer accounts, Deborah's story follows three shorter narratives of the judges Othniel, Ehud, and Shamgar (Judg. 3). Deborah is the first leader to be introduced at length in the book of Judges, and the only one to function as both prophet and judge.

The severity of the situation Deborah faced is compounded by the disturbing assessment, "Yahweh sold [Israel] in the hand" of the Canaanites—a divine, albeit temporary, abandonment of the chosen people. More specifically, these "Canaanites" were local non-Israelites identified with King Jabin's capital city of Hazor and his military general from Harosheth-hagoyim, Sisera, who commands nine hundred iron chariots. Hazor was the guardian of the northern entrance to Canaan under Joshua's conquest (Josh. 11:10). Its ancient ruins still

5. When the Hebrew term *hayil* is used of men, it is variously translated in the NIV as "special ability" (Gen. 47:6), "capable" (Exod. 18:21, 25), "strong" (Judg. 3:29), "of standing" (Ruth 2:1), etc. Since these characteristics also describe Deborah in Judges 4–5, the use of the term seems appropriate in this essay.

6. This is evident in the naming of the twelve judges in this book (also including Gideon, Tola, Jair, Jephthah, Ibzan, Elon, Abdon and Samson) and the seven foreign oppressors (also including Aram-Naharaim, Moab, Midian, Ammon and Philistia), along with their respective years of war and peace. To be complete, however, one should include the only judge who, like Deborah, is also a prophet—Samuel, the last of the judges (1 Sam. 1–8).

7. The others are Gideon (chs. 6–8), Jephthah (chs. 11–12) and Samson (chs. 13–16).

cover 175 acres (compare David's capital at Jerusalem, which covers only fifteen acres). Moreover, Harosheth-hagoyim is best translated "cultivated field of the Gentiles" referring to the plains in the Jezreel Valley near Mt. Tabor, just north of Mt. Carmel, a relatively flat area where iron chariots could function (cf. Judg. 4:7, 13; 5:21; Ps. 83:9; also Elijah's battle in 1 Kings 18:40). Taken together, the Canaanites, a formidable enemy, controlled the strategic trade and military route in northern Israel that connects Africa, Europe, and Asia—including the tribal territories of Naphtali and Zebulun (cp. Judg. 4:6). Moreover, their oppression of Israel had already lasted twenty years by the time of Deborah.

Identifying Deborah's own location is also important for fully appreciating the task she faced. Her area of influence was further south in Israel's central region connecting (what would later become known as) the territories of Samaria and Judea. Her being specifically situated "between Ramah and Bethel in the hill country of Ephraim" affects our understanding of her story in two ways. First, with Bethel more that seventy miles south of the Zebulun and Naphtali territories, Deborah was far removed from the place and circumstances of the conflict. She was safe in the isolated hill country, out of the reach of Sisera's chariots; whereas Barak lived in the place of conflict as part of the community of Kedesh in Naphtali, south of Hazor near the Sea of Galilee.[8] Second, Deborah's strategic location between Ramah and Bethel suggests that she had a regional reputation and function, like Samuel who later led Israel with his base of operation in this same territory (1 Sam. 7:15–16; 8:4). These commonly acknowledged facts aid greatly one's interpretation of this narrative.

Deborah's dramatic introduction (4:4–5)

The narrator of Judges strings together seven consecutive, grammatically feminine Hebrew words in order to introduce this story's main character: "Deborah, a woman, a prophet (fem. noun), a woman (repeated) of light/fire (fem. noun), she herself (added pronoun for emphasis), she was judging (fem. participle)." Several of these are worthy of discussion. For example, Deborah's name can denote "honey bee" (the traditional etymology), or may be associated with a different Hebrew root meaning "to lead or pursue."[9] The imagery of bees was later used by the prophet Isaiah to describe God's use of the Assyrian army against Israel (Isa. 7:18), and could make sense in Deborah's story. However, the mention of "prophet" and "judge" in this sentence fits better with the idea of Deborah "leading" Israel to "pursue" the enemies of the northern territories. Either understanding of the meaning of her name could carry symbolic significance.

Three pairs of words follow in the text. The first, "woman prophet," is slightly redundant in English, and therefore often translated in truncated form

8. The southern Kedesh is more likely the point of reference based on the geography of this story. See Way, *Judges and Ruth*, 44; also, Rainey and Notley, *The Sacred Bridge*, 136–38.
9. Hess, "Israelite Identity and Personal Names from the Book of Judges," 26.

as "prophetess."[10] However, "woman prophet" better reflects the emphasis of the Hebrew text, especially since contemporary English generally no longer adds feminine endings to nouns (i.e., "prophet-ess"). Either way, the author highlights Deborah as a woman who is functioning in a prophetic role. This emphasis becomes even more pointed with the second pair of words: "wife of 'Lappidoth,'" which is traditionally taken to be her husband's name—although the common reference to the man's father is missing (cf. "Barak, son of Abinoam" in Judges 4:6, 12; 5:1, 12). However, it seems more plausible to translate the phrase as, "a woman of fire," since the same word (Heb. *lappid*) is rendered "torches" in the Gideon story (Judg. 7:16); and "torch" in the Samson story (Judg. 15:4).[11] The remarkable emphasis on her being a woman prophet and judge suggests translating (rather than transliterating) this word. One could understand her as "a woman of light" in the sense of "giving spiritual guidance,"[12] or a "woman of fire,"[13] as a parallel to Barak's name meaning "lightning." Perhaps the writer even intended a dual meaning of guidance and valor—that is, a wise woman with great courage. Finally, the last two words in this string read (literally), "she herself, she was judging." In Hebrew, the pronoun is embedded in the verbal form, so that adding an additional pronoun (as the writer does here) puts an emphasis on her gender. Deborah is the only one already in divine service before she called Barak to military action. Her prior commissioning is likely the reason that she was not explicitly "raised up" for service on this special occasion, as were the other prophets and judges in this biblical book.[14]

In sum: This powerful, sevenfold emphasis on Deborah as a fiery woman prophet and authoritative judge prepares the reader for her summons of, and interaction with, Barak (4:9), Jael's surprising assassination of Sisera (4:16–21), and Deborah's lead role in the battle, as well as in the victory hymn of chapter 5. She is the "woman of valor" in this story—although not because "a good man is hard to find," as we shall see even more clearly later in the story.

Before leaving Deborah's introduction, a word is in order regarding the function of prophets and judges at this time. Israel had three official offices of leadership: prophet, priest, and king. In brief, the prophet spoke on behalf of God to the people, while the priest spoke on behalf of the people to God. In comparison, the king gave general leadership to the people, sometimes leading

10. So NRSV, NKJV, ESV; NIV simply has "prophet"; HCSB reads "a woman who was a prophetess."

11. Hess, "Israelite Identity," 33–34. This term occurs elsewhere in the Hebrew Bible meaning "torch/torches" (Job 41:19; Isa. 62:1; Ezek. 1:13; Dan. 10:6; Nah. 2:4; Zech. 12:6), although not with the identical grammatical ending found in Judges 4:4.

12. See Way, *Judges and Ruth*, 44.

13. See Talmud *Bavli Megillah* 14a, "a woman of flames" or "fiery woman"; cited in Gafney, *Daughters of Miriam*, 188, n. 42. See also Sasson, *Judges 1–12*, 255–56; Fewell and Gunn, "Controlling Perspectives," 391.

14. For examples, see Judges 2:16, 18; 3:9, 15; 6:–87, 12.

them in battle (David) and at other times enforcing justice based on the Law of Moses (Solomon). Each of the three was to be responsible to the other two in important ways. The prophet and priest served under the leadership of the king; the priest and king were to obey God's word through the prophet; and the king and prophet depended on the priest to offer sacrifices on their behalf. Through this threefold leadership model, God established a balance of power. With that in mind, judges can be seen as an earlier and less formal version of the kings who appear later. Judges were dissimilar to kings in that the former were raised up from among the people on occasion of need and led a volunteer army, whereas the latter were generally appointed by succession, eventually lived in palaces, and managed standing armies. Judges, however, were similar to kings in that both normally had sustained periods of recognized leadership that went beyond an immediate military crisis and extended over a time of peace.

So how does this help us understand the function of Deborah in the story? First, she was a prophet, meaning she brought God's authoritative word to God's people—a word they were expected to obey. Second, she was "judging" Israel at this time, meaning (for her specifically) that she gave prophetic leadership to her people based on Israel's Torah—in which she would need to be well-versed. Further, she gave her "judgments" (Heb. *misphat*) at a site named after her ("Palm of Deborah") in a central location that allowed for people from multiple tribes to seek out her guidance (4:5). Thus, her national influence reached beyond that of tribal and village elders who settled local, civil disputes.[15] Clearly, the people of Israel recognized and honored Deborah's leadership among them.

To further set Deborah's function in historical context, we should note as well that there was only one other person in the era of the judges who held the dual role of prophet and judge: Samuel (1 Sam. 1–8). Following the example of Deborah who preceded him, he also exercised his leadership between Ramah and Bethel (1 Sam. 7:15–16). Thus, Deborah's dual responsibilities set her apart as having a wider sphere of influence in comparison to the rest of her contemporaries in the book of Judges. She is placed on the par of Samuel, Israel's last—and arguably most significant—judge.

Deborah summons and commands Barak (4:6–7)

The language of the text, "[Deborah] sent and summoned Barak" (NASB, NRSV, ESV) is striking, and consistent with Deborah's responsibilities as prophet and judge. She did not merely send a request to him, but rather insisted he appear before her at the "Palm of Deborah," her recognized place of prophetic work. Moreover, the cryptic nature of the text suggests that he responded without hesitation. Upon his arrival, she confronted him with classical prophetic

15. See Way, *Judges and Ruth*, 22–23. For the common interpretation of Deborah as one who settles civil disputes, see Belleville, "Women Leaders in the Bible," in Pierce /Groothuis, 112, n. 8.

rhetoric: "Yahweh the God of Israel commands you, 'Go and gather 10,000 men from Naphtali and Zebulun.'" With these words, Deborah proved herself a fiery prophet delivering an oracular word of judgment from Yahweh.

The geographical references in these verses to Kedesh, Naphtali, Zebulun, Mt. Tabor and the Kishon River, together call to mind the international ramifications of this national crisis (see above at 4:1–3). If the strategic Jezreel Valley was controlled by the Canaanites, along with the northern Jordan Valley passageway to Lebanon and Syria, Israel would be confined to the considerably smaller territory of the central hill country, with virtually no access to the great trade routes to Egypt and the Far East. This was a crisis of extraordinary proportions, calling for the best of Israel's leadership.

One might ask, "Why did Deborah even send for Barak?" If she was the courageous and authoritative prophet and judge, why did she not simply lead the army into battle by herself (like Gideon and Jephthah), or singlehandedly fight the enemy by divine empowerment (like Shamgar and Samson)? The most reasonable answer is that Barak from "Kedesh in Naphtali" (cf. 4:10) already knew the local situation in the north, the people who lived there, and the topographical terrain on which he would fight. Because of this, he was the best person to function as a general under the command of Israel's premier prophet and judge Deborah—though both would be present in the fray of battle.

Deborah's prophetic commissioning of Barak (4:8–11)

Barak's puzzling response to Deborah's prophetic command, along with her equally concise—yet slightly mysterious—counter-response to him, has been the source of much dispute among commentators and interpreters of this account. This section will sort out several of the key issues, while seeking to dispel some of the misconceptions.

Barak's response to Deborah's command (v. 8)

In his terse comment in verse 8: "I will go, but only *if you go with me* (NLT, italics mine)," Barak submitted to Deborah's orders (as he should to the word of God through a prophet), but with a curious condition attached. Here one must ask, "Was a good man really hard to find?" It is not uncommon to hear criticisms of Barak's insistence on Deborah's presence in the battle. For example, one writer asserts, "Barak's lack of faith prompted Deborah to predict that the honor of killing Sisera would belong to a woman."[16] Some even see her rhetoric rising to the level of an intentional shaming of this man by the lead woman.[17] But, given the evidence of his bravery later in the account (4:10, 14–16, 22), it is far more likely that Barak wished to have available to him the wisdom and prophetic voice

16. Wolf, *Judges*, Expositor's Bible Commentary, Vol. 3, 404–04.
17. Yee, "By the Hand of a Woman, 114–17.

of Deborah while in the uncertainty of battle.[18] As far as one can determine the motive behind Barak's response, the evidence points to his being a "good man" and person of faith. More specifically, the assessment of Barak's character elsewhere in Scripture provides crucial, interpretive clues supporting this conclusion.

In addition to Judges 4–5, Barak is mentioned only twice in Scripture: 1 Samuel 12:9–11 and Hebrews 11:32–38. In the former text, Samuel provides a shorter list of some of the warrior-judges: Jerubbaal (Gideon), Barak, Jephthah and Samuel (himself). His emphasis is on divine deliverance of Israel through these persons sent by God. In the latter passage, Barak is listed among the great persons of faith from Abel's righteous sacrifice, to Abraham and Sarah's obedience, to Moses's leadership in the Exodus event, to Rahab's assistance in the conquest (vv. 1–31). Again, he is placed in the company of warrior-judges/kings such as Gideon, Samson, Jephthah,[19] Samuel and David. Moreover, the writer strikingly describes them as persons "who through faith conquered kingdoms" and "administered justice" (11:33), men who were "commended for their faith" (11:39)—indeed, believers of whom "the world was not worthy" (11:38).[20]

Both of these references to Barak portray him in a positive light as a courageous warrior and person of faith (i.e., "a worthy man").[21] Because of this biblical witness to his faith, assuming his cowardice in Judges 4:8–9 would run counter to what is known of him in the New Testament's evaluation of his character (Heb. 11:32–38). Therefore, we must reconsider traditional interpretations of his statement, "I will go, but only if you go with me" (NLT). This is arguably a statement of faith reflecting his willingness to go, and at the same time his respect for Deborah's role as a prophet and judge who can provide critical guidance when a field decision is needed. No, a good man was *not* hard to find! Rather, this is a wise response of a good man to the leadership of an equally good woman.

Deborah's counter-response to Barak (v. 9)

Deborah's reply as the prophet and judge (vv. 9–10) affirms Barak's compliance, yet adds a surprising challenge to him as a warrior. She says, "I will surely go with you; nevertheless, the honor shall not be yours *on the journey that you are about*

18. See Belleville, "Women Leaders in the Bible," 111, n. 6; also,. Moore, *The International Critical Commentary: A Critical and Exegetical Commentary on Judges*, 116–17. This is similar to King Jehoshaphat's insistence on obtaining wise counsel from Yahweh through his prophet Micaiah before going into battle (1 Kings 22:5–9; 2 Chron. 18:4–7).

19. These other three significant judges (Gideon, Samson and Jephthah) are also frequently misunderstood as simply having failed in their character. Yet, in light of their inclusion in the Hebrews 11 "persons of faith," a reconsideration of their stories is in order as well.

20. Because Deborah is not listed by name with Barak in Hebrews 11:32, one might assert an argument from silence challenging the appropriateness of her judgeship. However, the six men listed together are likely grouped as warrior-judges. Additionally, the men's names are followed by the phrase (in the same verse) "and the prophets," which would include Deborah.

21. Cf. the use of the Heb. *ish hayil* for "vigorous and strong" [enemy] warriors in Judg. 3:29.

to take, for the LORD will sell Sisera into the hands of a woman" (NASB, italics mine). Three interpretive issues are worthy of brief discussion. First, Deborah immediately, willingly, and emphatically consented to accompany Barak into battle as a wise advisor. This was based on her public track record of prophetic judgments drawn from both divine revelation and Torah. She gave no hint in her statement that it was inappropriate for him to insist on her presence.

The second matter requires a closer look at the translations of the central phrase in verse 9: literally, "on the journey [Hebrew *derek* = "path, way"] that you are about to take" (NASB; the ESV reads, "the road on which you are going"). Some interpreters understand *derek* in a more figurative way, to mean "regarding a course of action" (cf. NIV). This leads to speculations of a supposed resistance by Barak to God's call through Deborah, even mocking her commissioning speech,[22] or perhaps suspicion of her authority as a woman,[23] or even a diminishment of Barak's portrayal as a "hero."[24] A most striking example of this interpretation is found in *The Message*: "Of course I'll go with you. *But understand that with an attitude like that, there'll be no glory in it for you*" (italics mine)" But again, casting doubt on Barak's response flies in the face of the New Testament's reference to him as a person of faith (Heb. 11:32). Moreover, this is the only account of Barak's action to which the writer of Hebrews could be referring.

Third, what is one to make of Deborah's rejoinder that the honor of victory in the conflict would not be given to Barak, but instead would go to a woman—later identified as "Jael, the Kenite" (4:17, 21–22; 5:6, 24)? Were Jael's privilege and honor accrued only because of Barak's fainthearted resistance to Deborah's command from Yahweh? Or is it not more likely that this was the remainder of her now-completed commissioning speech (4:6–7, 9), which had been interrupted by Barak's eagerness to comply and secure her accompaniment (4:8)? The latter seems more likely. Indeed, Deborah was not chosen and used by God because a good man was lacking in Israel. Rather, she was in her own right a woman of valor, a faithful prophet, and nationally recognized judge in her time (4:4–5), who supplemented her own limited gifts and calling by choosing a strong counterpart—a complement, if you please—to partner with her in rescuing Israel from a national crisis. Barak's insistence that she accompany him should be understood as no less than an appropriate plea for the presence of God. He implicitly recognized Deborah's seasoned wisdom and vital connection with God's will and word.

Their journey begins (vv. 9b–11)

After both Deborah and Barak made verbal commitments regarding this divinely commanded journey, they put action to their words. A dual reference (4:9, 10) to

22. Block, *Judges, Ruth*, The New American Commentary, Vol. 6, 199.
23. Fewell and Gunn, "Controlling Perspectives," 398–99.
24. Webb, *The Book of Judges*, 186.

Deborah's action brackets this final section. At the close of verse 9, the text reads, "Then Deborah *arose* and went with Barak" (ESV, italics mine; Hebrew *qum* = "arise, stand up"). Thus far, they had spoken beneath the "Palm of Deborah," where she "sat" to render her oracular decisions as "the Israelites came to her for judgment" (4:5). But now, she decisively "arises" to leave this place in honor of her promise to accompany Barak on his arduous—yet divinely appointed—seventy-mile journey. Likewise, Barak keeps his word, not only to go but also to obey God's command through the prophet who called him (4:6, 10). The journey that he was about to take (4:9) had commenced. But, as it does, the author briefly introduces the tribal community of the Kenites, from which will come the other courageous woman, Jael, and to whom the honor of victory will eventually go. More will be said about her background and role in this story below at 4:17–23.

Deborah's commanding presence in the battle (4:12–16)

The relationship between Deborah and Barak is best described as a commander-in-chief accompanying her general-of-the-troops. Both willingly put themselves in harm's way, taking significant risks in response to God's calling and to be a part of Israel's deliverance. At the top of Mt. Tabor—a rounded mountain in the middle of the Jezreel Valley—Barak assembled his army of local foot soldiers from the territories most affected by the conflict, Zebulun and Naphtali. Prepared for battle, he awaited Deborah's command. Meanwhile, his actions evoked a countermove by Jabin's general-of-the-troops, Sisera, who called out nine hundred chariots of iron into the open plains a few miles west of Barak's position. Then Deborah issued the official order to strike: "Arise! This is the day in which Yahweh has given Sisera into your hands! Has not Yahweh gone out before you?" She did not merely give Barak information with which he could make a decision about engaging the enemy. Rather, she combined her roles of prophet and judge by commanding him once again to act, as she had done at the first (4:6–7). And, once again, Barak responded by following the word of Yahweh through Deborah. Moreover, this time his obedience reflected his heart of faith even more clearly. He experienced the sobering truth that the enormous risk of leading foot soldiers into combat against iron chariots would *not* honor his brave leadership. Nevertheless, he was willing to engage this formidable opponent, knowing that someone else—indeed, a woman—would eventually receive the credit. In Barak's obedience the person of faith celebrated in Hebrews 11 is revealed. Therefore, it is not only important to understand Deborah's place in this story as a courageous and godly prophet and judge, but also to see such a notable example of this man—"of whom the world was not worthy" (Heb. 11:38)—who was willing to follow her leadership at such great personal sacrifice.

Consider as well the blessing of God on the accomplishments of Deborah and Barak in this account.[25] Exactly as she had predicted, Yahweh "routed Sisera and

25. It is worth noting here that Huldah is the only other woman prophet who reveals the

all his chariots and all his army before Barak by the edge of the sword" (4:15–16, ESV). Notice the intentional contrast here between Sisera's "iron chariots" and Barak's "swords." The early readers of this text would have no doubts at this juncture that Deborah and Barak had believed and behaved in a manner worthy of receiving God's full blessing. Yet, as the general of God's people pursued his enemy, a surprising turn of events appeared in the narrative as a less-than-honorable Sisera abandoned his troops in the thick of battle and escaped their slaughter on foot. His cowardly decision set the stage for the continuation of, and conclusion to, the earlier brief mention of the community of Kenites in 4:11.

Military honors to Jael—the other courageous woman (4:17–23)

The next section begins by restating, for emphasis, that the powerful Canaanite general Sisera ran away from the battle on foot (cf. 4:15). The author directly contrasts his cowardice with the courage of Barak, a man who continued to pursue him—also on foot from the beginning of the battle. At this point the writer is especially keen on recounting the exploits of the daring Jael—also made a "vixen" by many interpreters—both in this story and the victory song that follows (5:24–30). Vindicating her in the larger story of Deborah is appropriate in this chapter as well.

A brief explanation of the background of the Kenites helps us understand Jael's part in this story. Combining information from their mention earlier (4:11) with the text under consideration, it becomes clear that Jael was not Israelite. Rather, she was a descendant of Hobab, son of Jethro/Reuel (Exod. 2–4,18; Num. 10:29–32), the father-in-law of Moses. By the era of the judges, the Kenite clans had migrated northward from the Midianite territory near Mt. Horeb (Sinai) and settled near Arad, in the Judean Negeb just east of Beersheba (Judg. 1:16). By the time of Deborah, Jael's group had separated itself from the rest of the Kenites and migrated (literally, "pitched their tents") to Naphtali territory, where her family had allied with King Jabin to live under his protection (4:11, 17).

Just as Deborah is called "woman/wife of 'Lappidoth'" (Judg. 4:4; see discussion above *ad loc.*), so Jael is called "woman/wife of Heber" (Judg. 4:17, 21; 5:24). Here again, the word could be transliterated as her husband's name connected with his tribal affiliation (the traditional reading, although again his father's name is absent), or translated as a woman in the "community" of Kenites,[26] or even as a "woman of divination."[27] Given the way she acts independently in

future, and for whom it comes to pass as she says (2 Kings 22:3–20; 2 Chron. 34:3–33).

26. The understanding of *heber* as a common collective noun was first asserted by Malamat, "Mari and the Bible: Some Patterns of Tribal Organizations and Institutions,"146. His work is followed by Soggin, *Judges*, 65–66; as well as by Bos, "Out of the Shadows: Genesis 38; Judges 4:17–22; Ruth 3," 52. Despite these reasonable (perhaps compelling) arguments, most contemporary OT scholars contend with this interpretation, including Butler, *Judges*, 100.

27. For the argument that *heber* means "diviner," see Sasson, *Judges 1–12*, 261–71; also,

the story, it is more plausible that the writer wishes to identify her only with her people or occupation, rather than with a husband.

Regardless of the meaning of *heber*, the writer describes Jael as nomadic and independent with no apparent allegiance to Israel. Both aspects of Jael's background provide context for her actions in the story. Sisera escaped the fighting, seeking refuge anywhere he could find it. Jael recognized him and lured him into her tent. Alone with him, she hid him under a rug and provided him with milk to drink (4:18–19). Sisera's gender-specific words to Jael are pointed: "Stand in the opening of the tent, and if any man [*ish*] comes and inquires of you saying, 'Is there a man [*ish*] here?' tell him 'No one [*'ayin*]!'" (4:20).[28] This language is a clear allusion to one "man" (Barak) hunting for the other "man" (Sisera), with the much anticipated "woman" (4:9) literally standing between them, about to rob Barak of his glory.

With courage, craft, and cunning—not unlike that of the judge Ehud, who assassinated King Eglon of Moab (Judg. 3:15–23)—Jael fulfilled Deborah's prophecy of military honor going to a woman (4:9). Stealthily she picked up a convenient tent peg and, as Sisera slept in sheer exhaustion from his frantic escape, hammered it through his head (4:21). Then, Jael proudly announced her assassination of the Canaanite general by going out of the tent to meet the arrival of Barak. She brought him back inside to display her trophy of victory, and with it her defection to Barak and the victorious Israelite army (4:22).

Appropriately, the story ends (4:23–24) with a closing emphasis on the true hero of the narrative. It is not Deborah, Barak, or Jael; rather, it is Yahweh, the one true God of Israel. The generals are no longer in view, nor the valiant women with whom they interacted. Yahweh subdues the Canaanite king Jabin before the Israelite forces, freeing his people of their oppression once again in this round of the ongoing cycles of the judges.

Summary of Deborah's story

A close reading of the characters in Judges 4 reveals that Deborah and Jael are not presented as inappropriately troublesome women, nor is Barak portrayed as a failed and frightened man. Rather, the account of their actions is perhaps the most positive of the longer stories of leaders in the book of Judges, reflecting rare moments of exemplary leadership by good people who are presented without the faults and foibles of other judges, such as Gideon's reluctance (Judg. 6–8), Jephthah's regretful vow (11–12), and Samson's bizarre escapades with Philistine women (14–16). In contrast, Deborah and Barak act with wisdom and bravery,

"Jael, *'eshet heber* the Kenite: A Diviner?" in ed. Brenner and Yee, *Joshua and Judges*, 139–60. Although "divination may be used in a positive sense as a synonym for prophetic "visions" (Mic. 3:6), it is generally condemned as a pagan practice in the OT. For a concise discussion of this term, see "Divination" in D. R. W. Wood, ed., *New Bible Dictionary*. 3rd ed., 270–80.

28. Author's literal translation; see also Webb, *Judges*, 184.

and exercise their respective giftedness under the all-powerful and all-faithful hand of Yahweh, the covenant God of Israel, who hears the cry of this people and delivers them in a desperate time of national crisis. Even the Kenite woman Jael acts on behalf of the welfare of God's people, despite her previous alliance with Jabin. This more favorable assessment of the main characters is affirmed and further celebrated in the victory song that follows, which complements their remarkable story. This more favorable assessment of the main characters is affirmed by the pause in the book, unlike other stories, in order to devote an entire chapter to praise and celebration through a victory song written by Deborah.

DEBORAH'S SONG: A BATTLE HYMN OF YAHWEH'S DELIVERANCE (JUDGES 5)

Although the poetic account of Judges 5 complements the remarkable story in the chapter it follows, the reader encounters significant difficulties when considering its intended literary divisions[29] and its many exegetical challenges. Because the purpose of Judges 5 is to better understand the person, position, and work of Deborah, the hymn it contains will be treated primarily in reference to its key characters and how they relate to her. Moreover, exegetical problems will be discussed only when they affect the reading of the song in relation to this purpose.

Deborah as author and lead character

The hymn's title and introduction (5:1–2)

The superb example of ancient Hebrew poetry[30] found in Judges 5 is introduced with the phrase, "And Deborah [she] sang (and Barak son of Abinoam) on that day." Regretfully, most standard translations give the impression that the verb "to sing" is plural here and therefore is generally inclusive of both persons.[31] Rather, the writer puts an emphasis at the outset on Deborah's primary role by using the third-person, feminine singular verbal suffix—as he does in her dramatic introduction in Judges 4:4–6.[32] Her preeminence is also evident several times through the use of first-person singular pronouns: "I, even I, will sing to Yahweh. . . . I will praise Yahweh" (5:3); "I, Deborah, arose . . . until I arose, a mother in Israel" (5:7); "My heart is with Israel's commanders, with those who offered themselves freely among the people" (5:9). Without question, she is the primary character in the poem.

29. Cf. Coogan's influential work: "A Structural and Literary Analysis of the Song of Deborah," 143–46.
30. Bakon, "Deborah: Judge, Prophetess and Poet," 111.
31. This is my literal translation. However, this detail of the Hebrew text is also reflected in the New American Bible (Revised Edition) and Young's Literal Translation (YLT).
32. This singular verbal suffix follows the pattern of the introduction to Moses's song in Exodus 15:1 where he, of course, is the primary author of the song, with the Israelites joining him in singing.

The actions of Deborah are also noted in two other ways. First, verbal imperatives mark a literary antiphonal exchange between Barak and Deborah: "Awake, awake, Deborah! Awake, awake, utter a song!" and "Arise, Barak, lead away your captives" (5:12). Here, she is portrayed as the source of the song, while he oversees the collection of those Canaanites taken alive in battle. Second, the reader is told that in the battle, "the princes of Issachar stood by Deborah, and [the rest of] Issachar were faithful to Barak" (5:15). In this instance, she appears to work closely with Issachar's leadership, while Barak manages the rest of the tribal warriors. Perhaps she devises a flanking strategy whereby the forces of Israel are divided, with the chief warriors accompanying Deborah so as to draw out Sisera so that Barak and the troops can launch a surprise attack from Mt. Tabor.[33] This is suggested by the first-person reference, "*My* heart is with Israel's princes," distinguishing them from the rest of the "willing volunteers among the people" (5:9; italics mine).

Although the interpretation of a key term (Heb. *pera*) in verse 2 is highly debated, I favor the rendering of the majority of translations that read something like, "When 'leaders lead' [*pera*] in Israel, / When the people willingly offer themselves, / Bless the LORD!"[34] (NKJV). The pairing of "commanders" (Heb. *haqaq*) and "people" (5:9), as well as that of "princes" and the rest of the people (5:15) in these two parallel verses suggests this choice. If this is correct, Deborah and Barak (and, perhaps, Jael) are referenced together here as "leaders"—which, in Hebrew grammar, requires the masculine plural ending if a man is included within a larger group of women.

Imagery of Moses (5:3–5)
Two factors imply that Deborah's poem is intentionally reminiscent of Israel's great redemptive event of faith—their deliverance by Yahweh through Moses from their four hundred years of bondage in Egypt (Exod. 1–18). First, the pattern in Judges 4–5 of a story of military conflict preceding[35] a victory song of praise is strikingly similar to that of the Exodus story (Exod. 14) followed by the victory song of Moses and the Israelites to Yahweh (Exod. 15). In that context, Moses writes the battle hymn with the people of Israel joining him in its singing. Deborah's song in Judges 5 can also be likened to David's hymn of victory in Psalm 68. There the Sinai imagery also appears (vv. 7–8, 17), as well as the service of women in the proclamation of God's word (v. 11), dividing the plunder of

33. This is a minority view—though plausible—suggested by Gafney, *Daughters of Miriam*, 91.
34. Other examples of this line of translation include the HCSB, NET, NIV and ESV. In contrast, the Hebrew term at issue here (*pera*) may come from a root that denotes "untrimmed hair," representing ritual vows like that of the Nazirite taken before going to war (cf. NRSV, NJPS, NJB). This may be its meaning in Deuteronomy 32:42.
35. Exodus 15:1 begins with the adverb "then" (Heb. *'az* = "at that time"), whereas Judges 5 clarifies the timing with the phrase "on that day"—perhaps while the aftermath of the battle was still being cleaned up (cf. 5:12).

battle (v. 12) and celebration of victory (v. 25). Although David's song is not given a specific narrative basis, the multiple recountings of David's military exploits and conquests from 1 and 2 Samuel and 1 Chronicles provide an adequate point of reference. Deborah's song, in the present context, takes its rightful place alongside these great celebrations of deliverance of Israel by Yahweh.

Second, the celebration of Israelite cooperation across the various levels of community status (5:2) is symbolically proclaimed to the "kings" and "princes" of Canaan in a battle hymn that appropriately honors the true victor: the God of Israel. Herein, the imagery of Yahweh coming out of Seir and marching from Edom (5:4) recalls the end of Israel's wilderness wanderings after the Exodus (Deut. 33:2). Moreover, the earth trembling and the mountains quaking (Judg. 5:4)—especially, the explicit mention of the shaking of Mt. Sinai in Yahweh's presence with Moses (v. 5)—take the reader to Moses's first encounter with God after arriving at Mt. Sinai (Exod. 19:18; cf. Hag. 2:21; Heb. 12:26).

By linking her song (accompanied by Barak) at its outset to that of Moses (accompanied by the Israelites), Deborah implicitly identifies herself with Moses. He was the first of Israel's judges (Exod. 18:13–23), the one who gave the initial instructions for appointing other judges (Deut. 16:18–20), and the greatest of the Old Testament prophets (34:10). This allusion to Moses, along with Deborah's location between Ramah and Bethel in the central hill country (Judg. 4:5; cf. 1 Sam. 7:15–16; 8:4), place her strategically between Moses and Samuel—both of them important prophets and judges who served Israel well in their respective days, just as Deborah does in her day.

A mother in Israel (5:6–11)

Brief references to Shamgar and Jael (5:6) provide the setting for Deborah's proclamation of herself as "a mother in Israel" who "arose" to deliver her people in their time of suffering and oppression (5:7). The cryptic account of the warrior-deliverer Shamgar, son of Anath (3:31), immediately precedes Deborah's story, which ends with the lengthy account of the warrior Jael, the Kenite victor for Israel (4:17–23). Similarly, Shamgar and Jael are marked as contemporary figures with the twice-mentioned introductory phrase "in the days of" (5:6). Further, they both act individually, rather than leading a group of warriors. With his oxgoad, Shamgar kills six hundred Philistines; with her tent peg, Jael kills the leader of nine hundred Canaanite charioteers (4:21). Yet Israel is depicted during this time as living in fear, avoiding the main highways while traveling, and afraid to fight back against their enemies (5:6–7a, 8). As significant as these two deliverers are in their respective contexts, they are pictured as inadequate to deliver Israel without the intervention of Deborah.

Against the backdrop of Israel's oppression in the days of Shamgar and Jael, the woman prophet and judge makes her dramatic reappearance in the song with the resumptive, "until I, Deborah, arose, until I arose, a mother in Israel" (5:7). The emphatic repetition of "I arose" (Heb. *qum*) has a twofold function.

First, it takes the reader back to the scene in 4:9 where she "arises" from her seat of judgment at the Palm of Deborah to accompany Barak to war, and where she calls him to "arise" and fight (4:14), then later to sing the victory song with her (5:12). Perhaps the reference in 5:7a to the reluctance of the "villagers in Israel" to fight (NIV)[36] alludes to Barak's unwillingness to go into battle without Deborah (4:8). So here, the villagers do not engage until Deborah arises. Second, the resumptive "I arose," along with the insertion of the personal name of the prophet and judge between the identical verbal forms, marks Deborah as the clear deliverer in her poem.

Deborah "arises" as "a mother in Israel" (5:7). This is one of the rare parental metaphors for Israel's leaders in the Old Testament. The fiery prophet Elijah is called "father" by his successor Elisha (2 Kings 2:12), who is in turn called "father" by Jehoash, king of Israel (2 Kings 13:14). Similarly, an Ephraimite named Micah—and later an army of Danites—implores a wandering Levite to dwell with him to be a "father and priest" (Judg. 17:10; 18:19). The connotation in both narratives is that of a "spiritual guide."

Finally, "a wise woman" from the walled city of Abel Beth Maakah calls the city "a mother in Israel" and "Yahweh's inheritance" (2 Sam. 20:14–21, especially v. 19). Living at the time of David (around 1000 BC), this wise woman describes this place with the words, "Long ago" people used to say, 'Get your answer at Abel [Beth Maakah],' and that settled it" (v. 18). Several things are interesting about this statement. First, her designation "long ago" could easily place the origin of this proverbial saying at the time of Deborah, about two hundred years earlier. Second, the city of Abel Beth Maakah is located in the same tribal territory of Naphtali, north of the village of Kedesh, where Barak lived. And, third, the idea of getting spiritual guidance from Yahweh is what the people of Israel used to do at the "Palm of Deborah" (Judg. 4:5) with the "wise woman," as well as judge and prophet, under consideration in this essay.[37]

So, how is Deborah using the metaphor "mother of Israel" in her song? When she accompanies Barak into battle, they are located with the troops in northern Israel from Mt. Tabor in the Jezreel Valley to the Jordan Valley near the Sea of Galilee. Given her function in the central hill country further south as a wise, prophetic judge to whom Israel came, she could have known of the reputation of this then-famous northern city as "a mother in Israel" and part of "Yahweh's inheritance." Therefore, it makes sense for her to describe her role in giving religious guidance to her people with the same imagery. In this way, she artfully communicates her part in the story as "a mother in Israel," a person who provides the same service to her nation as the legendary city of Abel Beth Maakah.

36. Or, perhaps due to their complacency, which resulted in their prospering and growing fat (cf. NRSV).

37. Bergen, *1, 2 Samuel*, The New American Commentary, Vol. 7, 436–38.

Other Supporting Characters to Deborah and Barak

Leaders and tribal groups (5:12–23)

From the beginning of the joined prose and poetic account of Judges 4–5, the biblical writer highlights the most relevant tribes of Zebulun and Naphtali (4:6, 10), with Zebulun singled out in the song, perhaps because of their location on the northern rim of the Jezreel Valley (5:14, 18). But, eight other tribes are referenced in the song as well: Ephraim and Makir (5:14; a clan in the southwestern half of Manasseh), Issachar (5:15), Reuben (5:16), Gilead (within the northeastern half of Manasseh), Dan and Asher (5:17), and "Meroz" (5:23; tribal affiliation and location unknown). Mention of these territories puts Deborah's last prophetic words into a larger geographical context. Asher is on the northwestern coastal plain; Manasseh and Ephraim comprise the Samarian hill country (where the Palm of Deborah stands); Reuben and Gilead span the entire eastern bank of the Jordan River;[38] and Issachar is, most specifically, where the decisive battle takes place. Only Benjamin and Judah in the south (the latter among whom the Simeonites lived) stand outside the geographical scope of Deborah's address.[39]

By addressing this broad range of representative tribes, Deborah once again demonstrates the extent of her influence as both prophet and judge (cf. 4:5). As with most Old Testament prophets, her prophetic utterances sometimes confront those who did not oppose the "enemies" of Israel's God (cf. 5:31a: Reuben, Gilead, Dan, Asher, and "Meroz") and at other times praise those who acted as Yahweh's "friends" (cf. 5:31b: Makir of Manasseh, Ephraim, and Issachar). With these words Deborah reminds the neighboring clans and tribes of their obligation to assist Zebulun and Naphtali, who are most affected by the oppression.

Jael and the mother of Sisera (5:24–31)

In addition to the lengthy recounting of the assassination of Sisera by Jael in the narrative of Deborah and Barak (4:17–23; discussed above), Deborah includes an equally lengthy poetic version of Jael's courage and cunning (vv. 24–27), as well as a dark look into the mind and heart of Sisera's mother (vv. 28–30)—with 5:31 serving as the concluding thought in the poem. Jael's section of this poem starts without transition after the curse on "Meroz" (v. 23), creating a sharp contrast between the Israelites who do not help and a Kenite woman who does.[40]

Jael is described as "most blessed of women"—and, more specifically, "most blessed of tent-dwelling women"—in the context of her single-handed assassination of the Canaanite general Sisera, which—as mentioned—is accomplished by

38. The tribes from the eastern side of the Jordan Valley supported Israel's conquest of Canaan once before (Josh. 4:12).

39. The tribe of Levi had no physical land inheritance, but were given forty-eight Levitical cities, including six "cities of refuge" (cf. Num. 35; Deut. 4; Josh. 20), which specifically included the city of Dan in the far north.

40. Bakon, "Deborah: Judge, Prophetess and Poet," 115.

luring him into her tent and sedating him with warm milk, thus creating an atmo-
sphere of comfort and false security. The story of her driving a tent peg through
Sisera's head into the ground while he slept (4:21) is supplemented here by lan-
guage of his final position on the ground—literally, "between her feet" (5:27; ESV,
NASB, NET). This description likely carries ironic sexual connotations, given the
allusions to rape used by Sisera's mother in verses to follow (esp. 5:30).

The reference to Sisera's mother may have been chosen in intentional contrast to
Deborah's presentation of herself as "a mother in Israel" (5:7). Whereas the prophet
and judge secured the deliverance of her people, Sisera's mother will only see the
ignoble death of her son and the defeat of his troops.[41] Further, her portrayal as
peering out of the latticework that surrounded her upstairs window, with the wisest
of her "ladies" in attendance (vv. 28–29), depicts her status and wealth, which surely
came, in part, at the cost of Israel's oppression. This Canaanite woman of privilege
calms her anxiety and fears caused by her warrior-son's late return by imagining
the violent abuse he is imposing on the captive women—a common practice in
ancient warfare carried out against young virgins. The second line in 5:30 translates
literally, "A womb or two for every head." In this way, the aristocratic woman crudely
describes the Israelite girls by reference to their reproductive organs (Heb. *raham
rachamatayim* = "a womb or two"). Her imaginary, triumphant warriors are referred
to only by the metaphor of "head" (Heb. *rosh* carries here the connotation of a domi-
neering force), taking these "unspoiled" women for their instant gratification, while
at the same time marking them as permanent possessions. The victimized virgins
are dehumanized as being merely "spoils" to be remembered only by their colorful,
embroidered clothing taken along with the rest of the "plunder" (5:30). At best, they
may be kept as conjugal conveniences to produce progeny for their captors. In this
context, Jael represents a courageous and victorious woman who avenges exploited
Israelite virgins of the past, as well as rescues those potentially to be assaulted by these
Canaanite soldiers. Representatively, a dead Sisera lying still "between [Jael's] feet"
can no longer abuse Israel's daughters by forcing himself "between their feet."[42]

The last verse of the song (5:31) seems to have a twofold reference. As noted
above, the designations of "enemies" and "friends" can apply to nearby clans and
tribes that were expected to support Zebulun and Naphtali in their resistance to
Jabin's domination. But it may also reference specific individuals. In the immediate
context, Sisera and his forces are the clearest enemies, while the clearest friends
include Jael, whose courageous engagement in the conflict supports the work of
the main characters, Deborah and Barak. Finally, the reference to the "sun (Heb.
shemesh), when it rises [Heb. *yatsa*, "goes out"] in its strength" also contains po-
etic irony, when considered as a symbol of the two strong Israelite leaders who
have arisen in this story and song: Deborah the woman of "fire" or "light," and
Barak whose name means "lightning." Because of God's remarkable work through

41. Ibid., 116.
42. Gafney, *Daughters of Miriam*, 93.

them—as well as through the unlikely Kenite Jael—"the land [of Israel] had peace for forty years." This single line of prose at the end of this remarkable poem speaks directly to the positive result of the obedience of Deborah and her associates.

SUMMARY OF DEBORAH'S SONG

Like the narrative that precedes it, Deborah's song provides poetic balance to the prose section before it, portraying in an unequivocally positive light all three of the main characters: Deborah, Barak, and Jael. Deborah is preeminent as the poem's author—a prophet and judge like Moses, a military leader of people, a strategist, a woman with a heart for God's people, *and* a wise mother in Israel. Barak is privileged to accompany her, and even receives some honor as he leads away his captives. But, as Deborah prophesied at the outset, a greater honor goes to Jael, the Kenite woman, who takes a significant risk to deliver God's oppressed people from Sisera—especially the young virgins who are so vulnerable in the conflict. In the end, the song reminds its readers that God blesses those who love him—his "friends"—with strength and courage for the most serious task at hand.

CONCLUSIONS

In this chapter, I have sought to counter the common assertion that God uses Deborah as judge and prophet, as recorded in Judges 4–5, only because there is no good man available to serve faithfully in these capacities. In this sense, she has been vixenized—that is, portrayed as a troublesome woman in Scripture. Moreover, such an unjust and unbiblical criticism has also been extended to Barak and Jael, the other significant man and woman in this closely paired story (prose) and song (poetry), which preserves their experiences with, and service on behalf of, God. After a careful reconsideration of these texts, the following conclusions can be drawn.

First, the lead person, Deborah—woman of light and fire—is portrayed consistently in a positive way throughout her story and song. The prose account introduces her as a woman serving faithfully in the dual capacity of prophet and judge, a service that is respected by her people. She appears on the scene when Israel cries out to Yahweh for help. Further, she acts authoritatively in her summons of Barak, challenging him to obedience, and accompanying him into battle, where she receives God's evident blessing in Israel's divine deliverance. In her poem—which Deborah herself writes—she arises as a wise and protective "mother in Israel," acting in the spirit of her forerunner, the great prophet and judge Moses. Moreover, she addresses ten of the twelve tribes by exhorting them to be "friends" of Yahweh, and not his enemies. There is not the slightest hint in this context of anything inappropriate regarding her admirable conviction, courage, and faithfulness. Although her story and song do not employ such terminology, she may rightly be described as a biblical woman of valor.

Second, there is indeed a good man in this text: Barak, the son of Abinoam, who agrees to go when he is called. His insistence on Deborah's presence implicitly invokes God's presence and guidance through the divinely inspired prophet and judge. She does not condemn him, though she adds the caveat that he must

serve without the customary honor given to military leaders in battle. Barak demonstrates his faith in, and honor of, God by going, despite this challenging condition. As a result, he obtains an even greater honor: being listed in the book of Hebrews among the notable persons of faith, of whom this world is not worthy. To speak of his failure in the only extant account of his life flies in the face of the endorsement of his character by the New Testament writer. By any measure he is a good man who works willingly under the leadership of a good woman, and through whom God delivers Israel in a time of national crisis.

Third, this account even describes the Kenite woman Jael as person of courage and wisdom. The amount of space devoted to this other brave and cunning woman is remarkable. As a migrating tent-woman she shows herself wiser than the aristocratic mother of the general she slays. Moreover, she avenges and delivers the victimized young women of Israel through her heroic actions against the leader of the Canaanite army bent on oppressing and defeating God's people.

In the end, God is the true hero and deliverer of his covenant people. However, he has chosen throughout redemptive history to accomplish his work on earth in times of great moral failure through mere mortals like those in the book of Judges. For sure, none of them is perfect. Yet some show greater faith and act more faithfully than others. Among the judges of Israel mentioned in this book—at a time when good persons were indeed hard to find—no major character is portrayed in a more favorable way than Deborah, Barak, and Jael.

PRACTICAL APPLICATIONS

So, what can we take away from this familiar story in the book of Judges to apply in our own walks before God? At least four enduring principles present themselves: *be faithful, be willing, trust,* and *remember.*

Be faithful to your calling, regardless of the risk or social stigma you may incur. Every believer has a calling from God on her or his life. Some enter into professional, full-time ministries, while others serve God faithfully in the everyday workplace or home. In either context there are risks involved, especially for women in Christian leadership.[43] Deborah is an example of a person who is faithful, and is subsequently used and blessed by God under the most difficult of circumstances. The church today must recognize and affirm more fully contemporary "women of fire," preachers and leaders who bring wisdom and maturity to the work of God's kingdom.

Be willing to follow the leadership of a godly woman, even when her calling and service are not as common in the culture in which you live. In many places in the modern world, leadership roles for women are as unusual as in the days of the judges. But even in more progressive societies, there is still considerable pushback on this matter. As a great person of faith, Barak willingly worked under

43. For an excellent book by a wide array of international women scholars that chronicles the significant risks women are taking in order to embrace their calling in uncommon ways and often in hostile circumstances, see Lutz, *Women as Risk-Takers for God.*

Deborah's leadership because he recognized God's hand upon her. The church today needs more men with this same spirit of respect and humility.

Trust God's grace and presence in your life, not worrying about whether you receive credit and honor in the eyes of others. In the end, neither Deborah nor Barak received the credit for the culmination of the battle in the death of Sisera. Yet, Barak was willing to follow Deborah's leadership as their hazardous journey began, and Deborah was willing to sing Jael's praises as God honored this woman on the decisive day of victory. Too many believers today are hesitant to respond to God's calling in their lives because they are concerned about what's in it for them—whether tangible rewards or personal honor. In contrast, God delights in humility and obedience on the part of his faithful servants.

Remember that God alone deserves the ultimate glory and honor, for he is the one who truly rescues and blesses. This chapter has focused primarily on vindicating good people in the era of the judges who have been maltreated by commentators for centuries. While that vindication is an appropriate and admirable endeavor, it is imperative to remember and acknowledge that any and all credit we may receive should, in turn, be reflected to God, the one true source of our praise. Even the persons of faith lauded in Hebrews 11 were only great as a result of their putting their faith in the one true God. Because we have their example, the biblical writer exhorts us, "Therefore, since we are surrounded by such a great cloud of witnesses, let us throw off everything that hinders and the sin that so easily entangles. And let us run with perseverance the race marked out for us, fixing our eyes on Jesus, the pioneer and perfecter of faith" (Heb. 12:1–2, NIV).

QUESTIONS FOR DISCUSSION

1. Have you ever heard or told a "story of struggle" that a woman endured in her faith journey—especially because of her sex—as she sought to lead in response to God's calling? What caused it? What could have been done differently?

2. If you are a man, have you ever had the opportunity to serve with a woman in ministry—even submitting to her leadership as Barak did with Deborah? What difficulties did you face? How did your cultural biases and background affect you?

3. If you are a woman called to ministry, what risks have you encountered in responding to that calling? What or who has helped you face these with courage and faith?

ERA OF KINGS

HULDAH: MALFUNCTION WITH THE WARDROBE-KEEPER'S WIFE

CHRISTA L. MCKIRLAND, THM

HULDAH WHO?

If you ask the average churchgoer to list all the prophets she can recall from the Old Testament, Huldah will not likely make the list. In fact, this prophet seems practically invisible in children's Sunday school lessons, sermons, and adult Bible studies. Yet she lived at the same time as Jeremiah and Zephaniah, and she played a significant role in the last major reformation of the kingdom of Judah before its final downfall.[1] She appears only once—in 2 Kings 22 and its parallel in 2 Chronicles 34—but her brief mention should in no way compromise her import as an authoritative voice on behalf of Yahweh. As we will see in this chapter, Josiah, the last righteous king of Judah (and, arguably, the most righteous king of the entire Divided Kingdom era) consults this spokesperson of God without hesitation, and Yahweh inspires this prophet to speak authoritatively in response to the king's inquiry.

To see the significance of Huldah, we will journey back to the context of her time, especially to the role of the prophet, and examine the text in greater detail. In so doing, we will note the uniqueness of this prophet, trace Christian and Jewish accounts of Huldah, and conclude with implications we can draw from her story today. Through all of this, we will see that Huldah's vindication comes through the simple act of making her visible once again.[2]

1. Depending on the dating of the prophetic ministry of Nahum and Habakkuk, they may have also been active during Josiah's discovery of the Book of the Law. See Belleville, "Women Leaders in the Bible," 113.
2. Although Huldah appears for only fourteen total verses (between 2 Kings 22 and its

HULDAH'S BACKGROUND

After the reigns of David and Solomon, the Hebrew nation became divided into Israel and Judah—Israel as the Northern Kingdom with one line of kings, and Judah as the Southern Kingdom with a separate line of kings. In the course of the Northern Kingdom's history, every king practiced idolatry and did what was evil in the sight of the Lord. On the other hand, Judah had a few righteous kings who honored the God of their ancestors and sought to obey Yahweh all of their lives.[3] Many of these kings, when they inquired of the Lord, did so through trusted prophets.[4] Jehoshaphat consulted Elisha (2 Kings 3:11), and Hezekiah conferred with Isaiah (20:1–11). During the reigns of Jotham and Hezekiah, the prophets Isaiah, Hosea, and Micah were the prophets on call (Isa. 1:1; Hos. 1:1; Mic. 1:1). At the time of Josiah, the last good king of Judah, Jeremiah and Zephaniah were prophets available for consultation contemporaneous to Huldah (Zeph. 1:1; Jer. 1:1).

Josiah, in particular, is the most righteous king in Judah's history, which is stated directly: "Neither before nor after Josiah was there a king like him who turned to the LORD as he did—with all his heart and with all his soul and with all his strength, in accordance with all the Law of Moses" (2 Kings 23:25, NIV). Hence, Josiah's life and actions have a pronounced weight as we examine his heart and his choices in the text at hand.

During the Old Testament period in the history of God's people, we must remember that individuals did not have a Bible or even portions of Scripture at their fingertips, nor did the Spirit tabernacle, or dwell, inside God's people permanently. For this reason, passing down the words of God was an oral tradition and received emphasis throughout the Law, especially in Deuteronomy: "And these words that I command you today shall be on your heart. You shall teach them diligently to

parallel in 2 Chron. 34), much greater significance has been placed on those who occupy far less textual space (e.g., Methuselah, Naaman, Jethro, Shamgar). An extreme example would be Jabez, who occupies one verse and yet practically became a household name in 2000, when *The Prayer of Jabez* by Bruce Wilkinson sold more than nine million copies as a *New York Times* bestseller. For an excellent overview of the comprehensive invisibility of Huldah, see Handy, "Reading Huldah as Being a Woman," 13–16.

3. Asa (1 Kings 15:11); Jehoshaphat (22:43); Jotham (2 Kings 15:34); Hezekiah (18:3); Josiah (22:2). All Scripture quotations, unless otherwise indicated, are taken from the ESV translation, thereby reflecting the verse numbers of the English text rather than the Hebrew text.

4. Of note is the story in 2 Chronicles 18, in which Jehoshaphat joined the king of Israel, Ahab, in fighting Ramoth-Gilead. Jehoshaphat encouraged Ahab to "inquire first for the word of the LORD" (v. 4) and Ahab consulted his four hundred unnamed prophets—all of whom spoke what Ahab wanted to hear. Jehoshaphat seemed to sense this and asked, "Is there not here another prophet of the LORD of whom we may inquire?" (v. 6). Ahab reluctantly admitted that there was another prophet, Micaiah, but Ahab did not like summoning him since Micaiah delivered to Ahab only messages of doom and gloom. But Jehoshaphat pressed the king, and Micaiah was summoned. His prophecy matched what Ahab had feared (vv. 18–22). Micaiah was compelled to speak only what the Lord had spoken (v. 13, even though he initially played along with the word of the other prophets), and his words came to pass (v. 34). Such fulfillment was the true test of a prophet's validity.

your children, and shall talk of them when you sit in your house, and when you walk by the way, and when you lie down, and when you rise" (6:6–7). As we will see, at the time of Josiah's reign, he would not likely have even seen or heard all of the Law, given the wickedness of his father and grandfather.

Occasionally, the Spirit would come upon certain people, but only for a particular period of time and only for a specific purpose. Often the purpose would be to speak a word of the Lord to a person or group, or to impart a skill, such as Samson's strength, for accomplishing God's plan (e.g., Num. 11:25–29, 24:2, 27:18; Judg. 3:10, 11:29, 14:6; 1 Sam. 10:6–10, 16:13–14; 1 Chron. 12:18; 2 Chron. 15:1; Ps. 51:11; Isa. 11:2; Ezek. 2:2, 11:5). The most regular appearance of the Spirit of God came in the form of filling or resting on individual men and women who would then deliver a message on behalf of God to the king, people, or both. These Spirit-filled people, known as prophets, would deliver messages concordant with the Law (Torah), often including words of judgment if their words fell on unrepentant hearts and deaf ears. Therefore, the prophet played a significant role as a communication agent on behalf of God to the people.

THE ROLE OF PROPHETS IN THE OLD TESTAMENT

At a time before the indwelling of the Holy Spirit, for God's people to know the direct words of God required the written words of the Law and also the prophets.[5] Most simply, the role of the prophet was to speak on behalf of God to the people, typically to the people of God—though sometimes recipients included non-covenantal people (e.g., Jonah to Nineveh, Daniel to Nebuchadnezzar). The communication could happen through verbal proclamation or even physical object lessons, so long as the message of God was communicated (e.g., Ezekiel lying on his side for more than a year [Ezek. 4:4–7], or Hosea taking a prostitute as a wife [Hosea 1:2–11]).

Prophecy took the form of a foretelling, a forthtelling, or a mixture of both. Foretelling is proclaiming a word of truth regarding what will happen in the future. Forthtelling is rebuking or encouraging the people at the present time with resultant events for the near future.[6] In the oracles of the prophets, forthtelling occured more often than foretelling, as the prophets urged the people to repentance due to forsaking their love for Yahweh. Consequently, these prophetic words often pointed the people back to the precepts of the Torah, since love for God manifested itself in faithfulness to the Mosaic Covenant. Hence, the prophet's clarion call typically related to covenant-faithfulness. However, the prophets also foretold of the disastrous consequences that would befall God's people if they failed to return to the Lord and obey God's commands. Because

5. The indwelling of the Spirit fulfilled the prophecies of the Old Testament that foretold a time when the Spirit would come upon all of God's people. Peter refers to this fulfillment in his sermon in Acts 2:14–21.
6. Blomberg and Klein, *Introduction to Biblical Interpretation*, 371.

the role of the prophet carried such authoritative weight, the penalty for a false prophecy was severe—death (Deut. 18:20–22).

Prophets were so influential that the New Testament refers to the Old Testament as the "Law and the Prophets" (Matt. 7:12, 11:13; Luke 16:16, 24:44; John 1:45, etc.). Such written words of these spokespersons for Yahweh formed a significant part of the Hebrew Scriptures, which would later become Christianity's Old Testament. Walter Brueggemann, in his commentary on 1 and 2 Kings, notes the significant linkage between these genres of text, in that "it is remarkable that Torah requires oracle, thus nicely bridging together the authority and importance of the 'law and prophets.' The Torah announces the threat, and the oracles make the threat of Torah quite concrete."[7] Just as the Spirit inspired the authors of the Law, so also the Spirit inspired the authenticators and interpreters of the Law through the role of the prophet.

Although the nature of inspiration is frequently the topic of debate, human agency does seem to be a consistent factor in the giving of prophecy in that the human conduit does not become a mindless puppet under the power of a ventriloquist God. If God wanted to communicate only words, a voice from heaven would suffice. Instead, God uses human beings within human culture to speak the divine words.

Such an understanding of the prophetic role was therefore well established by the time of Huldah's life and entrance into the biblical drama. As mentioned, Huldah's prophecy appears in both 2 Kings and 2 Chronicles.[8] First and Second Kings in particular, though historical accounts of the kingdoms of Israel and Judah, could more accurately be labeled 1 and 2 Prophets. As commentator Peter Leithart notes, "Jews have long classified the book of Kings among the Former Prophets. . . . The book of Kings is prophetic in the obvious sense that it centers attention on the words and works of Yahweh's prophets."[9] The prophets in these books declared the words and commands of Yahweh, which directed the entire history of the people of God. The prophets, in turn, were directly proclaiming a return to covenant faithfulness—a return to adherence to the Law. The kings, though significant, were only as effective as they were obedient to the covenant of the Lord, and as we will see in the case of Josiah, even the king's faithfulness could not countermand the judgments of God due to the generations of unfaithfulness by the people of Judah. Although the kings of both Israel and Judah were important to chronicle, the metanarrative of the entire Old Testament regards Yahweh's faithfulness to covenant-keeping, which includes multiple extensions of grace, even after multiple violations of the covenant by both Israel and Judah.

7. Brueggemann, *1 & 2 Kings*, 546.
8. First and Second Chronicles reflect much of the same material as 1 and 2 Kings, though instead of focusing on the kings of Israel and Judah, Chronicles focuses more on the priestly and religious aspects of the people of God.
9. Leithart, *1 and 2 Kings*.

Thus, the primary markers of 1 and 2 Kings are ironically not the kings of the two kingdoms that comprise the people of God. Instead, the books focus on the prophets, who establish the significant historical landmarks as the king and people either adhere to or reject Yahweh's covenant, when reiterated through the prophet's warnings and judgments. Leithart again notes, "The prophetic word shapes the destinies of various kingdoms, a point the narrator makes by repeatedly noting occasions of prophetic fulfillments. . . . For those who trust and honor the prophets, the word of Yahweh is a word of life and health. . . . Those who renounce the prophets face his wrath."[10] The rulers described in 1 and 2 Kings are but players in God's larger drama of eventually bringing about a way for all people to enter into blessings promised to Abraham (Gen. 12:1–3; Gal. 3:7–9).

Although most Old Testament prophets were men, the title of "prophet" is also given to Miriam, Deborah, Huldah, the woman with whom Isaiah fathers a child, and the false prophet Noadiah (Exod. 15:20; Judg. 4:4; 2 Kings 22:14 and 2 Chron. 34:22; Isa. 8:3; Neh. 6:14). Of these five women, only Deborah and Huldah speak a word of prophecy recorded in the text that also comes to pass.

Miriam is a prophet in her own right, although we do not have an account of any of her verbal prophecies or their fulfillment. The female prophet of Isaiah 8:3–4 does not speak, but the child she bears to Isaiah is used as a prophetic prop in the foretelling about the disaster ordained to befall God's people by the hand of the Assyrians. She is a prophet before conceiving a child with Isaiah, and the birth of this child serves as a prophecy via an object lesson. Unfortunately, we lack any detail about her life or prophetic function, but she seems to be a prophet herself and not simply because of her association with Isaiah. In the case of Noadiah, she played a negative role during the time of Nehemiah, and we also do not know the nature of her prophetic capacity—though it was enough to intimidate this man of God. Deborah, though a judge of Israel, is also called a prophet and speaks a foretelling word regarding the victory over Sisera (Judg. 4:14).[11]

In summary, we see that both male and female prophets played a critical role in Israel's history. They were the mouthpieces of God, consulted as those who spoke the very words of Yahweh authoritatively. The words of the prophets were the dictated words of God, although prophets still maintained their own agency and personalities in the divine-to-human transmission. Given this brief context, we now turn to the narrative in which Huldah figures so prominently.

HULDAH'S STORY IN THE TEXT: 2 KINGS 22

Second Kings 22 opens with the announcement of a new king of Judah (v. 1), and immediately his legacy as a righteous king introduces his narrative (v. 2). The fact

10. Leithart, *1 and 2 Kings*, 18. He notes the following scriptures as support: 1 Kings 14:18, 15:29, 16:12, 34, 17:5, 17:15–16, 22:38; 2 Kings 1:17, 2:22, 4:44, 5:14, 7:16, 8:2, 9:26, 10:17, 14:25, 23:16, 24:2.
11. See the chapter by Ron W. Pierce in this volume on Deborah's vindication.

that Josiah walked in the way of David, a man after God's own heart, and did "not turn aside to the right or to the left" is likely a direct allusion to Deuteronomy 5:32 or 28:14, perhaps both. Given that the Book of the Law is referenced later in this story (v. 8), the introduction to Josiah's reign may serve as an indicator that the book found was, in fact, Deuteronomy.[12] The first two verses of 2 Kings 22 also state that Josiah was eight years old when he took the throne.

Ten years passed between verse 1 and verse 3, as a new section began in Josiah's eighteenth year of life and tenth year of his reign. He initiated repairs to the house of the Lord by entrusting members of his court and the high priest, Hilkiah, with money collected from the people (vv. 3–6). The workmen received the money and were in charge of the oversight and repair of the house of the Lord since they were trustworthy workers (v. 7). These repairs were greatly needed as the temple had been in disrepair for 150 to 200 years, since the rule of Joash.[13]

As the house of the Lord underwent restoration, Hilkiah found the Book of the Law. The fact that such an important book could have been lost epitomizes the ignorance and moral decay of the people of God at this time. Josiah's father and grandfather, Amon and Manassah, were wicked kings without regard for either the Lord or God's laws. Upon the book's discovery, Hilkiah delivered it to Josiah's secretary, Shaphan, who read it himself and then took and read it to the king, (vv. 8–10). More indicators point to this book as Deuteronomy—the Book of the Law is the internal title in Deuteronomy's conclusion (Deut. 29:21, 30:10, 31:26); the text makes allusion to the book (v. 2); and Josiah's response to the content reveals it included oracles about the judgment of God. Josiah's response pointed to Deuteronomy, since the fifth book of the Pentateuch contains a clear formula about adhering to the book's commands and receiving God's blessing, or disobeying these commands and receiving God's judgment (especially Deut. 28).

The discovery of the Book of the Law shifted the action of the narrative. Whereas the temple had been taking center stage the clear focus shifted to the Torah. Upon hearing the words of the book, Josiah displayed a genuinely remorseful reaction, signified by tearing his clothes (v. 11). Such tearing of one's clothing accompanied other emotionally evocative scenes in the Old Testament. One was Reuben's response as he found Joseph gone from the pit and sold into slavery. Another was when all the brothers of Joseph found the silver cup planted in Benjamin's saddlebag and realized he would be taken from them—likely killing their father with grief (Gen. 37:29, 44:13). When the Israelites were defeated at Ai, Joshua tore his clothes and fell on his face before God (Josh. 7:6). Jephthah

12. That the "Book of the Law" in this text is Deuteronomy is the common consensus of commentators, though some see room for it being other parts of the Pentateuch. Regarding this consensus, see Brueggemann, *1 & 2 Kings*, 545; Gafney, *Daughters of Miriam*, 102; Barnes, *1–2 Kings*, 359; Youngblood, Patterson, and Austel, *1 Samuel–2 Kings*, 934; Nelson, *First and Second Kings*: 255; Cogan and Tadmor, *II Kings*, 281, 294; Fritz, *1 & 2 Kings*, 398.

13. Anders and Inrig, *1 & 2 Kings*, 346. See also 2 Kings 12.

similarly showed his remorse over keeping his vow to God, knowing it would cost him his only child (Judg. 11:35). David tore his clothes in response to the news of the death of Saul (2 Sam. 1:11). And Mordecai's discovery of Haman's plot to destroy all the Jews also resulted in this powerfully emotional reaction (Esth. 4:1).

Clearly, tearing one's clothes indicated a feeling of deep sadness, loss, and—sometimes—regret. Such a response further explains why Josiah was declared a righteous king at the beginning of this section, since he was moved to such remorse and repentance after merely hearing the words of the Law read aloud. He believed the truth of these words and that the God who inspired them was real and quite able to bring them about. On the heels of Josiah's telling response, seemingly immediately, the young king commanded the dignitaries of his court to "Go, inquire of the LORD for me, and for the people, and for all Judah" (vv. 12–13). While his response clearly signified his belief that the words he had read were authentic, having likely never seen nor heard this portion of the Pentateuch, he desired confirmation of its veracity and interpretation. Also, of significance is his command to "inquire of the Lord" without any indication whom the delegation should consult. The fact that they immediately sought Huldah would seem to indicate one of two possibilities: either Josiah's default prophet was Huldah, and the dignitaries already knew this; or Huldah was not the king's default prophet, but she was the obvious choice for the five dignitaries, for whatever reason. The first option seems more plausible. One would not likely choose a prophet without established credibility; thus, most likely, the delegation knew exactly whom the king would want consulted, considering the weight and urgency of Josiah's command.

After the command to inquire of the Lord, the dignitaries of Josiah's court all travelled to Huldah the prophet (v. 14). These dignitaries included Hilkiah the high priest, Shaphan the secretary, Ahikam (Shaphan's son), Achbor, and Asaiah.[14] As would be common in a culture in which women were identified by their association with men, Huldah is recognized as a wife, while the occupation and lineage of her husband are highlighted. Finally, in the list of Huldah's identifiers, the location of her home—the second quarter within Jerusalem—is mentioned (v. 14). However, given the order of associations, prophet (with a feminine ending) is mentioned before location, which typically communicated the priority of importance due to her title's preeminence. The brief introduction of Huldah precedes her prophecy, five verses long, which includes both components of forthtelling and foretelling—forthtelling in drawing attention back to the Book of the Law and foretelling in predicting Judah's destruction and God's mercy on Josiah.

Huldah began with the typical prophetic formula, "Thus says the Lord" (see below for specific examples). To the recipients of these words, her reply was "to the man who sent you to me" (v. 15). Throughout her prophecy, she spoke

14. Linda Belleville notes the prestige of this delegation in that Ahikam was the father of a future governor, Achbor was the son of a prophet, and Shaphan's role is more of a "secretary of state." "Women Leaders in the Bible," 113.

in the first person, literally as the voice of God. She repeated the prophetic formula (v. 16) and reiterated the judgment on Judah, which Josiah had already anticipated, given that the king's words were from the "words of the book that the king of Judah has read."[15] Huldah proceeded to detail how the people had been unfaithful to God, especially through their idolatry (v. 17). However, because of Josiah's contrite and humble response, she told the messengers—again, quoting the Lord—that Josiah would be spared from seeing this judgment in his lifetime (v. 20). She concluded this prophecy with a reiteration of God's mercy that would be shown to Josiah, in that he would be buried with his forefathers and spared from seeing his people's destruction (v. 20).[16]

Regarding her prophetic word, there has been some contention that Huldah's prophecy was inaccurate, given that Josiah died in battle instead of dying in peace (2 Kings 23:29). However, this seems to interpret the prophecy too narrowly. Instead of Huldah's prophecy being about the nature of Josiah's death event, it appears to be about the state of Judah at the time of his death. To read the prophecy as being about Josiah himself seems too individualistic, especially given that his remorse concerned his collective kingdom.

After Huldah spoke, the messengers returned to King Josiah to deliver the words of God through Huldah. Later, in chapter twenty-three, the text provides evidence again of Josiah's righteousness, as the certainty of a grim future fails to impede his wholehearted turning to the Lord and national reform among the people of Judah.

THE UNIQUENESS OF HULDAH

At a time in Judah's history when every king had acted wickedly, a rare exception stands out in the young king Josiah. We know that even as a boy he actively sought the God of his forefather David (2 Chron. 34:3), even though Josiah had evil role models in both his father and grandfather (33:22–23). He not only had the wisdom to tear down the altars of worship to other gods (34:3-7) but also had the discernment to rebuild the house of the Lord, thereby finding the Book of the Law. Josiah's character comes into even clearer focus when the reader sees that he, upon hearing the standards and statutes of the Lord, responded with deep repentance regarding himself and his people. As a sign of conviction, contrition, and humility, King Josiah tore his clothes as he heard the book read. The wickedness of his forefathers and the consequences of his dynasty's sinfulness overwhelmed this young king, compelling him to seek the will of the God who gave his people God's book.

15. This formula is deemed "technical," since it also follows from Josiah's request to "inquire" (*d-r-sh*) of the Lord. For other sources regarding the authoritative weight of this inquiry, see Barnes, *1–2 Kings*, 359; Gafney, *Daughters of Miriam*, 35.

16. Much more has been written about the nature of this prophecy and its fulfillment, but for more about this debate, see the commentaries cited in this chapter, and Daniel Oden's paper presentation at the Society of Biblical Literature (2015), "Northern Exposures: Huldah's Oracle and the Dynastic Doom Oracles of Kings."

At this juncture, the reader might expect Josiah to entreat the Lord himself, as his forefather David had done. If not appealing personally to God, he could have at least sought a better-known prophet such as Jeremiah—who had been commissioned as a prophet five years before this event (Jer. 1:1–3)—or even Zephaniah (Zeph. 1:1).[17] However, this is not what Josiah did (assuming the more likely reading that the delegation knew whom Josiah would want consulted). Instead, he sought the prophet Huldah. She enters the narrative as one seemingly known and trusted by the king, sought with urgency, entreated by his highest officials, and consulted on the most authoritative basis possible. At the same time, her being inquired of is stated as a matter of fact, without any need to explain why she is sought over anyone else. As we will see below, this is an unsettling thought for some commentators, requiring their speculation as to why the king preferred—and why God used—a woman instead of a man.

The nature of Huldah's consultation is also unique. Typically, the person of lower status or honor would be summoned to the presence of the person with higher honor. The power differential was such that the individual with the greater power or authority traveled to the individual with less power or authority (e.g., the Queen of Sheba honored Solomon by journeying to see him; Samuel acknowledged the future king of Israel by going to Jesse's house to anoint David; Abraham recognized the status of Melchizedek and moved toward him at their meeting). Therefore, the sending of Josiah's royal officials to Huldah communicated his (and/or their) respect for this woman even before she officially entered the story. The fact that she lived in the second quarter, an area within the walls of Jerusalem, reveals that she could have been summoned into the king's presence almost immediately. However, sending for her is not how this righteous king responded to the Book of the Law. His respect for the Law is communicated consistently in this narrative, even in so respectfully and reverentially seeking the woman he could trust. Surely asking the lower-ranking person to come to him—a woman who lived nearby, no less—would have been more efficient and culturally appropriate than sending five highly ranked male court-officials to inquire of the Lord on behalf of the king.

Now enters Huldah. Given the patriarchal context of this narrative, Huldah, though first described as a "prophet" (v. 14), is also associated with her husband. Likely, her husband managed the wardrobe of the priests, since he was of the Levitical line.[18] The second-quarter reference communicates that Huldah's home was near the king, since it was within the walled city of Jerusalem. After brief mention of her husband, the narrative moves immediately to the reason for the delegation's visit—to consult Yahweh. Josiah's express command had been, "Go, inquire of *the* LORD

17. Based on Jeremiah 1:2, Jeremiah began to prophesy in the thirteenth year of Josiah's reign; however, the prophecy from Huldah seems to have come in the eighteenth year of Josiah's reign, according to 2 Kings 22:3.

18. Sweeney, *I and II Kings*, 445.

for me and for those who are left in Israel and in Judah" (v. 13, emphasis added). By association, Josiah equated the words of Huldah with the response of the Lord. Such a statement could not communicate a more authoritative understanding of Huldah's counsel. Josiah's understanding of the prophetic role is immediately supported textually, as Huldah proceeded to use the prophetic formula, "Thus says the Lord" (v. 15). This oracular formula was repeated frequently in the history of Israel to this point and communicated the absolute authority of the speaker's words.[19] These verses all share in common the lexical root of *d-r-sh*, meaning "to ask," "to seek," or "to inquire." Thus, Wilda Gafney makes the argument that the Hebrew root is a consistent key indicator that a professional prophet is speaking on behalf of God: "There is one expression for the process of prophetic inquiry of the Divine that is used only by prophets in the canon; to inquire of the deity specified by the lexical root *d-r-sh . . . d-r-sh* inquiry is practiced virtually exclusively by professional prophets such as Ahijah, Elisha, Ezekiel, Huldah, Jeremiah, and Micaiah son of Imlah; therefore, I argue that is a professional practice."[20]

Given the consistent pairing of the "Law and the Prophets" both in the New Testament and in rabbinical understanding of the Hebrew Scriptures, we see that the role of the prophet was to confirm the Torah, the covenant of Yahweh. The prophets consistently pointed back to the Law-Giver and to the Law itself, warning of consequences for those who forsook the covenant. However, former kings seem to have possessed copies of the entire Law, unlike Josiah, who did not have Deuteronomy until its rediscovery. Although Josiah recognized this as the words of God, Huldah authenticated it for the first time (as far as we know from the written record).[21] Therefore, some have credited her with initiating the Old Testament canon as we know it today.[22] In the same way that women were the first to testify to the resurrection of Christ, the living Word, how poetic might it be that the first person to authenticate the written Word might also have been a woman? Regardless of whether she was the first to do such a pivotal act, we do see her confirming the words of this book coming to full fruition. However, because of the king's humble response, the consequences of Judah's wickedness

19. Cf. Exod. 4:22, 5:1, 7:17, 8:1, 8:20, 9:1, 9:13, 10:3, 11:4, 32:27; Josh. 24:2; Judg. 6:8; 1 Sam. 2:27, 10:18, 15:2; 2 Sam. 7:5, 7:8, 12:7, 12:11, 24:12; 1 Kings 11:31, 12:24, 13:2, 13:21, 14:7, 17:14, 20:13, 20:14, 20:28, 20:42, 21:19, 22:11; 2 Kings 1:4, 1:6, 1:16, 2:21, 3:16, 4:43, 7:1, 9:3, 9:6, 9:12, 19:6, 19:20, 19:32, 20:1, 20:5, 21:12.

20. Gafney, *Daughters of Miriam*, 35.

21. For this reason, one may speculate Huldah is "arguably the first person to grant authoritative status to the Torah scroll deposited in the temple treasury. That scroll is largely understood to have been the heart of the Deuteronomistic corpus." Ibid., 102.

22. For scholarship which supports this view, see Orth, "A Comment on 'Women and the Question of Canonicity,'" 353–55; Achtelstetter, "Huldah at the Table: Reflections on Leadership and the Leadership of Women," 180–83; Phipps, "A Woman Was the First to Declare Scripture Holy,"; Hamori, "The Prophet and the Necromancer: Women's Divination for Kings," 838; Terrien, *Till the Heart Sings: A Biblical Theology of Manhood and Womanhood*, 81–82.

would be delayed until the next generation. Thus, Huldah's prophecy began with a judgment on the people of the land of Judah as a whole, and then narrowed to a specific prophecy regarding Josiah.

How Huldah began her prophetic response is quite striking. Instead of prefacing her words with the normal accolades that often introduce the address of a king (see Bathsheba in 1 Kings 1:31; Nehemiah in Nehemiah 2:3; Daniel in Daniel 2:4, 3:9, 6:21; and the queen mother in Daniel 5:10), she said, "Tell the man who sent you to me" (v. 15). Such address underscores her status and authority as a prophet speaking on behalf of God, not impressed or coerced by rank and titles. Like other prophets of the Old Testament, when speaking the words of God, even to a king, the message spoke for itself. Titles, status, and position bore no consequence in God's economy (e.g., 2 Sam. 7:5; 1 Kings 14:7, 20:13; 2 Kings 7:1; Exod. 5:1). Though a woman and though addressing the king via his envoys, Huldah did not waste her breath on an honorific greeting, nor mince words about the Lord's judgment. The messengers thus returned to the king bearing both bad news and good, but all understood such news as coming directly from the Lord.

Upon hearing from his envoys about the word of the Lord, Josiah acted immediately by calling all of God's people together and requiring their devotion to the God of their fathers (2 Kings 23). The king did not delay, seek a second opinion, nor dismiss Huldah's words because she was a woman. Instead, this righteous king—full of wisdom, discernment, and spiritual sensitivity—sought to return to the covenant as an indication of his devotion to Yahweh—despite the fact that the damage was irrevocable, and the judgment final. Josiah, a rare example of a righteous king and obedient leader, submitted to the authoritative word of God communicated by a woman. We see his righteousness throughout this narrative. Even in response to this dismal oracle, his devotion persisted. Despite an inevitable judgment, Josiah instituted national reform in conformity to the covenant of Yahweh, based on the confirmation and interpretation of the Book of the Law by Huldah.

HULDAH IN CHURCH HISTORY

If Huldah played such a significant role in the history of God's people, why then do most Bible-reading churchgoers have blank expressions when you mention her name? Her lack of press actually seems to have a story of its own. To see it, we will now examine her legacy in the history of Christian writings.

To begin, any extensive writing on Huldah in Christian church history is scant. And when she is mentioned, she rarely receives unqualified recognition. One of the earliest mentions of Huldah comes from Clement of Alexandria (c. AD 150–215), as he lists the women included as prophets in the Old Testament. His only comment on this list is, "And of women (for these too prophesied)," which seemingly prioritizes male prophets, while acknowledging these women

in general and Huldah specifically.[23] Later, in the fourth century, Eusebius of
Caesarea mentions her as a prophet among the contemporaries of "Jeremiah,
Baruch, Huldah, and other prophets."[24] Although the mention is brief, he does
not rationalize her prophetic office nor try to explain why she would have been
consulted over Jeremiah. On the other hand, fourth-century theologian Jerome
significantly minimizes Huldah's ministry. He remarks that God uses women,
and Huldah in particular, since "it is the rule of Scripture when holy men fail,
to praise women to the reproach of men."[25] In other words, God uses women to
shame unrighteous men. How Jerome arrives at this conclusion derives not from
the text but from his biased interpretation of the text.

Mention of Huldah, then, hits a long dearth in prominent Christian writ-
ing, contributing to the invisibility of this woman. Yet, more than a millennium
later, the prevailing interpretation remains consistent with Jerome's, as seen in
John Calvin's works. Writing in the sixteenth century, Calvin pairs Deborah and
Huldah stating, "God doubtless wished to raise them on high to shame the men,
and obliquely to show them their slothfulness. Whatever may be the reason,
women have sometimes enjoyed the prophetic gift."[26] Calvin, therefore, intro-
duces his own opinion for the existence of these women as prophets. However,
in response to both his and Jerome's conjecture, one must ask: Did the men un-
derstand Jeremiah and Zephaniah as needing to be shamed? If so, why? The fact
that other male prophets existed during Huldah's time does not seem to fit with
the intent to shame that Jerome and Calvin suppose. Instead, these theologians'
presuppositions reveal more about them than it does about the men of Huldah's
day. Unfortunately, influential theologians such as Jerome and Calvin seem to
have contributed to the invisibility of Huldah, as her role is quickly qualified
when she is even mentioned.

In the following century, Matthew Henry gives the longest treatise on Huldah
up until this time. Although theologians had commented on God's reluctant use
of women as "Plan B" prophets, Henry is the first to give a lengthy exposition ex-
plaining why he believes Josiah does not consult Jeremiah or Zephaniah. Generally,
Henry comments that prophecy "was sometimes put not only into *earthen* vessels,
but into the *weaker* vessels, *that the excellency of the power might be of God.*"[27] Henry
proceeds to explain Huldah's ministry specifically, in that "her being a wife was
no prejudice at all to her being a prophetess." This description reveals his need
to justify God's use of a woman. Noticeably, he also speaks of Huldah as a "wife"
and not as a "woman." By viewing her chiefly as a wife, he seems compelled to
clarify that her marital status did not tarnish her prophetic role.[28] After all, she

23. Clement of Alexandria, 90.
24. Eusebius of Caesarea, *Praeparatio Evangelica*.
25. Jerome, *Against Jovinianus* 1.25 and *Against the Pelagians* 2.22.
26. Calvin, *Commentary on Ezekiel*, Volume 2.
27. Henry, *Commentary on the Whole Bible* (emphasis added).
28. Ibid.

was speaking not under her husband's authority, but under God's. Such a caveat would not be necessary for Henry to make regarding married male prophets, as men's authority is assumed. Following his reasons why God would use a woman, Henry proceeds to explain why God would not use the available men of that time. Henry's hypothesis regarding Josiah's preference for Huldah over Jeremiah and Zephaniah is twofold—due to her husband's job, putting Huldah in the acquaintance of the king longer; and her geographical proximity to the king.[29]

Fortunately, Henry does conclude with accurate assertions proceeding directly from the text itself. He recognizes that Huldah does not respond to the court officials "in the language of a courtier . . . but in the dialect of a prophetess, speaking from him [God] before whom all stand upon the same level. . . . Even kings, though gods to us, are men to God, and shall so be dealt with; for *with him there is no respect of persons.*"[30] Despite ending on this positive note, one wonders why Henry feels compelled to justify Huldah's being used as the prophet of choice in the first place. For instance, had Jeremiah been chosen, it is unlikely that Matthew Henry, John Calvin, Jerome, or any other commentator would have written about why that man was chosen over other candidates—but this is precisely the burden of proof these writers bear in their commentaries on this passage. Instead of allowing the text to speak for itself, these commentators integrated their own presuppositions into their interpretations, which have continued to influence the visibility and viability of this woman's role in Judah's history. Their views have carried implications for the ongoing ministry of women today.

Near contemporaries of Matthew Henry are John Wesley and Jonathan Edwards, who also propose interesting theories about Huldah. Wesley suggests that "Jeremiah might at this time be at Anathoth, or in some more remote part of the kingdom; and the like may be said of Zephaniah, who also might not be a prophet at this time, though he was afterward, in the days of Josiah."[31] Again, like earlier theologians, Wesley goes beyond the text to explain God's choice of a female prophet over Jeremiah or Zephaniah. Several observations stand out regarding his proposals. First, the assumption that a rationale is necessary to explain God's using a female prophet instead of a male prophet seems to motivate his interpretations. Second, his rationale for Josiah's court officials not

29. Henry words his argument thus: "Yet the king's messengers made Huldah their oracle, probably because her husband having a place at court (for he was keeper of the wardrobe) they had greater and longer acquaintance with her and greater assurances of her commission than of any other; they had, it is likely, consulted her upon other occasions, and had found that the word of God in her mouth was truth. She was near, for she dwelt at Jerusalem, in a place called *Mishneh,* the second rank of buildings from the royal palace. The Jews say that she prophesied among the women, the court ladies, being herself one of them, who it is probable had their apartments in that place. Happy the court that had a prophetess within the verge of it, and knew how to value her." Henry, *Commentary on the Whole Bible.*
30. Ibid. (emphasis added).
31. Wesley, *John Wesley's Notes on the Entire Bible.*

consulting with Jeremiah because of Huldah's proximity to the king's dwelling is unconvincing, because Anathoth was only about three miles north of Jerusalem. While Josiah's desire for a word from the Lord was urgent, the gravity of needing a word from the Lord should have warranted traveling to Jeremiah's home if Huldah was an inferior choice as a prophet. Finally, to speculate that Jeremiah may have been in an even more remote part of the empire and that Zephaniah did not receive his prophetic commission until later in Josiah's reign extends far beyond the text.[32] All of these proposals again reveal more about the presuppositions of these interpreters than they do about what the text actually says.

In refreshing contrast, Jonathan Edwards considers Huldah's prophetic ministry somewhat commonplace. He associates this with her living in the second quarter within Jerusalem, or Mishneh. According to Jewish tradition, this area had been established by Samuel as a place where prophets could be trained.[33] As appealing as this interpretation of her dwelling is, it also seems to go beyond the text.[34] Speculation stems from the etymology of "Mishneh," and does not appear to be corroborated outside of this rabbinical interpretation. Most likely, this word simply referred to homes within the walled city of Jerusalem. Regardless, Edwards' treatment of Huldah does not have any accompanying qualification.

Moving into the nineteenth and twentieth centuries, though, treatment of the story of Huldah remains sparse. However, when mentioned, the commentaries begin to justify her position less and highlight her significance more. For instance, the lesser-known nineteenth-century theologian Robert Jamieson briefly mentions Huldah and asserts (again, likely on the basis of Jewish tradition) that

32. Jamieson explicitly argues against this regarding Zephaniah, "He must have flourished in the earlier part of Josiah's reign. In Zeph. 2:13–15 he foretells of the doom of Nineveh, which happened in 625 B.C.; and in Zeph. 1:4 he denounces various forms of idolatry, and specially that of Baal. Now Josiah's reformation began in the twelfth and was completed in the eighteenth year of his reign. Zephaniah, therefore, in denouncing Baal worship, co-operated with that good king in his efforts, and so must have prophesied somewhere between the twelfth and eighteenth year of his reign. The silence of the historical book is no argument against this, as it would equally apply against Jeremiah's prophetical existence at the same time. Jewish tradition says that Zephaniah had for his colleagues Jeremiah, whose sphere of labor was the thoroughfares and market place, and Huldah the prophetess, who exercised her vocation in the college in Jerusalem." Jamieson, Fausset, and Brown, *Commentary Critical and Explanatory on the Whole Bible*.

33. Regarding the Mishneh, Edwards said this: "These schools of the prophets being set up by Samuel, and afterwards kept up by such as Elijah and Elisha, must be of divine appointment; and accordingly we find, that those sons of the prophets were often favoured with a degree of inspiration, while they continued under tuition; and God commonly when he called any prophet to the constant exercise of the prophetical office, and to some extraordinary service, took them out of these schools; though not universally. Hence the prophet Amos, speaking of his being called to the prophetical office, says, that he had not been educated in the schools of the prophets, and was not one of the sons of the prophets." Edwards, *Works of Jonathan Edwards*.

34. Scherman, *Tanach*, 941.

she "exercised her vocation in the college in Jerusalem."[35] Later, the most affirming interpretation prior to the twenty-first century comes from theologian Alexander Maclaren (1826–1910):

> The message to Huldah is remarkable. The persons sent with it show its importance. The high priest, the royal secretary, and one of the king's personal attendants, who was, no doubt, in his confidence, and two other influential men, one of whom, Ahikam, is known as Jeremiah's staunch friend, would make some stir in "the second quarter," on their way to the modest house of the keeper of the wardrobe. The weight and number of the deputation did honour to the prophetess, as well as showed the king's anxiety as to the matter in hand. Jeremiah and Zephaniah were both living at this time, and we do not know why Huldah was preferred. Perhaps she was more accessible. But conjecture is idle. Enough that she was recognised as having, and declared herself to have, direct authoritative communications from God.[36]

Maclaren is the first to comment extensively on Huldah in such a positive way and to recognize the significance of her role and status during Josiah's reign. Conjecture beyond the text about Jeremiah and Zephaniah is futile and distracting from what derives from the passage.

HULDAH IN RABBINIC HISTORY

The rabbinical perspective on Huldah is often even more negative than what is reflected in the Christian tradition (with the few positive exceptions already noted). Aaron Rothkoff chronicles the rabbinical treatment of Huldah in the *Encyclopedia Judaica*. Specifically, the rabbis dismissed Huldah's prophetic role as follows: by explaining that a woman would have been more compassionate, hence Josiah's consultation of her; saying Jeremiah would not have been offended, since she was his relative as both he and Huldah descended from Joshua and Rahab; arguing it was only on account of her husband's good deeds that she became a prophet; and defaming her reputation, since Huldah's name means "weasel," thereby reflecting her arrogance in how she refers to Josiah as "the man" (2 Kings 22:15).[37]

In her book-length treatments of the ancient Midrashic and Talmudic writings of the rabbis, Jewish scholar Leila Leah Bronner confirms sexist bias in the tradition.[38] She recognizes that while rabbis did acknowledge the female prophets of the Hebrew text, they were also "discomfited" by their existence and

35. Jamieson, Fausset, and Brown, *Commentary Critical and Explanatory on the Whole Bible*.
36. Maclaren, *Expositions of Holy Scripture*, 66–67.
37. Frymer, Sperling, and Rothkoff, "Huldah. In the Aggadah," 580–81.
38. See Bronner, *From Eve to Esther*.

prophetic activity.[39] Complementing Rothkoff's brief treatment, she notes how the rabbis systematically disempowered these women through three approaches: "defining her husband, attributing to her the unlovely quality of hubris (leaders often overstep that border, an invitation to Midrashic transformation), and redefining her functions."[40] Specifically, in Huldah's case, they suggest that she was under the tutelage of Jeremiah, since he was her relative, and also that her compassion as a woman instead of her intelligence were the reasons Josiah consulted the Lord through her.[41] Bronner does note, in contrast, that the *Targum* looks positively upon Huldah's public role by interpreting *bamishneh* as a "study house," instead of "second Quarter." [42] Such an interpretation emphasizes her instruction of men in the study of the Law and not simply proximity to Josiah's home or location within Jerusalem. However, this and all the negative assertions about Huldah's character seem speculative at best.[43]

HULDAH IN MODERN PERSPECTIVE

In more recent commentaries, views on Huldah are increasingly positive, though thorough treatment of her prophetic role is still rare. Those who attempt to minimize her position seem to do so in an effort to reconcile her ministry with a male-only authority structure—especially in the spiritual/religious realm. Fortunately, interpretations are increasingly coming to light that are more consistent with the spirit of the text, though more can be done to bring this woman and her ministry into discussion and study. We will look at both qualified/negative and neutral/positive portrayals of Huldah and draw some conclusions based on these perspectives and the reading of the text from above.

By examining commentaries from the twentieth century forward, we find that a few take the predominantly historical view of this prophet in seeking to qualify Huldah's role in this narrative. Richard Patterson and Hermann Austel

39. Ibid., 170.
40. Ibid., 170. Also, Gafney, *Daughters of Miriam*, 147.
41. Bronner, *From Eve to Esther,* 175.
42. Ibid., 175. See also, Handy, "Reading Huldah," 10.
43. Another appealing speculation regards the "Huldah Gates" in Jerusalem today. As wonderful as a direct connection between these gates and this prophet would be—implying honor on her life and prophetic ministry—these were built hundreds of years after her death, seemingly without any association with Huldah. In fact, they may bear this name because Huldah also means "rodent" or "weasel," and these gates lead to passageways going under the Temple Mount—much like tunnels that rodents would use. The earliest mention of these gates appears in the Mishnah (c. AD 100), Tractate Midot 1:3, "Mishnah: Middot," accessed online. Regarding these gates as tunnels, see Yadin et al., "Temple," *Encyclopaedia Judaica*, 601–27. While it is still possible that these gates were so named because of a belief that Huldah prophesied there, or that she is even buried nearby, the scholarly evidence is lacking to support this speculation. For the etymology of her name, see Frymer et al., "Huldah," 580–81; Rothkoff also proposes the speculation that these gates did have a connection to this pre-exilic prophetess.

minimize Josiah's inquiry of Huldah on the basis of Zephaniah and Jeremiah not being viable options. In their commentary they note, "The fact that Zephaniah was not consulted may indicate that his prophetic ministry had ceased by this time. Although Jeremiah had indeed been prophesying (cf. Jer. 1:1), it may be that his early ministry (Jer. 1–6) had been completed and, having contributed to Josiah's early spiritual concern he was presently at Ananoth."[44] These writers then explain the potential familial relation between Huldah's husband, Shallum, and Jeremiah. The reason for this statement is unclear, since such a link cannot be definitively established from the text. Perhaps this speculation is included to explain that Huldah would be pursued because of her association with Jeremiah via her husband (much like the perspective reflected in the rabbinic tradition). Even if such a familial relationship could be established, it does not seem sufficient to explain away Huldah's immediate consultation by the king/delegation. Warren Wiersbe's commentary is far less dismissive of Huldah, but does speculate as to why Jeremiah and Zephaniah are not chosen by Josiah.[45] Such questioning is appropriate for commentators; however, explanations for why a certain prophet is chosen over others should be asked evenhandedly of male prophets as well. In the case of women such as Huldah and Deborah, their roles are met with suspicion, requiring some type of explanation by some interpreters. Fortunately, despite these commentators' speculations for Huldah being chosen instead of Jeremiah or Zephaniah, none deny that she was indeed a prophet—one who spoke the very words of God.

In contrast, others simply state Huldah's role as the text itself presents her. Some move beyond the explicit textual statements as they interpret the implicit esteem that she may have been afforded, given her being the righteous king's first choice regarding the Word of the Lord and the nation's destiny. Walter Brueggemann's commentary views Huldah as apparently "well-known and well-connected at court." He goes on to observe that "no doubt important is that a female prophet is enlisted and obviously has authority in that environment, it is equally important that no special notice is taken of that fact, suggesting that Huldah's authority was not exceptional enough to evoke notice."[46] Letting the text speak on its own terms, Brueggemann sees both the uniqueness of a woman's authoritative role in such a male-dominant culture, while underscoring the unexceptional nature of Huldah's role as a human vessel for God's message.

44. Austel and Patterson, "1 and 2 Kings," 935. The same interpretation is given in the earlier version of this commentary under different editors. See Patterson et al., *The Expositor's Bible Commentary*, Volume 4, 284.

45. Wiersbe, *Be Distinct*, 199–200.

46. Brueggemann, *1 & 2 Kings*, 546, 552. Nelson reiterates this point as well, in that "we get the impression that women prophets were not so uncommon as to require special comment." Nelson, *First and Second Kings*, 256. See also Gafney, *Daughters of Miriam*, 100; Hamori "The Prophet and the Necromancer," 831; Handy, "Reading Huldah as Being a Woman," 7; Beal, *1 & 2 Kings*, 511; Konkel, *1 and 2 Kings*, 639–46.

Regarding the active status of other contemporary prophets, Holman's commentary notes, "We know nothing more about her other than what we read in this passage. Since both Jeremiah and Zephaniah were active prophets at this time, it shows the great respect in which she was held."[47] This fair assessment is corroborated in the Continental Commentary as well. In this series, Volkmer Fritz explains Huldah's role without fanfare: "Huldah is the only woman who is mentioned as the holder of this office [court prophetess] during the kingship; the incumbent was usually male."[48] These commentaries exemplify that the uniqueness of a female prophet, especially in a male-dominant culture, can be acknowledged without diminishing the validity of Huldah's ministry.

Given these interpretations that stand at odds with most historical views of Huldah, Wilda Gafney, in her treatment of women prophets in Israel's history, responds to the conjectures from earlier theologians and rabbis:

> It has been suggested that Jeremiah was away at Anathoth and therefore unavailable, but surely he would have made himself available to his king when the issue at hand was the word of his God. It has also been suggested that Zephaniah was inactive at this time. However, there are no textual grounds to support this suggestion, and, again, one would expect that a summons from the king, the high priest, or this uniquely varied delegation would cause any prophet worth his salt to respond with an immediate consultation on the scroll at hand.[49]

Commentator William Barnes, agrees with Gafney's understanding as he recognizes Huldah's prophetic office without personal comment, but does state the absurdity of rabbinic tradition that qualified her service: "Although the prophet Zephaniah (and possibly the youthful Jeremiah) was presumably also available for consultation, rabbinic tradition suggests Josiah consulted Huldah because he thought a woman would be more merciful!"[50] Both Gafney and Barnes insightfully respond to the historical interpolations that have been imported into the text regarding Huldah. The ministry of this woman, though unique for her time, was not unique for all time and should not be disqualified on the basis of its uniqueness.

In light of all these different opinions and interpretations, let us conclude with what the text does reveal. Huldah is a prophet. She is not qualified by anything explicit in the text, even though her spousal relations describe her. She is sought immediately by the king and/or official delegation to interpret the Book of the Law—the most significant discovery in the king's life. She is

47. Anders and Inrig, *1 & 2 Kings: An Exegetical and Theological Exposition*, 347.
48. Fritz, *1 & 2 Kings*, 400.
49. Gafney, *Daughters of Miriam*, 99–100.
50. Barnes, *1–2 Kings*, 359.

entreated by an official delegation rather than being summoned to the king. She speaks with the same authority as the prophets before her, including use of the *d-r-sh* formula and speaking in the first person for Yahweh. Her words are taken as authoritative in confirming the words of the Book of the Law by the most righteous king in the divided kingdom's history. Her prophetic ministry took place at the same time as both Jeremiah and Zephaniah's, and the text gives no consideration as to why these men were not consulted, nor was there a need to provide an explanation. In light of these direct observations from the text, let us now conclude with how we can apply this text to our lives today.

HOW CAN WE APPLY THIS TEXT?

The first lesson we can take from this story pertains not to Josiah or Huldah, but to God. God is the one in control throughout Israel and Judah's history and is still the one in control today. And God chooses to dignify people as vessels to serve plans and purposes much higher than our plans and purposes. I imagine that both Josiah and Huldah, if they were alive today, would exhort us back to our true love—to faithfulness to God, now through Jesus Christ. They would also be dumbstruck that we have the privilege of being indwelt by God's Spirit and that God's people have such free access to God's written Word at all times—and yet, how rarely we walk in this power or are penetrated by the Scriptures. Thus, in light of these high privileges, are we dedicated to the study and application of the Word of God, and to the testing of the Spirit who lives within us?

The first application from these texts is, therefore, introspective: Would our response look like Josiah's deep repentance, upon finding out we had disobeyed God? How can we become more like Josiah, not looking to the right or the left but fixing our eyes on the Founder and Perfecter of our faith (Heb. 12:2)? To be used by God is to be a people wholly dedicated to being both hearers and doers of God's Word, confidently walking in the power of the Holy Spirit.

A second lesson moves from the private to the public. The Law and the prophet are critical allies, as the Law states what reality should be, while the prophet reinforces, interprets, and applies this word to the listener. How can we become more like Huldah, speaking the truth no matter the status or title of our audience? The closest parallel today to an Old Testament prophecy would be preaching the Word, interpreting the text, and applying it to the lives of others. How faithfully are we doing this with both the Old and New Testaments? As was true of the Old Testament prophets, the authority of God was a gift given to them. Through the Holy Spirit today, each believer has a responsibility to personally study, apply, and speak God's Word into the lives of those around us—regardless of our sex, titles, degrees, status, or stations.

Herein lies a third lesson we can take from this text regarding how we view our role as God's vessels. Huldah was willing to be a vessel and conduit for the very words of God. We will be held accountable for the callings God has put on

our lives, and for the stewardship of the blessings and abilities God has given each one of us. While we are each unique and have differing amounts of these talents (Matt. 25:14–30), the requirement to leverage them for the furtherance of the kingdom of God is the same for each of us. Such leveraging means taking an honest assessment of our privileges and abilities. For instance, although I am a woman and may experience disadvantages because of how society gives preference to males over females, I may still have advantages due to being lighter skinned, able-bodied, and educated. These are just some components of my being a vessel, which I can use to serve others who do not share the social privileges currently associated with these advantages.

Finally, although the role of prophet in the Old Testament seems different from the gift of prophecy in the New Testament, Huldah is an example of a woman unambiguously occupying the most authoritative role possible in the Old Testament. Those who want to restrict women's leadership by arguing that women have never been anointed to lead men will need to reconcile Huldah's story with their understanding of gender roles. Sharing the story of this woman will help continue to validate the role of women in the Old and New Testaments. Therefore, by making Huldah visible, from Sunday-school lessons to coffee-shop conversations, we can contribute to the vindication of the Spirit's work in lives of women from the past and into the present.

QUESTIONS FOR DISCUSSION

1. Why is Josiah's righteousness significant to understanding the delegation's consulting Huldah, as recorded in 2 Kings and 2 Chronicles?

2. How can a model like Huldah encourage you to be faithful to preach and teach the word of God?

3. Given the authoritative role Huldah plays in these passages of Scripture, how might this inform one's understanding of women's roles in the church and home?

ERA OF EXILES

VASHTI:
DISHONORED FOR HAVING HONOR

SHARIFA STEVENS, THM

"Now, in Persia to be called more cowardly than a woman is the worst insult there is."
—Herodotus, The *Histories,* Book IX,107

DUMPED

The love of my life—or so I thought—casually broke up with me one balmy night in June. He was engaged to someone else by Christmas of the same year.

I felt so . . . replaceable. Betrayed. Abandoned. Our friends, our church, our hangout spots, all of them were now just his. Or theirs. I was relegated to my apartment, the classroom, or the library. Everywhere else promised a flood of bitter reminders that I wasn't "the one." Everywhere else held a threat of seeing him again. Happy. With her.

For him, it was a small thing to move on. For the community around us, it was fun to plan his wedding. (His fiancée was a lovely person, which didn't at all matter to me at the time.) For me, the post-breakup fallout was a hell built on pity stares and "friends" who stopped talking and inviting, laid on a foundation of constant self-ridicule of why I wasn't good enough for him to stay. I carried rolls of toilet paper to bed and cried myself to sleep. Bleary-eyed, I floated through classes like a specter.

At my alma mater, there was no one more invisible than the jilted woman. Those few people who sat with me, who carried my toilet paper and let me bawl, or forced me to take walks in the sunshine, those folks who stared hard into my eyes and said, "You. Will. Get. Through. This."—*those* people I count not only

as beloved friends, but as the hands, ears, and voice of Jesus in a time when I was slipping down, down, down.

What does this have to do with a Persian queen from the fifth century BC?

I can't help but read the first chapter of Vashti's story through the eyes of a woman who has experienced—albeit on a far less traumatic level—the shame of being replaced.

With these lenses, Vashti—a parenthetical episode in the grand narrative of the book of Esther—represents to me all that is fallen in a world without compassion. Vashti epitomizes the desperation of a woman married to the "king of kings," a god among men according to the culture. She represents the space to which women are relegated—the shadows—when others, especially their fathers, brothers, and husbands fail to see them as God does, as those who also bear God's image and are fearfully and wonderfully made. Without the compassionate eyes of Jesus, human power is limited by the fall's curse; humans seek only to "rule over."

Abuse of women isn't an outdated concept. Even now, we live in a world in which many of God's image-bearers are taken from their homes, used, and trashed—even before they reach puberty. Men with more means than their victims still desire to hunt and take young, beautiful virgins.

MINOR CHARACTERS MATTER

When I was in seminary back at the turn of the century, everyone buzzed about a man named Jabez. Every prayer involved border enlargement. Books unraveled the depth of meaning found in 1 Chronicles 4:10. I was fascinated by how so much could be elucidated from such a tiny verse about a man whose only words recorded in the Bible were a prayer. What's the big deal?

Beyond the merchandise and branding, the prayer of Jabez *ought* to have been elucidated, because *it's recorded in Scripture*, so it's there for a reason; and *Jabez matters*. God granted Jabez's prayer. It's worth exploring why.

And like Jabez, the little-known Bible character Vashti is also worth knowing. Why? Because *Vashti matters*.

Vashti, a Persian pet name meaning "desired," "best," or "beautiful one," is—in a sense—a mirror, reflecting scorn, compassion, or indifference. She is at the king's mercy, a reflection of his pride and possessions. She is also at the mercy of Ahasuerus's cohort, viewed only as bringing a threat of female uprising. She is even at our mercy as readers, as an echo chamber of our social culture and attitudes about marriage, power, and the role of women. Do we scan Esther 1 with detachment and apathy, or do we see Vashti? Do we take a moment to pause to consider the dimensions of her world? Or do we leave her in the shadows?

WHY INCLUDE VASHTI IN THE TEXT AT ALL?

What would the book of Esther have to lose by her absence? The book could have begun with Esther already installed as queen, or the narrative could have

begun with the royal decree to take beautiful virgins for Ahasuerus's harem/bridal search. What do we gain from Vashti's presence in the text?

Although Hollywood usually presents the Ahasuerus-Esther marriage as a love story, we miss the whole point of the book of Esther if we see Ahasuerus as the handsome hero. Vashti helps us see the real king, so we can see more clearly who Esther is, and thus, who Yahweh is.

While chatting on the phone with a relative, I asked her if she'd read the book of Esther lately and had any thoughts about Vashti that she'd like to share.

I heard, "Vashti? She's a shame. Disobedient to her husband. Setting a bad precedent. Just like the Lord had to divorce Israel and marry the church, Ahasuerus had to get rid of Vashti and take Esther as his bride. The Lord made the man the head of the wife. Vashti didn't regard God's law."

I stared at the phone. "Okay. Uh . . . thank you. So, what's the weather like where you are?"

My relative doesn't know this, but her opinion of Vashti is in league with interpretation found in both contemporary analysis and post-exilic Midrashic texts. Vashti is condemned by many as the epitome of an unsubmissive wife, the female representation of Persian debauchery, one whose shame and removal from the kingdom—and possibly from life itself—were her just deserts.

WHO IS VASHTI?

Vashti doesn't utter a word in the book of Esther, and is mentioned only in chapters 1 and 2: She threw a banquet (Esth. 1:9); she is summoned (v. 11); she refuses (v. 12); she is discussed and derided (vv. 15–18); judgment is pronounced on her and all the women of Persia (vv. 19–20); she is remembered by Ahasuerus (2:1); and she is replaced (v. 17). To discover more about her, we'll have to compare her to other characters and other biblical narratives, and investigate extrabiblical sources.

Vashti's identity in history remains a mystery; there are no extant extrabiblical accounts that record the name "Vashti." Vashti is, as previously stated, a pet name. And although we don't find her name, we do find in the annals of history who Vashti may have been.

Herodotus: Vashti is Amestris

Herodotus's *Histories* record a name for Xerxes's wife: Amestris.[1] The ancient historian paints a grisly, horrifying picture of Queen Amestris—a woman who would murder other people's children to appease the gods: "The practice of burying people alive is a Persian custom, because I hear that in her old age Xerxes's wife Amestris too had fourteen children, whose parents were distinguished Persians, buried alive as a gift on her behalf to the god who is supposed to live underground."[2]

1. Herodotus, *The Histories*, Book VII, 61, 429.
2. Ibid., 114, 443.

Amestris was keenly aware of her husband's lust for other women, according to Herodotus. Instead of confronting the king of Persia on his indiscretions, however, Amestris set her sights on the objects of his affection. In one tragic instance, Amestris exacted revenge on her sister-in-law—a woman who consistently *rebuffed* the king's advances. "Amestris sent for Xerxes's personal guards and, with their help, had Masistes's wife mutilated. Vashti cut off this woman's breasts and threw them to the dogs, cut off her nose, ears, lips, and tongue, and then sent her back home, totally disfigured."[3]

Charming.

Midrashic tradition: Vashti is Nebuchadnezzar's granddaughter

The *Seder Hadoros* identifies Vashti as "the daughter of Belshazzar, and the granddaughter of Nebuchadnezzar."[4]

According to Midrashic tradition, Vashti is well suited to the megalomaniacal Xerxes. Rabbi Rava writes that "Vashti would bring the daughters of Israel and strip them naked, and make them do work on the Sabbath."[5] From this belief grew the concept that King Ahasuerus summoned Queen Vashti to appear before him wearing *only* her crown.

The Midrash also mentions that Vashti was justly executed, not just dismissed from the presence of the king, because "she prevailed upon Ahasuerus to halt the construction of the temple which had begun with the permission of Ahasuerus's predecessor, Cyrus. She used to say to him, 'Do you seek to build what my ancestors destroyed?'"[6]

There are some scholars, however, who advise a critical review of midrashic texts concerning Vashti. One such scholar, Eliezer Segal, says this: "The vilification of Vashti, while it finds no apparent justification in the details of the biblical account, should not surprise us as a midrashic motif. Not only is there a general reluctance among the rabbis to acknowledge the righteousness of heathens, but in the particular instance of Vashti we have already noted on several occasions how her fate was identified with that of her ancestors Nebuchadnezzar and Belshazzar. From a midrashic perspective, the very fact that she is punished at the conclusion of the episode provides evidence that she was a sinner."[7]

In contrast to Herodotus's account and some midrashic commentary, if Vashti is indeed the historical Amestris, or the woman who stripped Jewish women, the book of Esther does not judge. The Bible is not at all concerned with painting a vivid picture of her wickedness, in the same way that the book minimizes and satirizes, rather than overtly indicts, the egotistical, fickle lusts of King Xerxes. The

3. Herodotus, Book IX, 112, 586.
4. *The Megillah, The Book of Esther*, 45.
5. Segal, *The Babylonian Esther Midrash*, 254.
6. *The Megillah*, 53.
7. Segal, *The Babylonian Esther Midrash*, 252.

details of the king and queen beyond what are provided simply do not matter, because the arch of the book—with its focus on a foreign, exiled, female, orphan Jew—ultimately glorifies the unseen, unstoppable hand of *providence*.

WHO IS AHASUERUS?

We can examine Vashti's husband to get an idea of what her life was like.

Outside of the Megillah (the collection of books in the Jewish scriptures comprised of Esther, along with Ruth, Ecclesiastes, Lamentations, and the Song of Songs), Ahasuerus is referred to as Xerxes. Yes, *that* Xerxes—the monarch legendary for his wealth and self-importance. The king who vowed revenge on the Greeks for the failed military campaign of his father, Darius. The same Xerxes that—2,500 years later—moviegoers flocked to watch in the movie *300*, which depicted his epic loss to the small, ferocious band of Spartans led by Leonidas. Scholars conclude Ahasuerus is Xerxes based on a key historical element: the failed Greek expedition of 480 BC, which most likely occurred between the end of Esther chapters 1 and 2. The banquet of Esther 1 could be the event that Herodotus records in the time preceding Xerxes's Greek expedition.[8]

Xerxes's frightening and erratic temperament is recorded by Herodotus. Granted, the Greek Herodotus was no friend to Xerxes, but there are parallels between the indecision and lack of leadership in Ahasuerus and the fickleness of Xerxes. Herodotus describes Xerxes as easily manipulated by his counselors when it came to military strategy.[9]

Xerxes had a self-control problem, and was susceptible to fits of rage. A famous and bloody example of his behavior was displayed at the banks of the Hellespont (the modern-day Dardanelles), the body of water that separates Europe and Asia. Xerxes had planned to attack Greece by bridging the Hellespont. Just as the bridge's construction concluded, however, a storm blustered in and smashed the structure. What happened next reveals the king's insanity: "[Xerxes] ordered his men to give the Hellespont three hundred lashes and to sink a pair of shackles into the sea . . . he did tell the men he had thrashing the sea to revile it . . . 'this is your punishment for wronging your master when he did no wrong to you, King Xerxes will cross you, with or without your consent. People are right not to sacrifice to a muddy, brackish stream like you!' So the sea was punished at his orders, and he had the supervisors of the bridging of the Hellespont beheaded."[10]

Xerxes lived for his own pleasure; a walking, talking, wielding, threatening example of the lust of the flesh, lust of the eyes, and the pride of life. The author of Esther is careful to describe in detail the sumptuousness of Xerxes's palace, the excess of drinking, and the insane amount of splendor that took half a year to view (1:4).

8. Herodotus, Book VII, 8, 406–8.
9. Ibid., 10–16, 409–15.
10. Ibid., 34–35, 420.

WHAT HAPPENS WHEN MEN
IN THE BIBLE MAKE MERRY?

In describing Vashti's banquet for women, the author of the book of Esther doesn't describe an open-bar equivalent to the days-long bender that was Ahasuerus's drinking party (1:6–9). There are some midrashic texts that assert "both of them had sinful intentions,"[11] but the biblical text refrains from editorial comment. It records only elaborate details about the linens, couches, royal drinking vessels, and free-flowing wine. Though it would be an argument from silence, it could be that the silence regarding details of Vashti's banquet speaks to the temperance and self-control she and her guests exhibited in contrast to King Ahasuerus.

As it happens, the Old Testament contains a few other circumstances in which men's "hearts were merry"—literally "hearts [were] good" (Heb.)—with wine. Women are not described as "merry" in any of these instances. In fact, these passages can shed some light on Vashti's defiance and dismissal. Thus, we will observe where her story lands in the context of other Old Testament narratives.

Judges 19

The author of Judges gives a grisly account of when merrymaking numbs the heart, or perhaps reveals true character (Judg. 19). The chapter opens with a Levite man living in the outskirts of Ephraim (against the law, according to Numbers 35:6, 7 and Joshua 20:7–8). This man's concubine (another Levite no-no) ran away after being unfaithful to him. After four months, the Levite went to the concubine's father's house, where the father attempted to delay the Levite's departure. The two men "ate and drank" (Judg. 19:4, 6), and the father adjured the Levite to make himself "merry" (vv. 6, 9). The Levite finally left with his concubine and spent the night in an old man's house in Gibeah, where the men commenced to eating, drinking, and celebrating (v. 22). Men of the town demand to have sex with the Levite. And his response was to throw the concubine to these men, who rape her to the point of unconsciousness (vv. 25–26). Also of note, the old man offered the crowd his daughter (v. 24). The Levite was unaffected by his concubine's ravaged state. He slung her on his donkey and went home. There he carved her—like a butcher—into twelve pieces to send to the twelve tribes of Israel (v. 29). It is unclear whether the concubine was already dead when the Levite carved her up. In the instance of this narrative, it seems that it would be prudent—indeed, lifesaving—for a woman to stay as far as possible from lustful, drunk men.

Ruth 3

In the book of Ruth, Naomi instructed Ruth to perfume and dress herself well in preparation for an encounter with Boaz at the threshing floor (see chapter 3). After Boaz ate and drank, he had such a merry heart (3:7) that he

11. Segal, *The Babylonian Esther Midrash*, 251.

was compelled to sleep at the edge of a grain heap. Ruth proposed marriage to him in the form of uncovering his feet. In response, a startled yet grateful Boaz committed himself to providing for Ruth in the form of redemption—meaning marriage and an heir—with barley for Ruth and Naomi as guarantee of his intentions (vv. 11, 15). In this threshing floor episode, Ruth courageously presented herself to Boaz and boldly proposed; and he in turn covered, protected, and provided for her.

1 Samuel 25

The story we find in 1 Samuel 25 has unique features to compare and contrast with that of Vashti. Abigail was a Jew, unlike the queen. Abigail was married to a rich man (1 Sam 25:2), and she was regarded as beautiful (v. 3). The writer of 1 Samuel, Nabal's servant, and Abigail herself all explicitly state that Nabal was true to his name, "fool." Like Ahasuerus, Nabal had a feast "like the feast of a king" (v. 36). In the same wording used to describe Ahasuerus (Esth. 1:10), Nabal was said to have a heart that was "merry with wine." When he was in such a state, Abigail considered it imprudent to appear to Nabal to discuss the near-disaster he had caused in refusing to honor David and his men with provisions. When Nabal sobered up, Abigail came before him and detailed the past day's events. Nabal recognized the error of his ways (1 Sam. 25:37) and had a stroke.

In Vashti's story, Ahasuerus also sobered up and remembered Vashti, but he didn't take responsibility for "what had been decreed against her" (Esth. 2:1). His decree had forfeited any opportunity for Vashti to explain her reasoning, and so neither he nor the reader ever heard her side of events.

2 Samuel 13

In 2 Samuel 13, the author records that it was sheep shearing time for Absalom's servants (as it was for Nabal and his household in 1 Sam. 25). Two years after Amnon had raped Absalom's sister Tamar without consequence (13:14), Absalom convinced their father, King David, to send Amnon to the sheep shearing festivities (v. 27). Absalom set an ambush, and as soon as Amnon's heart was merry with wine, Absalom's servants murdered him (vv. 28–29). In this story, the merrymaking itself was an accomplice to murder—a snare.

Only Ruth 3 stands out as an occasion in which once a man's heart is made merry, it *stays* that way. Consequently, the reader sees Boaz as a man of honor. It's as if merriment and wine serve to augment the impeccable character Boaz has already displayed.

In stark contrast to that in Boaz's story, the inebriation of merrymaking generally serves as a foil for calamity in other passages. Wherever men and strong drink are combined, it is in the best interests of a woman to remain as far away as possible.

UNDER THE INFLUENCE . . . OF PATRIARCHY, SEXISM, AND HORRIBLE COUNSEL

Vashti and Esther inhabited the same patriarchal system. Royal status did not inoculate either of them from the constant threat of removal or death. Yet Vashti was defiant; so was Esther. The insubordination was not varied by kind, but by degree. Whereas Queen Vashti's disregard for the king's command was explicit, Queen Esther's strategy for disregarding royal precepts was more ingratiating. Queen Vashti defied through her refusing absence, and Esther, through her unauthorized presence.

When Ahasuerus sobered up (Esther 2:1), he remembered Vashti, felt her absence, and perhaps experienced regret. Acknowledgment of the king's regret is critical in presenting the possibility that Queen Vashti acted wisely and was wrongly punished for her decision on that fateful partying night.

Ahasuerus's attendants observed their king's wistful disposition, but they didn't wait for him to decide how to respond. They suggested seeking "beautiful young virgins" (v. 2) for the king's harem, in order to choose the one who was "good in the eyes of the king" (the literal rendering of "pleases the king" in Hebrew, in v. 4) to be the replacement queen. It seems that the great and powerful King Ahasuerus was a pawn himself, manipulated by the council that surrounded him (2:2)—not surprising from Herodotus' historical accounts. The attendants reacted to Ahasuerus's remembrance of his wife by essentially saying, "new day, new woman."

Both the attendants and King Ahasuerus had a pitifully low view of characteristics necessary for a queen. They sought only a pretty face and a vessel for sexual satisfaction. To prepare for their queenly auditions, the girls were given cosmetics and food (v. 9) and only beautified externally (v. 12). No one takes an abacus, a tutor, or papyrus in for her night with the king.

Without explicitly didactic narration, Esther 1 compares Ahasuerus's focus on externals of the kingdom's trappings (vv. 4, 6) with the beauty of his own wife (v. 11), equating them as pretty property fit for consumption on demand. But Vashti's refusal to appear demonstrated that, whether for good or for ill, Vashti saw herself as more than just a pretty face.

What was "good in the eyes" and "made the heart merry"—that is, the sexual arousal from women and the stupor of wine—in the king's perspective, actually threatened his good and the good of the entire kingdom. Ahasuerus was blind and heartless as he rumbled toward the next stimulating pursuit, devoid of godliness.

It's worth noting that Vashti did not break any known law by refusing to be seen. When Ahasuerus asked his counselors what should be done to her according to the law, they had to create a *new* decree. In fact, it may well be that if Vashti had presented herself at the royal kegger, she might have broken a law. Plutarch in his *Advice to the Bride and Groom*, wrote this: "*When Persian kings dine, their legal wives sit beside them and share the feast. But if [the men] want to amuse themselves or get drunk, they send their wives away, and summon*

the singing-girls and the concubines. And they are quite right not to share their drunken orgies with their wives. So, if a private citizen, intemperate and tasteless in his pleasures, commits an offense with a mistress or maidservant, his wife ought not to be angry or annoyed, but reflect that it is his respect for her that makes her husband share his intemperance or violent behavior with another woman" (emphasis mine).[12]

Whether the king and queen acted legally, the power dynamic between Ahasuerus and Vashti challenged her right of refusal and consent. He put her between a rock and a hard place. As queen, it was likely culturally improper for her to be present for risqué soirees. As a woman, it would have been potentially dangerous for her to be around inebriated, uninhibited men. When King Ahasuerus sent for Vashti by way of *seven* eunuchs, that summons had to be intimidating. That these seven men were to escort her into a room with hundreds of men engaged in a week-long bender may have been a more terrifying proposition to Vashti than refusing the King of Media and Persia.

Vashti was deposed because she refused to be seen, but it was Ahasuerus's refusal to *see* her as a person and instead to see her as an extension of his property, that led to her banishment. Again, he was blind.

Ahasuerus was revealed as a man more concerned about showing off to his man-crowd than protecting his wife. The author of Esther demonstrates how the godless treat their women—as sex objects, as disposable—by casting the one who should be the figure of honor, Ahasuerus, the *king*, as the most loathsome example. He became the symbol of lusty caprice. And his ability to control his household, his subjects, or his kingdom, hung on the gallows with Haman. Esther's will was done, however, because the *genuine* figure of honor was Yahweh, and he, through providence, exalted Esther at every turn. Yahweh was and is the true king.

It can be presumed that if Persia's rulers sought to subjugate and dominate those who were "other"—women and Jews specifically—the True King would bring honor to those on whom Persia would attempt to cast shame. We see this play out when Memucan and his crew enact a law ensuring the unequivocal obedience of women in all stations, but also unintentionally set wheels in motion that end up leading to the possibility of their own slaughter by the preemptively defensive Jews. In seeking to keep women in line, the rulers rid themselves of Vashti, but made way for a much more influential queen—Esther. Yahweh has a sense of humor.

VASHTI AND ESTHER: JUST WOMEN

Esther is the epitome of powerlessness and invisibility. She was an orphan. She had to obscure her name, ethnicity, and religion to find favor within the prevailing power structure. She was taken against her will and trafficked into

12. *Plutarch's Advice to the Bride and Groom,* ed. Pomeroy, 7.

the king's harem. Her body, her beauty, her sexuality were all commodified as sources of comfort for the king. Esther was "taken"—*laqach* in Hebrew—into Ahasuerus's harem in the same way that Sarai was taken as an addition to Pharaoh's harem (Gen. 12:15). This was *not* voluntary.

Esther's suppression of her name—Hadassah—and people has modern-day parallels within the American experience. After slavery and during the Jim Crow era—a time of both legal and vigilante apartheid treatment of black people—there were blacks who chose to "pass" for white. To be black during Jim Crow meant constant terrorism, oppression, and restriction from the rights and privileges of white citizens. Many black people who appeared white decided to live as white people to enjoy the basic comforts of service, courteousness, and a chance at upward mobility. But passing was a complicated and lonely endeavor. Passing meant denying the existence of black relatives and friends, actively eradicating any cultural "tells," abandoning one's neighborhood, and dismissing part of one's heritage. And love and marriage would prove disastrous—a baby could betray the carefully constructed secret of one's bloodlines.

Of course, it's ludicrous that people would have to pass in order to experience the fullness of their humanity in society. Such was the case for Jews in exile: they should have been able to worship their God, keep their customs . . . keep their name. The atmosphere of Esther reveals a darker tale.

Vashti, in contrast, was most probably the daughter of royalty, married to Ahasuerus for the production of a royal heir, and to promote political union. Her bloodlines and her name would have been sources of pride. Yet her royal background didn't matter when the king was intoxicated. His request to show her off in front of drunk men reduced her to a mere concubine—her body, like Esther's, was commodified. No matter where Vashti came from, she was still just a woman.

Vashti's narrative exists within a framework of assertive redemption, despite confining circumstances. Her dignified stand against her husband's unreasonable command, rather than being in opposition to Esther's more subtle approach, could have been exactly the boost Esther needed to be brave. If Vashti could defy the king to protect her own *dignity*, how much more could Esther be inspired to have the courage to defy the king in order to protect her own *people*? Vashti set a precedent. Esther improved on it.

VASHTI AND MORDECAI

Both Vashti and Mordecai acted with decisive opposition to requests (Esth. 1:10–12; 3:2–4). Ahasuerus burned with anger (1:12) at Vashti's blunt refusal to come at his command, which cost her the crown and the honor of being queen, and adversely affected every woman in the land (1:20). Similarly, Haman was filled with rage (3:5) at Mordecai's blunt defiance, and placed all the Jews in jeopardy (v. 6). The juxtaposition of the defiance of Vashti and Mordecai

casts her in a favorable light, or at least puts her in league with one of the main protagonists of the book of Esther.

Mordecai and Vashti both represent courageous but unsuccessful attempts to subvert absurd and capricious authority. Only Esther, who fully embodies both the plight of women and Jews, is favored by God to successfully manage the king with subtlety and intrigue, and thwart attempted Jewish genocide.

ANOTHER SILENT CHARACTER IN THE BOOK OF ESTHER: GOD

A major character in the book of Esther who remains silent and unseen is God himself. The providential movement of God, gluing together the wretched shards of exile, powerlessness, politics, love, sex, and objectification to create a mosaic of favor and protection for the Jewish people, is not once explicitly acknowledged in the book of Esther. God never speaks, either. This seeming silence in no way diminishes his worth.

WHAT VASHTI REVEALS

Vashti's removal, stripping of title, and disappearance was not a commentary on the importance of female submission, but was rather a literary tool demonstrating the absurd litigiousness of Persian law, functioning as a commentary on the fickle indulgence of Ahasuerus and his cohorts. The queen's removal also served as a forewarning of what would become of the Jewish people without divine intervention.

Vashti's presence is vital in the narrative; with her, we see the impossible odds that Esther faces. Because of Vashti's defiance, the powerful men of Persia legally obliterate the influence of wives on their husbands. By the time Esther is installed as queen, complete wifely compliance has been the law of the land for four years. If Vashti, a woman of noble blood and ancestry, a rightful queen, could be deposed for her good sense, then Esther, the covert Jew, outsider, and provincial orphan—who couldn't (at least initially) think or act without Mordecai's input—doesn't stand a chance in the Persian court. Yet she rules it.

This is God's providence at work. Xerxes has billed himself as a god, but Xerxes bows to Yahweh's will. Yahweh's compassion pursues the Jewish exiles even when they fail to call on his name or trace his hand. Yahweh is sovereign, even when Xerxes believes he is the ultimate power. And when the Persian law prescribes the oppression of women, God doesn't choose to exalt the more likely hero, Mordecai, but rather the female orphan outsider, Esther. When the law of the land treats women as compliant sexual objects, God orchestrates a "pretty face" to thwart the law and to deliver his people.

In our sex-saturated world, knowing that God instead honors a woman's character is, frankly, liberating. God chooses the unlikely and the unwanted. He scans the fringes and sees invisible people. Mary's Magnificat echoes through the ages and perfectly summarizes Esther:

He has brought down rulers from their thrones,
 And has exalted those who were humble.
HE HAS FILLED THE HUNGRY WITH GOOD THINGS;
 And sent away the rich empty-handed.
He has given help to Israel His servant,
 In remembrance of His mercy (Luke 1:52–54, NASB).

The dichotomy of how Vashti's husband sees her versus how the author tells her story serves as foreshadowing: No matter how vigorously the leaders of Persia attempt to reduce a woman to body parts and brainless obedience, God never fails to value her for her character and courage. Just as Esther, the beauty queen, is seen by God as an instrument of his deliverance and a powerful ally for his people, Vashti is remembered in the first and second chapters of the book of Esther not for her looks, but for her courage. God's gaze is never skin-deep; he values the heart.

QUESTIONS FOR DISCUSSION

1. Can you remember a time when refusing someone has cost you dearly?

2. Who are the Vashtis and Esthers of our day? How may we advocate for them to be seen as God sees them?

3. God's providence is sure, and yet silent. What does God's silence in Vashti's and Esther's stories teach us about his providence in our lives?

SOME NEW TESTAMENT WOMEN REVISITED

THE "WOMAN AT THE WELL": WAS THE SAMARITAN WOMAN REALLY AN ADULTERESS?

LYNN COHICK, PHD[1]

Florence came to my house twice a week, selling vegetables. She carried on her back a bag weighing nearly forty pounds. With its strap across her forehead and the load on her back, she hunched along dirt roads about two hours each way to the cluster of houses where my husband and I lived in Kijabe, Kenya. There, my husband helped start a children's hospital, where he served as executive director, and I taught at the Nairobi Evangelical Graduate School of Theology.

One day, as Florence rested with me on my porch, we began to chat about her life. She told me her husband had died when her children were young. It was important that she remarry, she said, so her children could have a father figure. Her parents sought a suitable spouse, and the man they chose was her grandfather's age. Florence smiled, confessing that at first she disliked the idea. But then she saw the wisdom of their choice. I later met him, a wonderful, wizened man—mostly blind and deaf, but dignified. Florence cared for her elderly husband, and the marriage gave her stability and self-respect.

As I listened to her, I began to think about the Samaritan woman at the well (John 4:4–42). I saw parallels immediately, even as I recognized the distinct qualities of each culture. Florence's experience with marriage seemed unusual to me, but her culture approached marriage in ways similar to the ancient world.

1. This article first appeared in *Christianity Today*, October 12, 2015.

While in Kenya, I also learned that some couples didn't have a wedding, but simply "set up house" together. They called each other husband and wife, had children together, and were seen by their community as married. They had no money for a wedding ceremony and no government certificate establishing their relationship in a legal sense. To my Western and evangelical Christian sensibilities, they were cohabitating. But in their culture, they were married.

With these new perspectives, I took a closer look at the Samaritan woman. I researched the life settings of first-century women and discovered details about ancient marriage customs that illuminated her situation. My research—along with that of a small but growing number of other scholars—led me to suspect that the Samaritan woman has been misunderstood.

MARRIAGE IN THE ANCIENT WORLD

Most people in the ancient world got married—women often in their teens, men in their late twenties. Given the high death rate, people were often widowed and then remarried, perhaps two or three times. The Greeks and Romans did not practice polygamy, but evidence shows that some Jews entered bigamous marriages. The only legal document for marriage was a dowry document listing the property and wealth that the bride brought to the marriage. The husband could use this money however he wanted, and any profit he made was his to keep. Should they divorce, however, he must return the entire dowry—but if his wife was found guilty of adultery, he could keep the dowry. Couples could live together as husband and wife without a dowry contract, or even a wedding. By setting up house together, they signaled to their community that they considered themselves married.

Divorce was an option; it was typically not shameful, unless it resulted from adultery. Women could not initiate a divorce, but they could ask a male advocate to do so and thus regain the dowry. It is difficult to determine how common divorce was, but the disciples' reaction to Jesus's teaching in Matthew 19:9–11 tells us divorce wasn't unheard of. Even Joseph considered it when he learned that Mary was pregnant (Matt. 1:18–19).

The culture in which Jesus taught was indeed diverse and complicated. To understand his conversation with the Samaritan woman, we must examine it within its first-century Jewish and Greco-Roman context.

PROBABLY NOT AN ADULTERESS

John 4 tells us that Jesus left Judea because his ministry was heavily scrutinized. Returning to Galilee, he decided to travel through Samaria rather than take a longer route around the territory. Jews usually took the long route to avoid interacting with Samaritans, whose false religious views they opposed.

After walking all morning, Jesus and his disciples arrived at Sychar, the place of Jacob's Well. Jesus stayed behind while his disciples went to town to get food. What followed was a one-on-one encounter between Jesus and a religious seeker, as is frequent in the Gospel of John.

Jesus is thirsty, and a woman comes along with a bucket. Some scholars suggest she was a prostitute looking for customers. They argue that morally upright women drew water in the morning when it was cooler, not at midday.

It certainly would have been more efficient to get water earlier, but this value did not govern all ancient societies—nor does it today. In the village near my home in Kenya, for example, women washed and dried clothes in the hot equatorial sun. It would be more efficient to wash clothes early in the day, so that by evening the dry clothes could be folded and brought inside the house. But my Western assumptions were challenged when I saw women begin their washing at mid-afternoon, then hang the clothes to dry overnight and into the next afternoon—hardly efficient, but perhaps more conducive to their food preparation and fellowship with neighbors.

Notice John doesn't say why the woman was at the well at noon. Perhaps she was helping a neighbor with young children. Or maybe she needed more water to finish her tasks. John tells us the time of day to explain why Jesus would be hot and tired, not to comment on when virtuous women drew water.

We might wonder why the woman appeared to be alone (although John doesn't explicitly say she was alone). Most people traveled in groups, for daily chores and life's burdens are more bearable when singing and sharing with friends. But in itself, the detail that she was alone doesn't speak to her character. It is a detail later in the story—that the man she is with now is not her husband—that seems to cast a shadow of shame on her.

When the woman agrees with Jesus that she has had five husbands and the one she is with now is not her husband, it sounds like she is confessing sexual immorality. It sounds like she has treated marriage flippantly in the past, and is now cohabitating. But our assumption clashes with the other details John gives. He presents her as an inquisitive religious seeker who is trusted—perhaps even admired—by her fellow townspeople.

So if she wasn't sexually promiscuous, what could explain her history and current situation? It's unlikely that she was divorced five times, each time for committing adultery. No man would dare marry a convicted adulteress with neither fortune nor fame. That she was a serial divorcée is also unlikely. She would have needed the repeated help of a male advocate to do so. Further, we have no evidence that anyone in the ancient world, man or woman, divorced five times. The closest parallel is the first-century-BC general Pompey the Great, who married five times; he was divorced twice and widowed twice.

And since barrenness was not always a cause for divorce, we cannot assume she was divorced for that reason. Think of the long, childless marriage of Elizabeth and Zechariah, who were blessed late in life with a son, John the Baptist. Yet if she was known to be barren, can you imagine five men risking marriage to a woman everyone knew was infertile? Not in their culture.

It is more likely that her five marriages and current arrangement were the result of unfortunate events that took the lives of several of her husbands.

Perhaps one or two of them divorced her, or maybe she initiated divorce in one case. As for her current situation, maybe she had no dowry and thus no formal marriage, meaning her status was similar to a concubine's. Perhaps the man she was currently with was old and needed care, but his children didn't want to share their inheritance with her, so he gave her no dowry document. Perhaps he was already married, making her his second wife. While the ancient Jewish culture allowed it, such an arrangement went against Jesus's definition of marriage as a union between one man and one woman (Matt. 19:4–6). It makes sense, then, that Jesus would say she wasn't married. Scripture doesn't tell us why she had five husbands, but exploring first-century realities helps us imagine how her life might have unfolded.

LONGING FOR TRUTH

Five clues in the text support the view that John's Gospel does not condemn her as an immoral sinner, but highlights her as a seeker of truth.

First, while losing spouses was a tragic reality, being a widow or divorcée five times was unheard of. This means Jesus could not have guessed her situation; it was clear that his knowledge of her was divine.

Second, her response reminds us of Nathanael (John 1:43–49). As Nathanael approached Jesus, Jesus said to him, "Here truly is an Israelite in whom there is no deceit" (v. 47). Stunned, Nathanael asks why Jesus would say such a thing. Jesus replies that he saw Nathanael under a fig tree just moments beforehand. Jesus knew Nathanael's earnest desire to serve God, thus demonstrating Jesus's prophetic, messianic character.

Jesus could not say to the Samaritan woman that she served God well, because she, a Samaritan, held erroneous religious beliefs. But he could speak about her identity. Like most women, her identity was tied to her father, husband, or son. By knowing her history and current situation, Jesus signaled to her that he knew her. And, like Nathanael, she was astounded at Jesus's power.

Third, John presents her—along with other women, such as Martha (11:21–27)—as theologically astute or inquisitive.

Fourth, Jesus does not label her as a sinful woman. He doesn't say to "go and leave your life of sin," as he enjoined the adulterous woman in John 8:11. Instead, he talks with her about deep theological truths, including the claim that God must be worshipped "in the Spirit and in truth" (4:24). Those who say she is licentious often argue that she tries to divert Jesus's attention from her past by asking an unrelated religious question. But would Jesus really be dissuaded from pursuing his case? That happens nowhere in the Gospels. Why wouldn't she have religious questions? She probably had a hard life, and perhaps, like Naomi in the book of Ruth, wondered, Where is God? Here is a man who might have answers, so she asks him questions that have puzzled her.

Finally, the fact that the townspeople listen to her testimony suggests that she was not a shunned sinner. They believe Jesus is the Messiah not because of

the disciples' preaching, nor because she allegedly changed her ways, for that would take time to validate. Rather, they believe because of her testimony. They probably knew she had religious questions and was not easily swayed by every preacher passing through. She was, therefore, a credible witness.

Jesus knows the longing of our hearts, as we see in his desire to engage the Samaritan woman's questions.

For most early church and medieval interpreters, the Samaritan woman was a careful, polite seeker—a sinner who, once illumined, truthfully witnessed her new faith to others. But in the Reformation, she became a symbol of promiscuity. Whereas the church fathers believed Jesus was revealing himself to her, says historian Craig Farmer, the Reformers suggested that Jesus was revealing herself to her to get her to see her sin and repent.

Florence helped me see marriage in a new way. She shared with me her dreams, disappointments, and joy in the Lord. Her situation encouraged me to research more deeply and to see the Samaritan woman as three-dimensional. I now see her as one who probably endured more than the typical number of tragedies, yet never stopped seeking God. She was not an outcast or sexually immoral—according to the social codes of her village. And she embraced Jesus's message with such joy that her town believed.

All this has enhanced my gratitude for Christ's amazing love. Though tired and thirsty, he looked to the needs of another. He made clear that the Samaritan woman sinned in rejecting the one true God. And he showed her that God's love extended to her personally. He knows the longing of our hearts, as we see in his desire to engage the Samaritan woman's questions.

Moreover, Jesus guides us to answers for which we had no questions. The gospel is far more encompassing than either the Samaritan woman or Jesus's disciples realized. Jesus challenges social prejudices, and brings visibility and voice to the invisible and silent in society. In giving a voice to the Samaritan woman, John encourages us to tell others about our encounters with the Savior. And may those who hear our story, by God's grace, respond like the townspeople, believing because of our testimony.

MARY MAGDALENE: REPAINTING HER PORTRAIT OF MISCONCEPTIONS

KARLA ZAZUETA, MA

He took his twelve disciples with him, along with some women. . . .
Among them [was] Mary Magdalene.

—Luke 8:1–2 (NLT)

Mary Magdalene's long hair hangs loose and flowing over her exposed breasts, and with her right hand placed over her heart, she lifts a penitent gaze toward heaven, as if to ponder the Lord's mercy on her soul. Sixteenth-century Italian painter Titian emphasizes sensuousness, as well as chasteness, in his version of Mary Magdalene.[1] This so-called harlot and redeemed prostitute, the focus of many centuries of artists and painters, captured the imaginations of not just the Old Masters, but twenty-first-century artists and writers as well. Dan Brown, for example, weaves a tale of intrigue and conspiracy regarding Mary Magdalene, Jesus, and the Catholic Church in his novel *The Da Vinci Code*. Kirstin Valdez Quade's short story "Ordinary Sins" that ran in *The New Yorker* and the 2016 movie "Risen" depict her similarly.

Just who was Mary Magdalene? Was Titian's penitent and sensual version correct? Did she, as Dan Brown suggested, have secret status as Jesus's wife?

1. *Penitent Magdalen* (c. 1531–35). Titian. Florence, Palazzo Pitti, Galleria Palatina.

What is her real story? The Gospels give us few personal details about Mary Magdalene. Thus, since New Testament times, we have extrapolated, misinterpreted, and reinvented this biblical figure. Ask your friends to describe Mary Magdalene, and you will more than likely get one or more of the following answers:

> She was a former prostitute.
> The adulteress whom Jesus saved from stoning.
> That Bible girl from the wrong side of the tracks.
> The one with the alabaster jar.
> Don't ask me; I'm more of a Martha.

But a quick glance at the Gospels reveals she was not a former prostitute, an adulteress, from the wrong side of the tracks, nor did she pour perfume on Jesus's feet. She was also not Mary of Bethany, sister of Martha.

MARY MAGDALENE: THE NEW TESTAMENT VERSION

Who was Mary Magdalene? First, she was a witness of Jesus's ministry. A faithful follower and disciple, she was part of an entourage of women who traveled with Jesus and his twelve disciples throughout Galilee (Luke 8:1–2). Mary Magdalene and other women helped support, serve, and care for the material needs of Jesus and the Twelve (v. 3).[2] Cured of seven demons, she had firsthand knowledge of Jesus's miraculous powers and authority over the demonic world (v. 2).

Second, Mary Magdalene was a witness of Jesus's crucifixion and death.[3] She saw him hang on the cross in agony. She listened to him scream out to God, abandoned and forsaken (Matt. 27:46; Mark 15:34). She observed him give up his spirit and breathe his last (Mark 15:37–41). She felt the earth tremble and shake the moment he died, and heard the Roman centurion exclaim, "Surely he was the Son of God!" (Matt. 27:54–56).

Third, Mary Magdalene was a witness of Jesus's burial. She saw the exact location where his body was laid as she sat near his tomb, most certainly in shock and despair (Mark 15:47). She and other faithful women never left his side until his burial was complete and the Roman soldiers sealed the cold, dark tomb (Matt. 27:61).

Fourth, Mary Magdalene was the first witness of Jesus's resurrection. Bewildered—Mary Magdalene and other women discovered the empty tomb.[4] Shocked—she received proclamation from angels and the Lord himself that "he

2. Grassmick, "Mark," 190.
3. Matt. 27:56; Mark 15:40; John 19:25.
4. Matt. 28:1; Mark 16:1–4; Luke 24:1–3, 10.

has risen!"[5] Chosen, she broadcast the glorious news of Jesus's resurrection to the remaining eleven disciples and other followers.[6]

Of the thirteen times the New Testament mentions Mary Magdalene, none depict her as anything but a true and loyal disciple of Jesus.[7] The Bible does not support Mary Magdalene's standard and long-held résumé of reformed harlotry, let alone indicate she was the secret lover of Jesus. If the Bible does not support these views, when did the fables and myths about Mary Magdalene begin? How did her story become so distorted? Why did centuries of painters portray Mary Magdalene in such provocative ways?

THE BEGINNINGS OF MARY'S DISTORTION

Confusion regarding Mary Magdalene existed early on in the church. Pope Gregory the Great formalized the distortion of her character in his sermon from 591: "She whom Luke calls the sinful woman, whom John calls Mary [of Bethany], we believe to be the Mary from whom seven devils were ejected according to Mark. And what did these seven devils signify, if not all the vices?[8] It is clear, brothers, that the woman previously used the unguent to perfume her flesh in forbidden acts. What she therefore displayed more scandalously, she was now offering to God in a more praiseworthy manner. . . . She turned the mass of her crimes to virtues, in order to serve God entirely in penance."[9]

Pope Gregory solidified Mary Magdalene's reputation as a former prostitute in one single paragraph. He also linked together the "sinner" from Luke 7:36–50 (she "used the unguent to perfume her flesh in forbidden acts"), Mary of Bethany, and Mary Magdalene. He formed, consequently, what many scholars refer to as the "composite Magdalene."

Gregory's "composite Magdalene" mistake probably resulted from the close proximity of the story of the sinner (Luke 7) to the mention of Mary Magdalene (Luke 8), and from the similarities between the two anointings of Jesus's feet (Luke 7; John 12). The female sinner mentioned in Luke 7:36–50 washed the feet of Jesus with her tears, dried them with her hair, and then poured perfume on his feet from her alabaster jar. Her story occurs just prior to Luke's mention of Mary Magdalene.

5. Matt. 28:2–9; Mark 16:5–6; Luke 24:4–8; John 20:10–17.
6. Matt. 28:10; Mark 16:10; Luke 24:9–10; John 20:18.
7. The New Testament references Mary Magdalene in the following thirteen verses: Matt. 27:56, 61; 28:1; Mark 15:40, 47; 16:1, 9 (longer ending of Mark); Luke 8:2; 24:10; John 19:25; 20:1, 11, 18 (the context of verse 11 informs us that this Mary was Mary Magdalene).
8. Gregory the Great, Homily XXXIII, in Hooper, *The Crucifixion of Mary Magdalene,* 79. Gregory was referring to the seven deadly sins (or vices) commonly known as gluttony, lust, greed, sloth, wrath, envy, and pride. There exists the belief and misconception that these sins are "deadly," as in "unforgivable." Romans 6:23 teaches, however, that the wages for all sin is death. Sin is sin. Only by the grace of God through faith in Christ are our sins forgiven (Eph. 1:7, 2:8–9).
9. Ibid.

Luke, however, introduces Mary Magdalene as a new character in chapter 8. That the sinful woman and Mary Magdalene were not one and the same, professor of New Testament Studies Dr. Darrell Bock states, "Virtually all scholars now agree."[10] Mary Magdalene was not the female sinner of Luke chapter 7.

But what should we make of the similarities between the stories of the tears, anointings, and hair? Mary of Bethany anointed Jesus's feet with perfume made of nard and wiped his feet with her hair (John 12:3) in a manner similar to that of the female sinner recorded in Luke chapter 7. These stories are almost alike. But Mary of Bethany was the sister of Martha and Lazarus (Luke 10:38–42; John 11:1–12:8). She was a different Mary from Mary Magdalene (Luke 8:1–2; Mark 16:1; John 20:1).

Author Richard J. Hooper pokes fun at Pope Gregory's hair and feet confusion with this equation: "Jesus's feet + ointment + hair + Mary of Magdalene + Mary of Bethany + sinful woman = Mary the whore."[11] Unfortunately for Mary Magdalene (and Mary of Bethany), the Composite-Magdalene-the-Whore label stuck and became a common and accepted understanding—turning into what we call folk theology.[12] And as it was typically the Catholic Church that commissioned art, centuries of painters and sculptors documented Pope Gregory's sermon slip-up.

MARY MAGDALENE'S HOMETOWN: A PLACE OF PROSTITUTION?

Then there is the issue of Mary Magdalene's hometown. Did it not have a reputation for prostitution? If so, perhaps this explains why Pope Gregory linked Mary Magdalene to the sinner in chapter 7 of Luke. Just as Jesus was called "Jesus the Nazarene" (Matt. 2:23), coming from the town of Nazareth, Mary Magdalene (Luke 8:2) was "Mary of Magdala." The Gospel writers called her by the name of her hometown in order make a distinction between her and the many other Marys living in Palestine. Keeping track of and differentiating between all the different Marys was no easy task. (We should give some grace to Pope Gregory—especially because he didn't have the benefit of a searchable concordance.) About 25 percent of the Jewish women living in Palestine at the time were named Mary.[13]

Scholars believe Mary's hometown, Magdala (modern-day Migdal), was a fishing town located on the western side of the Sea of Galilee just north of Tiberius.[14] Rabbinic sources list the city as *Migdal Nunnayah*, meaning "Tower of the Fishes/Dyers."[15] As fishing on the Sea of Galilee was big business, Magdala was possibly a

10. Bock, *Breaking the Da Vinci Code,* 473.
11. Hooper, *The Crucifixion of Mary Magdalene,* 81.
12. Folk theology is a set of beliefs, passed down from generation to generation, based on tradition, myth, and biblical misunderstandings. Typically, folk theology is taken as truth, as it is what we have always been taught.
13. Bauckham, *Gospel Women,* 298–99.
14. Bock, *Breaking the Da Vinci Code,* 321; Powell, ed., "Magdala," 587.
15. Elwell and Comfort, *Tyndale Bible Dictionary,* 843.

town with much industry and affluence. The Talmud describes Magdala as having shops, wool works, and great wealth; but the Talmud also describes Magdala as a town of moral depravity.[16] The industry and wealth of the town explain why Mary Magdalene conceivably had resources to support Jesus and the Twelve (Luke 8:2–3).

Yet record of the town's depravity is not sufficient evidence—especially given lack of proof from the Gospels—that Mary Magdalene was a prostitute. Just as it is incorrect to assume that every woman of Las Vegas "works the streets," it is also assuming too much to conclude that Mary of Magdala was a whore simply due to the town's supposedly shameless reputation.

DEMON POSSESSION ≠ SEXUAL IMMORALITY

We still need to contend with the biblical fact of Mary Magdalene's seven demons. Does not demonic possession imply wayward living? Luke (and the longer ending of Mark) record Mary Magdalene's demon possession.[17] Some laypersons and scholars do assume demon possession is always connected to sexual immorality. Pope Gregory the Great suggested Mary's seven demons signified the seven deadly sins. Could fornication and lust (one of the deadly sins) have led to the other deadly sins, thereby giving way to Mary's complete and total demonization?[18] Does not her demon possession prove she was a woman of ill repute?[19] The Scriptures leave out any of the details of Mary's seven demons. Luke records only that she (and other women) were cured from evil spirits and diseases (Luke 8:2).

The New Testament gives many examples of demons inhabiting men and women and causing various mental and physical disorders,[20] but never once does it specifically link sexual immorality with demon possession. Men and women, young and old, are said to have suffered from demonic influence and control.[21] Furthermore, women of the Bible who were noted as sexually immoral were not described as being demon-possessed. The Bible does not specifically associate

16. Edersheim, *Sketches of Jewish Social Life in the Days of Christ*, 37.

17. Early manuscripts do not contain Mark 16:9–20, and biblical scholars have split opinions regarding its authenticity. Regardless, Luke 8:2 informs us of Mary Magdalene having seven demons.

18. Bible commentator John A. Martin explains, "Often in Scripture the number seven is used to denote completion. Apparently Mary had been totally demon-possessed." Martin, "Luke," *The Bible Knowledge Commentary*, 224.

19. Theologian Wayne Grudem disagrees with the terms *demon possession* and *demonized*, as neither are reflected in the Greek text. He writes, "The Greek New Testament can speak of people who 'have a demon', or it can speak of people who are suffering from demonic influence (Gk. *daimonizomai*), but it never uses language that suggests that a demon actually 'possesses' someone." Grudem, *Systematic Theology*, 423.

20. Some New Testament examples of demons inhabiting persons are as follows: Matt. 9:32; 12:22; 17:14–18; Luke 9:38–42.

21. A few examples of Jesus casting out demons are as follows: Matt. 4:24; 8:16–17, 28–33; 9:32–33; 12:22–28; 15:22; 17:14–18; Mark 1:34–39; 7:24–30.

demon possession with sexual immorality; therefore, we jump too far in linking Mary Magdalene's demon possession with sexual immorality.

THE PROSTITUTE NO MORE

The Catholic Church finally exonerated Mary Magdalene of her bad-girl reputation in the 1960s—some four hundred years after the mistake became known.[22] The Church officially separated the "composite Magdalene" into three distinct women: the sinful woman of Luke 7:36–50, Mary of Bethany, and Mary Magdalene.

Pope John Paul II, in his 1988 apostolic letter *Mulieris Dignitatem* ("On the Dignity and the Vocation of Women"), attempted to further restore Mary Magdalene's character when he reinstated her as "the apostle of the apostles," a title originally given to Mary Magdalene by the early church fathers. This title gives special consideration to Mary Magdalene as the first eyewitness of the risen Lord (John 20:14–18). Regarding Mary Magdalene's eyewitness experience, John Paul wrote, "This event, in a sense, crowns all that has been said previously about Christ entrusting divine truths to women as well as men. One can say that this fulfilled the words of the Prophet: 'I will pour out my spirit on all flesh; your sons and your daughters shall prophesy' [Joel 2:28]."[23] John Paul tried to portray a new portrait of Mary Magdalene by acknowledging her inherent dignity—and the inherent dignity of all women.

But unfortunately for Mary Magdalene, news does not travel fast. Unraveling 1,400 years of folk theology takes time. Most people in the world still believe Mary Magdalene was a penitent prostitute. Martin Scorsese's film *The Last Temptation of Christ* and movie director Mel Gibson's *The Passion of the Christ* portray Mary Magdalene as the woman caught in adultery (John 8:1–11).[24] And Andrew Lloyd Webber and Tim Rice's rock opera *Jesus Christ Superstar* displays romantic relations between Jesus and the forgiven prostitute, Mary Magdalene, with the hit song, "I Don't Know How to Love Him."[25] Mary Magdalene's wayward story, regrettably, continues.

WILDER SPECULATIONS

Upon release from her role as a penitent prostitute, Mary Magdalene became the poster child for radical feminism and mistrust of the canonical Scriptures.[26]

22. Griffith-Jones. *Mary Magdalene,* pp. x–xi.
23. Pope John Paul II, *Mulieris Dignitatem,* 1988.
24. Scorsese, *The Last Temptation of Christ* and Gibson, *The Passion of the Christ.*
25. Webber and Rice, *Jesus Christ Superstar.*
26. The canon is the list of books that the early church considered authoritative and divinely inspired by God. The word "canon" comes from the Greek word κανών (*kanon*) meaning a "measuring rod" or "measuring tape." Early manuscripts and writings were weighed and measured, so to speak, based on each writing's apostolic authority and/or whether or not it was in agreement with the overall theme of God's plan of salvation through Jesus Christ. Those books that "measured up" were then compiled by the early church fathers into what

Several gnostic texts, dated to the second and third centuries, swing Mary Magdalene's story from that of a former harlot to that of the primary leader of the apostles (greater than John or Peter), the companion of the Savior, the wife of Jesus, and the woman whom Jesus loved the most.[27]

Those who support gnostic literature (e.g., *The Gospel of Mary, The Gospel of Philip, The Gospel of Thomas*) consider these ancient writings to contain vital information regarding the role of women in the church. They believe the primary leader or "rock" of the church should have been Mary Magdalene, not Peter,[28] and that the Roman Catholic Church intentionally suppressed the gnostic gospels in favor of a male papacy. But art historian and author Susan Haskins explains, "Despite the inclusion of women within [the Gnostic] ranks, and the strong presence of a feminine element, the Gnostics could never be described as pro-female. . . . Mary Magdalene could only become a living spirit, 'resembling you males,' by becoming male, that is to say, spiritual and asexual, and transcending her feminine self."[29] So much for the gnostics upholding women as women—sexism existed even among their beliefs.

Dan Brown, author of *The Da Vinci Code: A Novel*, purported an elaborate plot of conspiracy regarding the Church and Mary Magdalene. In Brown's book and the subsequent movie by Sony Pictures, Mary Magdalene was the wife of Jesus, the Holy Grail (the carrier of Jesus's bloodline), and the mother of Jesus's children. Brown formed his hypothesis from the gnostic texts and the supposed evidence of Mary Magdalene's existence in Leonardo da Vinci's painting, *The Last Supper*.[30]

Brown claimed the church vilified Mary Magdalene, turning her into a prostitute, in order for men to lay claim to the leadership roles of the church. By the end of *The Da Vinci Code,* Brown even has the reader doubting the divinity of Jesus and questioning the entire basis of the Christian faith. Although the title of Brown's book states it is a novel (i.e., a work of fiction), Brown and many of his readers around the world have taken the book's hypothesis as historical and biblical fact and, therefore, more myths and legends about Mary Magdalene continue.

Biblical scholars on both sides of the conservative-liberal fence agree that no shred of evidence exists for the notion that Mary Magdalene and Jesus were married.[31] Regarding the theory of Jesus's marriage to Mary Magdalene, Dr. Darrell Bock states, "In my office there are thirty-eight volumes of early church

we call The Holy Bible. The Deuterocanonical books (i.e., the Apocrypha) were excluded from the canon, as were the gnostic texts, based on their lack of apostolic authority and/or lack of agreement, continuity, and harmony with God's plan of salvation. Strong, *Enhanced Strong's Lexicon,* no. 2583.

27. Haskins, *Mary Magdalen,* 31–43.
28. Matthew 16:18, however, tells us otherwise.
29. Haskins, *Mary Magdalen,* 54.
30. Brown, *The Da Vinci Code.*
31. For an in-depth, scholarly, and biblical review of *The Da Vinci Code,* I recommend Dr. Darrell Bock's book, *Breaking the Da Vinci Code: Answers to the Questions Everyone's Asking.*

documents, each of several hundred pages, double columns, in small print. The fact that out of all of this material, only two texts can be brought forward as even ancient candidates for the theory shows how utterly unlikely it is."[32] Whatever one may believe about the gnostic texts—truth or lies—these texts do not prove that Mary Magdalene had a sexual or marital relationship with Jesus.

Although proponents of *The Gospel of Mary* [Magdalene] and *The Gospel of Philip* believe the church excluded the gnostic texts from the canon due to a chauvinist conspiracy of the New Testament, we will later observe that the New Testament Gospels actually redeem and uphold women rather than demean them. The gnostic texts were considered heretical and excluded from the canon, but not because the church was anti-Mary Magdalene. The gnostic texts were late fabrications that cast doubt on the truth of the incarnation and divinity of Jesus and his singular plan for salvation by grace through faith, accomplished by his death on the cross and resurrection from the dead. They also suggested an unorthodox view of the human body that devalued females, insisting they had to "become males." For these reasons and others, the early church leaders excluded the gnostic writings from the canon, not for chauvinistic motives.

WORTHY OF A NEW PORTRAIT

When we view Mary Magdalene as the rehabilitated bad girl or the supposed sensual vixen of Jesus, we fail to see the real Mary Magdalene. How did she live her life? In what roles did she serve? How did Christ view Mary Magdalene? She was a woman noteworthy of preservation by the Gospel writers. Dallas Theological Seminary Chancellor Dr. Charles R. Swindoll instructs, "Each [Bible] character points us to a lasting lesson. [God] preserved these narratives for our spiritual development."[33] The previous portraits lacked biblical truth— for Mary Magdalene was neither a reformed harlot nor the wife of Jesus. Let us take a fresh look at Mary Magdalene and paint a new portrait, one without misconceptions, and one that sees her in light of the picture of Christ the Gospel writers were making when they included her. In these new brushstrokes, we will discover God's cherished view of women.

Mary Magdalene: The first female seminarian

Mary Magdalene was a faithful student of Jesus. She, along with other women and the Twelve, followed Jesus from town to town, throughout Galilee, hearing his preaching of the kingdom of God (Luke 8:1–2, 23:55, 24:6). By allowing women to travel with him, Jesus strayed from the norm of those times. What Christ allowed was, in fact, downright shocking and scandalous, especially from an educational standpoint. Seminary professor Dr. Craig S. Keener explains, "Adult coeducation [in the ancient Mediterranean] was unheard of, and that

32. Bock, *Breaking the Da Vinci Code*, 454.
33. Swindoll, *Fascinating Stories of Forgotten Lives*, 2916.

these women [were] learning Jesus's teaching as closely as his male disciples would surely bother some outsiders as well."[34] We might say that Jesus started the first informal Christian seminary, and it was not gender-biased.

This coed model of Christian learning does not always occur today. While many seminaries in the United States, Spain, and Guatemala, for example, allow both men and women students, many cities or regions in these countries do not permit a coed model of Christian learning. Several years ago I helped teach a one-week course on Bible hermeneutics to pastors and their wives in Guatemala. Due to the culture of this specific region of the country, we separated the men and women into two classrooms during their daily lessons and instruction. Their culture did not allow for women to be taught alongside men. The women's teaching team struggled on many occasions, as most of the indigenous Guatemalan women were illiterate. On one occasion, when the women teachers asked a pastor if he might help his wife with her hermeneutics homework, his wife was forbidden to return the next day. We had violated their unwritten cultural codes about what women could and could not do.

Yet Christ, in the ancient provinces of Judea and Asia, mentored women alongside the Twelve. What kind of rabbi was this who invited women into his classroom? Jesus's attitude toward women was different from that of other Jewish teachers of that era or any before it. Jesus's talking to the Samaritan woman at the well shocked the disciples (John 4:27). They could not believe their eyes. Jesus's approach to women was nothing they had seen before. Nineteenth-century Anglican reverend Donald Spence-Jones described Jesus's female disciples as fellow-heirs with men of the kingdom of heaven: "It was obvious that they could no longer occupy on earth their old inferior and subordinate position. The sex, as a sex, has made a noble return to the Master."[35] Christ reinstated women's roles as fellow image-bearers and representatives of God with his method of teaching (Gen. 1:27). They were worthy of instruction and discipleship along with the Twelve.

Mary Magdalene: A patron

Not only did Mary Magdalene learn alongside men, she helped support them. Luke informs us that Mary Magdalene and other women gave of their own financial means (Luke 8:3, Gk. τὰ ὑπάρχοντα)[36] to support the basic and material needs of Jesus and the twelve apostles. Jesus called the Twelve from their day jobs to full-time discipleship and vocational ministry. No longer did the apostles have their fishing or tax-collecting professions to provide for their needs (vv. 5:1–11, 27–28).

Mary Magdalene's provisions demonstrated a visible expression of her faith, as she did not give just a one-time donation. Commentator Richard C.

34. Keener, *The IVP Bible Background,* Luke 8:1–3.
35. Spence-Jones, ed., *St. Luke,* vol. 1, 200.
36. The Greek phrase τὰ ὑπάρχοντα can be translated as: possessions, what they owned, financial support, money, or resources. Blight, *An Exegetical Summary of Luke 1–11,* 2nd ed., 330.

Blight explains the meaning of the Greek verb tense in Luke 8:3: "The imperfect tense 'they were providing for them' indicates repetition, 'they kept providing for them.' Jesus and his apostles would have a common purse out of which all their expenses were paid and these women kept replenishing the purse."[37] Mary unselfishly used her wealth to continually back the Lord's ministry. She helped fill the bank account, so to speak, of the Twelve. God had endless options. He could have employed other means to support Jesus and the Twelve—prosperous businessmen, miraculous bread from heaven (Exod. 16:4; Neh. 9:15)—but he allowed women, working women, to support the ministry. This information from ancient times challenges what many conservatives in the Western world think is the norm for Christian finances.

Jesus's traveling coed, female-supported seminary probably received sneers and gossip whisperings. As we have learned, rumors spread throughout the centuries about Mary Magdalene—none accurate or true. Bible commentators Walter Liefeld and David Pao instruct us "it was not uncommon for ancient itinerant cult leaders, fortune-tellers, and their kind to solicit the financial support of wealthy women. In this case, however, it is in a Jewish, not a pagan, culture; and the relationship [was] morally pure."[38] Men and women disciples learned together from the Master as moral brothers and sisters in Christ.

How were the women able to provide for Jesus's needs? Some of the recognized female occupations of the time consisted of hairdresser, midwife, professional mourner, innkeeper, and cloth merchant—such as Lydia (Acts 16:14).[39] These professions were common if the women were unmarried, divorced, or widowed.[40] Magdala was a booming town with industry. Perhaps Mary Magdalene was engaged in one of these professions. Another possibility is that these women had a marriage contract, dowry, or inheritance from their deceased husbands' estates.[41] (If such were the case for Mary Magdalene, perhaps we need to view her as an older woman instead of how she has appeared in paintings, movies, and novels.) Following after Jesus would not have allowed much time for entrepreneurship; therefore, an inheritance might be a plausible explanation. The Gospel of Luke does not inform us as to Mary Magdalene's profession (we now know it was not prostitution), only that she continually provided for the Twelve.

Often we think of women primarily supporting their families or ministries in traditional ways. Western middle-class Christian circles have long assumed working inside the home is the biblical role for women; and for men, their biblical role is financially providing for the family. The separated spheres are especially prevalent in teaching in the developed world since the Industrial Revolution. But Luke 8:3

37. Blight, 330.
38. Liefeld and Pao, "Luke," *The Expositor's Bible Commentary*, 153.
39. Bauckham, *Gospel Women*, 132–33.
40. Ibid.
41. Ibid., 127.

provides us with a different view—women providing financially for the ministry of Jesus. During Jesus's three years of ministry, Christ received the financial gifts of Mary Magdalene and other women whom he had freed from bondage.

Jesus had a mission to fulfill in his three short years of ministry, and he used men and women to accomplish his work. Seminary professor and author Dr. Sandra Glahn writes, "Our Lord's practice of receiving the financial support of women suggests that doing so does not undermine manhood. And conversely, apparently a woman's femininity is not violated if she financially supports a man or men."[42] Jesus was not concerned with defending his manhood. His only concern was spreading the news about the kingdom of God. Reverend Donald Spence-Jones poses this challenging question, "How did the Master and his disciples, poor men among poor men, live during the years of public teaching?"[43] The answer is simple: women.

Mary Magdalene: A participant of prophecy fulfilled

What was Mary Magdalene's life like before she met Jesus? As has been established, Luke 8:2 tells us only that Jesus cured her of seven demons—one little line with no details. Thus, we look elsewhere in the New Testament for clues.

The New Testament describes men and women afflicted with demons as having various diseases and pains, uncontrollable seizures and convulsions, unusual strength, self-inflicted wounds, illness, and blindness; teaching deceitful doctrines; being mute, violent, severely tormented, crippled, insane, naked, or ostracized from society,[44] and yet—after encountering Christ—acknowledging him as the Messiah.[45]

In what ways did the seven demons affect Mary Magdalene? The biblical text does not say. For how long did she suffer? Again, we are not informed. But in whatever manner she suffered with the seven demons, her problems were possibly severe. The young boy Luke describes as having had just one evil spirit was thrown to the ground in violent seizures (9:38–43). Mary Magdalene had a total of seven evil spirits.

In describing these spirits, Luke uses the Greek word δαιμόνιον (daimónion) for demons (8:2).[46] This word "applied especially to evil spirits. They were considered unclean, wicked, or evil . . . influencing both the spiritual and physical life of individuals."[47] Perhaps Mary Magdalene had an illness (or illnesses), seizures, or was crippled. Perhaps she struggled with depression and self-inflicted wounds. The text does not elaborate, and we are unclear as to how she had an income (v. 3) if she also struggled with demons.

42. Glahn, "Seriously? Jesus Traveled with Women?"
43. Spence-Jones, ed., *St. Luke*, Vol. 1, 200.
44. Respectively: Matt. 4:24; Luke 8:2; Matt. 17:15–18; Luke 9:42; Mark 5:3–4, 5; Matt. 4:24; 12:22; 1 Tim. 4:1; Matt. 9:33; 12:22; 8:28; 15:22; Luke 13:11; Mark 5:15; John 10:20; Luke 8:27, 35.
45. Matt. 8:29; Mark 5:7; Luke 4:34; James 2:19.
46. Newberry and Berry, Luke 8:2.
47. Zodhiates, *The Complete Word Study Dictionary*, no. 1142.

If you have ever experienced an illness that lasted longer than a few weeks—violent nausea from chemotherapy cancer treatments, pneumonia that refuses to leave the lungs and racks the entire body in coughing fits, constant nerve pain from the shingles virus—then you know of the debilitating and frustrating feelings that follow when you receive no relief. In some small measure, you can put yourself in Mary Magdalene's sandals. Physical torment typically results in emotional and spiritual torment, and Mary Magdalene had it sevenfold.

The Gospel writers thought it important to include this one-line fact about Mary Magdalene's cure from seven demons. Maybe she conveyed her story to the Gospel writers and emphasized she wanted it retold. Perhaps Matthew and John observed the before-and-after transformation of Mary Magdalene, and Christ's healing powers amazed them. The Bible does not give us the backstory. Yet, the Gospel writers preserved this information. Why was it important? What does it tell us about Mary Magdalene? What does it further tell us about Christ?

Mary Magdalene had firsthand knowledge of Jesus's greatness and authority over the demonic world. The Old Testament prophecies told of the coming of the Messiah who would preach, heal, free, proclaim, forgive, and comfort (Isa. 53:4; 61:1–2; Matt. 8:17). Mary Magdalene was freed from suffering. The Holy Spirit preserved her testimony through the Gospel writers (2 Tim. 3:16). Why?

Luke has a notable Christological theme—establishing Jesus as the Messiah—in this section of his Gospel. Jesus calmed the wind and the waves, demonstrating power over creation (8:22–25). He subdued a legion of demons, demonstrating authority over the spirit world (vv. 26–39). He healed long-term sickness and also brought a young girl back to life, demonstrating sovereignty over life and death (vv. 40–56). Likewise, Mary Magdalene's healing gave evidence of Jesus's authority and power (v. 2). Her story validated the Old Testament prophecies as true. Her healing confirmed Jesus's claim to be the Messiah. Her story shows Christ's power, and it shows how he can change lives.

Mary Magdalene: A necessary informant

Where did the Gospel writers get their information about the crucifixion, death, burial, and resurrection of Jesus? Luke explains, "They used the eyewitness reports circulating among us from the early disciples . . . so you can be certain of the truth of everything you were taught" (Luke 1:2, 4, NLT). The disciples' eyewitness reports informed the Gospel writers. But after the Romans arrested Jesus, all the other disciples deserted him and fled (Matt. 26:31, 56). Among the males, only the apostle John (John 19:26–27) and Joseph of Arimathea (19:38) were present at the cross. Who else was an eyewitness to these events? Mary Magdalene.

Mary Magdalene informed the other disciples, giving the full report of the events (Matt. 28:8; Luke 24:10). She is the only woman to consistently appear in all Gospel accounts of Jesus's crucifixion, burial, and resurrection. Matthew

and Mark record the presence of Mary Magdalene at the cross,[48] burial,[49] and empty tomb.[50] Luke notes the presence of the women at the cross (23:49) and burial (23:55), and then specifically names Mary Magdalene at the empty tomb (24:1–4, 10). And John places her at the cross (19:25) and empty tomb (20:1). The lists containing the names of women differ in each Gospel, but only Mary Magdalene's name appears in all. She holds a special place in the list of witnesses. The following chart shows the women's names as listed in the Synoptic Gospels (Matthew, Mark, and Luke) and the Gospel of John.

Chart 13.1: Mary Magdalene as Key Witness

	Cross	Burial	Empty Tomb	Risen Christ
Matthew	**Mary Magdalene,** Mary (mother of James and Joseph), Mother of James and John	**Mary Magdalene,** the other Mary	**Mary Magdalene,** the other Mary	**Mary Magdalene,** the other Mary
Mark	**Mary Magdalene,** Mary (mother of James and Joseph), Salome	**Mary Magdalene,** Mary (mother of Joseph)	**Mary Magdalene,** Mary (mother of James), Salome	**Mary Magdalene** (longer ending of Mark)
Luke	The women	The women	**Mary Magdalene,** Joanna, Mary (mother of James), several other women	
John	Jesus's mother, Mary (wife of Clopas), **Mary Magdalene**		**Mary Magdalene**	**Mary Magdalene**

What was so special about Mary Magdalene? Why was she chosen to be present from early in Jesus's ministry to his resurrection? Her presence throughout the Galilean ministry of Jesus is important for the accurate recording of all that took

48. Matt. 27:56; Mark 15:40.
49. Matt. 27:61; Mark 15:47.
50. Matt. 28:1; Mark 16:1–7.

place. Professor of New Testament Studies Richard Bauckham explains, "The ideal eyewitness was not the dispassionate observer, but the person who, as a participant, had been closest to the events. . . . Historians valued as their sources direct experience of the event by involved participants in them. Eyewitnesses were 'as much interpreters as observers.'"[51] Unlike the Roman centurion (Matt. 27:54), Joseph of Arimathea (Matt. 27:57; Luke 23:50), and the male disciples, Mary Magdalene was an involved participant from start to finish.

Luke records Mary Magdalene as a disciple and follower of Jesus (8:2–3). Then he states, "But Jesus's friends, including the women who had followed him from Galilee, stood at a distance watching" (Luke 23:49, NLT). Again in verse 55 (NLT), Luke mentions the women: "As his body was taken away, the women from Galilee followed." In Luke 24:6, the angel reminded the women what Jesus had told them back in Galilee. In verse 10 (NLT), "It was Mary Magdalene, Joanna, Mary the mother of James, and several other women who told the apostles what had happened." Observing these verses from Luke informs us that Mary Magdalene's discipleship spanned the entirety of Luke's narrative and, therefore, the entirety of Jesus's Galilean ministry. She was not a "dispassionate observer," but rather, a spiritually and emotionally, physically present participant and eyewitness from beginning to end.

Let us examine the Greek verbs the Gospel writers use when describing the women's view of the events. Matthew 27:55 and Mark 15:40 use the Greek verb θεωρέω (*theōreō*), for "watching." This Greek verb means "to gaze, to look with interest and for a purpose, usually indicating the careful observation of details."[52] Luke 23:49 employs ὁράω (*horáō*), meaning, "to see, perceive with the eyes, look at, implying not the mere act of seeing, but also the actual perception of some object."[53] And Luke 23:55 makes use of θεάομαι (*theáomai*), meaning "to wonder, behold, view attentively, contemplate, indicating the sense of a wondering consideration involving a careful and deliberate vision which interprets its object."[54]

Mary Magdalene and the female witnesses of the Gospel events did not view these from the perspective of casual bystanders. They perceived the events as involved participants, taking note of all the details. We might consider the women as journalists, police detectives, or private investigators. But they did not simply report the information to the other disciples. They remembered what Jesus had told them (Luke 24:8). Then they interpreted the details in light of all that they had seen, heard, learned, and were taught during Jesus's ministry.

An architect observes minute details of a contractor's work, checking to see if construction has been built according to the drawings. A mother notes every finger, toe, and dimple of her newborn baby, determining if the child looks more like

51. Bauckham, *Gospel Women*, 296.
52. Zodhiates, *The Complete Word Study Dictionary*, no. 2334.
53. Ibid., no. 3708.
54. Ibid., no. 2300.

mom, dad, grandma, or grandpa—even distinguishing between identical twins. A preacher records the Greek and Hebrew details of the Scriptures to obtain a proper exegesis of the Word of God. Likewise, these women observed and recorded every minute detail of Jesus's crucifixion, burial, and resurrection, verifying that events occurred exactly as Jesus had proclaimed and the Old Testament prophets declared. Jesus was not a crazy heretic, blasphemer, or demoniac as the Pharisees accused (Matt. 9:34, 12:24, 26:65). He was not a thief like the two men crucified next to him (Matt. 27:38; Mark 15:27). He was the Son of God, the Holy One, and the Messiah—and the women, Mary Magdalene especially, could verify this as true. Mary Magdalene was a necessary informant, interpreter, and observer.

What initial impressions did the disciples have regarding Mary Magdalene and the women's report of Jesus's resurrection?[55] "Chosen by God as the first human witnesses to Christ's resurrection, these women were commanded to *go* and *tell*"[56] (Mark 16:7, emphasis mine), and so they did. Mary Magdalene and the women immediately shared the good news with the disciples. But the disciples thought the news of the risen Lord nonsense. They did not believe the women's story (Mark 16:11; Luke 24:11).

The lawful credibility of a woman's eyewitness report at that time was next to nothing; thus, the disciples initially ignored the news. In that day and age, a woman's testimony did not legally count in a Jewish court of law.[57] They were not allowed to be legal witnesses. Yet God chose women—and this is extraordinary—to be his witnesses in a time when they were considered less than second-class citizens. No Jewish historian wanting to fabricate a story would have chosen women as the primary witnesses.[58] Bible commentator Edwin A. Blum states that because of this, the women's eyewitness accounts "mark . . . the narrative's historicity."[59] A woman's very lack of credibility gave reliability to the Gospel narratives. God operates in fascinating ways, elevating the perceived weak and frivolous nature of women to that of valor, bringing honor to women and glory to God. The details of Christ's resurrection uniquely came from the women. "These women were true disciples of Christ. They had ministered to Jesus's needs and would be the first witnesses of His resurrection (Mark 15:40, 41)."[60] If not for the testimony of women, we would not know that Jesus truly was the Messiah, who died and rose again for our sins.

Mary Magdalene: An apostle of the apostles

Where would we be without Mary Magdalene's testimony? What is the importance of her eyewitness account? The early church fathers, and Thomas

55. Matt. 28:10; Mark 16:10; Luke 24:10; John 20:18.
56. Radmacher et al., *Nelson's New Illustrated Bible Commentary*, 1242.
57. Grassmick, "Mark," *The Bible Knowledge Commentary*, 193.
58. Blum, "John," *The Bible Knowledge Commentary*, 342.
59. Ibid., 342.
60. Radmacher et al., *Nelson's New Illustrated Bible Commentary*, 1241.

Aquinas after them, called Mary Magdalene an "apostle of the apostles," and Pope John Paul II reinstated this title in 1988. An apostle is a messenger, but not just any messenger. An apostle is a messenger who believes in and ardently supports the idea or cause which he or she is proclaiming. Mary was this kind of messenger.

The synoptic writers place Mary Magdalene first in all the lists of women disciples. Dr. Bauckham believes the arrangement of these lists—with Mary Magdalene at the top—implies "she must have been of special importance in the early Christian communities."[61] Indeed, if not for her, we would not have a continuous and harmonious account of Jesus's ministry, death, burial, and resurrection. Only Mary Magdalene and the other women are recorded as having felt the earthquake as the angel rolled the stone away from the tomb (Matt. 28:1–2). Only they received the angel's proclamation (vv. 5–7) announcing God had kept his promises. Bible commentators explain, "Mary, the last one at the Cross and the first one at the tomb, was given the privilege of relaying the first resurrection message (Luke 24:10; John 20:2)."[62]

The Gospel of John gives special preference to Mary Magdalene. John, the disciple whom Jesus loved (John 20:2), describes the morning of Christ's resurrection and casts Mary Magdalene as the main character. Other women were with Mary Magdalene when she saw the empty tomb, as we see in the first-person plural pronoun she uses to describe her experience: "They have taken the Lord's body out of the tomb, and *we* don't know where they have put him!" (John 20:2, NLT, emphasis mine). Yet John names only Mary Magdalene.

Finding the empty tomb, Mary ran and informed Peter and John. Peter and John both observed the empty tomb and then believed in the resurrection, but they returned home (John 20:2–10). Mary Magdalene, on the other hand, stayed behind weeping, still looking into the tomb (v. 11). Suddenly, she saw two angels where Jesus's body had been laid, and they asked her, "Dear woman, why are you crying?" (v. 12, NLT). At this point Mary Magdalene must have been alone, because she responds, "Because they have taken away my Lord, and I don't know where they have put him" (v. 13, NLT). She no longer uses "we" but "I" in her statement. She desperately wants to find the crucified body of Jesus, and she is the only one left at the tomb.

Dr. Charles R. Swindoll explains Mary Magdalene's distressed situation: "Mary's request for the body of Jesus was probably made in the same spirit as that of Joseph and Nicodemus (19:38). She wanted nothing more than to bury her Master with dignity and then get on with putting the pieces of her life back together."[63] Jesus rescued Mary Magdalene from seven demons and then taught her alongside the Twelve. Her search for Jesus was not that of a heartbroken

61. Bauckham, *Gospel Women*, 187.
62. Radmacher et al., *Nelson's New Illustrated Bible Commentary*, 1303.
63. Swindoll, *Insights on John*, 345.

lover, as some movie producers have portrayed her, but that of a dedicated disciple. He was her savior. He was her rabbi. He had transformed her life.

John then continues to build the emotion and expectation of the resurrection scene. Mary turns to leave when she sees someone standing near her (John 20:14). This time it is the resurrected Lord who asks her, "Dear woman, why are you crying?" He adds more emphasis by asking, "Who are you looking for?" (v. 15, NLT). The angels had asked Mary Magdalene this question, and then Jesus repeats it, adding the second sentence. Jesus is all-knowing. He knew her heart and mind. Why did he repeat this question?

Dr. Swindoll explains, "Never suppose that words are placed in the Bible to fill up space or simply to finish a sentence. Every word has a purpose. Every adverb. Every preposition. Every verb. Every noun."[64] We want to shout at the pages of our Bible and say to Mary Magdalene, "It's Jesus! Look closer! It's him! Don't miss him! Look again!" Mary again expresses her relentless pursuit for the Lord. Jesus's repeat of the question was for her benefit and for ours, so that Mary could express her heart and convictions, and, thus, her heart and convictions could have an impact on us. We must ask ourselves the question: "Are we pursuing Jesus with the same conviction?" Mary Magdalene pursued Christ, even to the grave.

Mary suspects Jesus to be the gardener (v. 15); we are unsure why. We know his body still bore the wound in his side and the nail holes in his hands (v. 27). Perhaps his face still bore the remnants of the flogging and beating from the Romans. Perhaps he had dirt on his face and arms from falling, as tradition—though not Scripture—records. Perhaps tears blinded Mary's vision. Perhaps the last person she ever expected to see was the risen Lord. She was, after all, looking for a dead body, not for a walking, talking, and breathing resurrected Jesus. She pleads for the location of Jesus's body so that she may go and retrieve it.

Jesus then gently, yet earnestly, calls her by name, "Mary!" (v. 16). At that moment Mary knew, and her heart leaped for joy. Her shepherd had called her by name and she recognized his voice, just as Jesus had taught his disciples, saying, "The sheep recognize [the shepherd's] voice and come to him. He calls his own sheep by name and leads them out . . . and they follow him because they know his voice" (10:3–4). Mary knew Jesus by the sound of his voice. She turned and exclaimed, "Rabboni!" (v. 16). She believed he had risen, just as he had said.

Post-resurrection Jesus first appeared to Mary Magdalene. He did not appear first to Peter, or any of the other remaining disciples. Nor did he appear at all to Pilate or the Pharisees. Jesus appeared to Mary Magdalene. He honors both men and women, as "women played a major part in Jesus's life and work,"[65] and Mary Magdalene was a main character. After meeting Christ, Mary Magdalene's life changed. Jesus took her from whatever road she was on and turned her into

64. Swindoll, *Abraham: One Nomad's Amazing Journey of Faith*, Kindle edition, location 1571.
65. Radmacher et al., *Nelson's New Illustrated Bible Commentary*, 1357.

a faithful disciple. She was esteemed and blessed. She was significant. Her gratitude and devotion to serve the Lord to the very end resulted in her receiving this unique honor. Her desperate pursuit brought much reward. And the historical events that undergird our faith depend on Mary Magdalene's faithful witness.

Jesus then continues to honor her with this most important assignment, "go find my brothers and tell them" (v. 17). Bible commentator Edwin A. Blum explains, "Mary's *new responsibility* was to testify to His risen presence. She was the recipient of four special graces: to see angels; to see Jesus risen; to be the first to see him alive; and to be a proclaimer of the good news."[66] Mary ran and found the disciples and told them, "I have seen the Lord!" She relayed Jesus's message to them (v. 18). Mary Magdalene had privileged information about Christ, indispensable information for the male disciples and the Gospel writers. The Gospel writers needed her testimony, and so do we—"so [we] can be certain of the truth of everything [we are] taught" (Luke 1:4, NLT).

A REMARKABLE PORTRAIT OF A WOMAN

We have examined, erased, painted over, and added new brush strokes to the canvas of Mary Magdalene. Mary Magdalene was not a prostitute, nor Jesus's lover, but a loyal female disciple, patron of finances, participant of prophecy fulfilled, and a necessary passive and active witness of Christ's ministry, crucifixion, death, and resurrection. She was the first to the grave, the first to see the risen Lord, the first to testify the news of his resurrection, and the only woman to consistently appear in all the lists of women disciples. Let us stand back, observe, and remember this new portrait of Mary Magdalene—a portrait based on biblical fact, not folklore. Her portrait is complete: Mary Magdalene is honored and revered as the first messenger of Christ's resurrection—the apostle of the apostles—declaring, "I have seen the Lord!" She saw and she proclaimed: He is risen. He is alive!

QUESTIONS FOR DISCUSSION

1. What previous distorted images of Mary Magdalene were painted in your mind?

2. How has this chapter challenged or changed your view(s) regarding the role of women in in the New Testament? Does this view transform any of your thoughts about present-day biblical role(s) of women? If so, how?

3. Jesus told Mary Magdalene to "go, find, and tell," and she did not hesitate (John 20:17). In what areas of your life do you feel the Lord is telling you, "Go"?

66. Blum, "John," 343.

JUNIA/JOANNA: HERALD OF THE GOOD NEWS

AMY PEELER, PHD

"Greet Andronicus and Junia, my kin and my fellow prisoners, who are well-known among the apostles,[1] who have been in Christ before me."
—Romans 16:7[2]

C an women believe in Jesus? Can women suffer for the gospel? Can Christians respect women? Most readers would reply with a strong "yes" to each of these questions. The gospel message of reconciliation in Christ comes to all people, men and women. Countless women throughout the history of the church have suffered for their confession of faith in Christ, and Christians look to faithful women from the first century to today as excellent examples of the Jesus Way. These basic affirmations are precisely what Paul claims for a woman named Junia in his list of greetings at the end of his letter to the Roman congregations.[3] She came to believe in Christ even before Paul did. She was imprisoned for her faith along with Paul, and she was held in high esteem by the apostles. On these points no interpreter of the New Testament would disagree.

1. I seek, with this translation, not to settle the argument before it is made. "Well-known among the apostles" could place Andronicus and Junia inside or outside the group of apostles mentioned, and is a translation allowed by the semantic range of the words in question.
2. Translations are my own, unless otherwise noted.
3. Based on Paul's greetings to a number of people, especially those who have others "with them" (Rom. 16:5, 14, 15), scholars conclude that there were several house churches in Rome at the time Paul is writing (Schreiner, *Romans*, 797; Dunn, *Romans 9–16*, 891).

Why, then, does this woman Junia earn her place as a vixen, a controversial figure who has been ignored and/or maligned? It is because Paul places her name in close association with the term *apostle*, and that association leads to the one controversial question about this otherwise widely agreed-upon verse: Can women be apostles?

That one question embraces two eras, the past and the present, and creates a slew of other questions. First, the association pushes readers to posit a historical inquiry: In the first century, the earliest days of the Christian movement, could women be considered apostles? What does Paul mean by the term "apostle"? What could apostles do? Second, the answer to the historical question entails implications for the contemporary world: If Junia was considered an apostle by the early church, what does that indicate about women's roles and leadership functions in the Christian movement today?

I offer, in this essay, an attempt to posit answers to those questions by investigating the colorful interpretive history of this woman, Junia. Lexically, translators have rendered her name both female and male; historically, interpreters have considered the text to call her an apostle or not; and ecclesially, theologians have held her up either as one who disturbs or one who confirms male leadership. I treat her story in three movements. First, I recount how scholars have arrived at the almost unanimous decision that the Greek name *Iounian* must be female. Second, I analyze the noncontroversial aspects of Paul's description—namely her ethnicity, conversion, and imprisonment— seeking to articulate what it would have been like for a Jewish woman in the first century to come to believe in Christ and then be imprisoned for that faith. Finally, I retrace the debate about her relationship to the apostles: Is she prominent among them or well known to them? I conclude by offering some contemporary implications for my suggested reading.

I should state at the outset that Junia alone cannot bear the weight of the "woman's question" in the church. Even if an essay such as this one, or the many others that have appeared in recent years,[4] could establish that Paul considered her a highly respected apostle and could prove that her apostleship is just as assured as her gender, those conclusions would not etch her name among the twelve, nor could they erase the passages that urge the silent submission of women in the church (1 Cor 14:34–35; 1 Tim. 2:11–15). Nevertheless, attending to Junia's story could contribute to a renewal of mission, no matter where one is located on the spectrum of the debate. Her existence serves as a needed reminder of the points that unite us: Everyone should hear the gospel, everyone should be willing to suffer for Christ, and everyone should respect those who are worthy of honor, without concern for gender. All Christians, like Andronicus

4. Bauckham, *Gospel Women*, 172–80; Epp, "Text Critical," 227–91; Belleville, "*Iounian*," 231–49; Epp, *Junia*; Pederson, *Lost Apostle*.

and Junia, are "apostles" in the sense that we are all "sent ones"[5]— sent out by God, commanded by Jesus, empowered with the Spirit to minister in word and deed; and any debate, ancient or modern, that would distract from rather than contribute to that charge is an unworthy one indeed. Whether one perceives Junia to be an apostle or not, reflecting on her witness should make Christians neither ignore her nor fight over her, but desire to emulate her life.

JUNIA IS A WOMAN:
THE LEXICAL AND HISTORICAL CONSENSUS

Names are gender-ambiguous. Some might work equally well for men or women, and some might be more likely male or female based on their geographic or historical setting. Names offer no guarantee, however, that a listener knows without a doubt that the person to whom the name refers is a man or a woman. One might think that in Greek, an inflected language that differentiates gender, the ambiguity would not exist. Such is not the case. Particular grammatical cases might have the same letters for both masculine and feminine nouns. Some masculine nouns are grouped in the first declension, a set dominated by feminine words; and vice versa, some feminine nouns appear in the largely masculine second declension. The existence of such overlaps and exceptions led to the later[6] confusion about the second name in Romans 16:7.

When Paul instructs the Romans to greet Andronicus and Junia, he follows the imperative verb, *aspasasthe,* "(you all) greet," with direct objects. In this sentence the instruction "greet" is followed by the names of the persons who should be greeted, and direct objects in Greek are typically—and in this instance the general rule applies—in the accusative case. The accusative in Romans 16:7, *Iounian,* can be the accusative form of one of three nouns: the feminine *Iounía,* the masculine *Iounías,* or the masculine *Iouniâs* (notice the latter two options are distinguished only by an accent, which would not be present in the oldest manuscripts).[7] Such options might make it seem that the conclusion has equal arguments on all sides. In their book on gender published in 1991, Wayne Grudem and John Piper describe the situation in just this way: "Was Junias a woman? We cannot know. The evidence is indecisive. . . . So there is no way to be dogmatic about what the form of the name signifies. It could be feminine or it could be masculine."[8]

The scholarly discussion no longer supports such ambiguity. Save one suggestion that the name might be a Greek form of a masculine Hebrew name

5. While this is true generally, see the discussion below where I argue that this general sense is not how Paul is employing the term "apostle" in Romans 16:7. Nevertheless, his definition is broad enough, I believe, to include her and hold her up as a noncontroversial example.
6. As I will show, early interpreters demonstrated no confusion, but accepted this as a feminine name.
7. Epp, *Junia,* 23.
8. Piper and Grudem, *Recovering Biblical Manhood and Womanhood,* 72–73.

yĕḥunnī,[9] all other published scholars concur that the name in question is most likely a feminine one.[10] The scholarly consensus at present is that Junia is a woman. The evidence for such a firm conclusion arises from two arguments. First, as much as is possible, scholars have investigated the historical occurrences of the name. "Junia" was a common name for Roman women in the ancient world. It has been found six times in extrabiblical texts, and more than 250 times in inscriptions.[11] Conversely, the suggested masculine names, *Iounías* and *Iouniâs* have never been found in either text or inscription.[12] Second, the witness of early generations of Christians overwhelmingly supports reading *Iounian* as a woman.[13] All church fathers read Romans 16:7 in this way,[14] save a later copy of a writing by Epiphanius (315–403), which also mistakenly refers to Prisca as a man (Acts 18:2, 18, 26; Rom. 16:3; 1 Cor. 16:19; 2 Tim. 4:19).[15] All early translations make no comment on the name either way or treat it as feminine. None treat the name as explicitly masculine.[16] The most prolific praise from a patristic source comes from John Chrysostom, the prominent Greek preacher (344/354–407), who says, "To be an apostle is something great but to be outstanding among the apostles—just think what wonderful song of praise that is!

9. Wolters, "IOUNIAN," 397–408.

10. Burer, "*Episēmoi*," 731. Concerning the question whether the name is a Hebrew masculine one or a Latin feminine one, Wolters himself concludes, "A plausible (but not decisive) case can be made for either position" ("IOUNIAN," 408, n. 70). Even Wayne Grudem takes the evidence of the prominence of this Latin female name as establishing a "probability" that here in Romans 16:7 it is feminine (*Evangelical Feminism and Biblical Truth*, 226).

11. Epp, *Junia*, 91–92, n. 2.

12. Ibid., 24–25. Some interpreters have suggested the possibility that the second name in Romans 16:7 might be the abbreviated form of the name *Iunianus*, but appeal only to analogous instances of other names, not the names in question. There is always a chance that such a name existed, but if it did, no record of it has ever been recovered. Bauckham carefully concludes, "The possibility that the person in Romans 16:7 bore the name *Iunias* cannot be ruled out. But it remains the case that the name is unattested in our evidence, whereas the name Junia is well attested" (*Gospel Women*, 169).

13. The only variants that occur here in Greek manuscripts change the name to Julia, a very common Roman name. This variant seems to support the fact that the scribes also read this as a feminine name, but misunderstood it as one of the more popular ones.

14. Grudem claims that Origen has a reference to this name in the masculine form, *Iunias* (*Evangelical Feminism and Biblical Truth*, 225) but now a critical edition of Rufinus's translation of Origen's commentary (where the masculine form occurs) exists and demonstrates that the earliest and best manuscripts have a feminine form of the name. The masculine form exists only in two texts, probably one is dependent upon the other, from the twelfth century. In other places where Origen refers to Romans 16:7, he uses a feminine form of the name. Other scholars who translate Origen's commentary also have the name as a feminine (Epp, *Junia*, 33–34).

15. Epp, *Junia*, 34. Moreover, because the statement in question comes from much later manuscripts, some scholars even doubt if the fourth-century bishop ever made this statement at all (Bauckham, *Gospel Women*, 166–67, n. 242).

16. Ibid., 23–24.

They were outstanding on the basis of their works and virtuous actions. Indeed, how great the wisdom of this woman must have been that she was even deemed worthy of the title of apostle" (*Epistle to the Romans* Nicene and Post-Nicene Fathers Volume 1, 11:555).[17]

If the historical witness is so consistent, from the Greco-Roman world through the time of the church fathers, then how could the situation change to one in which a masculine version of the name became a viable option? Before answering this question, it is important to ascertain when this change began to appear. The first instance of an interpreter understanding this name as a masculine one occurs in the early fourteenth century. Aegidius (or Giles) of Rome (1243/47–1316) prefers the variant *Iulian* and assumed it to be a masculine name. A French scholar, Jacques LeFèvre d'Étaples, makes a similar decision in his 1512 commentary on Paul's letters; but the assumption of a male name truly gained support when Luther, influenced by d'Etaples, presented *Iounian* as the masculine *Junias* in his translation of the German Bible and in his collected works.[18]

In the English-speaking world, the change came later. Until 1833, all English versions had the name as feminine, *Junia*, but when the Revised Version was produced in 1881 with the masculine name, its choice became influential until the contemporary era. Even though the Revised Version was based on a Greek text (Oxford Greek New Testament of 1881) that rendered the name as feminine, committee spokesman J. B. Lightfoot said that it seemed probable the name was masculine. He gave no explicit reason why, but claimed only that this person was one of Paul's kinsfolk and was noted among the apostles.[19] Attention to the moments of the change suggests an answer to the question of *how* this could happen. Both Luther and Lightfoot read Paul's statement as indicating that the person *was* an apostle. It seems that this person *Iounian*'s association with the apostles resulted in the conclusion that such a person must be male. Now that historical evidence weighs so heavily toward a female name, many English translations render the name as a "Junia," or at least include a footnote that does so. When they do, their translators share with their readers from the confident results of the last several decades of scholarship and the consensus of the first one thousand years of the church.

JUNIA: IMPRISONED JEWISH CHRISTIAN

Having established that extremely solid evidence exists to conclude that the second person named in Romans 16:7 is a woman, it remains for readers of Paul's letter to contemplate the character of the woman and man he mentions

17. Because John Chrysostom was not conflicted about a debate on the issue of women in ministry, he might have been more free to read the text in its simplest form, as referring to a woman who was an apostle. I am grateful to my colleague Lynn Cohick for calling my attention to this possibility.
18. Epp, *Junia*, 38.
19. Ibid., 26.

here. Bauckham claims this as one of the most elevated greetings Paul offers in this chapter: "No one else to whom Paul refers in Romans 16 has comparable standing."[20] The facts about Andronicus and Junia present excellent examples of the Christian faith, even without considering their relationship with the apostles.

Beginning in verse 3 of chapter 16, Paul, writing from Corinth,[21] commends the members of these congregations in Rome to extend warm greetings to twenty-six individuals and several groups. These are people with whom Paul worked, suffered, and evangelized, who are now present in Rome. For all of them he felt a high degree of Christian collegiality and love. He wishes to connect with them personally, as well as to demonstrate to the Roman Christians who do not know him his good connections with respected members of the faith.[22] These members can serve as his references as he anticipates coming to the Roman Christian community and using it as a missionary base for Spain.[23] Andronicus and Junia are included in this group of loved and esteemed people, and, based on Paul's specifications about them, it is highly likely that he knew them personally and spent time with them.[24]

Their names not only tell us their sex, as we have discussed at length, but also shed light on their life stories. *Andronikos* is a male Greek name, often given to slaves or freedman (manumitted slaves).[25] Junia is, as discussed, a common female Latin name, related to the esteemed Roman family the *gens Junia*,[26] which could be taken by their slaves or the descendants of their slaves.[27] It is clear, however, from Paul's first statement about them that they are not ethnically Greek and Latin. Instead, they are his *sungeneis*; in Greek, this word literally means that they are relatives of Paul. This might indicate that they are members of his own family, or this term could be Paul's way of saying, as he does in Romans 9:3, that they are fellow Jews.[28]

Why, then, would Jews have Greek or Latin names? Regarding Andronicus's Greek name, it is possible that he was a member of the Greek-speaking Jewish Christians mentioned in Acts 6:1 who were scattered out of Jerusalem because of persecution, went to Antioch, and began preaching to the Greeks about Jesus (11:19–20).[29] If this is the case, then Andronicus and Junia could be among the Jewish Christians who would have supported Paul's controversial mission to the Gentiles, and that would make them important allies indeed.[30] Conversely,

20. Bauckham, *Gospel Women*, 181.
21. Fitzmyer, *Romans*, 85–87.
22. Schreiner, *Romans*, 789–93.
23. Rom 15:23–24; Fitzmyer, *Romans*, 70.
24. Schreiner, *Romans*, 792.
25. Jewett, *Romans*, 961.
26. Bauckham, *Gospel Women*, 169.
27. Lampe, "*Iunia/Iunias*," 133–34.
28. Bauckham, *Gospel Women*, 170.
29. Sanday and Headlam, *Romans*, 424; Cranfield, *Romans*, 790.
30. Lampe, "Andronicus," 1:247.

Paul's recommendation of them and encouragement to greet them could add support for these Jewish Christians who were facing the disdain of the largely Gentile Christian gatherings in Rome.[31]

In the case of Junia, the adoption of a Latin name could signify that she was associated with the family of the Herods—one of the most Latinized groups in Palestine—either by blood or slavery.[32] Richard Bauckham suggests another intriguing possibility: He argues that Junia is the Latinized version of the Hebrew name *Yehohannah* or *Yohannah*—in English, Joanna, the follower of Jesus mentioned in Luke 8:3 and 24:10. It was a common practice for Jewish people to adopt Greek or Latin names that sounded similar to their given Hebrew names: Simon for Simeon, Jason for Yeshua, Rufus for Reuben. This would allow their Greek or Roman neighbors more ease in pronouncing their names.[33] Bauckham wonders if Joanna could have adopted this Latinized name "Junia" when she began missionary travels into the Greco-Roman world or even before she knew Christ, if she was a member of the Herodian elite as the wife of Chuza, Herod's steward (8:3). Bauckham concludes, "I cannot decide between these two possibilities, but the second alerts us also to consider how appropriate it would have been for Joanna, the wife of Herod's steward, member of the Romanized Herodian elite of Tiberias, to become a Christian missionary specifically in Rome. She would have known some Latin, doubtless a rare accomplishment among the first Jewish Christians of Jerusalem. She had the means to support herself and a degree of acculturation to Roman ways."[34] Although a solid suggestion, this remains only a possibility. It is clear, however, that both Andronicus and Junia were members of that select group of Jews in the first century who came to believe that Jesus was their long-awaited Messiah.

Next, Paul states that Andronicus and Junia were his fellow prisoners (*sunaixmalotous*). There were several Greek words possible to denote being in prison, but this one had the connotation of being a prisoner of war. Paul uses it in a few other places (Col. 4:10; Philem. 23) to refer to fellow Christian prisoners. Bauckham suggests, "While referring to literal incarceration, Paul uses a word that also interprets this fate as an event in the battle in which he and his coworkers are fighting as fellow soldiers of Christ. . . . The shame associated with imprisonment in the ancient world is transformed into the honor of a soldier who had stood his ground, refused to retreat, and had been captured."[35] Paul's language suggests several historical possibilities: (1) All three of them were in prison together at the same time; (2) they, too were imprisoned for preaching the

31. Jewett, *Romans*, 962.
32. Bauckham, *Gospel Women*, 182.
33. A modern parallel occurs when Asian students will often choose Western names to avoid embarrassment or frustration when Western people cannot correctly pronounce their Asian names. I have many students who adopt this practice.
34. Bauckham, *Gospel Women*, 186.
35. Ibid., 171.

gospel, but at a different time and place than Paul (maybe even they are in prison in Rome when he writes); or (3) they came and stayed with Paul while he was imprisoned to minister to him. The only other use of this specific word outside of the Bible appears in the writings of the author Pseudo-Lucian and suggests that a shared prison experience is most likely.[36]

The Greco-Roman prison situation was exceedingly harsh, including co-erced confessions, small spaces without windows or restrooms, lack of food and sleep, and chains and stocks.[37] This would not be easy for anyone, but for a woman, expected by her society to be sequestered from such ugliness, it would have been a shameful situation. Moreover, it was assumed by Jewish sages that a woman's imprisonment would include rape by the guards.[38] If Junia experienced such horrors and survived them, she resisted the great temptation of suicide in prison and remained faithful to continue her witness after her release.[39]

Skipping over for a moment the debated statement about their relationship with the apostles, the final thing Paul says about Andronicus and Junia also increases their status in the eyes of those listening. They were "in Christ"—one of Paul's favorite phrases to describe believers.[40] Moreover, they were brought into this position before him. Scholars posit that Paul was converted sometime in 33 or 34,[41] just a few years after the death, resurrection, and ascension of Christ. That would mean that Andronicus and Junia would have been among the earliest Jewish converts to Christianity. The timing puts into sharp relief Paul's respect for their chronological priority. Junia and her partner Andronicus believed in Christ while Paul was still persecuting him. Paul employs the perfect tense to express their status in Christ, which conveys the idea that they were in Christ before Paul and remain in him to the time in which Paul is writing.[42] This would place their conversion within a year or two of the Christ event[43] and indicate that they had been spreading the gospel for more than two decades by the time Paul is writing this letter.[44]

This further bolsters Bauckham's claim that Junia might be Joanna. If these people are esteemed by, or especially if they are esteemed among, the apostles, it seems odd that they are mentioned nowhere else in Scripture;[45] but if Junia is the Latinized name of Joanna, she would have been one of the very first witnesses

36. Jewett, *Romans*, 962.
37. Ibid., 962–63. There may not have even been room enough for the prisoners to lie down. Rapske, *The Book of Acts and Paul in Roman Custody*, 23.
38. Ibid., 259, 280.
39. Wansink, *Chained in Christ*, 55–61.
40. In Romans alone, this appears at Rom. 3:24; 6:11, 23; 8:1, 2, 39; 12:5; 15:17; 16:3, 9, 10.
41. Schnelle, *Apostle Paul*, 51.
42. Weymouth, *On the Rendering into English of the Greek Aorist and Perfect*, 26.
43. Morris, *Romans*, 534.
44. Jewett, *Romans*, 964.
45. Zahn, *Römer*, 608.

of the resurrection (Luke 23:55–24:7) and one of the first to testify about it (24:9–10). As a very early Jewish believer in Jesus, Junia almost certainly had connections with the Jerusalem church. She also faced the persecution of prison, in all likelihood with Paul.[46] These qualifications—being Jewish, being an early believer in Christ, and facing imprisonment—are true of the known apostles of Jesus,[47] but could such a designation be applied to a woman?

JUNIA: ESTEEMED AMONG OR WELL KNOWN TO THE APOSTLES

Throughout the long history of debate whether *Iunion* was a woman or a man, Paul's third statement was widely accepted as saying that the people in question were apostles. The phrase *episēmoi en tois apostolois* was almost always read as "esteemed among the apostles."[48] As Eldon Jay Epp so cleverly comments, "The male 'Junias' and the female 'Junia' each has his or her alternating 'dance partners' —first one, then the other: first and for centuries, Junia with 'prominent apostle'; then Junias with 'prominent apostle.' Then for a time Junia disappears from the scene, hoping upon her return to team up once again with 'prominent apostle,' only to encounter 'known to the apostles' cutting in during this latest 'dance.'"[49] This depiction captures the shifting dynamic through the centuries. It should be stated that modern commentators who adopted this view that Andronicus and Junia were apostles did so because the patristic sources—those who knew and spoke Greek—adopted this "inclusive" view, namely that the pair were included in the group of apostles who esteemed them.

That inclusion immediately raises the issue of the meaning of the word "apostle" as Paul employs it here. In a nontechnical sense, *apostolos* means "one sent," but this would be an odd way to designate all Christians, especially if Paul is seeking to support them in Rome and gain Roman support. On the other hand, he cannot mean that Andronicus and Junia are members of the twelve, named in the Gospels.[50] In his summary of the main points of his gospel

46. While Acts mentions three imprisonments for Paul, in Philippi (Acts 16), Caesarea (Acts 21), and Rome (Acts 28), and he writes four letters from prison (Philippians, Philemon, Ephesians, and Colossians), it is possible that he was in prison other times not explicitly mentioned.

47. I am indebted to Mark Goodacre for this point, having heard a paper he presented on the topic at the Society of Biblical Literature in 2011. He was kind enough to share a print version with me to aid my research and thinking.

48. Burer and Wallace, "Was Junia Really an Apostle?" 79; Bauckham, *Gospel Women*, 172.

49. Epp, *Junia*, 72.

50. Matt. 10:2; Mark 3:14; Luke 6:13. If Paul means this very technical sense for "apostle," it would be odd for him to disagree with the synoptic tradition. Some would suggest that this would push the meaning to "well-known to the twelve," but as I argue later, it would also be odd for Paul to put himself outside the apostolic group in his letter to the Romans.

I would argue that Jesus chose the twelve apostles as males because they represented the patrilines of the twelve tribes of Israel. While they were very important in the minis-

message, however, Paul provides an alternate definition. Paul mentions the twelve as a group differentiated from the apostles, of whom Paul says he is the least (1 Cor. 15:5–9). Based on his description, these must be people who saw the resurrected Christ and were given some kind of role of apostleship, since they were distinct from the five hundred to whom Christ appeared (v. 6). Admittedly, not all early Christians accepted Paul's claim to be an apostle, so he has to defend this broader definition. That is to say, Paul's definition of apostle is broader than "the twelve" but not applicable to all Christians charged to spread the gospel (Matt. 28:19–20). Epp's summary here captures the salient points:

> When Paul defends his apostleship—and thereby defines what apostleship means—he implies that to be an apostle involves encountering the risen Christ (1 Cor. 9:1; Gal. 1:1, 15–17) and receiving a commission to proclaim the gospel (Rom. 1:1–5; 1 Cor. 1:1; Gal. 1:1, 15–17), and in the process he strongly emphasizes (a) that being an apostle involves "the conscious acceptance and endurance of the labors and sufferings connected with missionary work," and (b) that apostleship is certified by the results of such toil, namely, "signs and wonders, and mighty works" (1 Cor. 15:9–10; 2 Cor. 12:11–12). Unless Paul recognizes these traits in others, he would not deign to call them "apostles," but Andronicus and Junia obviously met and exceeded his criteria.[51]

As I stated earlier, Andronicus and Junia, based on their ethnicity, belief, chronology of coming to faith, and suffering for Christ, sound similar to the other apostles.

While a few commentators raised the possibility that the phrase *episēmoi en tois apostolois* did not mean "esteemed among the apostles" but rather "well known to the apostles,"[52] Michael Burer and Dan Wallace presented the first full-scale argument for this translation in their 2001 New Testament Studies article,

try of Jesus, they were not the only ones who did ministry with him, and at the birth of the church they become less prominent in the spread of the gospel. Matthias is a perfect example here (Acts 1:21–26). They needed a replacement to complete the number of twelve, but Luke never mentions him again. Instead, Paul becomes the apostle that Luke focuses upon.

51. Epp, *Junia*, 70. Goodacre concurs, "His well-known sensitivity about the term makes it unlikely that he is excluding himself from a group that he is usually adamant about belonging to. Any conferring of apostolic esteem here would have included Paul too (cf. 1 Cor. 4.9, 'us apostles'). The final clause in Romans 16.7, *hoi kai emou gegonan en Christo* ('who also were in Christ before me') provides further helpful circumstantial evidence. It places Andronicus and Junia at the beginning of the new movement, increasing the likelihood that they were regarded as 'apostles' and witnesses to the resurrection. Appreciation of the broader context of Paul's brief comments about Junia lends support to the notion that she was an apostle like him, in Christ before him" ("Junia," 1).

52. In "Was Junia Really an Apostle?" Burer and Wallace mention Hodge, Murray, Meyer, Philippi, Lenski, and Zahn.

"Was Junia Really an Apostle? A Re-evaluation of Romans 16:7." There they argued that the phrase "is more naturally taken with an exclusive force rather than an inclusive one."[53] After surveying much Greek literature they conclude that the word *episēmos,* when followed by a dative noun—as it is in Romans 16:7—is much more often used in an exclusive sense; hence, Andronicus and Junia were "well known to the apostles (but not apostles themselves)." Three scholars produced responses to this article, Richard Bauckham, Eldon Epp, and Linda Belleville, all of whom argued that Burer and Wallace's suggestion was not as conclusive as they had argued. In 2015, Burer responded.[54] He defended and clarified several of their previous arguments as well as drew on additional Greek data. This new data, he argued, overwhelmingly supported their thesis—namely that when the *episēmos* is inclusive, it is followed by a genitive word, and when it is exclusive, it is followed by a dative. That is, when the author intends to include a person as a member of the group ("prominent among the apostles") then the genitive form is used, and when the author distinguishes a person from a group ("well known to the apostles"), the dative form is used.

This present essay is not the forum to respond to such a detailed linguistic argument, but I will note several concerns with his most recent arguments. First, in several places Burer argues for an exclusive interpretation of a passage that is not, at least to my reading and to several of their reviewers, clearly exclusive.[55] Second, he recognizes at least one example in the second essay that goes against their original thesis, namely a use of *episēmos* followed by a dative used in an inclusive sense, but does not adequately account for this occurrence.[56] Third, I perceive a tendency in their writing, particularly the first article, to overstate their case. Both Bauckham[57] and Epp[58] level similar charges against them in this respect. The tendency for overstatement is demonstrated clearly in the opening paragraph of their original essay, where, writing about the male/female name debate, they state that there is, "quite a bit of evidence enlisted on both sides."[59] This, as they recognize later,[60] is simply not the case. The evidence for the male name, as presented above, is almost nonexistent. In his 2015 response, Burer brings forth more texts but does not respond explicitly to the charges about the (overly?) bold claims made upon their original data.[61] However, Burer concludes

53. Burer and Wallace, "Was Junia Really an Apostle?" 84.
54. Burer, "*Episēmoi,*" 731–56.
55. I disagree with his translation of an inscription from Asia Minor (739–40) and his treatment of a passage from Lucian (742–43).
56. The reason Burer gives this example less weight is because the noun is impersonal (Burer, "*Episēmoi,*" 754). Bauckham questions why, grammatically, personal and impersonal should be so distinguished (Bauckham, *Gospel Women,* 178).
57. Bauckham, *Gospel Women,* 174.
58. Epp, *Junia,* 74–77.
59. Burer and Wallace, "Was Junia Really an Apostle?" 76.
60. Ibid., 78.
61. Burer, "*Episēmoi,*" 735–36.

in the second essay that his aim is to present the exclusive reading of the phrase as an option that must be considered.[62]

Nevertheless, I remain unconvinced of their interpretation of the phrase, because of the consistent witness of the ancient church. They acknowledge that their reading disagrees with the majority of interpreters.[63] Burer allows that "we should give credence to ancient commentators" but not that "we are to accept their assessments and arguments without critical examination." This seems to be a wise approach in general, but the example they bring forth for the necessity of criticism is the incorrect assessment of Epiphanius (or, as mentioned earlier, likely a later copyist of his material) that Junia was a man. If Epiphanius was wrong, then, so Burer continues, so could Chrysostom be; maybe he "misunderstood the Greek text he was reading."[64] The disagreement about the verse is not a fight between Chrysostom and Epiphanius as he intimates, but against every patristic commentator and a twelfth-century copy of Epiphanius' writings. Since the early believers assumed Junia, the woman, was an apostle, and since even Burer and Wallace allow that this is a grammatical option for this phrase, though they argue that it is an unlikely one, I conclude that this reading is precisely the way the early church consistently read Paul. Therefore, so do I.

IMPLICATIONS

Here Burer or Wallace,[65] or someone who does not favor women in ministerial leadership, might question my appeal to patristic sources. It is certainly not the case that, although these early readers seemed to believe that Junia was an apostle, they were ardent supporters of women in pastoral ministry.[66] Reading the phrase in Romans 16:7 in a particular way does not immediately result in one particular position on the question of women's ordination.[67]

If it is correct that Paul's use of "apostle" indicates neither the twelve alone nor every Christian,[68] and if his view is that apostles had to have seen the risen

62. Ibid., 755.

63. Regarding modern interpreters, this might be a good thing as arguments established sometimes need to be challenged. As they state at the end of their essay, "Our sense is that the unfounded opinions of a few great scholars of yesteryear have been, frankly, canonized." Burer and Wallace, "Was Junia Really an Apostle?" 91.

64. Burer, "*Episēmoi*," 745.

65. Wallace, "Some Reflections on the Role of Women in the Church." Dan Wallace's statement is an incredibly gracious one.

66. For statements from Tertullian, Origen, Clement and others, see the entry on "Women," in *A Dictionary of Early Christian Beliefs*, 609–95.

67. Douglas Moo, in his commentary on Romans, argues that this is a female name and that Paul regards her as an apostle (*Romans*, 923–24). His position is that women should not be in pastoral ministry. Moo, "What Does It Mean Not to Teach or Have Authority Over Men (1 Timothy 2:11-15)?"

68. Goodacre argues forcefully against Burer and Wallace's more conscribed definition of the term "apostle" ("Was Junia Really an Apostle?" 90, n. 67 and n. 68): "Could the apostle,

Christ (1 Cor. 9:1; 15:8), been called by God (Rom. 1:1; 1 Cor. 1:1; Gal. 1:1), and set apart for a particular ministry (Rom. 11:13; 1 Cor. 12:28–29) of evangelism and discipleship (9:1) accompanied by miraculous deeds (2 Cor. 12:12), then it seems rather uncontroversial to imagine what Junia might have done in the early church. Based on her experience of Christ and her being gifted by God, she was charged with spreading the gospel and encouraging those who accepted it,[69] as the women at the tomb did, as the women gathered in the upper room at Pentecost did, and as Priscilla did. Readers of the text today do not know what she thought or practiced about such things like authoritative public teaching of men, but we know what she thought about Christ and about his very good news. She is not "vixen"; she is a bold "herald," and all Christian women and men, indebted to her work, bear the responsibility to carry out the same gospel mission still.

QUESTIONS FOR DISCUSSION

1. Based upon what we know about this pair of people, what might have been the most difficult thing about professing Christ? Family background? Prison? What would have been the most rewarding thing?

2. Do you think the data better supports Junia as an esteemed apostle or as someone esteemed *by* the apostles?

3. If Junia was an apostle, do you think that should affect woman's roles in the church today? Why or why not?

who has to fight for the right to call himself an apostle, really use the term about another group? Could he afford to imply that he was not a part of a group commonly acknowledged to be 'apostles,' especially here, in Romans, where he is trying so hard to establish his authority as an apostle before he goes up to Jerusalem, in the priestly service of the gospel of God, with the collection for the saints in Jerusalem?" Goodacre, "Junia," 9.

69. I am pleased to see my colleague, Douglas Moo, with whom I respectfully disagree about the fittingness of women in pastoral ministry, arrive at a very similar conclusion about Andronicus and Junia: "They moved about in the eastern Mediterranean (where they encountered and perhaps were imprisoned with Paul) seeking to bring men and women to faith in Christ" (*Romans*, 924).

BIBLIOGRAPHY

Abasili, Alexander Izuc hukwu. "Was It Rape? The David and Bathsheba Pericope Reexamined," *Vetus Testamentum* 61, no. 1 (2011): 1–15.

Achtelstetter, Karin. "Huldah at the Table: Reflections on Leadership and the Leadership of Women," *Currents in Theology and Mission* 37, no. 3 (2010): 180–83.

Ackerman, Susan. "Digging Up Deborah: Recent Hebrew Bible Scholarship on Gender and the Contribution of Archaeology," *Near Eastern Archaeology,* 66, no. 4 (2003): 172–84.

Alexander, Wayne, and William Violet. "The Marketing of People: Slave Trade in the Ancient Near East," *Journal of Business and Behavioral Sciences,* 26, no. 2 (Summer 2014): 138–55.

Allen, Ron. "On the Threshing Floor," class notes supplement, Biblical Exposition at Dallas Theological Seminary, Dallas, February 2, 2016.

Alter, Robert. *The Art of Biblical Narrative,* revised and updated. New York: Basic Books, 2011.

Anchor Bible, The. Garden City, NY: Doubleday & Company, 1964–.

Anders, Max and Gary Inrig, *Holman Old Testament Commentary 1 & 2 Kings.* Nashville: Holman Reference, 2003, 346.

Anderson, Arnold A. *2 Samuel,* Word Biblical Commentary Series. Dallas: Word Books, 1989.

"The Anti-Marcionite Prologue (Mark)," accessed May 19, 2016, http://www.tertullian.org/fathers/anti_marcionite_prologues.htm.

Apocalypse of Moses. in *The Apocrypha and Pseudepigrapha of the Old Testament in English with Introductions and Critical and Explanatory Notes to the Several Books,* ed. R. H. Charles. Oxford: Oxford University Press, 1913.

Arndt, W., F. W. Danker, and W. Bauer. *A Greek-English Lexicon of the New Testament and Other Early Christian Literature* (BADG). Chicago: University of Chicago Press, 2000.

Arnold, Bill T., *1 and 2 Samuel,* The NIV Application Commentary, Vol. 11. Grand Rapids: Zondervan, 2003.

Arnold, Bill T. and Bryan E. Beyer, eds. *Readings from the Ancient Near East.* Grand Rapids: Baker, 2002.

"The Assumption of Moses" a.k.a. "The Testament of Moses," accessed May 19, 2016, http://wesley.nnu.edu/index.php?id=2124.

Augustine of Hippo. "On The Good of Marriage," accessed May 19, 2016, http://www.newadvent.org/fathers/1309.htm.

Austel, Hermann J. and Richard Patterson. "1 and 2 Kings." In Ronald F. Youngblood, Richard D. Patterson, and Hermann J. Austel, *1 Samuel–2 Kings*, eds. Tremper Longman III and David E. Garland, revised edition. Grand Rapids: Zondervan, 2010.

Bailey, Kenneth E. *Jesus through Middle Eastern Eyes: Cultural Studies in the Gospels*. Downers Grove, IL: InterVarsity Press, 2008.

Bailey, Randall C. *David in Love and War: The Pursuit of Power in 2 Samuel 10–12*, eds. David J. A. Clines and Philip R. Davies, Journal for the Study of the Old Testament Supplement Series 75. Sheffield: JSOT Press, 1990.

Bakon, Shimon. "Deborah: Judge, Prophetess and Poet," *Jewish Bible Quarterly* 43, no. 2 (2006): 110–18.

Baldwin, Joyce G. *1 and 2 Samuel: An Introduction and Commentary*, The Tyndale Old Testament Commentaries, ed. D. J. Wiseman. Leicester, England: InterVarsity Press, 1988.

Barnes, William. *1–2 Kings*, ed. Philip W. Comfort. Carol Stream, IL: Tyndale House, 2012.

Barth, Karl. *Church Dogmatics*, 3 vols. London: T. & T. Clark International, 1958.

Bauckham, Richard. *Gospel Women: Studies of the Named Women in the Gospels*. Grand Rapids: W. B. Eerdmans, 2002.

Baylis, Charles P. "Naomi in the Book of Ruth in Light of the Mosaic Covenant," *Bibliotheca Sacra* 161, no. 644 (Oct–Dec 2004): 413–31.

Beal, Lissa Wray. *1 & 2 Kings*. Downers Grove, IL: IVP Academic, 2014.

Belleville, Linda L. "*Iounian . . . episēmoi en tois apostolois*: A Re-examination of Romans 16.7 in Light of Primary Source Materials," *New Testament Studies* 51.2 (2005): 231–49.

————. "Women Leaders in the Bible." In *Discovering Biblical Equality: Complementarity without Hierarchy*, 2nd ed., eds. Ronald W. Pierce, Rebecca Merrill Groothuis, and Gordon D. Fee. Downers Grove, IL: IVP Academic, 2005, 110–125.

Bercot, David W. "Women," in *A Dictionary of Early Christian Beliefs: A Reference Guide to More Than 700 Topics Discussed by the Early Church Fathers*, 609–95. Peabody, MA: Hendrickson, 1998.

Bergen, Robert D. *1, 2 Samuel*, The New American Commentary, Vol. 7. Nashville: B&H, 1996.

Berlin, Adele. *Poetics and Interpretation of Biblical Narrative*. Winona Lake, IN: Eisenbrauns, 1999.

Blight, Richard C. *An Exegetical Summary of Luke 1–11*, 2nd ed. Dallas: SIL International, 2008.

Block, Daniel I. *Judges, Ruth*, The New American Commentary, Vol. 6. Nashville: B&H, 1999.

Blomberg, Craig L. and Robert I. Hubbard Jr., and William W. Klein. *Introduction to Biblical Interpretation,* revised edition. Nashville: Thomas Nelson, 2004.

Blum, Edwin A. "John," in *The Bible Knowledge Commentary: An Exposition of the Scriptures,* eds. John F. Walvoord and Roy B. Zuck. Wheaton, IL: Victor Books, 1983.

Bock, Darrell L. *Breaking the Da Vinci Code: Answers to the Questions Everyone's Asking.* Nashville: Thomas Nelson, 2006. Kindle edition.

_____. *Luke, Volume 1: 1:1–9:50.* Grand Rapids: Baker, 1994.

Booij, Thijs. "Hagar's Words in Genesis 16:13b," *VT* 30 (January 1980): 1–7.

Boraas, Roger S. "Floor," *The HarperCollins Bible Dictionary (Revised and Updated),* ed. Mark Allan Powell. New York: HarperCollins, 2011.

Borowski, Oded. *Daily Life in Biblical Times.* Atlanta: Society of Biblical Literature, 2003.

Bos, Johanna W. H. "Out of the Shadows: Genesis 38; Judges 4:17–22; Ruth 3," *Semeia* 42 (1988): 37–67.

Bradley, Carol Pratt. "Women in Hebrew and Ancient Near Eastern Law," *Studia Antiqua* 3, no. 1 (Winter, 2003): 1–46.

Brand, Chad, et al., eds., "Barley Harvest," *Holman Illustrated Bible Dictionary.* Nashville: Holman Bible Publishers, 2003.

Brenner, Athalya and Gale A. Yee. *Joshua and Judges.* Minneapolis: Fortress, 2013.

Brenton, Sir Lancelot C. L. *The Septuagint with Apocrypha, Greek and English.* Grand Rapids: Zondervan Publishing House, 1982.

Bronner, Leila Leah. *From Eve to Esther: Rabbinic Reconstructs of Biblical Women,* 1st edition. Louisville: Westminster John Knox Press, 1994.

Brown, Dan. *The Da Vinci Code: A Novel,* 2nd Anchor Books Mass Market ed. New York: Anchor Books, 2009.

Brown, Francis, S. R. Driver and Charles A. Briggs. *New Brown-Driver-Briggs Hebrew and English Lexicon of the Old Testament* (BDB). Peabody, MA: Hendricksen, 1996.

Brown, Raymond. *The Birth of the Messiah: A Commentary on the Infancy Narratives in the Gospels of Matthew and Luke.* New York: Doubleday, 1993.

Brueggemann, Walter. *1 & 2 Kings,* Smyth & Helwys Bible Commentary, CD-R edition. Macon, GA: Smyth & Helwys Pub., 2000.

Burer, Michael H. "*Episēmoi en tois apostelois* in Rom. 16:7 as 'Well Known to the Apostles': Further Defense and New Evidence," *Journal of the Evangelical Theological Society* 58, no. 4 (2015): 731–56.

Burer, Michael H. and Daniel B. Wallace. "Was Junia Really an Apostle? A Reexamination of Rom. 16.71," *New Testament Studies* 47, no. 1 (2001): 76–91.

Butler, Trent C. *Judges,* World Biblical Commentary, Vol. 8. Nashville: Thomas Nelson, 2009.

Calvin, John J. *Genesis,* Crossway Classic Commentaries. Wheaton, IL: Crossway Books, 2001.

_____. "Commentary on Ezekiel, Volume 2 Christian Classics Ethereal Library," accessed December 9, 2015, http://www.ccel.org/ccel/calvin/calcom23.ii.xviii.html?highlight=huldah#highlight.

Caneday, Ardel B. and Matthew Barrett, eds., *Four Views on the Historical Adam*, Counterpoints. Grand Rapids: Zondervan, 2013.

Carter, Jimmy. *A Call to Action: Women, Religion, Violence, and Power*. New York: Simon & Schuster, 2014.

Cassuto, U. *A Commentary on the Book of Genesis*. Jerusalem: Magnes, 1984.

Celoria, Heather. "A Cautionary Tale about Rape Culture in the Church and #TakeDownThatPost," Junia Project, June 17, 2014, accessed July 5, 2014, http://juniaproject.com/ rape-culture-church-takedownthat.

Chandler, Matt. "Recovering Redemption: The Genesis: Creation and Fall," August 18, 2013, accessed December 23, 2015, http://thevillagechurch.net/resources/sermons/detail/the-genesis-creation-and-fall.

Chankin-Gould, J. D'Ror, et al. "The Sanctified 'Adulteress' and Her Circumstantial Clause: Bathsheba's Bath and Self Consecration," *Journal for the Study of the Old Testament* 32, no. 3 (2008): 339–52.

Chertok, Haim. "The Book of Ruth—Complexities within Simplicity," *Judaism*, 1986.

Chicago Assyrian Dictionary, The. Chicago: Oriental Institute of Chicago.

Chisholm, Robert B. Jr., *From Exegesis to Exposition: A Practical Guide to Using Biblical Hebrew*. Grand Rapids, Baker Books, 1998.

Chrysostom, John. Vol. 11 of *The Nicene and Post-Nicene Fathers, Second Series*. Eds. Philip Schaff and Henry Wace. New York: Charles Scribner's Sons, 1908.

Clement of Alexandria. *Clement of Alexandria—The Stromata or Miscellanies*. CreateSpace Independent Publishing Platform, 2015.

Coats, George W. "The Curse in God's Blessing: Gen 12, 1–4a in the Structure and Theology of the Yahwist." In *Die Botschaft und die Boten: Festschrift für Hans Walter Wolff zum 70. Geburtstag*," eds. Jörg Jeremias and Lothar Perlitt. Neukirchen-Vluyn: Neukirchener Verlag, 1981.

Cogan, Mordechai and Hayim Tadmor. *II Kings*. Yale University Press, 1988.

Cohick, Lynn H. *Women in the World of the Earliest Christians: Illuminating Ancient Ways of Life*. Grand Rapids: Baker Academic, 2009.

Colette, Shelly. "Eroticizing Eve: A Narrative Analysis of Eve Images in Fashion Magazine Advertising," *Journal of Feminist Studies in Religion* 31 (2015): 5–24.

Collins, C. John. *Did Adam and Eve Really Exist? Who They Were and Why You Should Care*. Wheaton, IL: Crossway, 2011.

Complete Parallel Bible, The, Containing the Old and New Testaments with the Apocryphal/Deuterocanonical Books, NRSV, REB, NAB, NJB. New York: Oxford University Press, 1993.

Coogan, M. D. "A Structural and Literary Analysis of the Song of Deborah," *Catholic Biblical Quarterly*, 40 (1978): 143–46.

Cranfield, C. E. B. *A Critical and Exegetical Commentary on the Epistle to the Romans.* International Critical Commentary 28. Edinburgh: T. & T. Clark Limited, 1975–79.

Cruveilhier, P. "Le Droit de la femme dans la Genèse et dans le receuil de Lois Assyriennes," *Revue Biblique* 36 (1927): 350–76.

Dandamayev, M. A. "Slavery: Ancient Near East." In *The Anchor Bible Dictionary,* ed. D. N. Freedman. 6 vols. New York: Doubleday, 1992.

Davidson, Richard M. "Did King David Rape Bathsheba? A Case Study in Narrative Theology." *Journal of the Adventist Theological Society,* 17, no. 2 (Autumn 2006): 81–95.

Dawson, Nancy S. *Genealogies of the Bible.* 3 vols. Forthcoming.

de Vaux, Roland. *Ancient Israel: Its Life and Institutions.* Vol. 1: Social Institutions. New York: McGraw-Hill, 1965.

_____. *The Early History of Israel.* Philadelphia: Westminster, 1978.

Driscoll, Mark. *On Church Leadership: A Book You Will Actually Read.* Wheaton, IL: Crossway, 2008.

Driver, G. R., and John C. Miles, eds. *The Babylonian Laws.* Oxford: The Clarendon Press, 1968.

Driver, S. R., and Charles A. Briggs. *The New Hebrew and English Lexicon.* Peabody, MA: Hendrickson Publishers, 1979.

Dunn, James D. G. *Romans 9–16.* Word Biblical Commentary 38B. Dallas: Word, 1988.

Edersheim, Alfred. *Sketches of Jewish Social Life in the Days of Christ.* London: The Religious Tract Society, n.d.

Edwards, Jonathan. *Works of Jonathan Edwards, Volume One,* accessed December 9, 2015, http://www.ccel.org/ccel/edwards/works1.xii.iv.iv.html?highlight=huldah#highlight.

Elwell, Walter A. and Philip Wesley Comfort. *Tyndale Bible Dictionary,* Tyndale Reference Library. Wheaton, IL: Tyndale, 2001.

"Epiphanius of Salamis, Ancoratus," accessed May 19, 2016, https://books.google.com/books?id=gxHWAwAAQBAJ&lpg=PA9&dq=epiphanius%20ancoratus%20translation&pg=PA9#v=onepage&q=epiphanius%20ancoratus%20translation&f=false.

Epp, Eldon Jay. *Junia: The First Woman Apostle.* Minneapolis: Fortress Press, 2005.

_____. "Text Critical, exegetical, and socio-cultural factors affecting the Junia/Junias variation in Romans 16:7." In *New Testament Textual Criticism and Exegesis: Festschrift J. Delobel,* ed. Adelbert Denaux. Leuven, Belgium: Peeters (2002): 227–91.

Eusebius of Caesarea. "Ecclesiastical History." Translated by Arthur Cushman McGiffert. From *Nicene and Post-Nicene Fathers, Second Series,* Vol. 1. Eds. Philip Schaff and Henry Wace. Buffalo, NY: Christian Literature Publishing Co., 1890. Revised and edited for New Advent by Kevin Knight. accessed May 19, 2016, http://www.newadvent.org/fathers/250103.htm.

_____. "Praeparatio Evangelica: Preparation for the Gospel." Tr. E. H. Gifford, 1903, accessed December 9, 2015, http://www.earlychristianwritings. com/fathers/eusebius_pe_10_book10.html.

Everyday Life in Bible Times. Washington, DC: The National Geographic Society, 1967.

Falkenstein, Adam. *Das Sumerische.* Leiden: Brill, 1964, 6–60.

Fewell, Danna Nolan. "Joshua." In *The Women's Bible Commentary,* eds. Carol A. Newsom and Sharon H. Ringe. Louisville: Westminster/John Knox Press, 1992.

Fewell, Danna Nolan and David M. Gunn. "Controlling Perspectives: Women, Men, and the Authority of Violence in Judges 4 & 5," *Journal of the American Academy of Religion,* no. 58 (1990).

Finley, Thomas J. "The Ministry of Women in the Old Testament." In *Women and Men in Ministry: A Complementary Perspective*, eds. Robert L. Saucy and Judith K. TenElshof. Chicago: Moody, 2001.

Fishbane, Michael. "The Well of Living Water: A Biblical Motif and its Ancient Transformations." In *"Sha'arei Talmon": Studies in the Bible, Qumran, and the Ancient Near East Presented to Shemaryahu Talmon,* eds. Michael Fishbane and Emmanuel Tov. Winona Lake, IN: Eisenbrauns, 1992, 3–16.

Fitzmyer, Joseph A. *Romans: A New Translation with Introduction and Commentary.* New York: Doubleday, 1993.

Fokkelman, Jan P. *Narrative Art and Poetry in the Books of Samuel,* Vol. 1. Assen, The Netherlands: Van Gorcum & Company, 1981.

Fox, Michael V. *Character and Ideology in the Book of Esther*, 2nd Edition. Eugene, OR: Wipf & Stock, 1991.

Freedman, H., and Maurice Simon, trans. *Midrash Rabbah, Genesis*, Vol. 1. New York: The Soncino Press, 1983.

Fritz, Volmar *1 & 2 Kings.* Minneapolis: Augsburg Books, 2003.

Frymer, Tikva S., S. David Sperling, and Aaron Rothkoff, "Huldah. In the Aggadah," in *Encyclopaedia Judaica,* 2nd ed., Vol. 9, eds. Michael Berenbaum and Fred Skolnik. Detroit: Macmillan Reference USA, 2007, 580–81.

Frymer-Kensky, Tikva. *Reading the Women of the Bible: A New Interpretation of Their Stories.* New York: Schocken Books, 2002.

Gafney, Wilda C. *Daughters of Miriam: Women Prophets in Ancient Israel.* Minneapolis: Fortress Press, 2008.

Garland, David E. and Diana R. Garland. "Bathsheba's Story: Surviving Abuse and Loss." In *Flawed Families of the Bible: How God's Grace Works through Imperfect Relationships.* Grand Rapids: Brazos Press, 2007, 22–33.

Gelasius (Damasus). "Decretum Gelasianum," accessed May 19, 2016, http:// www.tertullian.org/decretum_eng.htm.

Gibson, Mel. *The Passion of the Christ.* Twentieth Century Fox Home Entertainment LLC: 2004.

Glahn, Sandra L. "The First-Century Ephesian Artemis: Ramifications of Her Identity," *Bibliotheca Sacra* 172, no. 688 (October–December 2015): 450–69.

_____. "The Identity of Artemis in First-Century Ephesus," *Bibliotheca Sacra* 172, no. 687 (July–September 2015): 316–34.

_____. "Seriously? Jesus Traveled with Women?" *Aspire2* blog, September 4, 2013. Accessed December 10, 2015, http://aspire2.com/2013/09/seriously-jesus-traveled-with-women.

Goodacre, Mark. "Junia: An Apostle in Christ before Paul." Paper presented at the Annual Meeting of the Society of Biblical Literature, San Francisco, November, 2011.

Gordon, C. H. "Biblical Customs and the Nuzu Tablets," *BA* 3 (1940): 1–12.

Grassmick, John D. "Mark." In *The Bible Knowledge Commentary: An Exposition of the Scriptures*, eds. John F. Walvoord and Roy B. Zuck. Wheaton, IL: Victor Books, 1983.

Grayson A. K., and J. Van Seters. "The Childless Wife in Assyria and the Stories of Genesis," *Or* 44 (1975): 485–86.

Griffith-Jones, Robin. *Mary Magdalene, The Woman Whom Jesus Loved*. Norwich, UK: Canterbury Press Norwich, 2008.

Grossman, Jonathan, *Esther: The Outer Narrative and the Hidden Meaning*. Winona Lake, IN: Eisenbrauns, 2011.

Grudem, Wayne. *Evangelical Feminism and Biblical Truth: An Analysis of More Than One Hundred Disputed Questions*. Sisters, OR: Multnomah, 2004.

_____. *Systematic Theology: An Introduction to Biblical Doctrine*. Grand Rapids: Zondervan, 1994.

Gunkel, Hermann. *Genesis*. Göttingen: Vandenhoeck & Ruprecht, 1910.

Hackett, Jo Ann. "Rehabilitating Hagar: Fragments from an Epic Pattern," in *Gender and Difference in Ancient Israel*, ed. Peggy L. Day. Minneapolis: Fortress, 1989.

Hallo, W. W., and K. Lawson Younger, eds. *The Context of Scripture* (COS). 3 vols. Leiden: Brill, 1997–2002.

Hamilton, Victor P. *The Book of Genesis: Chapters 1–17*, The New International Commentary on the Old Testament, ed. R. K. Harrison. Grand Rapids: William B. Eerdmans Publishing Company, 1990.

Hamori, Esther J. "The Prophet and the Necromancer: Women's Divination for Kings," *Journal of Biblical Literature* 132, no. 4 (2013): 827–43.

Handy, Lowell K. *The Book of Genesis: Chapters 18–50*, The New International Commentary on the Old Testament, eds. R. K. Harrison and Robert L. Hubbard Jr. Grand Rapids: William B. Eerdmans Publishing Company, 1995.

_____. "Reading Huldah as Being a Woman," *Biblical Research* 55 (2010).

Hanson, Anthony Tyrrell. *Studies in the Pastoral Epistles*. London: SPCK, 1968.

Harm, Harry J. "The Function of Double Entendre in Ruth Three," *Journal of Translation and Textlinguistics* 7, no. 1 (1995): 19–27.

Haskins, Susan. *Mary Magdalen: Myth and Metaphor*. Old Saybrook, CT: Konecky & Konecky, 1994.

Henry, Matthew. *Commentary on the Whole Bible, Volume II: Joshua to Esther,* 1708, accessed December 9, 2015, http://www.ccel.org/ccel/henry/mhc2. iiKi.xxiii.html?highlight=huldah - highlight.

Herodotus. *The Histories,* ed. and trans. Robin Waterfield. New York: Oxford University Press, 1998.

Hertig, Young Lee and Chloe Sun, eds. *Mirrored Reflections: Reframing Biblical Characters.* Eugene, OR: Wipf & Stock, 2010.

Hess, Richard S. "Israelite Identity and Personal Names from the Book of Judges," *Hebrew Studies* 44 (2003): 25–39.

Higgins, Jean M. "The Myth of Eve: The Temptress," *Journal of the American Academy of Religion* 44 (1976): 639–47.

Hooper, Richard J. *The Crucifixion of Mary Magdalene: The Historical Tradition of the First Apostle and the Ancient Church's Campaign to Suppress It.* Sedona, AZ: Sanctuary Publications, 2005.

Hubbard Jr., R. L. "Kinsman-Redeemer and Levirate," *Dictionary of the Old Testament: Wisdom, Poetry & Writings,* eds. Tremper Longman III and Peter Enns. Downers Grove, IL/Nottingham, England: IVP Academic/InterVarsity Press, 2008.

Huffman, Herbert B. *Amorite Personal Names in the Mari Texts.* Baltimore: The Johns Hopkins Press, 1965.

Hunt, Mary. "Eve's Legacy: Burden of Blame," *Media and Values* 49 (Winter 1990), accessed December 16, 2015, http://www.medialit.org/reading-room/eves-legacy-burden-blame.

The Infancy Gospel of Matthew a.k.a. *The Gospel of Pseudo-Matthew* and by its original title, *The Book About the Origin of the Blessed Mary and the Childhood of the Savior,* accessed May 19, 2016, http://gnosis.org/library/psudomat.htm.

Irenaeus of Lyons. "Contra Haereses," accessed May 19, 2016, http://www.earlychristianwritings.com/irenaeus.html.

Jacob, B. *The First Book of the Bible, Genesis,* trans. and ed. Ernest I. Jacob and Walter Jacob. New York: KTAV Publishing House, Inc., 1974.

James, Carolyn Custis. *The Gospel of Ruth.* Grand Rapids: Zondervan, 2008.

_____. *Half the Church: Recapturing God's Global Vision for Women.* Grand Rapids: Zondervan, 2011.

_____. *Malestrom: Manhood Swept into the Currents of a Changing World.* Grand Rapids: Zondervan, 2015.

Jamieson, Robert, A. R. Fausset, and David Brown. *Commentary Critical and Explanatory on the Whole Bible,* accessed December 9, 2015, http://www.ccel.org/ccel/jamieson/jfb.x.xxxvi.i.html?highlight=huldah #highlight.

Janzen, J. Gerald. "Hagar in Paul's Eyes and in the Eyes of Yahweh Genesis 16," *Horizons in Biblical Theology* 13 (June 1991): 1–22.

Jerome. *Against Jovinianus* 1.25, Nicene and Post-Nicene Fathers 2, 6:364.

_____. *Against the Pelagians* 2.22, Nicene and Post-Nicene Fathers 2, 6:469.

Jewett, Robert. *Romans: A Commentary.* Hermeneia. Minneapolis: Fortress Press, 2007.

Kasher, Menahem M. "Genesis," in *Encyclopedia of Biblical Interpretation*, Vol. 2, ed. Harry Freedman. New York: American Biblical Encyclopedia Society, 1955, 216–19.

Kautzsch, E., and A. E. Cowley, eds. *Gesenius' Hebrew Grammar,* Second English Edition (GKC). Oxford: The Clarendon Press, 1910.

Keener, Craig S. *The IVP Bible Background Commentary: New Testament.* Downers Grove, IL: InterVarsity Press, 1993.

Kemp, Barry J. *Ancient Egypt: Anatomy of a Civilization.* London: Routledge, 1989.

Kidner, Derek. *Genesis: An Introduction and Commentary*, Tyndale Old Testament Commentaries. Downers Grove, IL: InterVarsity Press, 1967.

Kim, Uriah Yong-Hwan. "Uriah the Hittite: A (Con)text of Struggle for Identity," *Semeia* 91 (2002): 135–44.

King, Philip J., and Lawrence E. Stager. *Life in Biblical Israel.* Louisville: Westminster John Knox, 2001.

Klein, Lilliam. *From Deborah to Esther: Sexual Politics in the Hebrew Bible.* Minneapolis: Fortress Press, 2000.

Koehler, Ludwig, Walter Baumgartner, and M. E. J. Richardson, eds. *The Hebrew and Aramaic Lexicon of the Old Testament* (HALOT). Accordance electronic edition, version 3.0. Leiden: Brill, 2000.

Konkel, August H. *1 and 2 Kings* , 1st ed. Grand Rapids: Zondervan, 2006.

Kreider, Glenn. "The Flood Is as Bad as It Gets: Never Again Will God Destroy the Earth," *Bibliotheca Sacra* 171 (Oct–Dec 2014): 162–77.

_____. *God with Us: Exploring God's Personal Interactions with His People throughout the Bible.* Phillipsburg, NJ: P&R Publishing, 2014.

Kristof, Nicholas D. and Sheryl WuDunn. *Half the Sky: Turning Oppression into Opportunity for Women Worldwide.* New York: Alfred A. Knopf, 2009.

Kuhrt, Amélie. *The Ancient Near East. C. 3000–330 BC.* Vol. I. London: Routledge, 1995.

Kuruvilla, Abraham. "Pericopal Theology: An Intermediary between Text and Application," *Trinity Journal* 31 (2010): 265–83.

LaCocque, Andre. *Esther Regina: A Bakhtinian Reading.* Northwestern University Press, 2008.

Lagrange, M. J. "L'ange de Iahvé," *RB* 12 (1903): 212–25.

Lampe, Peter. "Andronicus," *Anchor Bible Dictionary*, ed. D. N. Freedman. 6 vols. New York: Doubleday, 1992.

_____. *"Iunia/Iunias: Sklavenherkunft im Kreise der vorpaulischen Apostel* (Röm 16:7)." *Zeitschrift für die neutestamentliche Wissenschaft und die kunde der älteren Kirche* 76.1–2 (1985): 132–34.

Landy, Yehuda. *Purim and the Persian Empire: A Historical, Archeological, & Geographical Perspective.* Jerusalem: Feldheim Publishers, 2010.

Laniak, Timothy S. *Shame and Honor in the Book of Esther.* Atlanta: Scholars Press, 1998.

Leithart, Peter J. *Brazos Theological Commentary on the Bible: 1 and 2 Kings.* Grand Rapids: Brazos Press, 2006.

Lenski, R. C. H. *The Interpretation of St. John's Gospel.* Minneapolis: Augsburg Publishing House, 1961.

Lewy, Julius. "On Some Institutions of the Old Assyrian Empire," *Hebrew Union College Annual* 27 (1956): 9–10.

Licht, Jacob. *Storytelling in the Bible,* 2nd ed. Jerusalem: The Magnes Press, 1986.

Lichtheim, Miriam, ed. *Ancient Egyptian Literature. Volume 1: The Old and Middle Kingdoms.* Berkeley: The University of California Press, 1975.

Liddell, H. G., and R. Scott. *A Greek-English Lexicon.* Oxford: The Clarendon Press, 1968.

Liefeld, Walter L., and David W. Pao. "Luke." In *The Expositor's Bible Commentary: Luke–Acts Revised Edition.* eds. Tremper Longman III and David E. Garland, Vol. 10. Grand Rapids: Zondervan, 2007.

Luther, Martin. *Luther's Commentary on Genesis,* Vol. 1, trans. J. Theodore Mueller. Grand Rapids: Zondervan Publishing House, 1958.

Lutz, Lorry. *Women as Risk Takers for God: Finding Your Role in the Neighborhood, Church and World.* Grand Rapids: Baker, 1997.

Maalouf, Tony. *Arabs in the Shadow of Israel: The Unfolding of God's Prophetic Plan for Ishmael's Line.* Grand Rapids: Kregel Publications, 2003.

MacArthur, John. "The Fall of Man, Part 2 (Genesis 3:6–7)," March 12, 2000, accessed December 23, 2015, http://www.gty.org/resources/sermons/90-239/the-fall-of-man-part-2.

Maclaren, Alexander. *Expositions of Holy Scripture: Second Kings Chapters VIII to End and Chronicles, Ezra, and Nehemiah. Esther, Job, Proverbs, and Ecclesiastes.* CreateSpace Independent Publishing Platform, 2015.

Macquarrie, John. *Mary for All Christians.* Grand Rapids: Eerdmans, 1990.

Malamat, A. "Mari and the Bible: Some Patterns of Tribal Organizations and Institutions," *Journal of the American Oriental Society,* no. 8 (1962): 143–50.

Martin, John A. "Luke," in *The Bible Knowledge Commentary: An Exposition of the Scriptures,* eds. John F. Walvoord and Roy B. Zuck. Wheaton, IL: Victor Books, 1983.

Mathews, Kenneth A. *Genesis 1:1–11:26,* Vol. 1A, New American Commentary. Nashville: Broadman and Holman, 1996.

———. *Genesis 11:27–50:26,* New American Commentary. Nashville: Broadman & Holman, 2005.

Matthews, V. H. "Family Relationships," *Dictionary of the Old Testament: Pentateuch,* eds. T. Desmond Alexander and David W. Baker. Downers Grove, IL: InterVarsity, 2003: 293–294.

Mattox, Mickey L. "Eve in Early Reformation Exegesis: The Case of Iohannes Oecolampadius," *Reformation and Renaissance Review* 17 (July 2015): 203–4.

_____. *An Exposition of Genesis [1–3]*, trans. Mickey L. Mattox. Milwaukee: Marquette University Press, 2013.

Mazar, Amihai. *Archaeology of the Land of the Bible 10,000–586 B.C.E.* New York: Doubleday, 1990.

Mazar, Eilat. "Did I Find King David's Palace?" *BAR* 32, no. 1 (January/February 2006): 16–27.

_____. *Preliminary Report on the City of David Excavation 2005.* Jerusalem: Shalem Press, 2007.

McCabe, Elizabeth A., ed. *Women in the Biblical World: A Survey of Old and New Testament Perspectives*, Volume 2. Lanham, MD: University Press of America, 2011.

McCarter, Jr., P. Kyle. *II Samuel: A New Translation with Introduction, Notes, and Commentary*, Anchor Yale Bible Commentaries. Garden City, NY: Doubleday, 1984.

McColley, Diane. "Shapes of Things Divine: Eve and Myth in *Paradise Lost*," *Sixteenth Century Journal* 9 (1978): 47–48.

McEvenue, Sean E. "Comparison of Narrative Styles in the Hagar Stories," *Semeia* 3 (1975): 64–80.

McGee, J Vernon. *Ruth: The Romance of Redemption*. Reprint of 1943 edition. Nashville: Thomas Nelson, 1981.

McGrath, Alister E. *Christian Theology: An Introduction*, 5th ed. Malden, MA: Wiley-Blackwell, 2011.

McNamara, Martin. *Targum Neofiti 1: Genesis*, in The Aramaic Bible: The Targums, Vol. 1A, eds. Martin McNamara, et al. Collegeville, MN: The Liturgical Press, 1992.

Mendelsohn, I. "Slavery in the Ancient Near East," *The Biblical Archaeologist*, 9, no. 4 (Dec. 1946): 744–88.

Merrill, Eugene. "Chronology," *Dictionary of the Old Testament: Pentateuch*, eds. T. Desmond Alexander and David W. Baker. Downers Grove, IL: InterVarsity Press, 2003: 118–20.

_____. *Deuteronomy*, Vol. 4, The New American Commentary. Nashville: Broadman & Holman, 1994.

_____. *Kingdom of Priests: A History of Old Testament Israel*, 2nd ed. Grand Rapids: Baker, 2008.

_____. "A Theology of the Pentateuch." In *A Biblical Theology of the Old Testament*, ed. Roy B. Zuck. Chicago: Moody Press, 1991.

Milton, John. *Paradise Lost*, 9.424–25, accessed December 22, 2015, http://www.paradiselost.org/8-Search-All.html.

Moo, Douglas J. *The Epistle to the Romans.* New International Commentary on the New Testament. Grand Rapids: Eerdmans, 1996.

_____. "We Still Don't Get It: Evangelicals and Bible Translation Fifty Years after James Barr." Grand Rapids: Zondervan, 2014. Accessed May 17, 2016, http://www.thenivbible.com/wp-content/uploads/2014/11/We-Still-Dont-Get-It.pdf

_____. "What Does It Mean Not to Teach or Have Authority over Men (I Timothy 2:11–15)?" From the series "Recovering Biblical Manhood and Womanhood," accessed April 28, 2017, https://bible.org/seriespage/9-what-does-it-mean-not-teach-or-have-authority-over-men-1-timothy-211-15.

Moore, E. "Ruth 2: Ancient Near Eastern Background." In *Dictionary of the Old Testament: Wisdom, Poetry and Writings*, eds. Tremper Longman III and Peter Enns. Downers Grove, IL/Nottingham, England: IVP Academic/InterVarsity Press, 2008.

Moore, George F. *The International Critical Commentary: A Critical and Exegetical Commentary on Judges*. Edinburgh: T&T Clark, 1895.

Morris, Leon. *The Epistle to the Romans*. Pillar New Testament Commentary. Grand Rapids: Eerdmans, 1988.

Morris, Michelle J. "John Milton and the Reception of Eve." In *Bible Odyssey*, accessed December 22, 2015, http://www.bibleodyssey.org/en/people/related-articles/john-milton-and-eve.aspx.

Myers, Carol. *Discovering Eve: Ancient Israelite Women in Context*. New York: Oxford, 1991. Updated as *Rediscovering Eve: Ancient Israelite Women in Context*. New York: Oxford, 2012.

Nelson, Richard D. *First and Second Kings: Interpretation: A Bible Commentary for Teaching and Preaching*, Reprint edition. Atlanta: Westminster John Knox Press, 2012.

New American Commentary. Nashville: B&H, 1991–.

Newberry, Thomas and George Ricker Berry. "Luke 8:2." In *The Interlinear Literal Translation of the Greek New Testament*. Bellingham, WA: Logos Bible Software, 2004.

The NIV Study Bible, New International Version, ed. Kenneth Barker. Grand Rapids: Zondervan Bible Publishers, 1985.

Oppenheim, A. Leo. *Ancient Mesopotamia: Portrait of a Dead Civilization*. Chicago: The University of Chicago Press, 1964.

Orth, Maureen. "How the Virgin Mary Became the World's Most Powerful Woman," *National Geographic* 228, no. 6 (December 2015): 30–59.

Orth, Michael. "A Comment on 'Women and the Question of Canonicity,'" *College English* 49, no. 3 (1987): 353–355.

Ortlund, Raymond C. Jr. "Male-Female Equality and Male Headship." In *Recovering Biblical Manhood and Womanhood: A Response to Evangelical Feminism*, eds. John Piper and Wayne Grudem. Wheaton, IL: Crossway, 1991.

Patterson, Richard D., et al., *The Expositor's Bible Commentary Volume 4: 1 & 2 Kings, 1 & 2 Chronicles, Ezra, Nehemiah, Esther, Job*, ed. Frank E. Gaebelein. Grand Rapids: Zondervan, 1988.

Pederson, Rena. *The Lost Apostle: Searching for the Truth about Junia*. San Francisco: Jossey-Bass, 2006.

Phipps, William E. "Eve and Pandora Contrasted," *Theology Today* 45 (1988): 42–47.

————. "A Woman Was the First to Declare Scripture Holy," *Bible Review* (April 1990), BAS Library, accessed April 28, 2017, http://members.bib-arch.org.

Piper, John. "Affirming the Goodness of Manhood and Womanhood in All of Life," June 25, 1989, accessed December 17, 2015, http://www.desiring-god.org/messages/affirming-the-goodness-of-manhood-and-womanhood-in-all-of-life.

————. "Manhood and Womanhood: Conflict after the Fall," May 21, 1989, accessed December 17, 2015, http://www.desiringgod.org/messages/manhood-and-womanhood-conflict-and-confusion-after-the-fall.

Piper, John, and Wayne Grudem. "An Overview of Central Concerns: Questions and Answers." In *Recovering Biblical Manhood and Womanhood: A Response to Evangelical Feminism*, eds. John Piper and Wayne Grudem. Wheaton, IL: Crossway, 1991.

————, eds. *Recovering Biblical Manhood and Womanhood: A Response to Evangelical Feminism.* Wheaton, IL: Crossway Books, 1991.

Plutarch. *Advice to the Bride and Groom* and *A Consolation to His Wife: English Translations, Commentary, Interpretive Essays, and Bibliography,* ed. and trans. Sarah B. Pomeroy. New York: Oxford University Press, 1999.

Pope Benedict XIV. "De Festis Domini nostri Jesu Christi et Beatae Marie Virginis," accessed May 19, 2016, https://babel.hathitrust.org/cgi/pt?id=nyp.3 3433038469742;view=1up;seq=1.

Pope John Paul II. *Mulieris Dignitatem.* Libreria Editrice Vaticana, 1988.

Powell, Mark Allan, ed., "Magdala." In *The HarperCollins Bible Dictionary (Revised and Updated).* New York: HarperCollins, 2011.

Pritchard, James B., ed. *Ancient Near Eastern Texts Relating to the Old Testament* (ANET). Princeton, NJ: Princeton University Press, 1955.

————, ed. *Ancient Near Eastern Texts Relating to the Old Testament,* 3rd ed. *Princeton, NJ: Princeton University Press, 1969.*

The Protoevangelium of James a.k.a. *The Infancy Gospel of James,* accessed May 19, 2016, http://www.earlychristianwritings.com/infancyjames.html.

Radmacher, Earl D., Ronald B. Allen, and H. Wayne House, eds. *Nelson's New Illustrated Bible Commentary.* Nashville: Thomas Nelson, 1999.

RAINN. "Was I Raped?" accessed June 2, 2014, http://www.rainn.org/get-information/types-of-sexual-assault/was-it-rape.

Rainey, Anson F. and R. Steven Notley. *The Sacred Bridge: Carta's Atlas of the Biblical World.* Jerusalem: Carta, 2015.

Rapske, Brian. *The Book of Acts and Paul in Roman Custody.* Grand Rapids: Eerdmans, 1994.

Reed, John W. "Ruth." In *The Bible Knowledge Commentary: An Exposition of the Scriptures,* Vol. 1, eds. J. F. Walvoord and R. B. Zuck. Wheaton, IL: Victor Books, 1985.

Reynolds, John Mark, ed. *Three Views on Creation and Evolution*, Counterpoints. Grand Rapids: Zondervan, 2010.

Ringgren, Helmer. *Religions of the Ancient Near East*. Philadelphia: Westminster, 1973.

Ritner, Robert K. "The Turin Judicial Papyrus." In *The Context of Scripture*, 3 vols., eds. W. W. Hallo and K. Lawson Younger. Leiden: Brill, 1997–2002: 3:27.

Robertson, A. T. *A Manual Grammar of the Greek New Testament in the Light of Historical Research*. Nashville: Broadman Press, 1934.

Sailhamer, John H. "Genesis," in *The Expositor's Bible Commentary: Genesis–Leviticus*, eds. Tremper Longman III and David E. Garland, revised ed. Grand Rapids: Zondervan, 2008.

Sakenfeld, Katherine Doob. *Just Wives?: Stories of Power and Survival in the Old Testament and Today*. Louisville: Westminster John Knox Press, 2003.

Sanday, William, and Arthur C. Headlam. *A Critical and Exegetical Commentary on the Epistle to the Romans*, International Critical Commentary. Edinburgh: T&T Clark, 1902.

Sarna, Nahum. *The JPS Torah Commentary: Genesis*. Jerusalem: The Jewish Publication Society, 1989.

Sasson, Jack M., ed. *Civilizations of the Ancient Near East*, vol. II, 5 Vols. New York: Scribner, 1995.

————. *Judges 1–12*, Anchor Yale Bible Commentaries. New Haven, CT: Yale University Press, 2014.

Sayers, Dorothy L. *Are Women Human? Astute and Witty Essays on the Role of Women in Society*. Grand Rapids: Wm. B. Eerdmans Publishing Co., 1971. p, 68–69.

————. "The Other Six Deadly Sins," *Creed or Chaos?* New York: Harcourt, Brace and Company, 1949.

Scherman, Rabbi Nosson. *Tanach*, Stone edition—Student Size. Brooklyn: Mesorah Pubns Ltd, 2001.

Schlegel, William. *Satellite Bible Atlas: Historical Geography of the Bible*. Published by the author.

Schmandt-Besserat, Denise. "How Writing Came About," *Zeitschrift für Papyrologie und Epigraphik* 47 (1982): 1–5.

Schnelle, Udo. *Apostle Paul: His Life and Theology*. Grand Rapids: Baker Academic, 2005.

Schreiner, Thomas R. *Romans,* Baker Exegetical Commentary on the New Testament 6. Grand Rapids: Baker, 1998.

————. "The Valuable Ministries of Women in the Context of Male Leadership: A Survey of Old and New Testament Examples and Teaching." In *Recovering Biblical Manhood and Womanhood: A Response to Evangelical Feminism*, eds. John Piper and Wayne Grudem. Wheaton, IL: Crossway, 1991.

————. "Women in Ministry," in *Two Views on Women in Ministry*, eds. James R. Beck and Craig L. Blomberg, Counterpoints. Grand Rapids: Zondervan, 2001.

Schwab, George M. "Ruth." In *The Expositor's Bible Commentary: Numbers–Ruth*, Vol. 2., revised edition, eds. Tremper Longman III and David E. Garland. Grand Rapids: Zondervan, 2012.

Scorsese, Martin. *The Last Temptation of Christ.* Universal Pictures: 1988.

Segal, Eliezer. *The Babylonian Esther Midrash: A Critical Commentary*, Vol. 1. Atlanta: Scholars Press, 1994.

Shehadeh, Imad Nicola. "Ishmael in Relation to the Promises to Abraham," Th.M. thesis, Dallas Theological Seminary, 1986.

Soggin, J. A. *Judges,* Old Testament Library. Louisville: Westminster John Knox, 1981.

Speiser, E. A. *Genesis,* AB. Garden City, NY: Doubleday & Company, 1964.

_____. "New Kirkuk Documents Relating to Family Laws," *AASOR* 10 (1928–1929): 1–73.

Spence-Jones, H. D. M., ed. *St. Luke*, Vol. 1, The Pulpit Commentary. London/New York: Funk & Wagnalls Company, 1909.

Sperber, Alexander, ed. *The Pentateuch According to Targum Onkelos*, Vol. 1, The Bible in Aramaic Based on Old Manuscripts and Printed Texts. Leiden: E. J. Brill, 1959.

Spina, Frank Anthony. *The Faith of the Outsider: Exclusion and Inclusion in the Biblical Story.* Grand Rapids: Eerdmans, 2005.

Stone, Rachel Marie. "Saving Bathsheba," *Prism Magazine,* January/February 2013, accessed July 5, 2014, http://prismmagazine.org/saving-bathsheba.

Storms, Samuel C. *Tragedy in Eden: Original Sin in the Theology of Jonathan Edwards.* Lanham, MD: Rowan and Littlefield, 1985.

Strong, James. *Enhanced Strong's Lexicon.* Woodside Bible Fellowship, 1995.

Sweeney, Marvin A. *I & II Kings: A Commentary.* Westminster: John Knox Press, 2014.

Swindoll, Charles R. *Fascinating Stories of Forgotten Lives.* Nashville: W Publishing Group, 2005. Kindle edition.

Terrien, Samuel. *Till the Heart Sings: A Biblical Theology of Manhood and Womanhood.* Philadelphia: Fortress Press, 1985.

Theological Dictionary of the Old Testament, eds. G. Johannes Botterweck and Helmer Ringgren; trans. David E. Green. Grand Rapids: William B. Eerdmans Publishing Company, 1980.

Titian. *Penitent Magdalen, c.* 1531–35. Florence, Palazzo Pitti, Galleria Palatina.

Torah, The: The Five Books of Moses: A New Translation of the Holy Scriptures according to the Masoretic Text. Philadelphia: The Jewish Publication Society of America, 1962.

Toivari-Viitala, Jaana. "Marriage and Divorce," in Elizabeth Frood and Willeke Wendrich, eds. *UCLA Encyclopedia of Egyptology.* Los Angeles: The University of California Press, 2013, 1–17.

Trible, Phyllis. "Eve and Adam: Genesis 2–3 Reread," *Andover Newton Quarterly* 13 (1973): 251–58.

_____. "The Other Woman: A Literary and Theological Study of the Hagar Story." In *Understanding the Word: Essays in Honor of Bernhard W. Anderson*, eds. James T. Butler, et al., *JSOT Sup.* 37, eds. David J. A. Clines and Philip R. Davies. Sheffield: JSOT Press, 1985, 221–46.

Tsevat, Matitiahu. *The Meaning of the Book of Job and Other Biblical Studies: Essays on the Literature and Religion of the Hebrew Bible.* New York: KTAV Publishing House, Inc., 1981.

Tverberg, Lois. "*Ish* and *Ishah*—Together Fully Human," accessed 28 January 2016, http://www.egrc.net/articles/Rock/HebrewWords2/Ish&Ishah.html.

VanGemeren, Willem A., ed. *New International Dictionary of Old Testament Theology and Exegesis,* 5 vols (NIDOTTE). Grand Rapids: Zondervan, 1997.

von Rad, G. *Das erste Buch Mose: Genesis.* Göttingen: Vandenhoeck & Ruprecht, 1981.

Wallace, Daniel B. "Some Reflections on the Role of Women in the Church: Pragmatic Issues," accessed April 28, 2017, https://bible.org/article/some-reflections-role-women-church-pragmatic-issues.

Wansink, Craig S. *Chained in Christ: The Experience and Rhetoric of Paul's Imprisonments.* Journal for the Study of the New Testament Supplement Series 130. Sheffield, England, 1996.

Ware, Bishop Kallistos. *Festal Menaion.* London: Faber and Faber, 1969.

Way, K. C. *Judges and Ruth.* Teach the Text Commentary Series. Grand Rapids: Baker, 2016.

Webb, Barry G. *The Book of Judges,* NICOT Grand Rapids: Eerdmans, 2012.

Webber, Andrew LLoyd, and Tim Rice. *Jesus Christ Superstar: The Original Motion Picture Soundtrack Album.* Decca Records: 1970.

Webster's Seventh Collegiate Dictionary. Springfield, MA: G. & C. Merriam Company, 1976.

Weisberg, Dvora E. "The Widow of Our Discontent: Levirate Marriage in the Bible and Ancient Israel," *JSOT* 28 (2004): 403–29.

Wells, Evelyn. *Hatshepsut.* Garden City, NY: Doubleday, 1969.

Wells, L. S. A. "Introduction." In *The Apocrypha and Pseudepigrapha of the Old Testament in English with Introductions and Critical and Explanatory Notes to the Several Books,* ed. R. H. Charles. Oxford: Oxford University Press, 1913, 2:127

Wenham, Gordon J. *Genesis 16–50,* Word Biblical Commentary, Vol. 2, eds. David A. Hubbard and Glenn W. Barker. Dallas: Word Books, 1994.

Wesley, John. *John Wesley's Notes on the Entire Bible.* Oxford City, UK: Benediction Classics, 2010.

Westermann, Claus. *Genesis 12–36,* trans. John J. Scullion. Minneapolis: Augsburg, 1981, 1985.

Weymouth, Richard Francis. *On the Rendering into English of the Greek Aorist and Perfect: With Appendixes on the New Testament use of* gar *and of* oun. London: J. Clarke, 1903.

Wiersbe, Warren W. *Be Distinct*, 2nd ed. Colorado Springs: David C. Cook, 2010.

Wilkinson, Bruce. *The Prayer of Jabez: Breaking through to the Blessed Life*. Sisters, OR: Multnomah, 2000.

Witcombe, Charles L. C. E. "Eve and the Identity of Women," accessed January 22, 2016, http://witcombe.sbc.edu/eve-women/1evewomen.html.

Wolf, Herbert. *Judges*, Expositor's Bible Commentary, Vol. 3, ed. Frank E. Gaebelein. Grand Rapids: Zondervan, 1992.

Wolters, Al. "IOUNIAN and the Hebrew name *Yĕḥunnī*," *Journal of Biblical Literature* 127 (2008): 397–408.

Wood, D. R. W., ed. "Divination." In *New Bible Dictionary*, 3rd ed. Downers Grove, IL: InterVarsity, 1996, 270–80.

Woolley, Leonard. *Ur of the Chaldees: A Record of Seven Years of Excavation*. New York: W. W. Norton, 1965.

Wright, Christopher J. H. *The Mission of God: Unlocking the Bible's Grand Narrative*. Downers Grove, IL: InterVarsity Press: 2006.

Yamauchi, Edwin M. and Marvin R. Wilson. *Dictionary of Daily Life in Biblical & Post-Biblical Antiquity*. Peabody, MA: Hendrickson, 2014; Vol. II, 2015; Vol. III, 2016.

Yee, Gale A. "By the Hand of a Woman: The Metaphor of the Woman Warrior in Judges 4," *Semeia* 61 (1993): 99–132.

Youngblood, Ronald F. "1, 2 Samuel." In *The Expositor's Bible Commentary*, Vol. 3, revised edition, eds. Tremper Longman III and David E. Garland. Grand Rapids: Zondervan, 2009.

Youngblood, Ronald F., Richard D. Patterson, and Hermann J. Austel. *1 Samuel–2 Kings*, revised edition, eds. Tremper Longman III and David E. Garland. Grand Rapids: Zondervan, 2010.

Zahn, Theodor. *Der Briefe des Paulus an die Römer*. Leipzig: A. Deichert, 1910.

Zlotowitz, Rabbi Meir. *The Book of Esther: A New Translation with a Commentary Anthologized from Talmudic, Midrashic and Rabbinic Sources*. Brooklyn: Mesorah Publications, Ltd, 1989.

Zodhiates, Spiros. *The Complete Word Study Dictionary: New Testament*. Chattanooga, TN: AMG Publishers, 2000.